TREASURES FROM THE RIETBERG MUSEUM

TREASURES
FROM THE
RIETBERG MUSEUM

by Helmut Brinker *and* Eberhard Fischer

THE ASIA SOCIETY
In association with John Weatherhill, Inc.

TREASURES FROM THE RIETBERG MUSEUM is the catalogue of an exhibition shown in Asia House Gallery in the spring of 1980 as an activity of The Asia Society to further understanding between the peoples of the United States and Asia.

© The Asia Society, Inc., 1980

This project is supported by grants from The Friends of Asia House Gallery, the Andrew W. Mellon Foundation, and the National Endowment for the Arts, Washington, D.C., a Federal agency. Indemnity for the exhibition was provided by the Federal Council on the Arts and the Humanities.

Library of Congress Cataloguing in Publication Data:

Brinker, Helmut.
 Treasures from the Rietberg Museum.

 "Catalogue of an exhibition shown in Asia House Gallery in the spring of 1980."
 1. Art, Asian—Exhibitions. 2. Zürich. Museum Rietberg —Exhibitions. I. Fischer, Eberhard, 1941- joint author. II. Zürich. Museum Rietberg. III. Asia House Gallery, New York. IV. Title.
N7262.B74 709'.95'07401471 80-12528
ISBN 0-87848-055-2

Contents

Foreword

I WAS DEEPLY PLEASED when I heard that the small but universally popular Rietberg Museum of the city of Zürich had been invited by The Asia Society to exhibit selected masterpieces in the Asia House Gallery, New York, and in the Asian Art Museum of San Francisco. We are grateful to these institutions for agreeing to assume all the costs of the exhibition. The project appears sensible to me because it will enable those Americans interested in Asian art who cannot come to Zürich to see at least part of our collection, and may stimulate others to travel to Zürich to visit both the museum and the city.

With Eberhard Fischer, director of the Rietberg Museum, and Helmut Brinker, curator of the museum's East Asian department, I would like to thank Allen Wardwell, director of Asia House Gallery, for his initiative and the excellent handling of the exhibition and the catalogue. Collaborating on the intensive preparatory work in Zürich have been photographers Isabelle Wettstein and Brigitte Kauf, and the museum's secretary Edith Schacher. The preparations for the shipping of the objects to the United States have been made by Paul Pfister of the Kunsthaus Zürich and Ernst Bär of the Rietberg Museum. The staff of Asia House Gallery have made arrangements for the exhibition with thoughtful care and efficiency, and I am grateful to Sarah Bradley, assistant director of the Gallery, for editing and coordinating production of the catalogue.

I would also like to express my gratitude to all those who during the twenty-eight years of the existence of our museum have helped to publicize its collections, scholars whose publications have been a great help in the writing of this catalogue, especially Osvald Sirén and J. E. van Lohuizen-de Leeuw who prepared catalogues of the Asian collections, Elsy Leuzinger who wrote the museum's handbook, and Jean Boisselier and B. N. Goswamy whose articles have appeared in *Artibus Asiae*. The authors of this catalogue wish to acknowledge the help of the following friends and colleagues: Terukazu Akiyama, Fumiko E. Cranston, Anand Krishna, Bunsaku Kurata, Nilamani Mishra, Taka Yanagisawa, and Joanna Williams.

Even though a large part of the Rietberg Museum's collections, comprising the arts of Africa, ancient America, and Oceania, has not been represented in the selection, I am very pleased with the attention directed to our museum in America by means of this exhibition. Perhaps this event may also stimulate interest in the treasures of the Rietberg Museum at home and increase understanding of the need to enlarge its facilities.

DR. SIGMUND WIDMER
Mayor of Zürich

Preface

ALMOST EXACTLY TWENTY YEARS AGO, during its first year, Asia House Gallery opened an exhibition of "Gandhara Sculpture from Pakistan Museums." It was the first of a series of exhibitions that served to show Asian treasures from museums that were not well known or easily accessible to Americans. Since then, we have shown "Treasures of the Kabul Museum," "Selections from The Kempe Collection" in the Ekolsund Museum, Sweden, "Ancient Indonesian Sculpture" from the museums of Indonesia, and "Rarities of the Musée Guimet" in Paris. The exhibition of "Treasures from the Rietberg Museum" is thus part of a long established tradition.

The idea of this particular collaboration was one result of a five-day seminar that took place at the Aspen Institute, Berlin, in May 1978. Twenty specialists of Asian art history from the United States and Europe met to discuss mutual concerns and interests. One of the recurring themes of the meetings was the need for greater cooperation and communication between sister institutions across the Atlantic. The fact that Lionel Landry and myself as representatives of The Asia Society and Professor Helmut Brinker of the Rietberg Museum participated in the seminar led to close contact between two of these institutions and has been one of the most tangible results of the meetings.

Because of the great efficiency of the Rietberg Museum's director, Eberhard Fischer, and curator of East Asian art, Helmut Brinker, this project was brought to completion in a very short period of time. It has been a pleasure working with them and thanks to their hard work the entire effort has been free from the problems that accompany most other international loan exhibitions of this nature. Indeed, it is hard to believe that it was only in October 1978 that I telephoned Professor Brinker to ask with some trepidation if it might be possible to bring a selection of the great Asian pieces from his museum to our country. As the reader of this catalogue will soon understand, however, the success of this project is due not only to efficiency but also to enthusiasm combined with a deep knowledge and love of the collection. We are also grateful to Dr. Sigmund Widmer, mayor of Zürich, whose initial and continuing support has been indispensable.

In a certain sense, what we present here can be looked upon as a microcosm of the museum's Asian collections. The objects have been selected to show the relative strengths of the Chinese, Japanese, Indian, and Southeast Asian holdings, and the great majority have been taken from display rather than storage. Although a number of the pieces assembled by Baron von der Heydt are well known and have been part of the collections since the opening of the museum in 1952, many others are published here for the first time. New acquisitions from such sources as Dr. Alice Boner, Heinz Brasch, C.A. Drenowatz (whose collection of Chinese paintings was given to the museum only last year), Gret Hasler, Mary Mantel-Hess, J.F.H. Menten, and Dr. Pierre Uldry are included with other objects that have been purchased. One interesting aspect of the museum's recent history of acquisitions has been the way in which the collections have become enriched by paintings. What has always been regarded as first and foremost a museum of sculpture must now be thought of in broader terms.

There were, of course, certain objects that simply could not be sent to the United States because of their fragile condition or because they are rightly regarded as "pilgrimage pieces," that is, those that people from around the world go to the museum to see and expect to find in Zürich. Also, it is important to point out that the Rietberg is much more than a museum of Asian art. As the only museum of non-European art in Switzerland, its purview includes the art of Africa, pre-Columbian America, the American Indian, Oceania, and Egypt. There are, therefore, many surprises and satisfactions awaiting the visitor in Zürich besides those that may be encountered here.

To bring this survey to America required even more than the great willingness and enthusiasm of those we have already mentioned. We are grateful to Swissair and its president, Armin O. Baltensweiler, for considerable assistance, and to the Andrew W. Mellon Foundation for a generous, continuing grant that has underwritten part of the costs of producing this catalogue. The Friends of Asia House Gallery, an organization which has supported many exhibitions and projects of the Gallery for the past fifteen years, has chosen to make a welcome general assistance grant to this exhibition, and The Starr Foundation continues to help with installation costs. We have received an Aid to Special Exhibitions Grant from the National Endowment for the Arts. Additional and sorely needed government support for the exhibition came from the Federal Council on the Arts and the Humanities, which agreed to indemnify the loans against damage or loss.

Once again the staff of the Gallery has performed with skill, diligence, and efficiency in carrying out the many details of this enterprise. Specifically, I thank assistant director Sarah Bradley for her fine editing of the catalogue and the attention she has given to many facets of this exhibition, registrar Terry Tegarden for the careful shipping, packing, and security arrangements and the detailed condition reports she has made, program associate Mahrukh Tarapor for the additional educational activities that were prepared in conjunction with the exhibition, publicity coordinator Kay Bergl for keeping up with the demands of the press for information, and secretaries Peggy O'Neill and Carol Lew Wang for coping with the inevitable paperwork. We are also indebted to Peter Glum and Rika Lesser for their skillful translation of a large part of the catalogue text from German. Mr. Glum was responsible for the introduction and entries 26–34, 37, 49, 50, 54, 57; Ms. Lesser translated entries 1–25. Andrea Miller cheerfully assisted us in preparing the manuscript for publication. Once again Cleo Nichols and his installation crew have met the challenge of designing and constructing a proper setting for these fine but diverse objects.

Lastly, I wish to thank Yvon d'Argencé, Director, and the other members of the staff of the Asian Art Museum of San Francisco, The Avery Brundage Collection for their enthusiastic interest and collaboration which enabled the exhibition to travel to their museum.

ALLEN WARDWELL
Director
Asia House Gallery

Introduction: Museum Rietberg Zürich

by Eberhard Fischer

IN THE FOLLOWING I am going to introduce our Rietberg Museum. I hope I will be forgiven if I am unable to detach myself enough and sometimes praise the merits of this beautiful museum too much; after all I have to stand up for it every day. The American reader may think that I consider it to be one of the new wonders of the world, a Swiss Metropolitan Museum as it were. Well, the Rietberg Museum is the place where I work, and I do like it—and I also very much appreciate being able to live in cosmopolitan Zürich. Because I am not Swiss, I have ever since my childhood considered everything Swiss to be superb, better, more accurate and polished, and Switzerland to be a European country of manifold possibilities. In this small country, however, it is all too easy to forget the scale and to compare this city with others of much larger dimensions and greater cultural potential. We must not forget that Zürich has about 400,000 inhabitants and that the entire canton of Zürich has only about a million. The Rietberg Museum is also small; it houses approximately 4,500 works of art, of which about 1,130 are on permanent display in 20 rooms.

I shall try not to bore the reader unduly with dates, lists of patrons, and descriptions of the collection. Yet I think it might interest him to hear something about the history and organization of a small museum which was founded twenty-eight years ago. Perhaps visitors to the exhibition may then ask themselves at what expense this much has been achieved, and generous founders of museums or collections may be able to draw their own conclusions about maintenance costs, growth potential, and future needs. For this reason I shall also give some information about local administrative structures, internal organization, and the like which is not customary.

The Rietberg Museum (pronounced "Reetberg") in Zürich is the only museum in Switzerland devoted to non-European art. But it also has a few works of Greek antiquity, some Romanesque and Gothic sculptures, Flemish tapestries, and a collection of Swiss masks, and thus the collections constitute a potential nucleus of a "museum of world art." Unlike an ethnological museum which shows works revealing aspects of a culture, the Rietberg Museum contains works of non-European cultures that have been chosen and exhibited exclusively according to aesthetic criteria which make their function and meaning almost a secondary consideration. Of course many Swiss museums have non-European material. The Völkerkundemuseum in Basel certainly owns superb works of art from Melanesia and ancient America, the Völkerkundemuseum of the University of Zürich has a Tibetan collection important for the history of religions and, among other things, exquisite African sculptures. One of the focal points in the Historisches Museum in Bern is an impressive Islamic collection, while the Musée d'Ethnographie in Geneva has important material on the cultures of the American Indians and the one in Neuchâtel arranges imposing exhibitions. In addition to the ethnographical museums, most of which were established in the nineteenth century, Switzerland also has a few specialized collections of non-European art, such as the Baur Collection of East Asian ceramics in Geneva, the (private) Barbier-Müller Collection of primitive art in Geneva, and the Abegg Foundation in Riggisberg near Bern, specializing in textiles and European and non-European arts and crafts.

Many Swiss cities have good museum collections, the most numerous being in Basel, and usually these museums were founded with donations of private collections (although in Switzerland such donations are not tax deductible to the extent that they are in the United States). The Schweizerisches Landesmuseum (a federal institution of Switzerland), housing exclusively cultural objects directly related to Switzerland, is located in Zürich, where we also find the Kunsthaus (sponsored by an art society and subsidized by the city and the canton) that is focused on Swiss painting, Impressionism, and modern art, and stages large international exhibitions. Furthermore, the Kunstgewerbemuseum (a department of the Kunstgewerbeschule of the city of Zürich) has collections documenting European stylistic trends, and a branch for exhibitions, the Museum Bellerive. The University of Zürich houses several collections open to the public, such as the above mentioned Völkerkundemuseum, the Archäologisches Museum, the Medizinhistorische Sammlung, and several science collections. Zürich also possesses various municipal exhibition halls (Helmhaus, Kunstkammer zum Strauhof, Stadthaus), and collections of graphic arts (Eidgenössische Technische Hochschule, Zentralbibliothek), as well as the Indianermuseum that had its origin in the systematically organized collection of G. Hotz. In addition to various libraries and archives there is also the Bührle Foundation, a collection of renowned Impressionist paintings. All these are independent institutions loosely connected in the Museums Association.

The Rietberg Museum was founded in 1952 and is thus one of the youngest museums in Zürich. It is also the only one that is directly subordinated to the office of the mayor of the city. "Rietberg" is the actual name of the area and this locally well-known and neutral name was consciously chosen because it would not limit the scope of the museum and would leave room for further growth. Even Baron von der Heydt, the most important donor to the museum since its foundation, magnanimously renounced giving it the name of his family and merely expressed his wish that the "uniform character" of the collection be maintained.

As a collector, the baron highly valued the image of the dignified and exalted human being (be it in the various images of the Buddha or in African sculptures). This gave his collection a certain homogeneous character in spite of the variety of art styles. For the same reason, these monumental works, often of archaic simplicity, fit in, at least in their formal aspect, with the sober, unpretentious, and severe tradition of Zürich that was shaped by austere Protestantism and excludes the amusing, eccentric, and playful. Baroque art, the expression of the Counter-Reformation in Europe, never took root in Zürich. "Nudes and saints" were, and really still are, taboo in the art and environment of Zürich. Therefore—and of course for many other reasons—the Rietberg Museum fits well into the city. Yet during the twenty-eight years of its existence it has not become one of the locally favored museums in Zürich. This, I think, can only be explained by the lack of information on the cultural history of the world presented in our schools. The "value" of the museum is known in Zürich, but because of lack of knowledge people do not venture into it, and this in spite of the fact that it offers so much even to the visitor without a worldwide cultural background. The number of visitors to the main building in one year does not reach 30,000. The majority of the visitors are foreigners (mostly from Germany, America, and Japan). Moreover, the visitors to the evening programs constitute an important part of this number. It is surprising that "Zürich society" contributes generously to the growth of the collections of the Kunsthaus and particularly likes to donate modern paintings, while only a relatively small, almost exclusive circle patronizes the Rietberg Museum. Once their interest is caught, however, the members of this group participate regularly in events at the museum (but the "East Asians" show hardly any interest in African topics and vice versa). The patrons of the Rietberg Museum also contribute generously to the cause, not because this is considered chic or social in Zürich but because they have a firm commitment to the institution, and they too have decided preferences for certain art forms, styles, and philosophies.

The international appreciation of the Rietberg Museum is mainly focused on the von der Heydt Collection, which even after twenty-eight years of the development of the museum surpasses in quality and quantity most of the collections and single works added since. Who was von der Heydt, the man and the collector?

Baron Eduard von der Heydt

Baron Eduard von der Heydt was born in 1882 in Wuppertal-Elberfeld, then one of the wealthiest cities in Germany. His father was a partner in an important banking house, and also a collector and a patron of the local museum. After studying economics and graduating with a Ph.D. in political economy, von der Heydt worked for a year in a private bank in New York, then as a banker in London from 1901 to 1914, and after 1920 in Amsterdam and Berlin. He acted as financial adviser to the German emperor Wilhelm II, exiled in the Netherlands, and to the industrialists August Thyssen and Hugo Stinnes. For a short time he was married to Vera von Schwabach, a psychotherapist; they had no children. From 1926 on he led a hospitable life in or near the elegant hotel Monte Verità, near Ascona, which he owned, and in 1936 he became a Swiss citizen. Ever since his youth he had been collecting, especially Asian art, and in 1952 he gave his collection to the city of Zürich for the newly founded Rietberg Museum; his collection of European paintings and considerable estate were left to the "Von der Heydt Museum" in Wuppertal, his native city. This important patron of the arts died in 1964, rather lonely, in Ascona.

Eduard von der Heydt was the scion of a wealthy cosmopolitan banking family of northern Germany with artistic interests (his great-grandfather had been minister of finance in Prussia under Bismarck). In his student days he seriously studied the philosophy of Schopenhauer, which led him into the orbit of Indian thought. He knew that Schopenhauer had a small statue of the Buddha in his study. For this reason von der Heydt acquired a head of the Buddha in stone in Amsterdam in 1908, less for its aesthetic appeal than for the literary associations it evoked. But then he became fascinated by the world of the Buddha. Not only did he read works on Indian philosophy but he also began to collect various types of images of the Buddha. He acquired the collection of the Sinologist Raphael Petrucci. As early as 1924 he had his Asian collection published by Karl With and arranged it in his house in Amsterdam in such a fashion that the public could be given access to it. He always wanted to know the meaning of the sculptures and wanted to learn more about the spirit that emanated from them. Art was never merely decor in his environment, even though he enjoyed living in elegant rooms filled with works of art. Yet he thought art should never become a substitute for religion. Furthermore, von der Heydt believed that an individual had the right to own important works of art but that these ought to be always accessible to the

public. This is the reason for the recurrent publications of his collection (1932 by William Cohn and Eckart von Sydow). He asked scholars to study his collection because he himself wished to deepen his views and his knowledge of cultural history, and to develop his aesthetic judgment. He was well informed about the art historical research of his time, as the many books and articles he read and marked with his heavy lead pencil attest. He also wrote several articles for popular periodicals. Until his old age those things that ultimately supported or only slightly modified Schopenhauer's *Weltanschauung* interested him most; this shows how seriously he had studied the works of this philosopher as a student and how deeply he had become involved. Baron von der Heydt was a conservative, a German nationalist and royalist, even though he spent most of his life outside of Germany. He never sympathized with Nazi ideology.

Of course, von der Heydt was a banker, and a successful one. But he never looked upon his collection as an investment. His passion for art was as genuine as his pleasure in making a good bargain. Asked by a journalist why he had collected Asian art, he could answer that he had done it because in his time (especially in 1926 in France) prices for this kind of art had been "ridiculously low." But behind such an answer he was hiding his emotional involvement, and in the manner of a gentleman, he evaded a question that touched him personally. Altogether, he is usually described as a reserved man who was very discreet about his private affairs. His inscrutable smile was proverbial. In Ascona he was nicknamed "the Buddha from the Mountain of Truth (Monte Verità)." Memoirs of visitors often praise his talent for conversing with each guest on a suitable topic, and record that he not only found arguments embarrassing but fundamentally abhorred them. He was a man of compromise and disliked taking sides.

More important than all this, however, is the fact that von der Heydt collected Chinese sculpture at a time when only Chinese porcelain was generally collected and appreciated for its tasteful craftsmanship, that he bought Indian sculptures not as illustrations to the history of religions but for their strange beauty, and that he was one of the first to acquire African sculptures and Swiss masks. He was independent in his judgment, generous, and made up his mind quickly. He had no definite advisers but was a friend of many scholars (to whom he remained loyal in times of hardship), and he liked to buy from respected art dealers. It seems that he never asked at first for the date or place of origin of a piece but tried to determine whether it was an original artistic creation. He never collected typological series or variants of a style, and never strove to fill in lacunae of certain art forms in his collection. At an auction in Paris he was capable of bidding twice as much for an African sculpture from the grassland of Cameroon as for a Benin plaque because the composition of the sculpture was full of movement and he knew only static works from that area. In another case, a torso might have interested him more than its complete counterpart. Although he had a wide range of interests—a Chinese *T'ao-t'ieh* could excite him as much as a mask from the Lötschental—his personal preference was for the image of the dignified man, especially that of the authoritative Buddha. The grotesque, the fanciful, the effeminate, the quaint, the elegant, eccentric, or mannerist, all these did not interest the very reserved, conservative, aristocratic von der Heydt. Nor did he show interest in or collect works that displayed only technical perfection—effective, theatrical, merely iconographically interesting, or rare works—if they did not satisfy him aesthetically. That his sensibility was often touched by works of archaic periods may have been a coincidence, for he never bought a piece because it had an early date. His collection contains, for instance, a surprisingly large number of late medieval sculptures from Rajasthan, India. It also seems that he had a preference for sculpture; he owned many European paintings and some East Asian hanging scrolls but no Indian or Islamic miniatures.

Baron von der Heydt himself never went to Africa or Asia. He bought only from dealers, mainly in Paris (P. Mallon, C.T. Loo), Amsterdam, and London. He preferred offers from the large, well-known dealers to bargains, and rarely trusted the lucky find. When he acquired a larger work (or a collection) he often left it on long-term loan in a museum in the city where the work just happened to be, or in a museum that he knew would particularly appreciate it. Sometimes he bought a whole collection already on loan to a museum and left it there under his name (as, for

instance, the Nell-Walden Collection in Bern). This was not only expedient but also guaranteed a distribution of risk. His parents' important collection of Impressionist paintings had been completely destroyed in their house during the First World War, and he intended to prevent a similar disaster. During World War II his collections were distributed among thirty museums. Only his collection of Ordos bronzes in Vienna was destroyed, and a few Chinese sculptures were lost in Berlin.

In 1952, when the Rietberg Museum was founded with his loans and it was legally arranged that his entire collection of non-European art had to be exhibited together, most of his loans to other museums were withdrawn. For many curators this was quite annoying; others returned the loans only under legal pressure. To a very few museums the baron gave some of the pieces, among them the Rijksmuseum voor Volkenkunde in Leiden, or let them have things he considered to be unimportant, as in the case of a few ethnological museums in Switzerland. Other museums suddenly discovered that they had serious gaps in their collections. The Schweizerisches Landesmuseum in Zürich, for instance, has only a modest collection of Swiss masks because the large collection of Baron von der Heydt had been stored and partially exhibited there for decades. Every curator knows how easily one becomes accustomed to considering loans as part of a museum's collection and forgets to acquire similar works. Their disappearance creates a painful wound that cannot immediately be healed. No one likes to return loans: just last year I selected "von der Heydt loans" from among works from Melanesia in the Historisches Museum, Bern, for an exhibition in Zürich and then discovered in the museum's archives that in 1952 the curator had been "unable to find" these attractive trifles. Perhaps the most important portions of the von der Heydt Collection, Chinese works of art, among them the larger stelae, had in 1950 been stored in East Berlin. The first director of the Rietberg Museum obtained the cooperation of the German Democratic Republic by means of a special gift. He sent president Wilhelm Piek the tea glass, strainer, and butter knife used by Lenin in 1916-1917 when he was living in Zürich, which had been acquired from the estate of his landlord, and thus obtained the permit to export these works of art worth millions.

In 1937, before the war, Baron von der Heydt had become a Swiss citizen. Since 1926 he had maintained his permanent residence in Ascona in the Ticino. His estate in the Netherlands had been blown up by the German army, and after the war he was classified there as a victim of the German occupation. The United States is the only country in the world that refused to return works of art to the Rietberg Museum. These had been bought by Baron von der Heydt during the war and deposited in the Buffalo Museum of Science. It was alleged (hitherto without proof and, according to the baron, on the basis of false affidavits by double-dealing spies) that he had financially supported German intelligence through the August Thyssen Bank in Zürich that was controlled by Dutch interests and in which he as well as the Hungarian Thyssen had a share. During the trial, the American museum directors had rightly declared that the pieces were peerless works of art and that it was in the national interest to keep them. The verdict (Public Law 89-503, 89th Congress, S.2266, July 18, 1966), reached after some exonerating documents disappeared during the trial, may perhaps become of interest to historians. Baron von der Heydt considered it sheer robbery not only because he lost his property, but more so because he was wrongly given the insulting label of a helper of the Nazis. I must confess that I myself find this allegation, which is most likely unjustified and is morally damaging, quite irritating, and that I should like to obtain more detailed information from an impartial source. The Asian sculptures may well remain in the Freer Gallery of Art where they honorably represent Swiss collectorship.

There are many reasons why von der Heydt, after making a loan agreement in 1948–1949 and a bequest agreement, finally donated his non-European works of art to the city of Zürich in a deed of gift. This was not at all an obvious choice because Zürich had hardly played any role in his life. He never lived there, and it had not been a focal point of his financial transactions. A few threads in the web of causes which we will never understand completely may have been the following:

The architect Alfred Altherr senior (1875–1945), for many years director of the Kunstgewerbeschule and the Kunstgewerbemuseum in Zürich, had been a friend of the von der Heydt family since 1904, when he taught at the Kunstschule in Elberfeld where they lived, and had designed and built a home for them. Altherr returned to Zürich in 1912. Beginning in the early 1920s Alfred Altherr placed works of Asian art loaned by von der Heydt on permanent display in the Kunstgewerbemuseum; these were augmented in 1932 by the important South Indian bronzes from the von der Heydt Collection. Through the scholarship of the German ethnologist and Japanologist Ernst Grosse, a wider audience in Zürich became interested in Asian art; Grosse taught for some time in Basel and lectured in Zürich, and with his stimulating knowledge became a pioneer of the appreciation of East Asian art and culture among his large circle of friends in Switzerland. From 1932 on, Altherr arranged various special exhibitions of Chinese porcelain, shadow puppets, East Asian household implements (a memorial exhibition for Ernst Grosse), the art of India, East Asian paintings, Japanese architecture, Indonesian textiles, and other Asian art forms, but he also showed prehistoric rock paintings of South Africa and the works of primitive art in the collection of Eduard von der Heydt (in a selection made by Eckart von Sydow). In many of his exhibitions Altherr was able to make use of loans from Ascona. After his retirement Altherr and his son Alfred Altherr junior were also welcome and frequent guests at the Monte Verità in Ascona.

Altherr's successor, Johannes Itten, director of the Kunstgewerbeschule and museum from 1938, also became a lifelong friend of Baron von der Heydt, although their relationship began with strong dissonance. When Itten tried to find additional space for his first special exhibition and wanted to put a few loans from the baron temporarily in storage, he got a vehement reaction from Ascona. If his collection were not exhibited in its entirety, i.e. not appreciated in Zürich, the baron would withdraw everything at once. Itten pacified him with a letter saying that these loans were a "necessity" for Zürich, that he would immediately exhibit all the pieces again, and that the planned special exhibition would be reduced in size, and he promised "never to change the exhibit without your consent." Von der Heydt left his loans in Zürich.

Johannes Itten, one of the great artists of concrete painting, a former disciple of Adolf Hölzel and later a teacher at the first Bauhaus in Weimar, participant in the exhibition of the "Sturm," and founder of unconventional art schools in Vienna and Berlin, was open minded and appreciated all styles of art. In 1932–1937, he had employed two Japanese ink painters of the Nanga school as teachers in his school in Berlin and had himself experimented with the technique. In his educational publications he had also analyzed a Chinese painting (the Arhat Vanavāsin by Mu-ch'i), and he was interested in the structural principles of African art. Therefore, he continued the series of exhibitions of non-European art in Zürich: arts of Asia in 1941, modern Chinese painting in 1942, Chinese rubbings in 1944, and African art in 1945. In 1948 he asked Alfred Salmony, a longtime friend and adviser of Baron von der Heydt (professor at the Institute of Fine Arts of New York University and editor of *Artibus Asiae*), to write the catalogue of the collection of Chinese ceramic figures of J.F.H. Menten (not identical with the Nazi art collector).

During the war years, when Switzerland and with it the commercial and financial center Zürich were cut off from the free world, there appeared in this rather cosmopolitan city a provincial narrowness, supported by the legitimate fear of aggressive neighbors and increased by the often encountered parochial feelings towards all "non-Swiss." At that time, Itten realized that exhibitions of non-European art were particularly important. Those that he arranged had a local success even greater than our recent exhibitions of gold treasures which created such a stir. The exhibition "Art of Asia," held in 1941, was an especially notable event that brought various collectors together, attracted a large audience, and may even have caught the attention of the city council. The most numerous loans came from von der Heydt. It is possible that the idea of creating a museum of non-European art in Zürich was conceived shortly after that, perhaps because there was a strong interest in transforming this exhibition into something permanent. Such a plan was vigorously supported by both Alfred Altherr and Johannes Itten, and was eventually combined with von der Heydt's wish to find a museum for his collection.

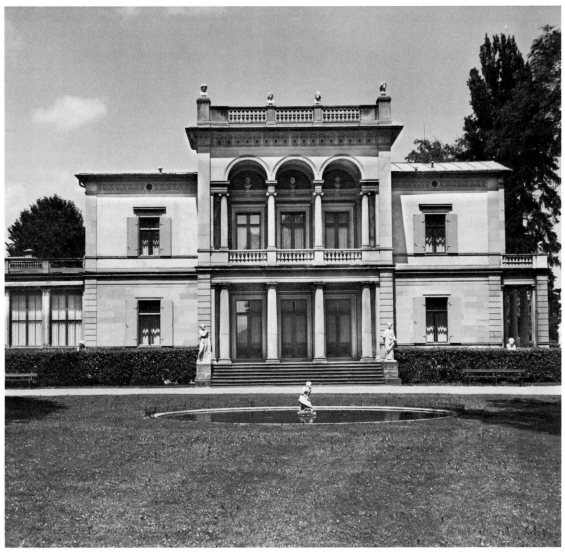

Museum Rietberg Zürich

It seems that in the late 1930s Baron von der Heydt was already inspecting various villas in Zürich in order to find a place for exhibiting his collection. In 1945 it was decided to use the Villa Wesendonck in the Rieterpark, which had been acquired by the city. Adolf Lüchinger, then mayor of the city, concluded a loan agreement with von der Heydt. But first the citizens had to approve the project. All parties (except the Communist Party) supported the "International Museum." The population voted for it, and the architect Erwin Gradmann was commissioned to remodel the villa into a museum. The house had been built in 1857 by the architect Leonhard Zeugheer for Richard Wagner's friends Otto and Mathilde von Wesendonck. It was a center of Zürich society where not only Wagner but also Franz Liszt and Johannes Brahms were guests. The neoclassical building with its pleasing proportions and its manorial situation in a large park seems to have been predestined to become an intimate museum, although it still lacks a large-scale area for special exhibitions. Mayor Emil Landolt and Bundesrat Ernst Nobs persuaded von der Heydt to make a permanent donation of his collection. The solemn opening of the Rietberg Museum took place on May 24, 1952. The collection had been installed by Johannes Itten and his wife. After his retirement from the Kunstgewerbemuseum, Itten was director of the Rietberg Museum for another four years, until 1956. This creative, courageous artist, who was farsighted enough to imagine a museum encompassing the arts of the entire world, was able to recognize aesthetic qualities also in the art

forms of foreign cultures and knew how to put them into the right light. He created a display rich in contrasts, not only arranging objects according to cultures, their chronology or stylistic development, but freely mixing in one room works from different continents into "system groups" of impressionist, constructivist, or expressionist formal treatment.

But after Itten had spent a few years mainly occupied with the task of assembling the scattered collections, which required much tact and perseverance, his age forced him to retire to his studio. He was succeeded by Professor Elsy Leuzinger, a specialist on non-European art who had written her dissertation for the Ph.D. at the University of Zürich on African jewelry and had subsequently written a substantial book on African art. During the many years that she was curator at the Völkerkundemuseum of the University of Zürich, she rapidly became acquainted with the manifold areas of non-European art history through scholarly research as well as extensive travel. She also became one of the rare few in Europe to teach this subject as professor at the university's Institute of Art History. At the Rietberg Museum she began the task of classifying the objects and started inventory ledgers, card files, photographic files, and rearranged the rooms according to styles and cultures. Meanwhile donations and purchases had increased the inventory to such an extent that this became possible and even necessary. According to her plans scholarly catalogues were written by experts and were published, richly illustrated, bilingually in English and German; the Chinese sculptures by Osvald Sirén (Stockholm), the Indian sculptures by J.E. van Lohuizen-de Leeuw (Amsterdam), the African sculptures by herself, the art of Oceania by Alfred Bühler (Basel), that of the American Indians by Wolfgang Haberland (Hamburg). She also wrote a "guide-book," which was published in German, English and French, presenting a general view of the various realms of art represented in the Rietberg Museum and information on specific groups of objects.

In 1958, because of Professor Leuzinger's initiative, the activities of the Rietberg Society, an association of friends and patrons of the museum founded in 1952, were expanded. She organized monthly lectures or tours of the museum for the members and their guests, and arranged the first performances of Indian dances and classical non-European music, as well as demonstrations of Ikebana and other arts. The director of the museum serves as Secretary of the Rietberg Society, and the secretary of the museum also handles the society's paperwork; the finances are managed free of charge by the Schweizerische Kreditanstalt. The board of trustees consists of Zürich collectors and connoisseurs of non-European arts. Hitherto, the only honorary president has been Baron von der Heydt. Honorary members include the following donors and supporters of the museum: the late Julius Mueller; the late Johannes Itten; the late Willy Boller; the late Charles A. Drenowatz; Ernst Gamper, the longtime manager of the Society's finances; Dr. Martin Hürlimann; Dr. Emil Landolt; and, after her retirement, Professor Elsy Leuzinger. Corresponding members are Professor J. E. van Lohuizen-de Leeuw, Amsterdam; Professor Edith Porada, New York; Heinz Brasch, Zürich; Professor Alfred Bühler, Basel; Professor Roger Goepper, Cologne; and Professor Dietrich Seckel, Heidelberg. As presidents of the Rietberg Society, Dr. H.A. Mantel-Hess, Dr. Martin Hürlimann, and, since 1975, Dr. Pierre Uldry have rendered great service to the museum, as have vice presidents Dr. Fritz Rieter and Dr. Willy Staehelin.

The present appearance of the Rietberg Museum in the Villa Wesendonck, as a museum that has both the intimate character of a private gallery and the ambition of being an informative museum of non-European art, is the work of Elsy Leuzinger, although some minor changes have been made in recent years. Since 1972 when she retired, the museum has grown, especially through the loan of the important collection of Chinese paintings of Charles A. Drenowatz, transformed into a gift in the summer of 1979. This has given the museum a new focal point, which is balanced in the Indian section by an anonymous loan of an exquisite collection of Rajasthani and Pahari miniatures of excellent quality. All this has caused minor rearrangements in the museum; but there has been and continues to be a need to enlarge the space for display. In the rooms of the Villa Wesendonck, the works of art are crowded, the vitrines too full, the newly painted walls are covered with pictures and rugs. In order to demonstrate to the citizens of Zürich the possibility of

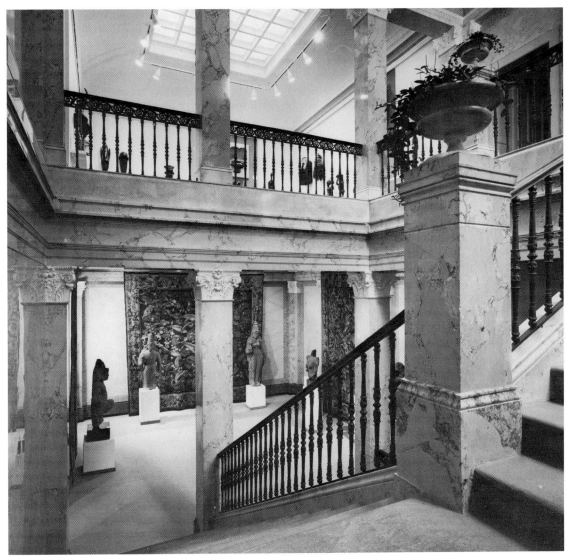

Main staircase, Museum Rietberg Zürich

gaining a better understanding of transoceanic cultures through non-European art, every year since 1972 we have presented progressively larger special exhibitions in the Helmhaus of the city of Zürich. Most of these we have produced ourselves, often after several years of collaboration with foreign colleagues or after personal field trips. These exhibitions include: "Traditions of Art in North India" (with Haku Shah), "The Art of the Jaina" (with Dr. Jyotindra Jain), "Tantra" (a travelling exhibition), "Art from Mexico" (with Dr. Gerhard Baer), "The Art of the Dan" (with Dr. Hans Himmelheber), and "Sculpture from Japan" (a travelling exhibition). Some of our exhibitions went on tour to Basel, Bern, Vienna, Cologne, and other cities because they could never be shown for more than six weeks in Zürich, which in many cases would not have justified the great effort involved in organizing them. In 1974, we acquired an annex in the "Haus zum Kiel" in the center of the city right next to the Kunsthaus. Here there is a beautiful hall decorated with stucco and paintings in 1776 by Valentin Sonnenschein and several neighboring rooms where we can at least periodically show some works not on permanent display. We hold three small exhibitions per year in the annex, such as "Gold in the Arts of East Asia," "Gold in the Arts of West Africa," "Bronzes from Ancient China," "Textiles from Egypt," "Poetic Painting—Painted Poetry," "The Lion as a Symbol of Power," and "Chinese Fan Paintings." These were organized alternately by my

colleague Helmut Brinker and myself. We also use these rooms for exhibitions of collections of other museums that are ordinarily inaccessible; for instance, in the fall of 1979, we showed works of art from Africa and Melanesia from the Historisches Museum in Bern. Two years ago the Rietberg Museum obtained a third area for exhibitions in the Villa Schönberg, which so far has only been partially renovated. It is directly next door to the Villa Wesendonck, was built at the end of the last century, and lies in a beautiful small park that formerly contained the garden pavillion where Richard Wagner once lived and was inspired by his friendship with Mathilde Wesendonck to write *Tristan and Isolde.* Plans for subterranean exhibition halls connecting both villas already exist, and currently Japanese woodblock prints, Indian miniatures, and Oriental rugs from the Rietberg's collections are exhibited in the Villa Schönberg. In the attic, offices have been built, including one for the "Dr. Alice Boner Foundation" for research on the *Śilpa śāstra* texts of India, the traditional manuals for Hindu artists.

Thus in recent years the exhibition potential has been vastly enlarged, based on the experience that local interest in the museum can only be kept alive by special exhibitions. We have also increased our lecture programs, for in Zürich there is a great interest in educational activities, and we can find an audience for lectures in German and French, as well as in English. Every year we also have about ten concerts of non-European music, demonstrations of calligraphy, and other presentations.

In conclusion, we ought to mention that the museum issues its own publications; in addition to the catalogues of the collection, some of which have been reprinted, there are the catalogues of the special exhibitions, all in the same nearly square format. Besides these, we have started two series, "Masks in West Africa" and "Non-European Artists and Their Workshops," which are comprised of monographs only indirectly related to works in the Rietberg Museum; small special exhibitions are often coordinated with these when they are published. Despite all of these activities, we should not forget that the Rietberg Museum is still a "small" museum in Zürich, at least in terms of its personnel and budget. Thus the director has to handle administration, personnel, finance, publications, the organization of special exhibitions and events, the daily chores of managing public relations and responding to inquiries, and is at the same time responsible for all curatorial areas other than East Asia. Of these I personally enjoy India and Africa.

Since 1970, Dr. Helmut Brinker has been curator of the East Asian department, serving at the same time as professor of the history of East Asian art at the University of Zürich. That he teaches at the university is of great importance for the museum, since it educates and interests a larger public in East Asian art. Professor Brinker's seminar room is in the remodeled coachman's house next to the museum that also houses the library of Osvald Sirén. The students thus have the opportunity to see original works of art in the museum and even to handle them. Our museum's staff consists of one secretary, one museum workman, two photographers, receptionists, and guards. There is also an assistant's position that is always filled for an eighteen-month term. The library and photographic files are kept by volunteers, the accounting is done by the central administration in the city hall.

The museum administration is directly subordinate to the mayor of the city. One should know that in Zürich there is first of all the cantonal government (to whom, for example, the university with the Völkerkundemuseum is subordinate), and that there is also the municipal administration of the city whose executive is the Stadtrat (city council) presided over by the mayor. Since 1966 the mayor has been Dr. Sigmund Widmer, a historian and a vigorous supporter of the cultural life of the city. Thanks to his generosity (although he is unfortunately hampered by the present not very prosperous financial situation of the city), Helmut Brinker and I were enabled again and again to travel to Asia and Africa and given the opportunity to create and freely execute new special exhibitions.

The budget of the Rietberg Museum is very modest. It should be made clear that except for rare donations all financial support for the museum comes from the city of Zürich. At present

there are only two small funds available to the museum: the Elisabeth de Boer Foundation grant for the East Asian department and a publications fund that supports the two monograph series. In addition to that, the Volkart Foundation has fortunately given financial support to several research projects of the museum, such as those concerning Jainism in India and Islamic calligraphy in Egypt. Similarly, Dr. Pierre Uldry, president of the Rietberg Society, has made possible the acquisition in Japan of two valuable Japanese sculptures, as well as a trip of the curator to the Far East; and my wife and I have for many years been financing our own research trips, production of films, and collaboration with African and Indian colleagues.

A curiosity of the division of responsibilities may be mentioned here. In the Rietberg Museum the director has full administrative powers; even the objects, vitrines, pedestals, and frames are his responsibility, but the walls, floors, alarm system, and furniture of the buildings are not. These belong to the real estate administration and their maintenance is the responsibility of the building inspector of the city of Zürich and his staff. Although we are cooperating well, it is obvious that this separation of powers sometimes leads to comic or irritating situations.

Finally we should mention the commissions and controlling institutions. The highest of these is the community council with its financial committee and an auditing commission that changes every year. The accounts and books are regularly checked by the inspector of finance, who also totals the cash on hand from time to time, in order to determine the daily intake from the sales of postcards and checking of coats (admission is free). For the acquisition of works of art there is the acquisitions committee, a group of well-known citizens of Zürich, which is composed of the following men and women: the collectors Edith Hafter and Carmen Oechsle; the former director of the Kunsthaus, Dr. René Wehrli; Dr. Cornelius Ouwehand, professor of Japanese studies; the art dealer Emil Storrer; the sculptor Franz Fischer; and the art critic Dr. Willy Rotzler. The mayor is usually represented by his secretary, at present Urs Peter Müller. Professor Brinker and I have the privilege of making proposals and, in the case of a tie vote, can determine the decision by casting one vote together. The members of this group, who judge works mostly on the basis of their own personal taste, always enjoy the irregularly scheduled meetings. The discussion of the individual objects that have been proposed, the free exchange of opinion, and also sometimes the support for the refusal of an offer not worthy of the donor nor up to the standards of the Rietberg Museum make the acquisitions committee a very positive institution. Under Professor Leuzinger's guidance, the museum acquired in the 1950s primarily African sculptures and in the 1960s mostly Pre-Columbian works of the Americas. In recent years we have mainly acquired Japanese works, Chinese and Indian paintings, and African sculptures. Once again it must be emphasized that we have a small budget and that the museum cannot purchase very expensive pieces; it can only receive them as gifts.

When the Rietberg Museum was founded, its holdings consisted of selections from the collection of non-European art in the Kunstgewerbemuseum (which included, for example, African sculptures from the former H. Coray Collection and Chinese ceramic figures from the former J.F.H. Menten Collection), the great collection of Baron von der Heydt, and a few loans. The first large donation was that of Japanese woodblock prints (approximately 660 single prints and 110 books) belonging to Willy Boller, who began to collect with passion when he was in Paris as a student around 1920. He exhibited selections from his collection in Zürich several times, first in a survey in 1928 and later in a series of special exhibitions of the works of Utamaro, Hokusai, and Hiroshige that were donated to the museum in 1957. A second collection of Japanese art, consisting primarily of woodblock prints but also including sculptures and screens, had been assembled in Japan by Julius Mueller, a businessman and for many years Swiss consul, in collaboration with Heinz Brasch, and was given to the museum. Julius Mueller had been in Japan since 1917. He learned Japanese and founded his own firm for trading between Japan and Switzerland in 1927. As a patron of the arts he also supported Japanese music and sponsored performances of it in Europe. He donated the Heinz Brasch collection of Japanese woodblock prints to the museum. Over the years Heinz Brasch himself also donated several works from his collection, and recently

the museum was given a selection of ten of his most important Japanese literati paintings by generous sponsors.

The late Charles A. Drenowatz, businessman and citizen of Zürich, became interested in East Asian philosophy and began to collect Chinese paintings after the Second World War. His most important dealer for many years was Walter Hochstadter, who had left Hong Kong and stored his Chinese art treasures in Zürich. Again and again he sold single paintings to Drenowatz and eventually parted with even his most important pieces. Charles Drenowatz completed his collection of Ming and Ch'ing paintings with acquisitions at auctions and purchases from European and American dealers, sometimes with the assistance of his friend Chu-tsing Li, who published the collection in supplements of *Artibus Asiae*. Less well known is the fact that Drenowatz also collected "modern" Chinese paintings. These too were catalogued and recently published by Chu-tsing Li.

Mr. and Mrs. Drenowatz never went to the Far East. But they visited all the museums in Europe and America that own Chinese paintings, and they also knew the important private collections in Europe. They were friends of Professor Osvald Sirén and his wife, and it was through Mr. Drenowatz that Sirén's large library on the arts of China was donated to the Rietberg Museum. This reserved businessman, who (like Baron von der Heydt) gave somewhat the impression of a Chinese sage, and who recently donated his collection of paintings, which was entirely his own creation, to the museum without any fanfare, used to reminisce with pleasure that once in an American museum he overheard whispers: "That's the man who owns the Kung Hsien."

Other collections, too, have been assembled with expertise and given as a whole to the museum. Among these is the collection of Indian sculptures of Dr. Alice Boner, mostly from Uttar Pradesh and adjacent regions of central India. These were sent to Zürich with the permission of the Archaeological Survey of India, thanks to the efforts of the Swiss ambassador Dr. Fritz Real. In the collection, in addition to representative sculptures, we also find fragments that show interesting stylistic or iconographic details. One can see that a great connoisseur of Indian art assembled them without large financial expenditures. A collection of more than 200 Luristan bronzes has been bequeathed to the museum by Dr. Rudolph Schmidt from Solothurn, and will soon be published in a catalogue by Professor Peter Calmayr. It contains a representative selection which is also of interest to the experts because of its large number of weapon types. A large collection of Egyptian textiles of the Hellenistic, Coptic, and Islamic periods has been given to the museum by an anonymous donor. It has been published by Dr. Irmgard Peter (Basel). The collection of Oriental rugs of Robert Akeret has now been reduced to those that he donated years ago; the loans have, with a few exceptions, been withdrawn by his heirs. What remains gives a good survey of Anatolian manufactures and otherwise consists of single pieces of diverse origins. The museum has been enriched by many other loans and legacies, especially those of Mary Mantel-Hess, Gret Hasler, and Jürg Stockar.

Regular yearly subsidies for the acquisition of single works have for many years been given by the Ernst Müller Foundation, the Volkart Foundation, and the Dr. Carlo Fleischmann Foundation. The Lottery Fund of the canton of Zürich has contributed to two larger acquisitions, and important financial contributions have been made several times by three of the major banks in Zürich, namely the Schweizerische Kreditanstalt, the Schweizerischer Bankverein, and the Schweizerische Bankgesellschaft.

Thus, with concerted efforts, the Rietberg Museum is growing in substance as well as in appeal. In some years the growth rings are thinner than the gardener would have liked, but in others we may remember many generous patrons with gratitude.

SOUTH ASIA
SOUTHEAST ASIA

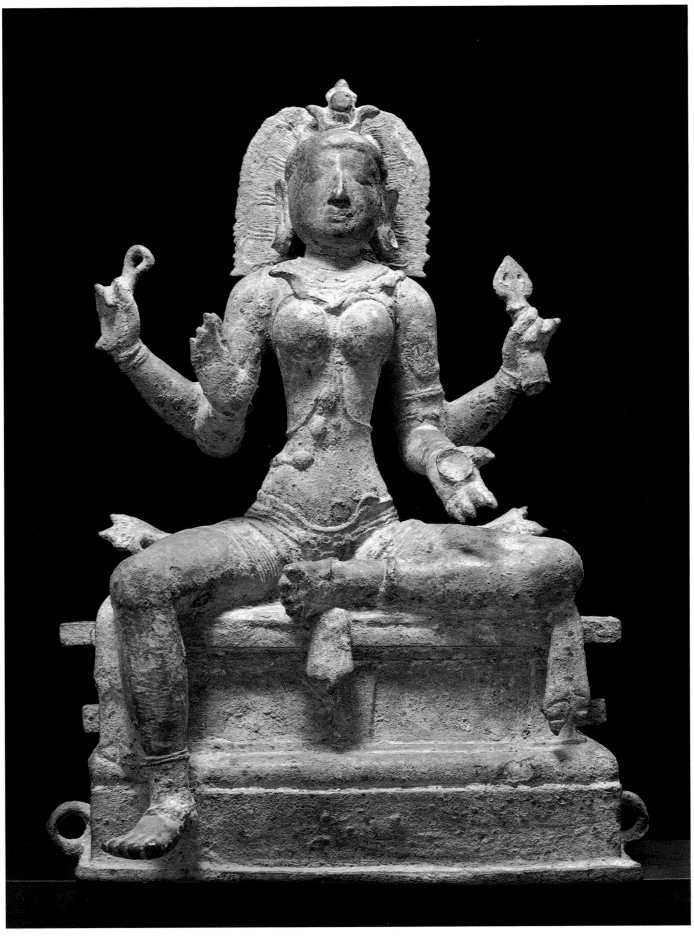

12. Kālī

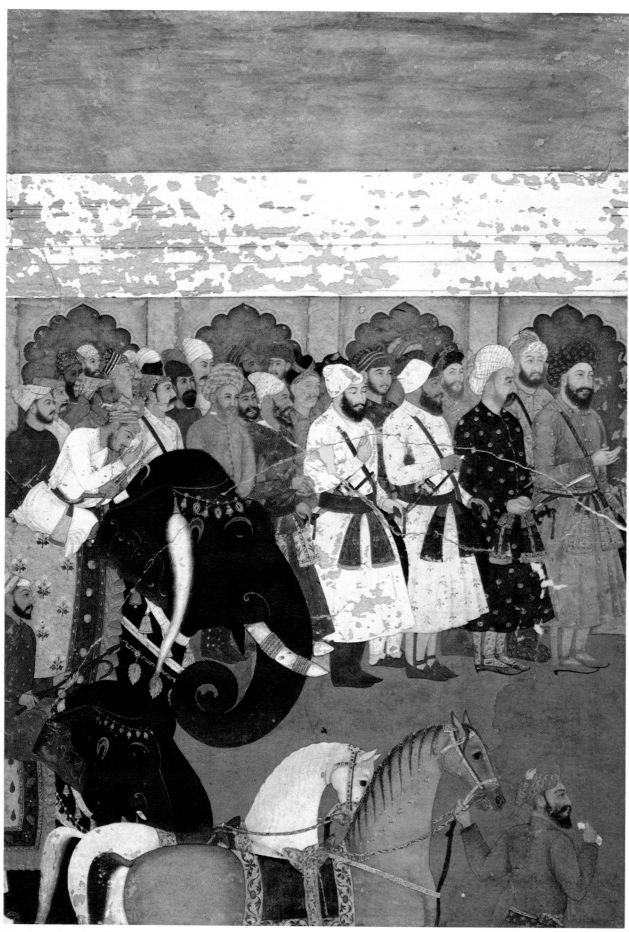

16. Reception of an Embassy

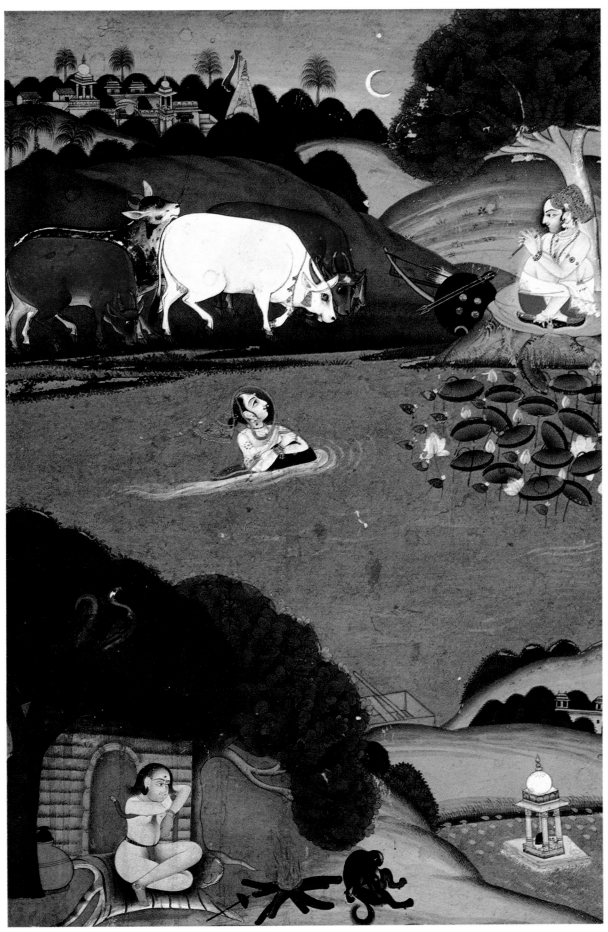

20. Sohnī and Mahīnvāl

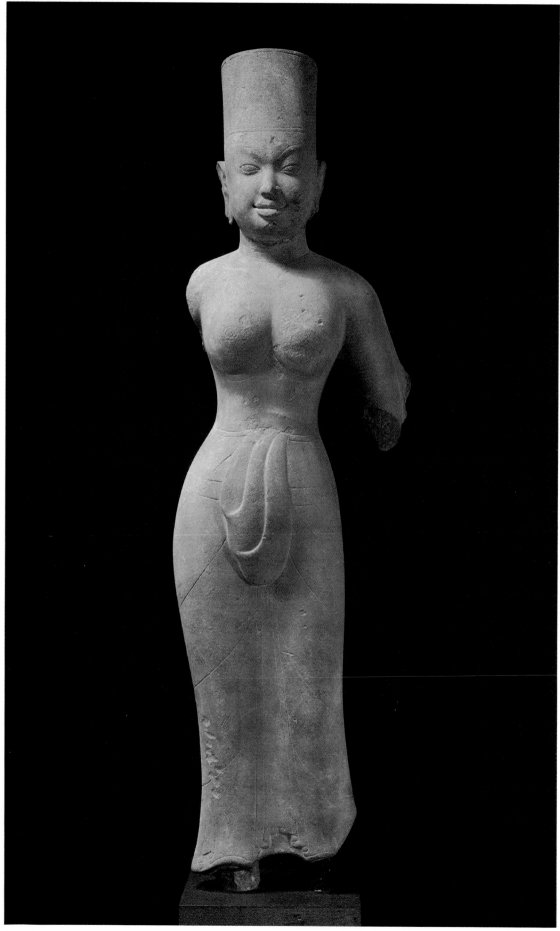

22. Umā

1 The Interpretation of Siddhārtha's Horoscope

Pakistan, probably Swāt Valley; Gandhāra style,
ca. second century A.D.
Steatite; H. 12.5 cm, W. 21.5 cm, Depth 4.5 cm

Buddhist narrative reliefs in the Gandhāra style come chiefly from the bases of large statues, from reliquary shrines, and votive offerings. Most of them depict events in the life of Siddhārtha Śākyamuni, Gautama Buddha, the Buddha of our age. His birth, his enlightenment, his first sermon, and his entering into nirvana are often portrayed. Seldom rendered (and therefore often absent from books about Gandhāra art or about the life of Gautama Buddha) is the incident of the interpretation of the newborn Siddhārtha's horoscope. This scene should not be confused with another which is formally similar: the interpretation of the dream of Queen Māyā during her pregnancy.

This small fragment of a multipartite frieze shows, on the right, near a tenon, a royal couple seated on a wide chair which has elaborate legs, a cover, and two kinds of high footstools. Queen Māyā, her luxuriant hair tied up, wears a sari-like dress and a necklace; in her right hand she holds a flower as if it were a fan. King Śuddhodana wears a turban, earrings, a shawl, and a dhoti. His left hand is propped up on his knee; his right hand gives orders. A nurse, possibly the future foster mother of the boy, Mahāprajāpatī, presses forward; behind the royal pair stands a page—only his patient face is recognizable. On the left, turned toward the group, is the long-haired, bearded sage who is versed in the reading of corporal marks and the interpretation of horoscopes: the Brahman Asita. He sits on a low stool which has a plain footrest, holds the tightly swaddled newborn on his knees, and might be saying: "Know, O King, that the child's body is marked with the thirty-two infallible signs of greatness, and that persons so marked are of two kinds: if they be laymen, they are universal monarchs or *chakravartīs*; but should they be religious persons, they are perfect *tathāgatas*, 'those who have arrived at the truth.'"

A disciple—possibly Asita's nephew, Naradatta—looks over the Brahman's shoulder. His arm bent, the hand touching the shoulder, is in *vismaya-mudrā*, a gesture that expresses astonishment. An engaged Corinthian column set within a frame ends the scene.

A similar relief, somewhat more straightforward in presentation, and with one less figure, was found in the Swāt Valley (fig. 1a).[1] Another relief, probably earlier in date, can be found in the Victoria and Albert Museum in London.[2] Additional representations in the Museum of Lahore, from the Loriyan-Tangai region and now in the Indian Museum, Calcutta,[3] and appearing in the fine arts trade[4] generally show the group without the two accompanying people.

We can regard this little relief — beautifully composed, lovingly and poetically shaped in every detail — as a relatively early Gandhāra work from the Swāt Valley. The broad, flat, framed cornice consisting of uniform rows of lanceolate leaves is typical of this region and others; in most cases, this frame of leaves separates two scenes that are placed one above the other.[5] On the basis of Ackermann's stylistic investigations, this work can probably be included with the "late Hellenistic group," dating from the first half of the second century after Christ.[6] The lively arrangement, the individual facial features, the soft drapery that suits the bodies' contours, and also the framed Corinthian-type half-column in the rectangular niche can be seen as typical of this early period of the Gandhāra style; in later periods, as designated by Ackermann, only the heavy, rectangular Corinthian pilasters are used to separate scenes.

Not previously published.

Notes

1. M. Taddei, Descriptive Catalogue, in D. Faccenna, *Sculptures from the Sacred Area of Butkara*, vol. 1, part 2 (Rome, 1962), p. 23, pl. 63.
2. H. C. Ackermann, *Narrative Stone Reliefs from Gandhāra in the Victoria and Albert Museum in London* (Rome, 1975), p. 62, pl. 10b.
3. A. Foucher, *L'Art Gréco-bouddhique du Gandhāra,* vol. 1 (Paris, 1905), pp. 314 ff.
4. Spink & Son Ltd., *Gandharan and Other Buddhist Indian Art* (London, 1973), pl. 3C.
5. See, for example, Taddei in Faccenna, *Sculptures from the Sacred Area of Butkara,* vol. 1, part 2, pl. 79.
6. Ackermann, *Narrative Stone Reliefs,* pp. 22 ff.

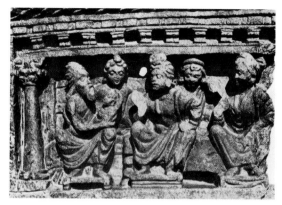

Fig. 1a. The Interpretation of Siddhārtha's Horoscope. Pakistan, Swāt Valley, ca. second century A.D.

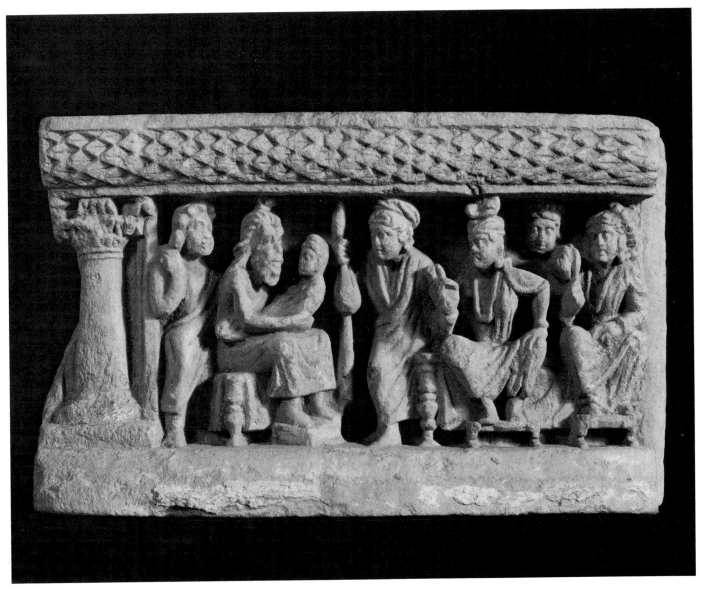

1. The Interpretation of Siddhārtha's Horoscope

Two Heads of Adoring Attendants

2 Northern Pakistan, probably Peshawar region;
Gandhāra style, ca. fourth century A.D.
Stucco with traces of red and dark blue color;
H. 10.5 cm

3 Northern Pakistan, probably Peshawar region;
Gandhāra style, ca. fourth century A.D.
Stucco with traces of red and dark blue color;
H. 10 cm

The stucco and terracotta fragments of the Gandhāra period come chiefly from the mountainous region of northern Pakistan and from Afghanistan (Hadda). A great number of separate heads have been found in the numerous shrines of the Peshawar region. The bodies of these figures, mod-

elled out of clay and covered with only a thin layer of stucco, have mostly crumbled into dust. At one time cult niches were decorated with these figures.[1]

The first of these two small heads has, in its wavy hair, a diadem whose central ornament is a teardrop-shaped gem set in front of a flower; to its right is another flower, to its left a crescent moon. Above the straight nose, the smooth forehead is bounded by the edges of the eyebrows; heavy lids overshadow the open eyes; the nostrils and the line of the mouth are deeply carved. In the wavy hair are traces of dark blue paint and on the ears and lips there are still traces of red. The remaining surface — after having been cleaned of deposits of lime — has a strong orange yellow hue.

The second small head has less sharply delineated features, appears softer, in part because of

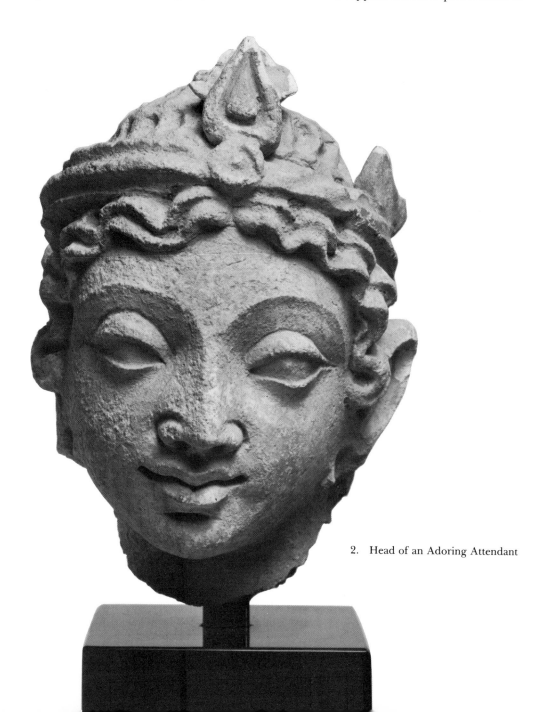

2. Head of an Adoring Attendant

the closed eyelids. The hair is up, bound by a band with a medallion. Here, too, traces of paint are evident; red on the wreath and ears; blue and black in the hair and between the lids and eyebrows.

Both heads belong to the heavenly beings, *devatās*, or perhaps to bodhisattvas, images apparently adoring a Buddha. The first head in particular has features which resemble those of the famous, somewhat larger head from the Museum of Fine Arts in Boston.[2] The general shape, forehead, and eyes, may have been pressed from a mold, the nostrils and hair added on, the lips and cleft of the chin at least reworked. This head is strikingly asymmetrical, which "adds to the aliveness and piquancy of expression."[3] One may imagine that it was once attached to a body like that of the beautiful stucco half-figure of an "adoring attendant" in the Cleveland Museum of Art: the youthful being is clad in a loosefitting robe and richly ornamented; leaning toward the central figure, he sits with his legs pendant, his hands in *anjali-mudrā*, folded in adoration.[4]

Not previously published.

Notes
1. B. Rowland, *The Art and Architecture of India* (Harmondsworth, 1970), p. 168; M. Hallade, *Gandharan Art of North India* (New York, 1968), p. 138.
2. Rowland, *Art and Architecture of India,* p. 168.
3. Ibid.
4. The Cleveland Museum of Art, *Handbook* (Cleveland, 1978), p. 288.

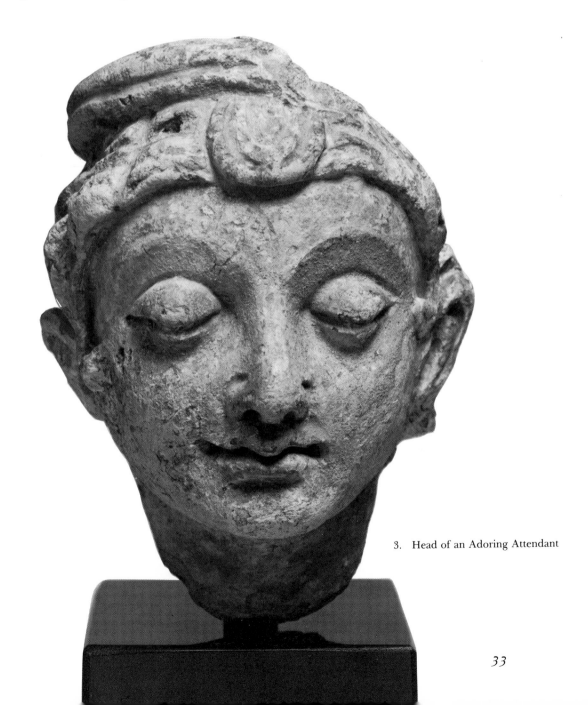

3. Head of an Adoring Attendant

4 Lokanātha

India, Bihar, probably from the Teladha
Vihāra; early Pāla period, ca. ninth century
A.D.
Black basalt; H. 96 cm, W. 47 cm, Depth 14 cm
von der Heydt Collection

This sculpture, beautiful in minutest detail, has
been fully described and interpreted by J. E. van
Lohuizen-de Leeuw. Her intelligent observations
and account are here quoted verbatim — although
greatly abridged:

"This image representing Lokanātha, a special
form of the Bodhisattva Avalokiteśvara or Padma-
pani, belongs to the early Pāla school of art, and
strongly resembles some of the sculptures found in
the great monasteries of Nālandā and Kurkihār in
Bihār. I found a more precise indication of its prov-
enance in a short note giving its origin as Teladha
Vihāra. . . .

"The figure, represented in very high relief,
stands out from a slab with a semi-circular top in the
easy pose of *ābhanga* on a large lotus with a pearl
border along the upper edge of its petals. Lokanā-
tha's right hand hangs down in front of an open
lotus in *varamudrā*, the attitude of bestowing a
boon. . . . In his left hand the Bodhisattva holds the
stem of a padma or pink lotus which springs up
from entangled plant motifs at his side and ends in a
large circular flower in full bloom. . . . The
Bodhisattva is dressed in a striped dhoti sprinkled
with various flower motifs, held up by a jewelled
girdle with a central clasp. . . . Lokanātha wears a
diadem and his hair is arranged in jatāmukuta as is
usual with ascetics, with a few locks falling on to
both shoulders. In his hair he wears a small image of
the Dhyāni-Buddha Amitābha seated with his
hands in dhyānamudrā, the attitude of meditation,
a detail which refers to the fact that Lokanātha is an
emanation of Amitābha. . . . The oval halo with a
flaming rim behind the head carries a Sanskrit in-
scription in 9th or possibly early 10th century script.
The contents read: 'Ye dharmmā hetuprabhavā
hetum tesam tathāgato hyavadattesā (a) ñca yo
nirodha evamvā (a) di mahā (a) śramanah.' In trans-
lation this formula, often called the Buddhist creed,
runs: 'Of all phenomena sprung from a cause the
Tathāgata (i.e. the Buddha) the cause hath told and
also their cessation. Thus spake the great mendi-
cant.'

"In the upper left-hand corner of the sculpture
a small image of a Buddha, or more likely a
Dhyāni-Buddha with damaged head, is seated on a
lotus with a pearl border, with an undecorated au-
reole behind him. . . . In the lower part of the stele
two more figures are depicted. On the right the
deity Hayagrīva (the Horse-necked One) can be
identified by the horse's head emerging from the
centre of his wild and curly coiffure. He is one of
the Dharmapālas or Defenders of Buddhism and
figures regularly as an attendant of Lokanātha. . . .

"On the left of the stele a small figure of a monk
is seated on a low stool with his legs folded in the
attitude of vīrāsana. He is dressed in the usual
monk's robe and his head is clean-shaven. In his left
hand he holds up a bunch of lotus flowers and in his
right he carries a censer from which arises incense.
Underneath a short inscription on the base gives
the name of this personage as Prajñāsena. Probably
the small figure is a representation of the donor of
the Lokanātha image. . . .

"Apart from the slightly abraded face of
Lokanātha and the missing head and damaged
right hand of the small Buddha figure, the
sculpture under discussion is in almost perfect con-
dition. It is an important example not only on ac-
count of its interesting iconographical details but
also because it belongs to the very best Pāla
sculptures which have come down to us. In contrast
to the stereotyped products of the later Pāla school
this Lokanātha displays a lively animation com-
bined with the grace and charm which early Pāla art
inherited from the Gupta period, in fact the
sculpture represents mediaeval Buddhist art at its
very best."[1]

It may be of interest that Baron von der Heydt,
at about the same time as he purchased this piece
from the collection of Messrs. Luzac & Co. in Lon-
don, bought additional Pāla fragments and later
donated them to the Rijksmuseum voor Volken-
kunde in Leiden.

Published: "Messrs. Luzac's Collection of Indian
Sculpture," *Rupam*, no. 11 (July 1922), p. 112; K. With,
Bildwerke Ost- und Südasiens aus der Sammlung Yi Yuan
(Basel, 1924), p. 54, pls. 84, 85; W. Cohn, *Asiatische Plastik:
Sammlung Baron Eduard von der Heydt* (Berlin, 1932), pp.
122 ff; J.E. van Lohuizen-de Leeuw, *Indian Sculptures in the
von der Heydt Collection* (Zürich, 1964), pp. 54–62.

Notes
1. J.E. van Lohuizen-de Leeuw, *Indian Sculptures in the
von der Heydt Collection* (Zürich, 1964), pp. 54–62.

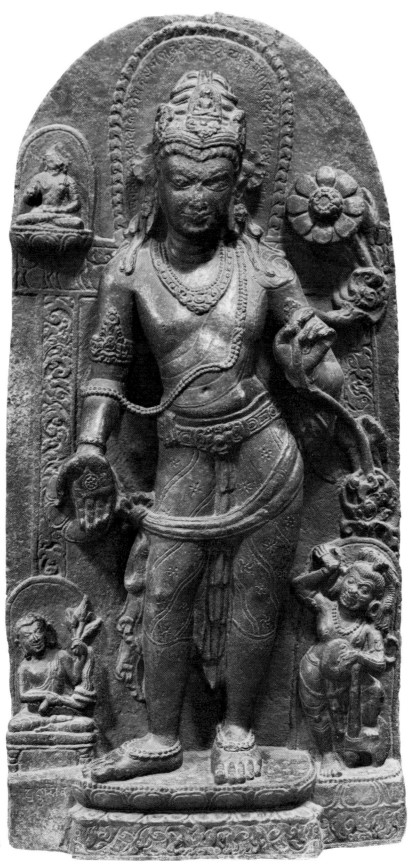

4. Lokanātha

5 Head of a Youthful Deity

India, Uttar Pradesh, probably from Rajghat at
Varanasi; Post-Gupta period, ca. eighth cen-
tury A.D.
Reddish gray sandstone, traces of lime; H. 26
cm, W. 22 cm
Dr. Alice Boner Collection

This head is said to have been found in Rajghat; in
any case it was acquired by the donor in Varanasi
where this type of reddish gray, quite fine-grained
sandstone occurs.

Relatively large, the head has a roundish face
with a flat forehead. The eyebrows are highly
arched; the heavy eyelids have fallen shut; the
mouth has a prominent lower lip; and the chin is
short and round. Short, tight locks of hair lie flat
across the crown and fall perpendicularly from a
middle part in thick masses of curls that appear
across the forehead as delicate spirals. The earlobes
are long and pierced; the earrings have been bro-
ken off. The neck is marked with shallow grooves.
The head was once part of a relief, and the remains
of a nearly quadratic tenon can be seen on the
crown.

It is difficult to determine whether this repre-
sents the face of a male or a female. All distinguish-
ing characteristics — apart from the striking
hairstyle — are lacking, and even for the hairstyle
there are no direct parallels. Conceivably, this rep-
resents the head of a youthful *dvārapāla*: in late
Gupta times these still lack almost all grotesque,
fierce features. Alternatively, it may have rep-
resented the head of a *nāga* figure, for which the
broken places on the back of the head lend evi-
dence, or the head of river goddess. Whomever
the fragment portrayed, the fine, endearing face shows
an understanding of form characteristic of late
Gupta times.[1] Certain harsh and stiff qualities
should not be overlooked. Still, the eyebrows are
not yet poutingly raised, the corners of the mouth
are rounded, the corners of the eyes are gently
protracted, the chin is still full and the hairline a low
arc.

Not previously published.

Notes
1. Compare, for example, P. Chandra, *Stone Sculpture in
the Allahabad Museum*, American Institute of Indian
Studies Publication no. 2 (Bombay, n.d.), pl. 79.

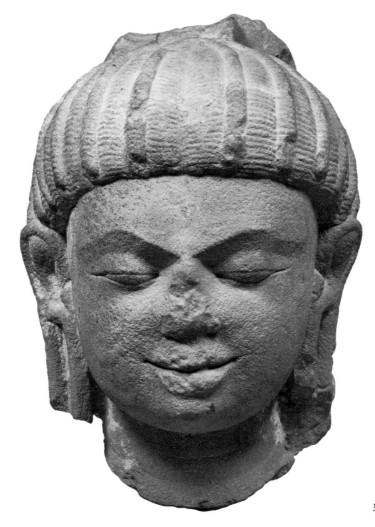

5. Head of a Youthful Deity

6 The Naked Śiva with a Female Companion

India, Uttar Pradesh or Madhya Pradesh (probably Bundelkandh); ca. late eleventh century A.D.
Gray sandstone; H. 58 cm, W. 33 cm
Dr. Alice Boner Collection

The naked god is ascetic and seducer at the same time. But for the snake and the armlet of skulls which adorn him, Śiva is naked; most likely daubed with ashes, he is the ascetic to whom worldly conventions do not apply, who begs for what little he and his wife require to go on living, whose nakedness signifies purity. As the god himself says: "I am naked because all the sages and good men are born naked, and a man with uncontrolled senses is naked though he be clothed in silk. A man should clothe himself in patience and passionlessness."[1] But even this nakedness forms "a theoretical mediating motif as a transitional phase between ascetic clothes and erotic clothes."[2] This naked, savage Śiva is the man who attracts Parvatī precisely because he is frightening and repugnant. But it is not only she who burns with desire for this god; as a naked man he also seduces the wives of the ascetics in the pine forest.

This four-armed naked Śiva stands in exaggerated *tribhanga*, or *contrapposto*; his front left hand rests on the shoulder of a lovely, graceful woman who looks up at him and smiles. With one hand she points to him in astonishment; with the other, grasping her necklace, she touches his hand. She is richly adorned with chains, necklaces, earrings, and armlets; and her hair is arranged in a complicated manner, as if to demonstrate "the inappropriateness of skulls as ornaments."[3] For the naked god wears nothing but a snake as a neck ornament, a *śrivatsa* on his chest, and a chain made out of miniature human heads around his front right arm. A thick strand of pearls, betokening his divinity, falls below his knees. The body of the god has been modelled softly. It is not the body of an athlete; all the muscles and ribs have vanished under the well-padded, uniformly taut skin. Hairless down to his genitals, with soft rolls of flesh below his navel, Śiva stands with his right hip thrust far out and his left leg set straight in front of him; the graceful torso is then turned and his left breast drawn backward so that he can lean with his left elbow on the girl while his shoulders remain in a horizontal position.

This fragment lacks a head, both back arms, the attribute of the front right hand, feet, and the base.

Stylistically, especially in the treatment of his body, this "Śiva with a female companion" is in complete accordance with the Bhairava representations from Khajurāho (like those, for example, on the Devi Jagadambā temple). Only the strong turning of the body, occasioned by Śiva's leaning on the smaller being, is more pronounced. That the sculpture once stood in a projecting corner niche is probable, because the back part of the women is, to some extent, worked out in detail.

On the temples of Khajurāho, the naked Śiva is found only in his fear-instilling form, as Bhairava ("The Terrible"): he is generally accompanied by a dog; in his right hand he holds a sword, in the left a severed human head (fig. 6a).[4] As Bhikṣātana ("The Vagrant Mendicant") the naked Śiva often lowers one hand, but in his left there is always an almsbowl, and he is accompanied by a *gana*, an obese dwarf; for it says in the Satarudrīya text that the god Śiva, as a naked beggar, nourishes the entire world with what few gifts he assembles, and that a *gana* follows him.[5] Śiva appears naked in still a third meaningful context: as Lord of the Universe, as master of the *dikpālas*. As Īshāna, embodying the northeast, Śiva is *digambara*, air-clad, hence naked;[6] in Khajurāho, however, he is always portrayed clad.

J. Filliozat has pointed out that the naked Śiva on the temples of Khajurāho must be seen as Bhikṣātana, and that this manifestation could be connected with the incident in the pine grove men-

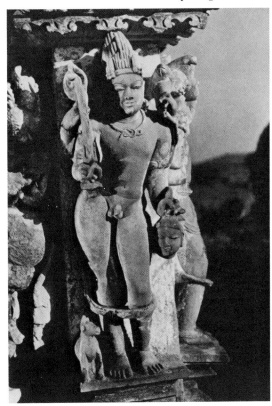

Fig. 6a. Bhairava. India, Khajurāho, ca. eleventh century A.D.

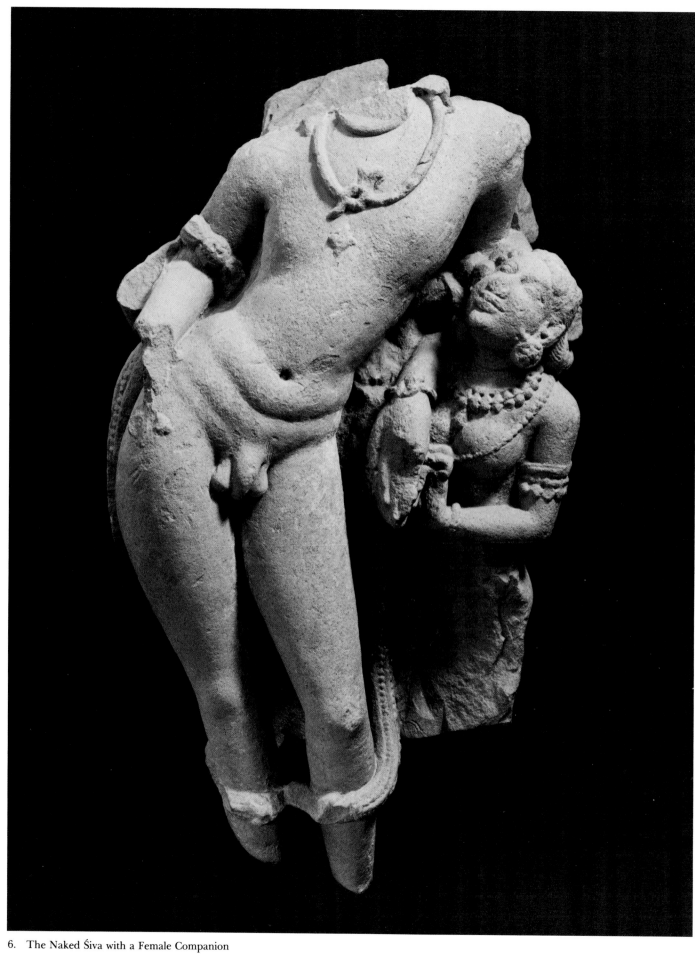

6. The Naked Śiva with a Female Companion

tioned in various puranic texts.[7] To the best of my knowledge, up until now no such representation displaying this iconographic correspondance has been found in Khajurāho.[8] Here all the naked Śiva figures hold a severed head and a sword, never an almsbowl and trident. But the Lingapurāna, so important for the cult of this Chandella temple, conveys in detail the story of Śiva in the pine grove. In it Śiva, the seducer of the wives of the *rishis* or sages, is "excessively beautiful," "wind-clad," hence naked, with a fine smile that is reflected in the souls of the women. And the women, no matter how faithful they have been, succumb to him instantly. It is probable that this myth makes its appearance in this sculpture, that here—in the pine grove—Śiva leans on a captivated woman who is the wife of one of the *rishis*. This would also explain the lack of a crown and the difference in proportion between the huge god and the diminutive *rishipatnī*.[9]

Not previously published.

Notes
1. W.D. O'Flaherty, *Asceticism and Eroticism in the Mythology of Siva* (London, 1973), p. 244.
2. Ibid.
3. Ibid., p. 239.
4. U. Agarwal, *Khajurāho Sculptures and Their Significance* (Delhi, 1964), p. 56.
5. C. Sivaramamurti, *Satarudrīya: Vibhūti of Siva's Iconography* (New Delhi, 1976), p. 94.
6. Ibid., p. 44.
7. J. Filliozat, "Les Images d'un jeu de Śiva à Khajurāho," *Artibus Asiae* 24, no. 3/4 (1961), pp. 283–294.
8. Ibid., pl. 9, "Bhiksātanamūrti," shows only clad Śiva figures.
9. Compare a similar scene from distant Alampur in A. Lippe, "Some South Indian Icons," *Artibus Asiae* 37, no. 3 (1975), pl. 30.

7 Mithuna

India, Madhya Pradesh; Chandella dynasty, ca. eleventh century A.D.
Reddish sandstone; H. 78 cm, W. 38 cm, Depth 23 cm
Dr. Alice Boner Collection

Reliefs with *mithuna,* amorous couples, often in erotic poses, are components of the decorated facades of most north Indian temples of the later periods. Often, however, what is portrayed is a god with his *śakti*; less often is it a "true" *mithuna,* an amorous human couple, distinguished neither by crowns nor by any other attributes as heavenly beings.

Rectangular mortises, by which such plaques were attached to temple facades, have been cut into the background and the upper edge of this rectangular relief plaque. The plaque shows, in high relief, a couple standing in somewhat stiff *tribhanga,* or *contrapposto.* The bodies are powerful, manifesting urbane, cool elegance. As they stand side by side, each figure lays an arm over the other's shoulders; he rests his right hand on his hip; she has placed her left hand on her breast.

Stylistically striking are the faces with their low foreheads; their strong, surprisingly long, eyebrows; their almond-shaped eyes that have no pupils; and their ears which look as if they are rimmed with metal and which are adorned with flowers. If this relief were not carved out of reddish sandstone, one could easily take it for a work from Khajurāho, for example, from the Chitragupta temple (about A.D. 1020). Even such details as the jewelry and the *dhammila,* the bun in its spherical net, appear in the sculptures on the facade of that temple; the single exception, perhaps, is the unexpected but clear rendering of a rib-muscle under the right breast of the man.

Not previously published.

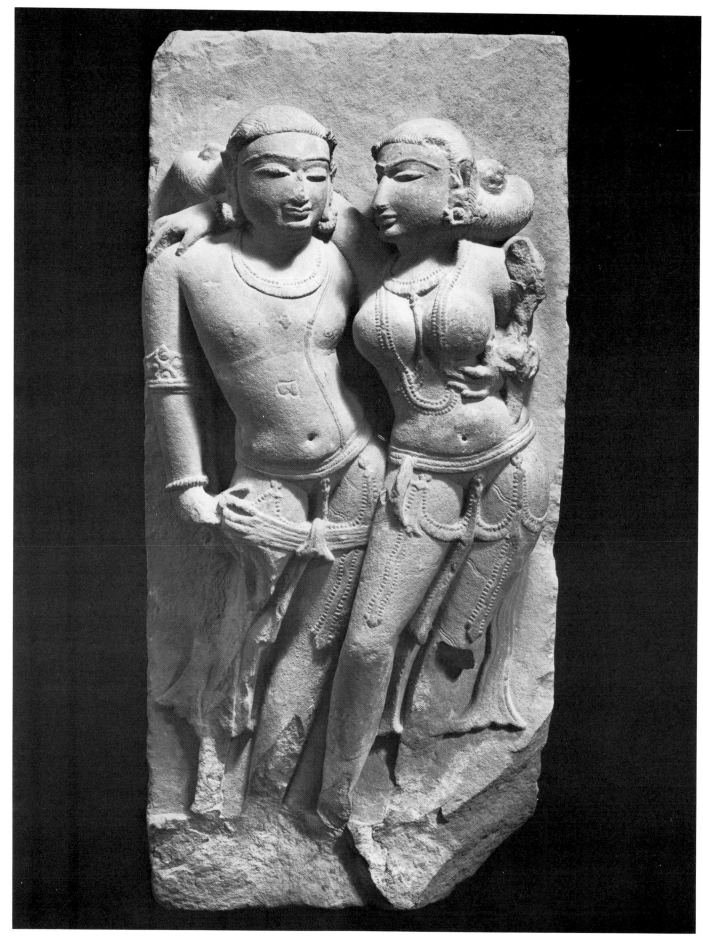

7. Mithuna

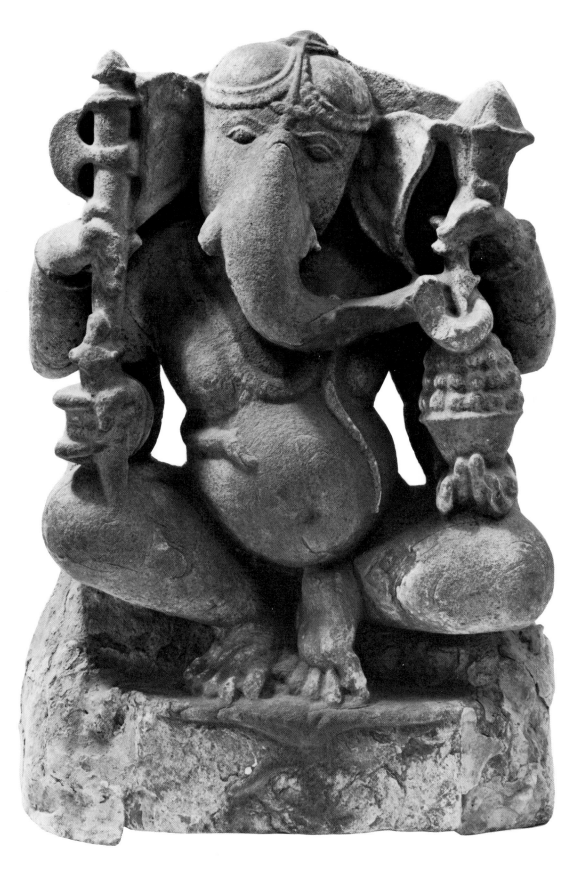

8. Ganeśa

8 Ganeśa

India, eastern Uttar Pradesh or northern
 Madhya Pradesh (possibly Baghelkhand);
 Chandella dynasty, ca. eleventh century A.D.
Gray sandstone; H. 43 cm, W. 31 cm., Depth
 13 cm
Dr. Alice Boner Collection

Fig. 8a. Ganeśa. India, Uttar Pradesh, Chandpur, ca.
eleventh century A.D.

The elephant-headed god sits, his legs folded
under him, on a crumbling base. The outline of a
rat, Ganeśa's mount is barely discernible on the
front of the base. The sculpture served as an object
of worship for a long time; its uncleaned parts are
still thickly encrusted with vermillion and lime.

Despite his obesity, Ganeśa endeavors to as-
sume a suitable sitting position and carries as
emblems *paraśu*, the axe; *danta*, his broken-off left
tusk; a bowl of *laddu* sweets; and *padma*, a lotus
whose stem he grasps with his trunk. His naked
body is encircled by a snake in place of a *yajnopavīta*
or "sacred thread", a double string of pearls loops
down on each side of his forehead, which bears a
trifoliate ornament. The edges of the ears are
gently raised and the veins show slightly. Ganeśa's
eyes are level, open, and have clearly marked upper
lids and eyebrows. His trunk is smooth, without
wrinkles or ornaments.

Such details as the simple rendering of the ears
and eyes, the ornaments on the forehead, the snake
around the belly, the coquettish placement of the
toes, and the fingers spread wide apart allow com-
parison of this sitting Ganeśa with, for example, a
dancing cult-image in a niche of a temple at
Chandpur in the environs of Lalitpur, Uttar
Pradesh (fig. 8a); however, this Ganeśa also closely
resembles another from Rewa (Baghelkhand).

Not previously published.

42

9 The Tīrthankara Rishabhanātha

India, South Rajasthan, possibly Chandrāvatī;
ca. eleventh century A.D.
White marble with traces of red color; H. 161
cm, W. 61 cm, Depth 22 cm
von der Heydt Collection

The doctrine of the Jainas denies the existence of a creator-god set above the workings of the cosmos. Apart from heavenly beings who possess specific magical capabilities, for orthodox Jainas there is no divine power that has created and rules over the world. There are only laws of causality, by which—through bad actions—matter attaches itself to souls, thereby preventing a living being from attaining a higher plane of existence in its next reincarnation. Asceticism and meditation, however, are means of purifying souls, of releasing them from these entanglements. The perfectly pure, or enlightened soul frees itself forever from the body and abides in eternal bliss on the edge of the cosmos. Such was the teaching of the *jinas,* the liberated ones, the Master Teachers of the Jainas, also called *tīrthankaras,* or "finders of the ford." The *tīrthankaras* were twenty-four in number; the first, Rishabhanātha, lived millions of years ago; the last, Mahāvīra, was a contemporary of Gautama Buddha and proclaimed the orthodox teachings. Mahāvīra was a strict ascetic who demanded from his monks complete withdrawal from society. Nakedness was but an outward sign of this; it indicated the complete renunciation of possessions and attachments. The reform group of Śvetāmbara, which soon emerged, permitted its monks to wear white cloth and also represented the *tīrthankaras* in clothing.

The faithful raised devotional images of these Master Teachers in their temples. It is said that meditation on the material form of a *jina,* one who has found final liberation, purifies the soul. Not only does the meditator forget his everyday cares, it is also said that his soul becomes like a mirror: if a red flower is held up before him, he becomes red; if he meditates on the perfect, old karma can be destroyed. Worship, among the Jainas, is thus primarily purification of the soul, not supplication for aid or gifts.

In this sculpture from the Rietberg Museum, the first *tīrthankara* stands erect; he looks straight ahead with his shoulders thrown back. His feet and legs are parallel and slightly apart, his arms hang straight down. This strict posture of meditation is called *kāyotsarga,* "dismissing the body." The Master's body is "perfect," neither youthful nor aged, soft, rounded; all bones, veins, hardnesses are covered with smooth flesh. He is at peace with himself, motionless; only the lower, expanded part of his chest hints at regular breathing. The face, with its somewhat pointed chin, is transfigured by a placid smile. In the holy writings of the Jainas, "The master's body, perfectly symmetrical, the lord's toes were like the flame of a lamp, motionless, steady, shining, touching each other, straight like petals of a lotos . . . the breast, broad as a slab of gold . . . the firm, massive, high shoulders resemble the hump of a bull . . . massive arms, terminated by hands like serpent's hoods, hanging down to the knees . . . the ears pretty with inside convolutions, hanging to the shoulders. . . ."[1]

With few exceptions, all the *jinas* are portrayed in accordance with this ideal image. Rishabhanātha, however, always has locks that curl down to his shoulders, and on the socle his distinguishing attribute, a couchant bull, is visible. This strict, clean image of the self-contained holy man is surrounded by a complex openwork shrine that is animated by small figures, elephants, tendrils, jewels, pillars, and niches. Here are celestial beings that fly about playing music, goddesses of the diverse regions of the cosmos, and additional *jina* figures, as well as human worshipers paying homage to the perfect one.

Quite correctly referred to as one of the most beautiful Jaina sculptures outside of India, this stele has been thoroughly described by J. E. van Lohuizen-de Leeuw.[2] We are also grateful to her for having alluded to the brief account in the Indian journal *Rupam* where the piece was first published and reproduced, and in which the place of its origin, "Chandravarte" or Chandrāvatī, is named.[3] Baron von der Heydt, probably at about the same time that he acquired this piece, purchased from his London art dealers (Messrs. Luzac) a fragment of a similar stele, namely the bow-shaped pediment which is now to be found as his bequest in the Rijksmuseum voor Volkenkunde in Leiden, Holland (No. 3436-128). Both sculptures presumably came from the same site: Chandrāvatī, near Mt. Abu. Here there is a great field of ruins with several earth-covered temple mounds and an open square under the trees where at least a hundred fragments are gathered. Sculptures of comparable quality, and sometimes with identical details, lie on all sides; in years past they were repeatedly visited and plundered by vandals, that is if they had not already been used to shore up the nearby road.

Published: "Messrs. Luzac's Collection of Indian Sculpture," *Rupam,* no. 11 (July 1922) p. 112; K. With, *Bildwerke Ost- und Südasiens aus der Sammlung Yi Yuan* (Basel, 1924), pp. 60 ff., pls. 90–93; W. Cohn, *Asiatische Plastik: Sammlung Baron Eduard von der Heydt* (Berlin, 1932), pp. 126–131; H. Zimmer, *The Art of Indian Asia* (New York, 1955), vol. 2, p. 55, pl. 389; J.E. van Lohuizen-de Leeuw, *Indian Sculptures in the von der Heydt Collection* (Zürich, 1964), pp. 110–117; J. Jain and E. Fischer, *Jaina Iconography* (Leiden, 1978), part 1, pp. 38, 39; part 2, p. 15.

Notes
1. In the *Trisastisalakapurusacarita,* see J. Jain and E. Fischer, *Jaina Iconography,* part 2 (Leiden, 1978), p. 15.
2. J. E. van Lohuizen-de Leeuw, *Indian Sculptures in the von der Heydt Collection* (Zürich, 1964), pp. 110–114.
3. "Messrs. Luzac's Collection of Indian Sculpture," *Rupam,* no. 11 (July 1922), p. 112.

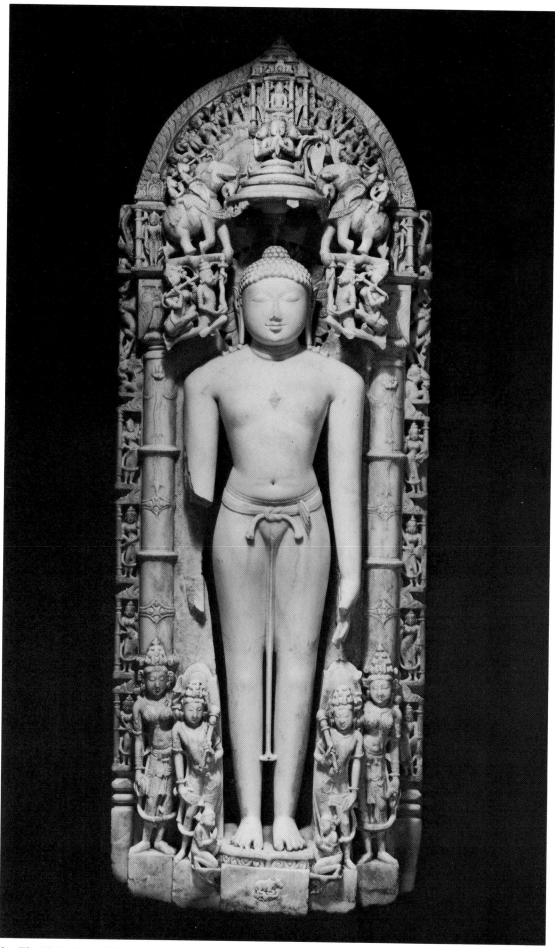

9. The Tirthankara Rishabhanātha

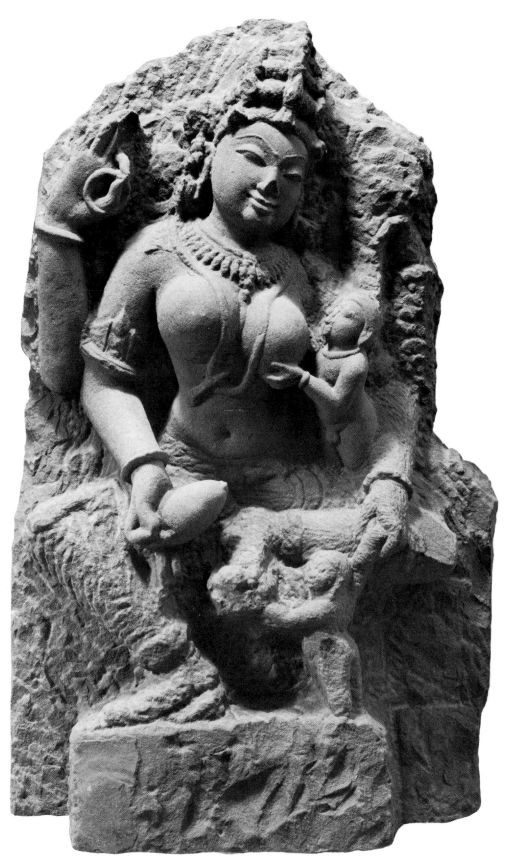

10. Ambikā

10 Ambikā

India, Rajasthan or Madhya Pradesh; ca. eleventh century A.D.

Black sandstone; H. 60 cm, W. 39 cm, Depth 19 cm

Dr. Alice Boner Collection

"Gods" for the Jainas are superhuman beings who, on the grounds of "right knowledge, right faith, and right conduct"—the three jewels of Jainism—once, as humans, had attained such "purity of soul" and had acquired so many "merits," that in their next existence they became "gods." As such, they are not immortal, but they live for millennia before they are once again reborn as male human beings; whereupon they use this opportunity to renounce the world, to become monks, and to attain *moksha,* a state of eternal separation of body and soul. Gods inhabit and rule the three worlds of the cosmos: Ambikā, along with her male counterpart, Gomedha, is one of the gods of the underworld. According to a Śvetāmbara-Jaina tradition, "Ambikā was thrown out of her house by her husband because she gave away to a Jaina monk the food cooked for Brahmins. She went to the forest and sat under a mango tree along with her two sons. When the repenting husband approached her, she jumped into a well misunderstanding his intentions and died along with her sons. She was reborn as a *yakshī* and her husband as a lion, her mount."[1] As a *yakshī,* or celestial attendant, she takes into her charge the *tīrthankara* Nemīnātha. She is venerated in almost all Jaina temples, and there her name as well as her mount (lion/tiger) corresponds to that of the powerful Hindu *śakti* Ambikā (venerated as the mother goddess Amba in Ambaji, northern Gujarat), both goddesses merging into one powerful godhead for many Jainas.

The sculpture of the goddess Ambikā remained incomplete, perhaps because the sculptor, while working, had damaged her nose or one of her fingers. The only parts of the goddess that were finished are the face, the breasts, the trunk, and the two right arms. Chiselled only roughly were the pedestal; the background (it seems that parts of the background, on the left, were broken off later); Subhankara, her small son who stands on the base; part of her hip; and her left leg. Her crown, her front left arm, Priyankara — the small son at her breast—and her earrings were touched up with a fine chisel. In *lalitāsana* posture with one leg folded, the other set on the ground, the goddess sits on an unfinished seat; whether the sculptor intended to carve a lion cannot be discerned. She bears the following attributes: a ring, a mango, and her two sons. Her ornaments are a necklace and two chains between her ample breasts. Her face is round, her eyes are almond-shaped with heavy upper lids, her eyebrows stand out, her chin is pointed, her lips are thin.

Stylistically she resembles the Ambikā sculpture of the *yakshī* Chakreśvarī in the Ahar Museum that is said to have come from the Tikamgarh region of Madhya Pradesh.[2] The goddesses resemble one another specifically in posture, facial features, and the jewelry that adorns their bodies. The crown occurs in the same form on another Chakreśvarī from the Dewas district in the Paramāra style.[3] Thus it is conceivable that this Ambikā comes from northwestern Madhya Pradesh.

In conclusion it should be noted that as late as 1971 the sculpture was still covered with a thick layer of black soot and oil—a sign of long years of veneration — which was then thoroughly cleaned out of every pore. Now the sculpture looks so fresh, it appears to have been only recently discarded, unfinished, from a stonemason's workshop.

Published: E. Fischer and H. Shah, *Kunsttraditionen in Nordindien* (Zürich, 1972), pl. 197; J. Jain and E. Fischer, *Jaina Iconography,* 2 parts (Leiden, 1978), part 2, pl. 40c.

Notes
1. J. Jain and E. Fischer, *Jaina Iconography,* part 2 (Leiden, 1978), p. 24.
2. A. Ghosh, ed., *Jaina Art and Architecture,* 4 vols. (New Delhi, 1975), vol. 2, pl. 180.
3. Ibid., pl. 182.

11 Chāmundā

India, Tamilnadu (probably from the Kāñ-chīpuram region); Chola dynasty, ca. ninth or early tenth century A.D.
Dolerite; H. 52 cm, W. 51 cm
von der Heydt Collection

This fragment of the goddess Chāmundā was purchased before 1934 by Baron von der Heydt from the Parisian dealer C.T. Loo; but it originally came from the collection of G. Jouveau-Dubreuil in Pondicherry. It was first reproduced and briefly described in 1935; later J. E. van Lohuizen-de Leeuw published a detailed account.[1] Her exposition is essential to the following discussion.

The fragment shows the thin, proudly erect body of a goddess. Almost emaciated, yet showing hardly any folds or ribs and without a sunken abdominal cavity, the torso towers from the narrow hips to the sloping shoulders and the straight neck. At the right on the background two strands of flaming hair and the edge of an earring are still recognizable. The hanging breasts are encircled and seemingly supported by two cobras. Below a narrow band worn around the neck and a tapering pearl necklace with a flower medallion, a larger cobra lies; another snake winds around the upper part of her right arm. The three-strand *yajnopavīta* that lies across the torso in an S-shape has been knotted at irregular intervals. Of the goddess's four arms, only one — the rear right arm — remains intact. In her hand she holds a stalk or the end of a handle.

The gray dolerite has been worked with a fine chisel, and its grainy surface appears to have been ground in such a way that it resembles fine scales; a certain "stoniness" has remained. The almost tulip-shaped torso with its outreaching arm leaves us with the impression of something primordial.

The torso of Chāmundā presumably belongs to a group of *mātrikā* sculptures, all of which were carved from a heavy ground. Some reached a height of 112 centimeters. Of these goddesses, three are in the Musée Guimet, Paris; others are in Kansas City, in Toronto, in Detroit, in the Sackler Collection in the Brooklyn Museum, in Minneapolis, in San Francisco, and in the British Museum. All the goddesses are portrayed sitting with slackly crossed legs, and all probably have *jvālākesa* or "flaming hair" that shoots out around a crown. A few of these were exhibited by C.T. Loo shortly after 1935, others were shown in New York in 1942.[2] It can be supposed that Baron von der Heydt saw all these goddesses in Paris. He bought only this fragment; iconography never interested him, but the extraordinary quality of this Chāmundā torso inevitably appealed to him.

Because there is such a great number of these sculptures belonging to one group, Professor van Lohuizen-de Leeuw is of the opinion that they do not belong to a series of the *saptamātrikā*, "seven mother goddesses"; rather they presumably belong to a group of sixteen goddesses headed by Gaurī-Pārvatī, the *gauryādi-sodaśamātrikā*, previously only known through texts.[3]

Published: P. Dupont, "Sculptures Indiennes et Indochinoises de la collection von der Heydt," *Maandblad voor Beeldende Kunsten* 12, no. 2 (1935), p. 3, pl. 2; J.E. van Lohuizen-de Leeuw, *Indian Sculptures in the von der Heydt Collection* (Zürich, 1964), pp. 166–170.

Notes
1. J. E. van Lohuizen-de Leeuw, *Indian Sculptures in the von der Heydt Collection* (Zürich, 1964), pp. 166–170.
2. J. Pope, *The Sculpture of Greater India* (New York, 1942), nos. 32, 33, 36–38.
3. van Lohuizen-de Leeuw, *Indian Sculptures*, p. 168.

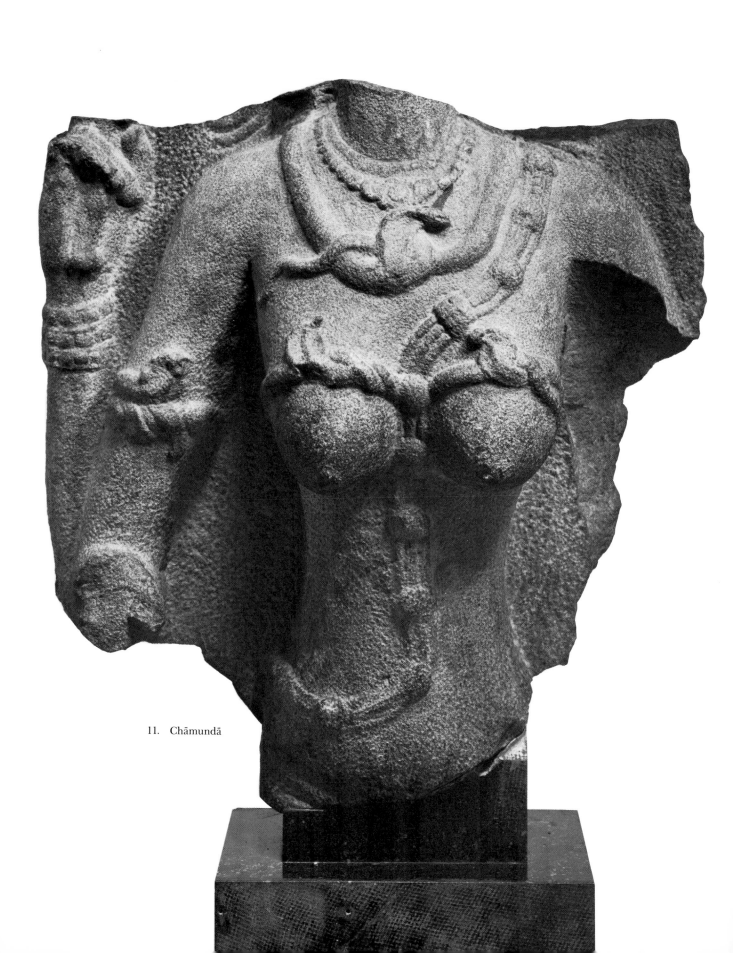

11. Chāmundā

12 Kālī

India, Tamilnadu (probably Tanjāvūr region);
 early Chola dynasty, first half of the tenth
 century A. D.
Bronze; H. 40.5 cm
von der Heydt Collection

This early Chola bronze, acclaimed by C. Sivaramamurti as "aesthetically the best early Kālī,"[1] comes from the collection of G. Jouveau-Dubreuil in Pondicherry. Before 1930 it was acquired by C.T. Loo, and was published for the first time in 1931, as an acquisition of Baron von der Heydt. J.E. van Lohuizen-de Leeuw has thoroughly discussed it.[2] The following is taken, in condensed form, from her ingenious exposition:

"The great goddess is seated in lalitāsana on a moulded base which is divided into panels. There are circular lugs at the bottom on either side meant for the poles with which the image could be carried around in procession. Two further square lugs higher up on each side of the base were meant to hold the ornamental aureole which, as with most ancient bronzes, has disappeared. In her left hands the goddess holds a skull-cup used for drinking human blood and a ghantā or ritual bell with a handle in the form of a triśūla or trident. Her upper right hand holds the noose with which she catches her victims and the lower right hand is held up in abhayamudrā, assuring protection to those who come to her. She is dressed in a very short striped skirt, which looks more like a loin-cloth and which is held up by a triple girdle with ornamental jewelry on the front and back A snake knotted round the chest acts as a brassière and the upavīta shows thick beads which are meant to represent human heads or skulls. The face of the goddess is worn away as a result of continual worship and so we can no longer discern the two small fangs protruding from both corners of the mouth which the iconography of Kālī requires. She wears a diadem or ribbon with pieces of jewelry on either side and on top of the head two snakes hold a skull as a central ornament. Her hair stands out wildly, almost giving the effect of a halo, and in front it is covered with a fringe of pearl strands and loops. On the left, near the top of this halo of hair, faint traces of a crescent moon are still visible."

Professor van Lohuizen-de Leeuw has pointed out the exceptional form of the *ghantā*, whose handle turns into a trident (the usual emblem of the goddess).[3] She also calls our attention to the strong resemblance that the stone Chāmundā torso (no. 11) bears to this Kālī, especially in the treatment of the hip and waist part. In the early Chola period it seems that only one form was given to images despite the use of different materials.

Published: E. von Sydow, "Sammlung Eduard v.d. Heydt," *Die Weltkunst* 5, no. 30 (1931), p. 1; W. Cohn, *Asiatische Plastik: Sammlung Baron Eduard von der Heydt* (Berlin, 1932), p. 170; C. Sivaramamurti, *South Indian Bronzes* (New Delhi, 1963), pl. 100b; J.E. van Lohuizen-de Leeuw, *Indian Sculptures in the von der Heydt Collection* (Zürich, 1964), pp. 170–177.

Notes
1. C. Sivaramamurti, *South Indian Bronzes* (New Delhi, 1963), p. 59, pl. 100b.
2. J. E. van Lohuizen-de Leeuw, *Indian Sculptures in the von der Heydt Collection* (Zürich, 1964), pp. 170–177.
3. Ibid., p. 176.

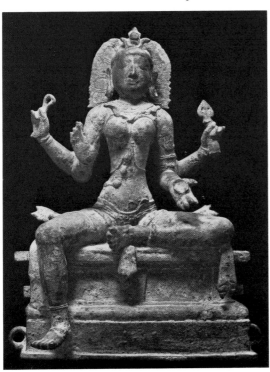
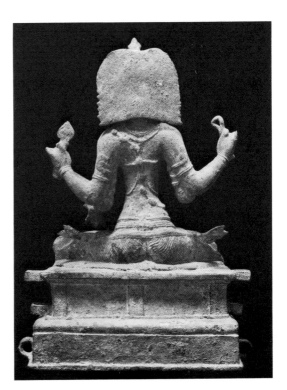

12. Kālī (color illustration p. 25)

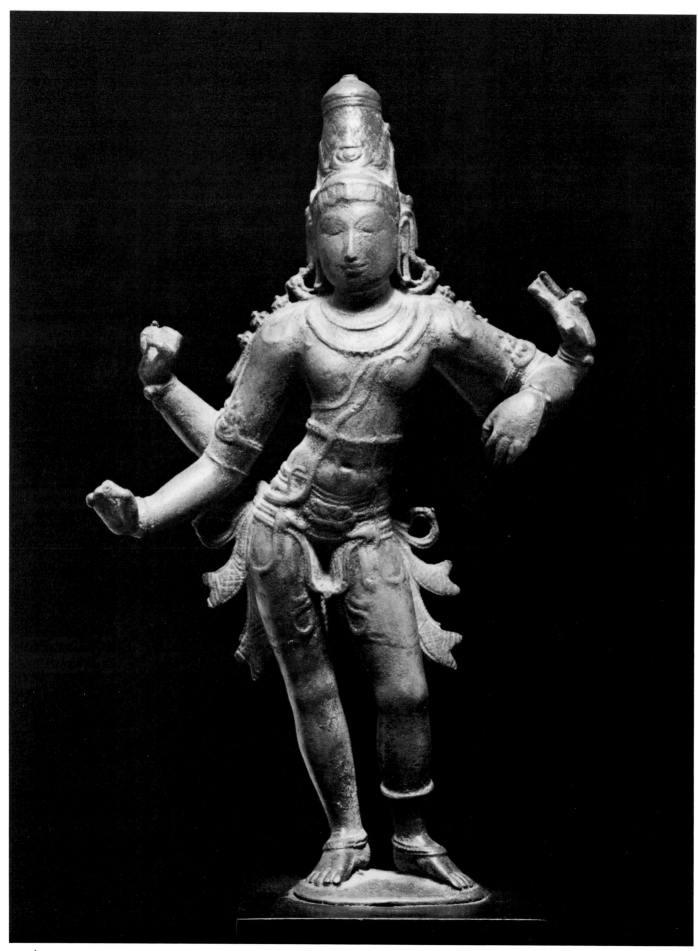

13. Śiva

13 Śiva

India, Tamilnadu; early Vijayanagara period,
 ca. fourteenth century A.D.
Bronze, H. 22 cm (without socket)

The Rietberg Museum houses a number of large
Sivaitic bronzes of the Chola period from Baron
von der Heydt's collection. Miniature bronzes,
however, are not among them. This small Śiva was
purchased in 1974 and comes, surprisingly enough,
from an old private collection in Thailand.

Śiva stands in completely balanced *tribhanga*
posture. His weight rests on his right leg whose hip
is thrust slightly outward; his head is perpendicular
to the straight horizontal line of his shoulders. Four
arms, whose hands no longer hold any attributes,
rise fluidly from the narrow upper part of his body.
The face and body are charming, displaying
neither mannered elegance nor coarse robustness.
The god wears a *makuta* crown that has a crescent
moon at the center front. It is edged with a band
and strands of pearls hanging down in loops over
his forehead. A *śiriśchakra*, a small nimbus com-
posed of radially arranged lanceolate leaves, is
rimmed by a narrow band. Over the ears are flow-
ers and rings, in the earlobes *makara,* or crocodile
motifs. He also wears a two-strand pearl necklace,
shoulder tassels (*skandhamālā*); three flowers on
each shoulder; a multipartite *yajnopavīta* or sacred
thread—the strands of which are held together by a
ring — on his breast; a narrow band around his
stomach; and a four-part hip girdle (*katisūtra*) that
shows, on each side, a bow and two sash ends. Loose
anklets encircle his feet, and there is a single, coil-
shaped ring around his left calf.

Unfortunately the attributes of the graceful
divinity are missing. Only the front left hand is
lowered, more as if it were resting on something
(for example, like Śiva as Vrishavāhana leaning on
the bull Nandi), than as if it were about to grasp a
vīna (like Śiva as Vīnādhara).

All these singularities of ornament and attire
allow the small bronze to be identified as a work
typical of the early Vijayanagara period.[1] Compar-
able to the Śiva, both in size and in many of the
details, is the charming Rāma from the James D.
Baldwin Collection.[2]

Not previously published.

Notes
1. C. Sivaramamurti, *South Indian Bronzes* (New Delhi,
 1963), pp. 24 ff.
2. J. Maxon, *Bronzes of India and Greater India* (Provi-
 dence, Rhode Island School of Design, Museum of
 Art, 1955), no. 55.

Divine Dalliance

14 India, Tamilnadu (possibly Tanjāvūr region);
 Madurai period, early eighteenth century
 A.D.
 Teak wood; H. 54 cm, W. 27 cm, Depth 9 cm

15 India, Tamilnadu (possibly Tanjāvūr region);
 Madurai period, early eighteenth century
 A.D.
 Teak wood; H. 56 cm, W. 28 cm, Depth 9.5 cm

These two wood carvings—on loan to and exhibited
in Liebighaus, Frankfurt am Main, in the 1930s—
have been comprehensively described by J.E. van
Lohuizen-de Leeuw (see *Published* reference be-
low). In recent years many wood carvings from
South India have become known, but very few pos-
sess the charm of these moving and lively reliefs
that depict Krishna in dalliance. Still another wood
carving, probably made in the same workshop, now
in the collection of Haridas Swali in Bombay, shows
a similar *mithuna,* or "amorous couple," and is said
to come from Tanjāvūr.[1]

In one of these carvings we see Krishna in the
act of taking his sensual beloved who yields to him.
The youthful-looking god — recognizable by his
high, hourglass-shaped coiffure — walks up to his
beloved and grasps her waist with his left hand,
while the girl acrobatically lets herself fall back-
ward. She stands on one leg, the other is stretched
out in the air behind Krishna. Her body is bent back
so that her head rests on a round cushion. With one
hand she holds onto her lover's ear, with the other
she grasps his right calf. The god is richly adorned
with jewelry on his shoulders and arms, and even
the hem of a short *dhoti* has been carved on his
thigh; the girl is naked but for her rich jewelry.

This sculpture may seem to have been crudely
carved, but this does not detract from the quality of
the piece. The impressive composition skillfully
exploits the possibilities of full relief. He is placed
on a diagonal, and her torso and his shoulders form
opposing diagonals. The oblique placement of his
shoulders and the silhouetting of her body also
contribute movement and energy to the piece. The
relationship between the two bodies and the gaze of
the two pairs of eyes bring the scene to life.

The second carving shows a more peaceful,
more intimate scene: the lovers kiss, kneeling on
their bed, their legs and arms tenderly entwined. In
this carving the hair of the woman is plaited into a
long, loose braid. She may also be wrapped in a
dress, because folds are indicated under her breasts
and on her thigh. In the background stands a con-
templative boy, his right hand touching his chin. He

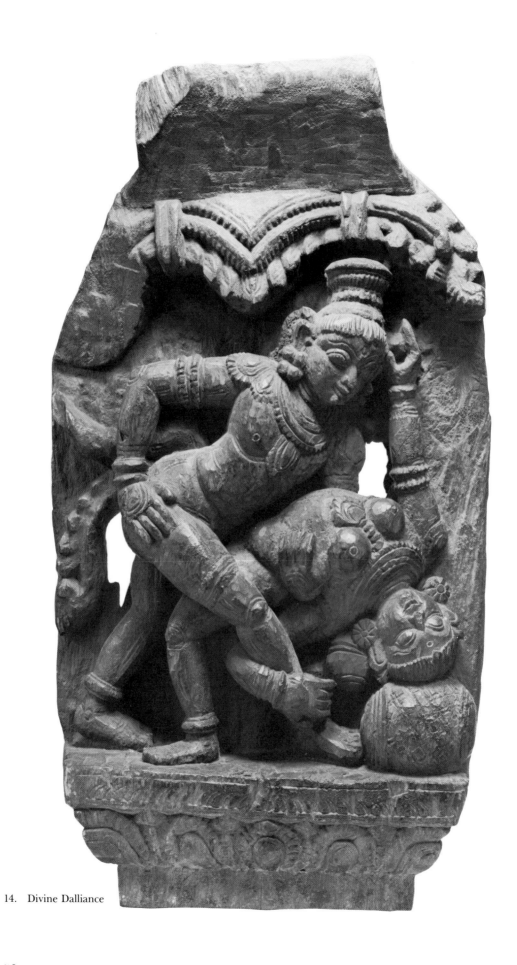

14. Divine Dalliance

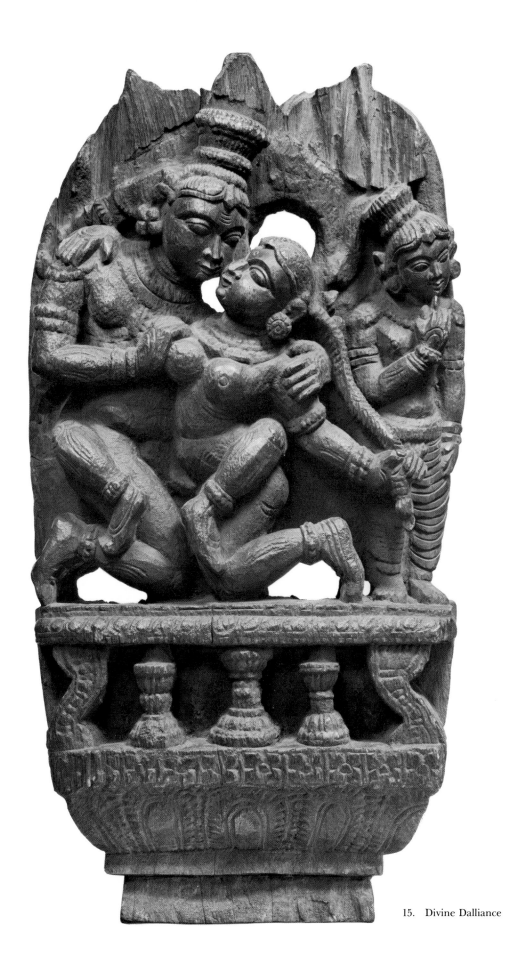

15. Divine Dalliance

looks out in front of him as if to say: "Now what is going on here?" This wood sculpture too appears to focus on the entwinement of the two bodies that culminates in the deep gaze of the lovers. The charming boy and the bed — under which implements have been laid aside — frame the closed triangular composition.

Both reliefs were once part of one of the large wooden cars that were used to carry devotional images from the temples in procession during the great annual festivals.

Published: W. Cohn, *Asiatische Plastik: Sammlung Baron Eduard von der Heydt* (Berlin, 1932), pp. 182 ff.; J.E. van Lohuizen-de Leeuw, *Indian Sculptures in the von der Heydt Collection* (Zürich, 1964), pp. 210–217.

Notes
1. K. B. Iyer, "Wood Sculpture from South India," *Lalit Kalā* 13 (1967), pp. 38–40.

16 Reception of an Embassy

India; Mughal style, ca. A.D. 1650
Gouache on paper; H. 24.5 cm, W. 17.5 cm
On the reverse: four lines of calligraphy in
 Nasta'liq
Gift of the Volkart Foundation, Winterthur

This picture, perhaps unfinished and later trimmed, may once have been part of the *Shāh Jahān-nāma* or *Padshāh-nāma*, a memorial manuscript for the emperor Shāh Jahān. Many painters made illustrations, but the manuscript was not written down until 1656/58 and may never have been finished. Two of its volumes came into the possession of the English royal family and are now kept in Windsor Castle. Another volume was taken apart in Oudh and its individual leaves are widely scattered.[1]

This painting shows the foreign dignitaries who have assembled in a courtyard of the palace. Behind them, partially obscured — their faces are not aligned and often overlap — are additional members of the embassy or the court. On the left, a mighty elephant with uncropped tusks comes into the picture; a young mahout kneels on top of him and bends forward. Below this elephant is another, younger elephant with short tusks and no orna-

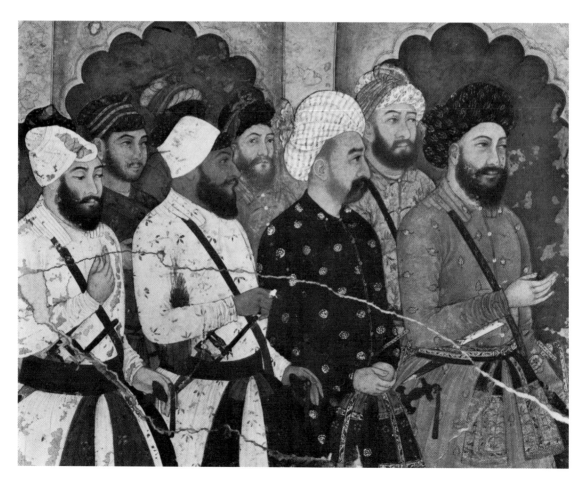

16. Reception of an Embassy, detail (color illustration p. 26)

mental whisk-tassel. A man leads two splendid riding-horses forward by their bridles.

Many portrayals of receptions of embassies which date from the late years of Shāh Jahān's reign and from the early years of that of his successor Aurangzēb are known. Mostly ambassadors from the Persian court were received, but according to François Bernier the messengers of the Tartar Khans and of the Uzbeks of Samarkand were also often called together. It is conceivable that this picture portrays foreign ambassadors, for they wear clothing and turbans that were otherwise not worn in Mughal India; particularly divergent from Rajput clothing are the *jama* costumes, which button up the middle, worn by most of these men; one of them —the fourth from the right—who looks out at the observer critically, could be one of the Europeans at the court.

The people's costumes are painted in various delicate colors (from which one gets the impression that they correspond closely to clothes worn for such receptions, rather than that they had been chosen on the grounds of composition). The leading stallion is blue gray, the ground is clay colored, and the architecture is in various tones of gray. Above an uncompleted white beam lies the shaded blue of the sky. The individual portrayal of the people, who face in different directions, creates an expectant group; nonetheless, the character and demeanor of each single member is strikingly rendered. We may conclude that this is the work of a painter like Payāg.[2] He illustrated not only the battle of Qandahar, but also the visit of the Persian ambassador Muhammad 'Alī Beg in 1630–1631, as well as that of Yādgār Beg after the fall of Qandahar in 1638. It is therefore conceivable that it was Payāg, too, who has rendered the reception of another embassy to Shāh Jahān's court. In any case, this picture has been cut from the lefthand page of an album—and one may imagine that the right half perhaps resembled the Ouseley page Add. 173 of the Bodleian Library at Oxford.[3]

The quality of the picture (in spite of the damage and the unfinished condition) makes it plainly comparable to a similar leaf that also depicts a court reception at Delhi but was painted one or two decades later for Aurangzēb by the painter Hūnhar (fig. 16a).[4] Here, too, two elephants and two horses are led into the picture, and various types of ambassadors (dressed in different fashions) appear. Groups loosely fill the center of the picture; important figures mingle with attendants, but even the former appear only as bearers of titles and costumes, not as individuals. With few exceptions they look toward where the emperor presumably stands, and all are rendered in three-quarter or full profile. In our picture, however, the painter has concentrated on the personality of the strangers whose characteristics of face and bearing he has rendered in such minute detail that the emperor himself would be able to recall the whole event in all its vividness simply by looking at the picture. Despite the psychological portrayal of the various members

of the embassy, this is not a tiresome picture of a court assembly; rather it is a vivid, extremely fresh, and yet detailed representation of a specific event.

On the reverse of the painting a four line poem by an anonymous poet is mounted:

Poem on the Appearing Moon

You, whose substance is a streaming donor for the searcher
And by whose beauty taste and happiness multiply,
You are the mine of the country of generosity;
The eyes of the high-ranking are placed at your feet, in genuine courtesy.

Not previously published.

Notes
1. M.C. Beach, *The Grand Mogul: Imperial Painting in India 1600-1660* (Williamstown, Mass., 1978), pp. 78 ff.; S.C. Welch, *Imperial Mughal Painting* (New York, 1978), pp. 112 ff.
2. Compare Beach, *The Grand Mogul,* pl. 25.
3. P. Brown, *Indian Painting under the Mughals* (New York, 1924), pl. 24.
4. J. Soustiel and M.C. David, *Miniatures orientales de l'Inde* (Paris, 1974), vol. 2, p. 16.

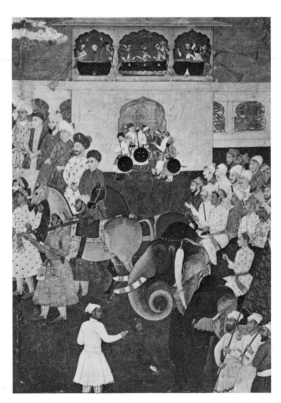

Fig. 16a. Court Reception by Hūnhar. India, Mughal style, mid-seventeenth century A.D.

17 Shāh Jahān in Old Age

India; Mughal style, ca. A.D. 1650
Perhaps a work of Muhammad Hāshim
Gouache on paper; Diam. 8.2 cm

It is said that Sir Thomas Roe in 1615 presented the
Mughal Emperor Jahāngīr with English medallion
miniatures, and that from that time on, this picto-
rial format became popular at the Mughal court.
Most of these round or oval miniatures were worn
as pendants or as ornaments on turbans. Especially
in the late years of the reign of Shāh Jahān, these
portraits were also executed by important paint-
ers.[1]

Shāh Jahān has aged; his beard is white, his
moustache and hair darker gray. Erect, he leans
against a bolster of gold brocade. He wears a plain
cotton shirt that buttons high up on one side; a red
turban which has a broad brocade band rimmed
with pearls and a feather crest that tilts back;
strands of pearls and rubies; rings; bangles; and a
narrow, jeweled band on his right upper arm. He
has musk under his arms; in his right hand he holds
two flowers with a leaf; in his left he holds a delicate
flywhisk. Golden rays fill up most of the medallion;
the round halo about his head has remained green.

There are several portraits of Shāh Jahān in
old age. Most of them date from the time his son
Aurangzēb had him imprisoned in the fort at Agra.
This may be because they took great pains in Delhi
to prove that the former ruler was still alive; or it
may be because the sitting for and having conversa-
tions with painters made the emperor's time pass
more quickly—those long, last eight years of his life.
Even before his imprisonment, Shāh Jahān was
portrayed with a gray beard, but generally he was

shown in conversation with his sons and friends.[2]
After 1650, however, portraits of the emperor
alone predominate: at first he appears still in court
attire, a sword over his shoulder; later only with
flowers, garlands of roses, and the flywhisk—those
few things still left to occupy him.

From these late years there is still another pic-
ture; it, too, probably was painted by Muhammad
Hāshim—who had also painted one of the portraits
of the emperor with his shouldered sword men-
tioned above.[3] This picture is almost as small as the
one under discussion; it is rectangular and has a
similar green ground.[4] Shāh Jahān's attire remains
almost identical, and the positioning of his arm suits
the format of the picture. Different, however, is the
emperor's gaze. In the rectangular picture the em-
peror still looks straight ahead; while in the round
medallion he seems to withdraw his gaze. He nar-
rows his eyes or holds them open only with great
effort, once again aged, plagued by sorrows, embit-
tered, and resigned to his imprisonment.

Not previously published.

Notes
1. See M.C. Beach, *The Grand Mogul: Imperial Painting in
 India 1600-1660* (Williamstown, Mass., 1978), p. 167,
 no. 64, "Portrait of the Prince Dārā Shikōh" by
 Muhammad Hāshim. In this oval medallion miniature
 of Shāh Jahān's eldest son, a portrait pendant can be
 seen in the middle of the necklace.
2. J. Strzygowski, *Asiatische Miniaturmalerei* (Klagenfurt,
 1933), pl. 100 (figs. 261, 262).
3. Beach, *The Grand Mogul,* pp. 127 ff.
4. Ouseley Add. 173, folio 17v in the Bodleian Library,
 Oxford University. See B. Gascoigne, *The Great Moguls*
 (London, 1972), p. 207.

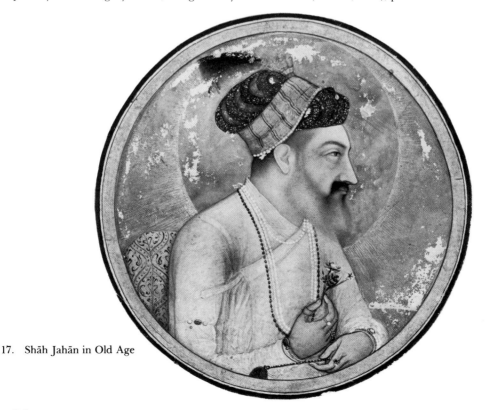

17. Shāh Jahān in Old Age

18 Hanuman Leaping Over the Ocean

India, Pahari region, Guler; ca A.D. 1720–1725
Gouache on paper; H. 17.5 cm, W. 26 cm
On the reverse: No. 34 and twelve lines of
black and red Devanāgarī script with white
corrections

This and the following leaf belong, with seven others in the Rietberg Museum, to the so-called "Smaller *Rāmāyana* Series"; thirteen other leaves from this manuscript are kept in the Lahore Museum, two in the National Museum of Pakistan in Karachi, and twelve in the Chandigarh Museum. Pictures from the unfinished "Greater *Rāmāyana*," also called the "Siege of Lanka Series," are to be found, among other places, in Boston, Cleveland, Bombay, and London. The Rietberg leaves were acquired in Basel in 1976 from a collector who years before had bought them from a rug-dealer in Kabul, Afghanistan. These nine pictures have been identified and described by B.N. Goswamy.[1]

Hanuman, Rāma's monkey-like assistant, a son of the wind god, leaps in gliding flight to the island of the demon king to search for the kidnapped Sītā. Blue air fills most of the upper half of the picture; Hanuman leaps toward the left; on the right edge of the composition tower the bare, golden beige hills of the mainland. The ocean, barely moving, shows a uniformly gray band and then a white strip of foam enclosed between two stippled lines. The glimmering gray ocean surface is crimped with ripples that look like the grain in wood, and it teems with three monstrous gray green trout and three bright fabulous creatures. One is a dragon with a scaly tail; he looks toward Hanuman and spews black threads of breath out of his open mouth, which has the tusks of a wild boar, the snout of a swine, and the teeth of a crocodile. Another fish-tailed monster has the head of an elephant without a trunk but with fish-shaped ram's horns; the third has the body of a snake and atop a long neck the red head of a dog.

Hanuman glides toward the upper edge of the picture; one peak of his crown even breaks through the frame. His light brown body is shaped like that of a man, but his face is brilliant red and monkey-like. His scant shorts are striped red and gray; around his waist is a belt of small bells and a *patkā*, or girdle, which is white and has a pattern of gold brocade flowers; from his shoulder flies a yellow shawl. His tufted tail is that of a tiger. On his ankles he wears bands of little bells, on his wrists bangles, on his upper arms bands that are adorned with tassles and pearls, around his neck several necklaces, in his earlobe a ring. The leaping Hanuman is clad like a Kathak dancer. It should be noted that the corners of his eyes are reddened.

The leaves of the "Greater *Rāmāyana*" (the "Siege of Lanka Series") are generally considered to be the work of one painter from Guler. The portfolio was in the possession of the Guler ruling family, and it renders peculiarities of the local landscape. It was painted around 1725, in a time of religious crisis, and was not completely finished.[2] Whether this marks the "commencement of a tradi-

tion" arising in Guler, or whether it is a transitional phase from an older Basholi style in Guler to a new "intrinsic" Guler style is uncertain. It is, however, probable that the large-format, illustrated leaves of the *Yuddha Kānda* — the sixth section of the *Rāmāyana* — have precursors in the "Smaller *Rāmāyana*," as do the *Aranya Kānda* (or third section), the *Kishkindha Kānda* (fourth section), and the *Sundara Kānda* (fifth section).[3] In the creation of both series, which were probably executed by the same painter, what B. N. Goswamy presents as the idiom of the painter Manaku of Guler applies: besides intense color—the thickly applied sandy royal blue of Rāma's body, the red of the corners of his eyes — and besides the experimentation with new paints that at times hardly adhered, this painter shows a preference for great empty picture planes with very high horizons; he often renders people and animals in a somewhat pale and rigid manner, while his trees are painted with a loving individuality, giving them a "loneliness and austere appearance."[4] These observations are further expanded through statements which have been applied to the large format series: "the emphatic reliance on plain backgrounds, whether scarlet or orange-red, its bold use of gold as in the palace walls, its recourse to nimble naturalism, seen especially in the treatment of the monkeys, its flair for abstract composition . . . and its adoption of the actual Guler landscape as background for mythical scenes. . . ."[5] To the already mentioned background colors, a washed-out olive green can be added. Another tendency this painter displays is that of introducing figures from the righthand side of the picture. All these observations apply to both *Rāmāyana* series, as well as to the

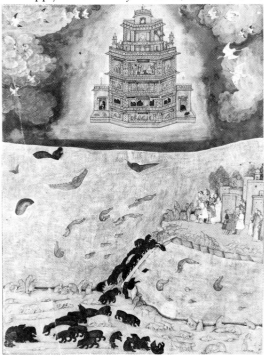

Fig. 18a. The Dream Castle of Lanka from a *Rāmāyana*. India, Rajasthan, Bikaner, late seventeenth century A.D. Collection of Edwin Binney, 3rd.

57

Gita Govinda series. In the presumably large compass of these portfolios, not all the leaves can be of equal quality. Thus there is discussion of a workshop, or collaborative work done by Manaku of Guler and a simpler assistant from Nurpur, the smaller leaves of the *Rāmāyana* being ascribed to the latter. This, however, is certainly not correct, for pictures like the following "Bears Wrestling With Monkeys" show a witty, innovative master. Thus we can probably assume that all the leaves were painted by the Guler Master who completes one phase of transitional art; in some paintings, going by the name of Manaku, he kept to the constraints — passed on from his father, Seu — of the older Basholi style; while in others he was innovative in portraying his own vision of the landscape, and in taking his subject matter from the lowlands. It is no surprise that these stylistic breaks and stiffnesses seem "awkward,"[6] but on the whole they result in a "happy synthesis of the old and new."[7]

We do not know what influences the Guler Master, around 1720,[8] assimilated — whether he perhaps could have seen a leaf like "The Dream Castle of Lanka" which is now in the collection of Edwin Binney, 3rd (fig. 18a).[9] That miniature was probably painted a few decades earlier in Bikaner. In it black bears and brown rhesus monkeys trot around, tumbling head over heels; the heads and tails of seamonsters plough through the waves of a wood-grained sea, and threads of breath waft out of the jaws of the monsters.

Not previously published.

Notes

1. B.N. Goswamy, "Leaves from an Early Pahari *Rāmāyana* Series: Notes on a Group of Nine Paintings in the Rietberg Museum, Zürich," *Artibus Asiae,* forthcoming (1980).
2. W. G. Archer, *Indian Paintings from the Punjab Hills* (London, 1973), vol. 1, pp. 147 ff.
3. F. S. Aijazuddin, *Pahari Paintings and Sikh Portraits in the Lahore Museum* (London, 1977), pp. 69–72.
4. B. N. Goswamy, "Pahari Painting: The Family as the Basis of Style," *Marg* 21, no. 4 (1968), pp. 32 ff.
5. Archer, *Indian Paintings from the Punjab Hills,* vol. 1, p. 147.
6. K. Khandalavala, *Pahari Miniature Painting* (Bombay, 1958), p. 128.
7. S. C. Welch, *A Flower from Every Meadow* (New York, 1973), p. 78.
8. The date should be slightly earlier than the fall of Delhi in 1739 when the "Muhammad Shahi revival" should have influenced Guler artists. See R.C. Raven, *A Concise History of Indian Art* (London, 1976), p. 233.
9. Welch, *Flower from Every Meadow,* p. 65.

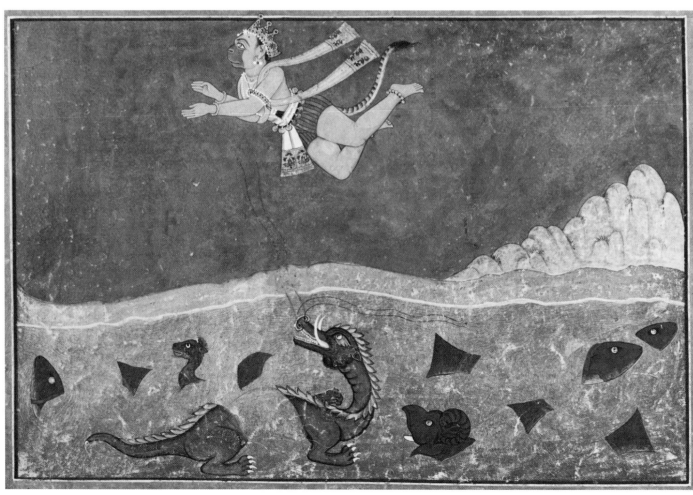

18. Hanuman Leaping Over the Ocean

19 Bears Wrestling with Monkeys

India, Pahari region, Guler; ca. A.D. 1720–1725
Gouache on paper; H. 17.5 cm, W. 26 cm
On the reverse: ten lines of black and red Devanāgarī script

In his version of the *Rāmāyana*, the poet Vālmīki describes how Hanuman finds the abducted Sītā and happily returns (*Sundara Kānda* 61, 62): all were so happy that Hanuman's army of Vānara bears managed to invade the honey-forest (*madhuvana*) of Sugrīva, prince of the monkeys, and despite the opposition of the monkey-guardians the intruders got intoxicated on the honey. In Hari Prasad Shastri's translation of the *Rāmāyana* of Vālmīki, the *Vānara*, literally "Dwellers of the Forests," are also monkeys. It goes on: ". . . all those virtuous inhabitants of the forest, eager to assist Rama and avid for combat, jumping and frisking, reached Madhuvana . . . , that picturesque and spacious garden, . . . extremely anxious to partake of the fruits of the beautiful orchard . . . to drink of the honey; those monkeys ascended the trees, swarming with bees, feasting on the fruit and roots and, in an access of intoxication, began to frolic here and there. Singing, laughing, dancing, bowing, declaiming, running, capering and clapping their hands, some supported others, some quarrelled and some talked at random. Some leapt from tree to tree, springing down from the highest branches. . . ."[1] A fight breaks out between the drunken intruders and the defenders.

This charming picture shows how the bears try to capture and the screaming and biting monkeys try to defend a clearing in the forest. Even though the monkeys bite into the thick ruffs on the bears' necks, no blood flows. The trees are regularly spaced in a large oval. Because a dark-green glaze shades the foreground, we get the impression of looking out from the darkness of the forest onto a sunbright hill. Thick banana shrubs, cypresses, and other trees—some forked and dropping their fruit, partly bent by the wind, some leafless showing gnarled knot-holes — contrast strikingly with the symmetrically conceived and conventionally painted plants that grow close to the ground at the shady edge of the forest. The horizon is high: a cloudy strip of the sky—dark blue and black-white — above an austere, greenish distance that looks blanched by the midday sun.

Not previously published.

Notes
1. H.P. Shastri, *The Ramayana of Valmiki,* vol. 2 (London, 1957), p. 488.

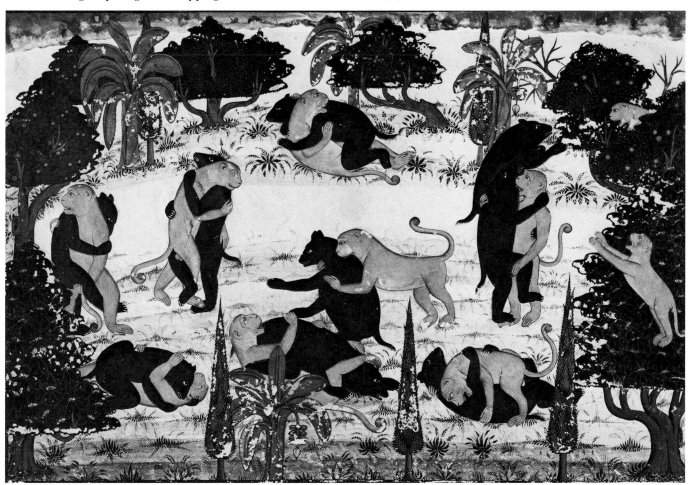

19. Bears Wrestling with Monkeys

20 Sohnī and Mahīnvāl

India, Rajasthan, Kotah; ca. A.D. 1810
Gouache on paper; H. 29 cm, W. 20.5 cm

That Indian painters surprisingly seldom illustrated fables and folktales was noted by Ananda Coomaraswamy,[1] who was probably the first to have called attention to illustrations of the melodramatic story of Sohnī and Mahīnvāl. This folktale from the Punjab appears to have been written down in Persian by Amir Khushrau and in Gurmukhi by Fazl Shah. Even today it is still known to the potters of Panjab/Gujrat in Pakistan, where it originally took place: an elaborate version from there has been told by Owen S. Rye.[2] Considerably summarized, the action is as follows: Mirza Izzad Beg, a merchant from Bukhara or a Mughal prince from Delhi, fell in love in Gujrat with the daughter of a potter. In order to be near her, he took on the work of a buffalo-herd (*mahīn vāla*). He pastured his herd on the shore of the Chenab River, across from the potter's village. The maid Sohnī ("Beautiful") loved the stranger. At night she swam upon an overturned water-jar to her beloved. She was spied on by her sister-in-law, who exchanged her swimming-jar for a vessel of unfired clay. On a moonless night Sohnī sank into the river.

The picture is painted in the cool colors of a bright, moonlit night. A broad, silver-gray gleaming river with a few gentle ripples pulls sluggishly across the picture. On the far shore, on a shelf of ground, a princely herdsman sits on a flat stone and leans against a tree. His bow, arrows, and round shield are laid aside; the gold-brocade turban and the embroidered shoes reveal to us the Mughal parentage of Mahīnvāl. He has slung his shoulder cloth around his drawn-up knees. He touches a bamboo flute; his bright, beardless face is turned toward Sohnī in the river. Near him, in a lush meadow, four brightly colored cows push forward. Behind them rises a small palace, a pair of houses with tile roofs, and a Nagari temple with a red banner; on the horizon are treetops and datepalms, in the bright gray sky a thin crescent moon.

The herdsman looks lovingly at Sohnī; Sohnī, swimming in the water, keeps her arms folded on the black vessel. Her body is concealed under water; a veil plays about her smiling, upward-tilted profile. Near her, lotus blossoms open in the silver gray water.

In the foreground, diagonally across the river from Mahīnvāl, a youthful ascetic sits in front of his beehive-hut, under some trees (in which there is one peacock). Naked except for his amulet and loincloth, daubed with ashes, he sits on a tiger skin, pondering, his arms propped up on a forked staff. Near him is a large water-jar with a smaller jar for a lid, before him a smoldering fire whose bluish smoke covers the surrounding area, a sacrificial

ladle, and a dog licking his right hind leg. Only a short distance away, upon a little platform in shallow water, stands a Śiva shrine with a lingam and an image of Nandi. At the edge of the river, at a mooring, is a box-shaped boat with rudder.

The theme of the maid who — despite the danger involved — goes to her beloved, has charmed many Indian painters. Sohnī swimming in the river has often been painted. A group of late Mughal period illustrations from Farrukhabad dated around 1770 is curious;[3] in them Mahīnvāl appears actually taking buffalos to pasture; Sohnī is shown gliding with her whole body underwater; and the ascetic who sits outside his beehive-hut is an old, bearded man who could be a sadhu or a fakir, sitting alone smoking a hookah or with young disciples and dogs around him. Sometimes an additional expanse of water occupies the foreground.

The painters from Bundi and Kotah now modify the contents of these pictures. Mahīnvāl is changed from a buffalo-herd to a cowherd. This slight alteration, however, makes for a profoundly symbolic re-casting of this figure, putting him on the same plane as the flute-playing herdsman

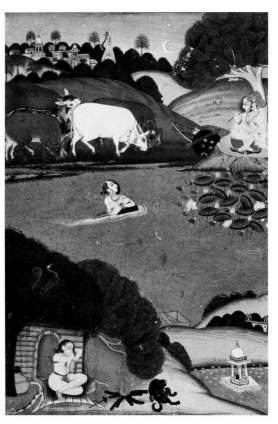

20. Sohnī and Mahīnvāl (color illustration p. 27)

60

Krishna. In a picture from Bundi, dating from 1790, the herdsman Mahīnvāl is portrayed like Krishna with blue hair and a white nimbus (fig. 20a).[4] Even if the Kotah painter does not go as far, he still gives his herdsman a light-shaded aura. Every observer understands this stranger with the cows to be the god who loves his worshippers and who demands their loving devotion. And as in many Rajasthan pictures, the cows and the earth symbolize nature pressing toward the protective god; so, too, Sohnī swims—against all social mores —to her beloved, and only the lotus in the water near her may make plain her purity. The painter, however, may have wanted the observer to understand a third plane of thought: the ascetic, his eyes sunken in dreams and yet awake, looks toward his deity, Mahādeva. He knows the boat in which all rivers can be crossed without danger.

The development of this pictorial complex of thought certainly goes back to influences from Mughal models. Even in them Mahīnvāl sits with his legs drawn up, his weapons laid aside, and he plays a wooden flute. In the ascetic, however, M.S. Randhawa sees a fakir who prays to Khwaja Khizar, the river god, for Sohnī's safe return.[5] The first transformation probably arose in Bundi, from whence comes the picture mentioned above (fig. 20a). Here the scene is magically transformed into a romantic moonlit night; the young ascetic has fallen asleep in his banyan tree, near his two dogs. Waterfowl inhabit the river; a small temple and a boat are hidden in the bushes. Some twenty years later the Kotah painter has become sparser, cooler. He limits himself to the three planes of action he considers important: cows with the flute-playing herdsman, Sohnī in the water, and the ascetic with a little temple and a boat. Certainly he has a few details in common with the Bundi painter (the beehive-hut, the dog that licks himself, a cow that begrudges the others fodder). The Kotah painter, less romantic, less concerned with moods, is conscious of parallelism when he places in one descending line a white cow, who in turn bars the way of a brown one to nourishment and to the herdsman, Sohnī drifting on her water-jar, and the motionless ascetic. This painter seems clearly and intellectually to have grasped the interaction of the three planes of relationship (cows and cowherd, lover and beloved, ascetic and divinity).

The contemporary picture, "A Bather," was probably painted by the same painter from Kotah.[6] Here, once again, it looks as if the painter made use of Sohnī's upward gaze. Even if the faces of his figures always appear somewhat cool and blasé, they are not without sensuality. Often their clear eyes are directed towards someone, extant or anticipated. This painter always limits the action to the important characters and concentrates on only those accessories which are necessary to his statement or to his composition; his pictures therefore acquire readability and invite interpretation.

Not previously published.

Notes

1. A.K. Coomaraswāmy, *Rajput Painting*, vol. 1 (London, 1916), p. 64.
2. O.S. Rye and C. Evans, *Traditional Pottery Techniques of Pakistan*, Smithsonian Contributions to Anthropology, no. 21 (Washington, D.C., 1976), p. 194.
3. E. Binney, 3rd, "Later Mughal Painting," in P. Pal, ed., *Aspects of Indian Art* (Leiden, 1972), p. 212, pl. 66.
4. M.S. Randhawa and J. K. Galbraith, *Indian Painting* (London, 1969), pp. 87 ff., pl. 17.
5. W. G. Archer, *Indian Paintings from the Punjab Hills* (London, 1973), vol. 1, p. 151.
6. M.C. Beach, "Painting of the Later Eighteenth Century at Bundi and Kota," in P. Pal, ed., *Aspects of Indian Art*, (Leiden, 1972), pl. 72.

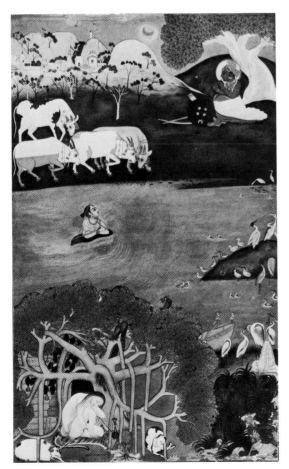

Fig. 20a. Sohnī Swimming to Meet Mahīnvāl. India, Rajasthan, Bundi, ca. A.D. 1790.

21 Rāginī Madhumādhavī

India, Rajasthan, Mālpurā near Jaipur; from
a *Rāgamālā* set painted by Jai Kishna, dated
A.D. 1756
Gouache on paper; H. 23.5 cm, W. 17 cm
On the reverse: blue stamp, "Klaus Ebeling"
Gift of the Indo-Swiss Society, Zürich

In the middle of the eighteenth century, the painter
Jai Kishna worked in Mālpurā—once an important,
small center of commerce south of Jaipur. Of his
works we know single leaves from a *Rāgamālā* set,[1]
miniatures inspired by musical themes, and illustra-
tions for Keśavdās's *Kavipriyā*. It is probable that
some of these pictures exist in several versions (we
know at least two *bārāmāsā* sets) and that they come
either from him or from his workshop. His oeuvre
is scattered worldwide.[2]

A storm that arises suddenly — gray banks of
clouds shot through by snaky lightning bolts— sur-
prises a young lady on a terrace in front of an ornate
palace. Outdoors, in expectation of the arrival of
her beloved, she has spread a cloth on the ground;
on the cloth she has placed a cushion, betel, and a
spittoon for him. Before the first heavy drops fall,
three female companions of the same age call her
into the house: two sit, their arms around each
other, in a little tower with window shutters, and
from their secure shelter they point to the light-
ning; a third stands in the doorway and beckons
her inside. The heroine has jumped up and stops half-
way between the cloth she has laid and the door
leading inside; she turns around and veils her face
from the sudden lightning; her right hand is
stretched, in fear, toward her friend. In this stormy
atmosphere, peacocks bend their necks backward
in the wind-shaken trees. They scream. Small, white
cranes fly up in the air: the first one, boldest, turns
around. Like the heroine he looks back at the light-
ning which separates him from the three cranes
that follow him. Above the painting are four lines of
Devanāgarī script in silver and gold on black.

With its variegated gray blue sky, its fresh
foliage, its "delicate lace work style of architecture,"
and its extremely gay costumes, the picture
expresses in composition — through the vertical
division of the house (with its related persons, the
girlfriends, its sense of protection) and the out-
doors (with its sudden thunderstorm, its screaming
peacocks, its wind-shaken trees, its prepared but
untasted sweets, its liberty)—what is to be pictorially

understood and comes under the title of
madhumādhavī or "springtime honey." Even more
than the coming of spring, this external occurrence,
the blowing up of the monsoon through sudden
thundershowers in the cool morning hours, corres-
ponds to the feelings of the young woman. She is
still youthful; she has prepared a sitting place for
herself and her expected friend neither voluptu-
ously nor opulently, nor hidden from the gaze of
her friends — it is set up on the terrace; moreover,
she is afraid of the storm that suddenly breaks over
her, the powerful unbridled welling up of her emo-
tions. She flees, once again, to the protection of the
home, to the nearness of her friends. And yet, as if
curious, she hesitates at the corner of the house,
halfway between stormy freedom and well-known
protection.

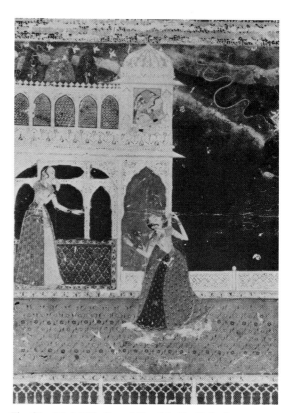

Fig. 21a. Rāginī Madhumādhavī. India, Rajasthan,
perhaps Mālpurā, ca. A.D. 1755.

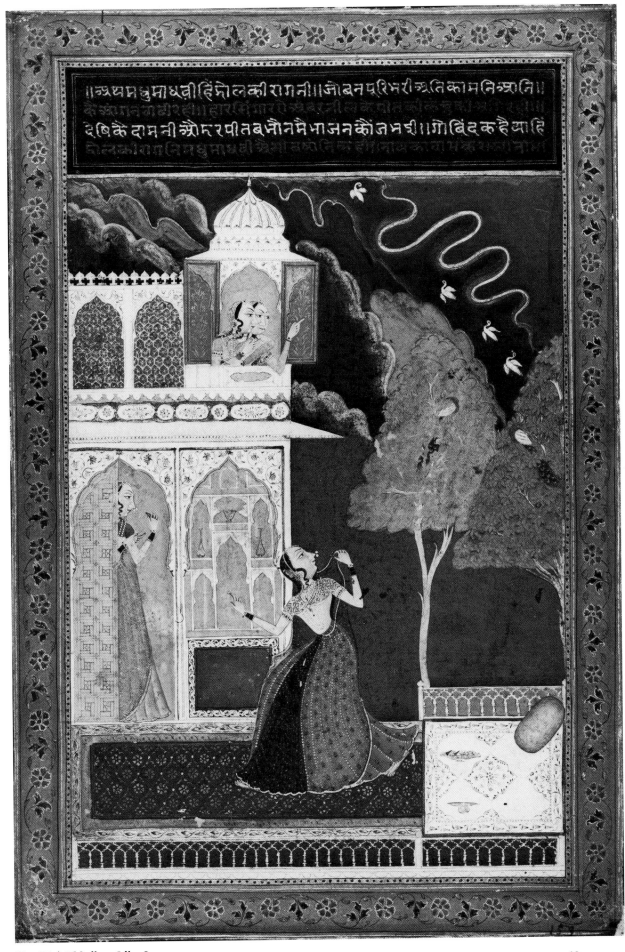

Another version of this picture—ingenious in its wealth of relationships and yet harmoniously composed — has been preserved. This leaf, of roughly the same size as the one under discussion and heavily worn, may have been a preliminary study (fig. 21a).[3] In it already the heroine is shown in the typical posture of stepping forward while turning back, but the bisection of the picture with the love nest set outdoors has not yet been realized. Trees and birds are placed above the pavilion, the significance of which has not yet been worked out.

Published: K. Ebeling, *Ragamala Painting* (Basel, 1973), pl. C 22.

Notes

1. The most interesting collophon on *Āsāvarī Rāginī* from the same Rāgamālā set, in the Fogg Art Museum, Cambridge, Mass. (acc. no. 241.1941), has kindly been transcribed and read by Dr. Anand Krishna, Varanasi, as follows:

 Īti Srī rāgamālā citra-pustaka sampūrna samaptā bhavati idam pustakam panditaji srī

 This Sri Rāgamālā illustrated manuscript completely finished is this book for Panditji Sri

 Cimnājikasye darsanarthah citra likhate kārigara Jaikīsna Mālpurā Madhe dasakata

Chimanji; for viewing the painting(s) were drawn (by the) craftsman Jai Krishna in Mālpurā (who has) signed.

Raiji Motiram likhite Mālapurā madhe patra samasta 43 samvat 1813 miti pō

Raiji Motiram scribed in Mālpurā in leaves altogether 43, at samvat 1813 day

sa sudi 7 mangalvār sampūrnam srī
Pausha sudi 7, Tuesday completed, Sri.

This collophon clearly indicates that the painter's name is Jai Kishna (Jai Krishna), the scribe's name Raiji Motiram, and the person commissioning the Rāgamālā series Pandit Chiman, both craftsmen being from Mālpurā. The manuscript consists of 43 pages and was ready in A.D. 1756.

2. See K. Ebeling, *Ragamala Paintings* (Paris, 1973), pl. C22, p. 212; E. Binney, *Rajput Miniatures* (Portland, 1968), p. 36; J. Soustiel and M.C. David, *Miniatures Orientales de l'Inde* (Paris, 1974), p. 53; Spink & Sons, *Paintings for the Royal Courts of India* (London, n.d.), p. 38; J. W. Watson, *Indian Miniature Painting* (Madison, 1971), p. 194; A.L. Dallapiccola, *Princesses et Courtisanes* (Paris: Galerie Marco Polo, 1978), pp. 29, 30, 42.

3. Sotheby Parke-Bernet, sale 4264 (New York, 1979), no. 54.

22 Umā

Cambodia; Pre-Angkor style of Prasat Andet,
late seventh century A.D.

Reddish gray sandstone; H. 95 cm, W. 23 cm
von der Heydt Collection

Aside from the Vishnu sculptures in the Cleveland
Museum of Art and the smaller fragments in the
Musées Guimet in Paris and Lyon, for a long time
this graceful sculpture was the only work of the
Pre-Angkor period in the style of Prasat Andet to be
found outside of Southeast Asia; before it was ac-
quired by Baron von der Heydt, it was exhibited in
the Metropolitan Museum of Art in New York, on
loan from the Mallon Collection. In his comprehen-
sive compilation of Pre-Khmer style, P. Dupont was
the first to have analyzed the piece and classified it
according to period and style (see *Published* refer-
ence below).

The "Prasat Andet style" takes its name from
the Hari-Hara, "the most remarkable male statue of

all Pre-Angkor art," found at Prasat Andet, a small
shrine.[1] Its ornaments indicate the transition from
the style of Prei Kmeng to that of Kompong Preah.
These sculptures—made in the last few decades of
the seventh century—are generally a meter high;
they represent Hindu divinities who stand erect,
and whose fresh-smiling faces are crowned by
cylindrical mitres. All the goddesses wear long
skirts that fall in graceful folds to their ankles; verti-
cal gathers—generally three—are draped in front
of the belly.[2]

The Umā stands before us in youthful, yet fully
blossomed beauty, one hip thrust slightly outward;
she has softly sloping shoulders and full breasts. Of
her four arms only the left front upper arm re-
mains. The head, resting upon a neck marked with
several grooves, is also greatly damaged. The face is
fascinating with its soft smiling mouth; its high-
arched, hairless brows; and the large ears with short
earlobes. The eyes of the goddess are wide open,

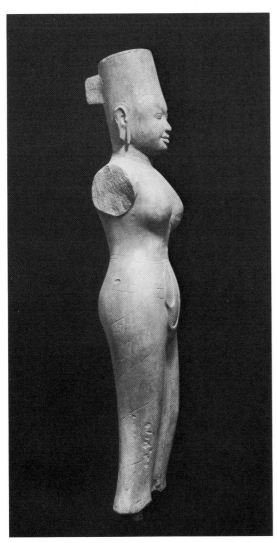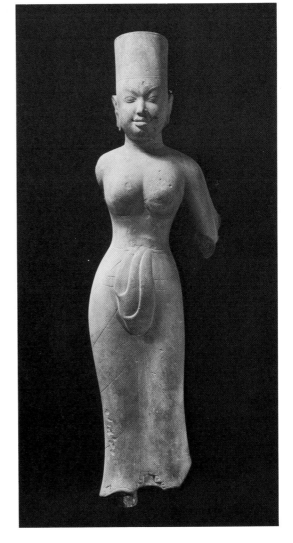

22. Umā (color illustration p. 28)

the pupils gaze straight forward. The mitre on her head is edged with incised lines.

Aside from the full breasts, only the pocketlike pleats over her stomach and the graceful folds of the robe between her feet and over her ankles are plastically sculpted on the curving body perceived like a silhouette. A broad sash, fringes, obliquely falling folds, the circles around her nipples, the irises, and the double lines under her breasts are indicated by incised lines.

The back side of this freestanding sculpture reveals the soft modelling of the body, evident only in the deep indentation of the spinal column; everything is exact, terse. The arms come out of the back and shoulders with no sign of shoulder blades. The remains of a cubic tenon for a nimbus can still be recognized on the back of the mitre. Despite the fragmentary condition of the Rietberg sculpture, the radiant impression left by this sublime "proudly erect body of a standing goddess"[3] is powerful. Because of this one scarcely asks oneself how she once might have looked in her entirety, with nimbus and emblems.

There is another, quite similar Umā, whose place of origin also cannot be precisely determined, in the Musée Albert Sarraut in Phnom Penh. Of about the same size as the Rietberg Umā, she too lacks a nimbus and arms, but has strands of hair on her crown. Standing on the head of a buffalo, she is an image of Durgā Mahishāsuramardinī (fig. 22a).[4]

A third, comparable sculpture, the Umā from Samlanh in the Musée Albert Sarraut, stands on a squared stone base and is surrounded by a horseshoe-shaped nimbus, on which her two rear arms—extended upward—are placed (fig. 22b).[5] Thus the sculpture has the appearance of being confined, stiff—an impression that is underscored because her right hip is thrust outward far less, and she lacks the "gently swinging rhythm"[6] of the Rietberg Umā.

Published: O. Fischer, "Die Sammlung von der Heydt in Ascona," *Pantheon* 3 (1929), p. 277; W. Cohn, *Asiatische Plastik: Sammlung Baron Eduard von der Heydt* (Berlin, 1932), p. 186; P. Dupont, *La Statuaire Préangkorienne* (Ascona, 1955), pp. 166–179.

Notes
1. M. Giteau, *Khmer Sculpture and the Angkor Civilization* (New York, 1966), p. 59.
2. P. Dupont, *La Statuaire Préangkorienne* (Ascona, 1955), p. 169.
3. O. Fischer, "Die Sammlung von der Heydt in Ascona," *Pantheon* 3 (1929), p. 277.
4. G. Groslier, "Les Collections Khmères du Musée Albert Sarraut à Phnom-Penh," *Ars Asiatica* 11 (1931), p. 68.
5. Dupont, *La Statuaire Préankorienne*, pl. 38A.
6. W. Cohn, *Asiatische Plastik: Sammlung Baron Eduard von der Heydt* (Berlin, 1932), p. 190.

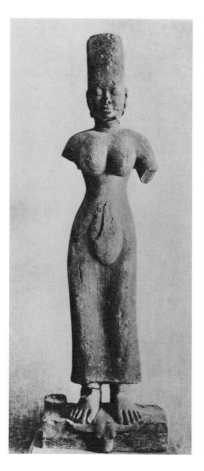 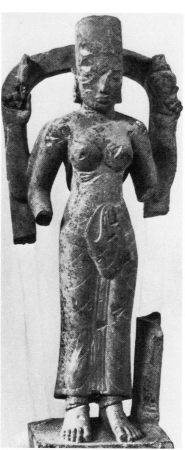

Fig. 22a. Durgā Mahishāsuramardini. Cambodia, Pre-Angkor style, late seventh century A.D. Musée Albert Sarraut, Phnom Penh.

Fig. 22b. Umā. Cambodia, Pre-Angkor style, seventh century A.D. Musée Albert Sarraut, Phnom Penh.

23 Head of a Buddha

Thailand; Lopburī style, ca. mid-twelfth century A.D.
Gray sandstone; H. 25 cm, W. 15 cm
von der Heydt Collection

This lovely head of a Buddha was acquired in the late 1920s by Baron von der Heydt. The back of the less than lifesize head is flattened, the ears are damaged, their lobes broken off. The *ushnīsha*, the chignon on the top of the head, is also worn down; otherwise the (cleaned) surface of the sculpture is intact; the eyes are full of expression, with both upper and lower lids chiselled in. The eyebrows have a fine sweep, the cheeks are modelled fully, and the lips are soft, almost edgeless.

The lively head shows a happy synthesis of two Southeast Asian styles. Still vibrant in it are elements of Dvāravatī art of central Thailand: the roundness of the face; the tight curls of hair that cover the head, without headband, and frame the forehead; the full but soft lips. On the other hand, Khmer elements should not be overlooked: the even, angular hairline, the dimple in the chin, the pointed ears.[1] Thus it can be inferred that the origin of this sculpture is to be sought outside of the Khmer center, presumably in central Thailand. That the facial features "are remarkably like those of the heads of Buddha from Java in the classical period," has been noted also by William Cohn, who at that time associated them with the art of Śrīvijaya.[2]

The piece was praised by the collector's friend, Frank Davis, who wrote that this Khmer head "is sensitive enough even in the photograph, but immeasurably finer when it is seen as it stands in the house, backed by a seventeenth-century tapestry. . . . How difficult is the task of the average museum director, with a dead-weight of tradition behind him which demands glass cases — the very things which make even the finest work without form and void. . . ."[3]

Published: W. Cohn, *Asiatische Plastik: Sammlung Baron Eduard von der Heydt* (Berlin, 1932), p. 204; F. Davis, "A Page for Collectors: A Highly Individual Collection," *The Illustrated London News* (August 27, 1938), p. 376.

Notes
1. Compare, as an example of Bayon-Khmer style, the famous "Buddha Commaille" in the Musée Albert Sarraut, Phnom Penh, illustrated in J. Boisselier, *La Statuaire Khmère et son évolution* (Saigon, 1955), pl. 100.
2. W. Cohn, *Asiatische Plastik: Sammlung Baron Eduard von der Heydt* (Berlin, 1932), p. 204.
3. F. Davis, "A Page for Collectors: A Highly Individual Collection," *The Illustrated London News* (August 27, 1938), p. 376.

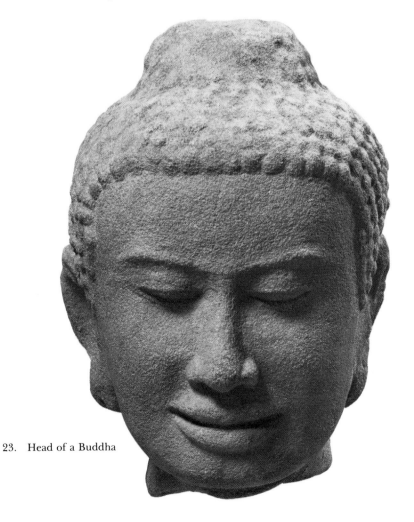

23. Head of a Buddha

24 Bodhisattva

Vietnam; Champa, ca. ninth century A.D.
Light brown sandstone; H. 76 cm, W. 38 cm
von der Heydt Collection

The Rietberg Museum owns four exceptionally beautiful works of the early culture of Champa. Three of these, a seated Deva, a bust of a Deva, and this bodhisattva, come from the monastery at Dong-duong (fig. 24a); the fourth, an *apsaras*, nymph, probably comes from Ba-nghi in the Quang-tri region. The three pieces from Dong-duong have been published in detail by J. Boisselier (see *Published* reference below). What follows is a summary from his essay, limited, above all, to his comments on the bodhisattva.

The monastery of Dong-duong was founded in A.D. 875 by Indravarman II as the first and largest Mahāyāna Buddhist temple compound of the Cham empire. Although it undoubtedly served as a place of worship for a few centuries, almost all the stone figures remained unfinished. In 1902 the collapsed sanctuary was excavated by French archaeologists; a few sculptures no longer attached to buildings were given to the museum in nearby Tourane, a few "duplicates" given to the Mallon Collection in Paris. Thus the bodhisattva has a companion piece in Tourane.[1] The bodhisattva was displayed for a few years in the Metropolitan Museum, and later, after Baron von der Heydt had acquired it, in the Museum für Völkerkunde, Berlin.

The bodhisattva sits in *mahārājalīlāsana*, the posture of royal ease; his right hand rests on his drawn up right knee, his left hand on the thigh of the outspread leg. His naked torso is slightly bent toward the left, the shoulders broad, the body soft and full, clad only in a loin cloth decorated with flowers and stripes. Above an ample but sharply cut

mouth is a little moustache; upon the forehead is a rhombic *urna;* in the ears hang *kundala* earrings that fall to the shoulders; on his head is a powerful double crown with two flower-like ornaments at the front center — a *kirita mukuta*. Behind the head, a pointed oval nimbus, ornamented with leaping tongues of flame, rises up from the shoulders to above the crown.

A pilaster is carved on the back of the figure. Presumably, the bodhisattva was placed in a wall. Boisselier speculates that the sculpture was set up in the *vihāra*, in the eastern part of the main sanctuary. There in the center a huge Buddha (Śākyamuni after his victory over Māra) with pendant legs sat enthroned; to his sides sat the two bodhisattvas Avalokiteśvara and Maitreya in "royal ease," each one's body turned slightly toward the Buddha.[2] This would make the Rietberg bodhisattva the Maitreya, though the iconography of the piece itself lends no supporting evidence to this theory. Boisselier goes on to say that the iconographic features reproduced here — those of Śākyamuni's victory over Māra—can also be applied to Akshobhya, the "Unshakable One" of the East; in this case the two side figures should be taken merely as attendant bodhisattvas.

Already self-defined and established, the early Cham style from Dong-duong gives to these Buddhist sculptures the physiognomic characteristics of the local population, or at least of its rulers; moreover, it shows a preference for swelling, deeply carved ornaments, heavy body-jewelry, and soft, flowing corporeality. Like Annam, the Cham region in the ninth century was a protectorate of China's T'ang dynasty. For this reason it can be presumed that the preference for distinct fashions of dress spread from the models of northern Chinese Mahāyāna Buddhism to the Champa empire, where at the same time Indian and Indonesian influences were being assimilated and transformed into an unmistakable local style.[3]

Published: W. Cohn, *Asiatische Plastik: Sammlung Baron Eduard von der Heydt* (Berlin, 1932), pp. 210 ff.; J. Boisselier, "Les Sculptures de Dong-du'o'ng du Musée Rietberg de Zürich," *Artibus Asiae* 26 (1963), no. 2, pp. 132–150.

Notes
1. H. Parmentier, "Les Sculptures Chams au Musée de Tourane," *Ars Asiatica* 4 (1922).
2. J. Boisselier, "Les Sculptures de Dong-du'o'ng du Musée Rietberg de Zürich, *Artibus Asiae* 26 (1963), no. 2, p. 149.
3. See P. Dupont, "Les Rapports chinois dans le style bouddhique de Dong-du'o'ng," *Bulletin de l'Ecole Française d'Extreme Orient* 44, pp. 267–274; and J. Boisselier, *La Statuaire de Champa* (Paris, 1963), no. 54.

Fig. 24 a. Two bodhisattvas at Dong-duong. Vietnam, Champa, ninth century A.D.

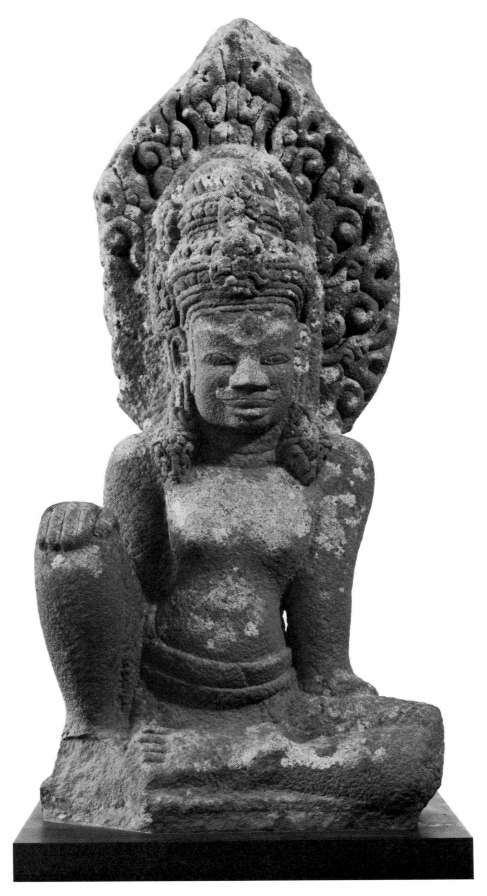

24. Bodhisattva

25 Chandra, the Moon God

Indonesia, Java; late central Javanese period,
ca. tenth century A.D.
Black tuff stone; H. 62 cm, W. 34 cm
Bequest of Mary Mantel-Hess

On a low, double lotus socle, the male divinity sits in
padmāsana posture — the shins flat on top of one
another, the back of the left hand laid on top of
them; the right hand (broken off) was probably
lowered in *varada-mudrā*. He has a high *mukuta*
crown, heavy *kundala* earrings, and a simple
necklace. Of specific interest is the fact that he is
wearing a close-fitting, collarless jacket with
rounded corners above his hips. Upon his shoul-
ders rests an oval nimbus that has a stepped rim; on
the left side of the nimbus is part of a crescent moon
which has been broken off on the right side, above
the locks on his shoulder. The calm, expressive face
has closed eyes, lively eyebrows, and a sharply cut
mouth.

Throughout the ninth and tenth centuries in
Java, it was common to use a crescent "to denote
boys of supernatural descent. Thus it came to be
associated with Gods or Bodhisattvas of a youthful
appearance (*kumārabhūta*), usually either Kuvera or
Mañjuśrī."[1] Often there are representations of
half-moons in the hair of Mañjuśrī, as in the tem-
ples of Sadjivan or Plaosan.[2] Of greater icono-
graphic significance than the half-moon is the little
jacket worn by the divinity; it points clearly to the
moon god Chandra. Chandra, also called
shītamārīcī, "the one having cool rays," is enveloped
by coldness and thus requires clothing, for he sends
the soft rays "to soothe the earth burnt by the solar
ardours. . . ." He is the place of the "primeval wat-
ers"; he is the dispenser of life, master of the stars,
"symbol of the world beyond death, the world of
immortality, the sphere where the ancestors dwell."
Although he is only little revered as a Hindu god, by
worshipping him two things can be attained: "to
gain the ability to concentrate one's mind — and to
gain physical beauty. . . ."[3]

Individual cult-images of the moon god —
which also incorporate the Soma drink of the gods
—are seldom found in India and Southeast Asia. In
Gujarat, for example, at Modhera's sun-temple, the
Chandra image wears the crescent moon upon the
mukuta crown and has half-closed eyes; on this
sculpture no jacket can be recognized. The Indian,
like the Javanese cult-image, however, conforms in
expression to the following iconographic require-
ment: "Chandra's countenance should be beautiful
and possess a peaceful look."[4]

Chandra is one of the *navagraha*, "nine planet
deities," but he is also a *dikpāla*, "a guardian of one
of the cardinal points," where—next to Isāna and
Prthivī—he guards the northeast.[5] There do not
seem to have been many representations of groups
of *dikpāla* images in Java, and among these no
Chandra has ever been found in situ. Thus, this
Chandra can lay claim to being a rarity.[6]

Notes
1. J. Fontein, R. Soekmono, and S. Suleiman, *Ancient Indonesian Art of the Central and Eastern Javanese Periods* (New York, 1971), p. 145.
2. *Catalogue Museum van Aziatische Kunst in het Rijksmuseum Amsterdam* (Amsterdam, n.d.), p. 79, pl. 49.
3. A. Danielou, *Hindu Polytheism* (London, 1963), p. 98.
4. T. A. Gopinatha Rao, *Elements of Hindu Iconography* (Madras, 1914), p. 318.
5. J.E. van Lohuizen-de Leeuw, "The Dikpālakas in An-cient Java," *Bijdragen tot de Taal-, Land-, en Volkenkunde* 111 (1955), pp. 356–384.
6. According to the statement of the collector who be-queathed it to the museum in 1968, this sculpture was presumably owned by Dr. J. R. van Blom, the ar-chaeological excavator of Tjandi Sadjivan. The sculpture most certainly does not come from that Buddhist temple compound. The iconographic iden-tification of the image as a representation of Chandra, the moon god (and not a bodhisattva Mañjuśrī), came orally from J.E. van Lohuizen-de Leeuw.

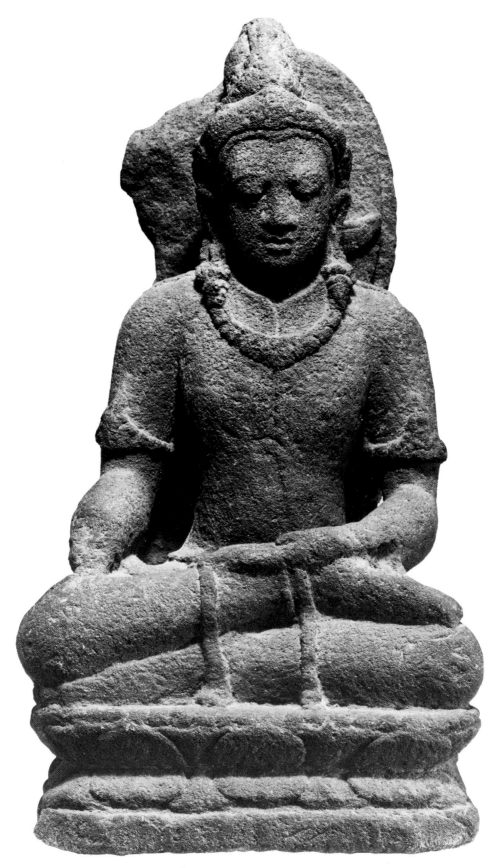

25. Chandra, the Moon God

CHINA
JAPAN

27. Ting

41. Seated Lady

54. Seated Bodhisattva

56. The Four Pleasures of Nan Sheng-lu, detail

57. The Song of the Great Land of Wu, detail

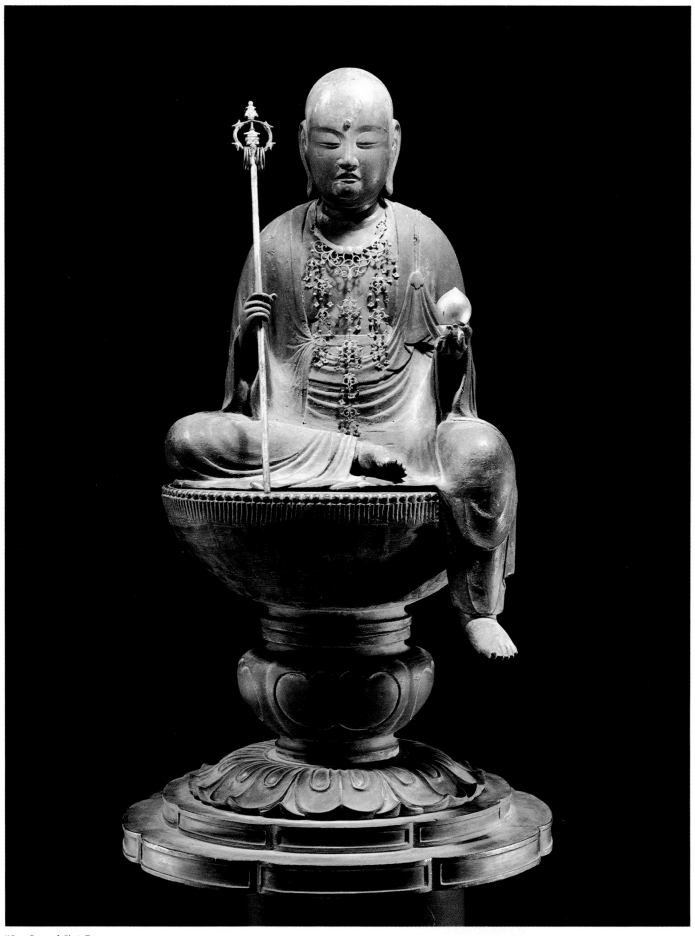

59. Seated Jizō Bosatsu

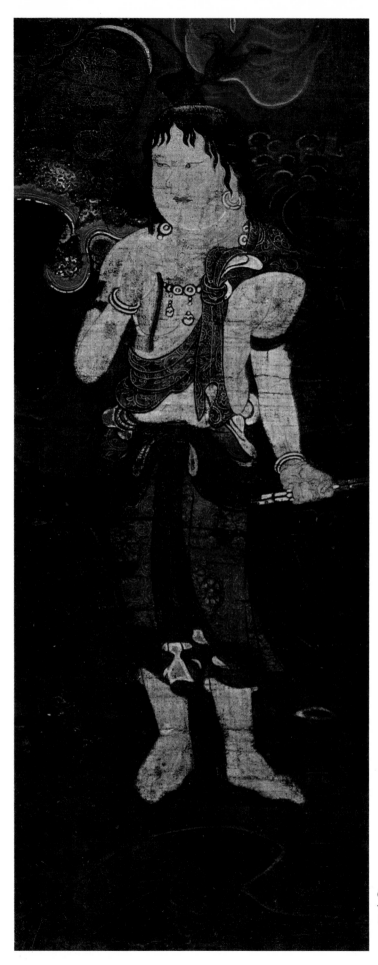

62. Blue Fudō Myōō
with Kongara and
Seitaka Dōji, detail

80

65. Idealized Portrait
of the Haiku Poet
Matsuo Bashō

26 Tsun

China; late Shang dynasty, ca. twelfth-
eleventh century B.C.
Bronze; H. 32.2 cm, Diam. 24.5 cm

Due to the penchant of Chinese scholars for sys-
tematizing and cataloguing, the archaic ritual ves-
sels were classified according to their presumable
use no later than the eleventh century A.D., and
each distinctive form was given a name. The ritual
sacrifices to the spirits of the ancestors, which fol-
lowed a strict ceremonial, seem to have required the
use of several basic types of ritual bronzes: vessels
for the preparation, cooking, steaming, and heat-
ing of sacrificial food or drink, others for libation
and drinking, as well as those for serving and stor-
age. Some of these names were derived from in-
scriptions on the ritual vessels themselves or from
oracle bone inscriptions; others are generic terms
for "ritual vessel" that scholars of the Sung dynasty
(A.D. 960–1279) used as names for specific forms of
bronzes. The term *Tsun* is one of these expedient
designations.

The Rietberg *Tsun*, acquired in 1970 from the
collection of Ernst Gross-Spühler, looks like a
monumental beaker of the *Ku* type with squat pro-
portions. It shows the same clear structure of three
superimposed sections. Over a slightly splayed base
on a sharply cut ring foot, the body of the vessel
expands in the midsection and then rises to the
trumpet-shaped mouth in an elegant curve. Plain
narrow bands isolate and accentuate the gently
swelling central zone which carries the main design;
at the same time they correspond with the sharply
cut lip and the heavy plain foot ring. They are cut
through the strong, incised flanges that not only
accentuate the vertical axes of the design but also
emphasize the contrasting directions of the curves
of the contour of the vessel. Similar in structure,
proportions, and the organization of its decor is a
slightly smaller *Tsun* in the Idemitsu Bijutsukan,
Tokyo.[1] However, in some details its decor is differ-
ent. On the Rietberg *Tsun*, the flatly treated
zoomorphic designs emerge in clearly defined con-
tours from the delicate spirals of the ground, which
are cast with extraordinary precision. On the base,
on either side, are a pair of confronted, horned
dragons in profile; they have thin, elongated
bodies, curled tails, long curved beaks, and large
protruding eyes. These conventional mythical ani-
mals reappear in a different form but in a similar
arrangement on the band above the bulging middle
zone. They also appear in vertical pairs, with their
heads down and twisted back, fitted into the lancets
rising on the upper part of the vessel. The domi-
nant design motif, however, is spread out on the
wider middle zone which is framed, like the frieze

of *K'uei* dragons on the foot, by rows of circlets. It is
a *T'ao-t'ieh*, a fantastic, evil-averting, ferocious
animal-mask, which later writers took to mean a
glutton. It has protruding eyes slit horizontally and
two rudimentary bodies folded over into the same
plane. Recessed spiral lines with hooks on the out-
side define the nostrils and lips; elongated horizon-
tal S-curves designate the eyebrows and the median
line of the short bodies. The vertical flanges not
only limit the *T'ao-t'ieh* on the sides but also form the
bridge of the nose of the frontal monster mask and
enhance its aggressive, awe-inspiring expression.
With its monumental appearance, its choice of de-
signs and their arrangement, and the clearly de-
fined treatment of the relief, the Rietberg *Tsun* rep-
resents the work of one of the great periods of
Shang bronze art.

On the inside of the hollow foot we see, sunken
as if it were intaglio, a short dedicatory inscription:
Fu Ting Tsun, "*Tsun* [sacrificial vessel for] Father
Ting" (see detail). The surface of the bronze is co-
vered with a dull patina, partly grayish brown,
partly malachite green.

Published: D. Lion-Goldschmidt and J.-C. Moreau-
Gobard, *Chinesische Kunst: Bronze, Jade, Skulptur, Keramik*
(Fribourg, 1960), pl. 23; Higuchi Takayasu, ed., *Chūgoku
Bijutsu* [Chinese Art in Western Collections], vol. 4: *Bronze
and Jade* (Tokyo, 1973), pl. 29; H. Brinker, "Chinesische
Kunst im Museum Rietberg, Zürich," *du* (April 1974), p. 4;
H. Brinker, *Bronzen aus dem alten China* (Zürich, 1975), no.
42.

Notes
1. Sugimura Yūzō, *Chūgoku Kodōki,* Idemitsu Bijutsukan
Sensho 3 (Tokyo, 1966), pp. 124–127.

26. Detail

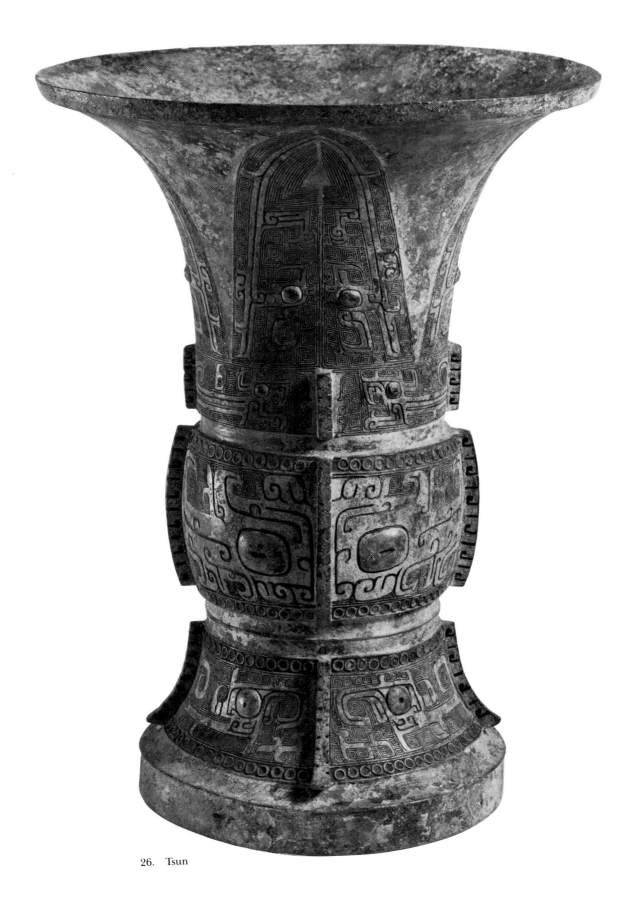

26. Tsun

27 Ting

China; late Shang dynasty, ca. twelfth-
eleventh century B.C.
Bronze; H. 22.3 cm, Diam. 18.4 cm
von der Heydt Collection

Most of the archaic Chinese bronzes were found in
the tombs of an obviously wealthy ruling elite.
Therefore, we may assume that in many cases they
were buried with the dead during the funeral rites
or a sacrifice — perhaps sometimes after they had
been used for a certain period.

This deep bellied cauldron of the *Ting* class
stands on three cylindrical legs and has two handles
rising vertically from the everted lip. The powerful
relief decoration consists of two zoomorphic motifs
characteristic of late Shang art: pairs of confronted
K'uei dragons in side view and a row of strongly
conventionalized cicadas in birds-eye view; the
former are placed in a narrow band on the shoul-
der, the latter on a frieze of juxtaposed triangles
running around the belly of the vessel—both filled
with a spiral design cast with great precision. The
clear structure of the decoration combined with the
simple contours and the somewhat squat propor-
tions give the *Ting* an appearance of self-contained
robust power and stability.

Tripods closely related in form and decor are in
the Atami Art Museum in Japan[1] and the collection
of F. Brodie Lodge in England.[2] Other pieces that
can be compared to the Rietberg vessel are a *Ting*
from the collection of the late Gustaf VI Adolf, king
of Sweden,[3] a tripod in the Museum für Ost-
asiatische Kunst der Stadt Köln, formerly in the
collection of H. J. von Lochow,[4] and a vessel of the
same type from the collection of Anders Hellström
in the Museum of Far Eastern Antiquities, Stock-
holm.[5] The loop handles rising from the lip of

tripods of the *Ting* type are usually facing each
other. Their placement is often unrelated to the
arrangement of the decoration. It seems that more
practical functional considerations were involved.
The handles have been positioned so that the vessel
is balanced when it is lifted up by means of hooks or
a rod passed through the loops of the handles.

The inscription, clearly showing a horse-
carriage with a single shaft and all the accessories, is
placed below the lip on the inside of the wall of the
vessel, which has a green patina with some crusty
spots (see detail). The same inscription appears
with minor variations on a *Yü* in the Freer Gallery of
Art, Washington, D.C., and is usually read *i ch'e*,
which means "arm-pit" and "chariot."[6] However,
hitherto this combination of pictographs has not
been interpreted convincingly.

Published: H. Brinker, "Chinesische Kunst im Museum
Rietberg, Zürich," *du* (April 1974), pp. 6-7; H. Brinker,
Bronzen aus dem alten China (Zürich, 1975), no. 1.

Notes
1. Mizuno Sei'ichi, ed., *Tōyō Bijutsu* [Asiatic Art in
 Japanese Collections], vol. 5: *Chinese Archaic Bronzes*
 (Tokyo, 1968), pl. 4.
2. W. Watson, *Ancient Chinese Bronzes* (London, 1962), pl.
 12c.
3. N. Palmgren, *Selected Chinese Antiquities from the Collec-
 tion of Gustav Adolf, Crown Prince of Sweden* (Stockholm,
 1948), pl. 103.
4. H. J. von Lochow, *Sammlung Lochow: Chinesische Bron-
 zen*, vol. 2 (Peking, 1944), no. 12.
5. B. Karlgren, "Bronzes in the Hellström Collection,"
 Bulletin, The Museum of Far Eastern Antiquities, no. 20
 (1948) pl. 9:1.
6. J. A. Pope et al., *The Freer Chinese Bronzes*, vol. 1:
 Catalogue (Washington, D.C., 1967), no. 61. p. 345.

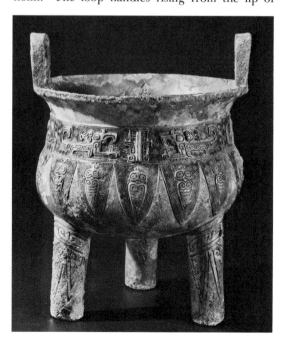

27. Ting (color illustration p. 74)

27. Detail

28　Fang-Ting

China; late Shang or early Western Chou
dynasty, ca. eleventh century B.C.
Bronze; H. 25.5 cm, W. 18.8 cm, L. 14.7 cm

Structure and articulation of the four-sided *Ting* are
determined by tectonic features. The rectangular
cauldron rests on four legs of approximately the
same height as the walls of the vessel, affixed at the
corners. On the short sides, the loop handles rise
vertically from the rim. Vertical flanges delimit each
field of decoration at the corners and also appear as
the central axis of a *T'ao-t'ieh* rendered in several
layers of relief. The monster mask, endowed with
sharp fangs, bulging eyes, and pointed ears, is
characterized by two long plumes, above the
C-shaped horns, which spread on both sides up to
the edge. This feature also appears, however, in a
stylistically much advanced, extreme formulation
on a *Fang-Ting* in the Avery Brundage Collection in
San Francisco, where it undoubtedly represents a
characteristic of early Western Chou art.[1] On the
tetrapod from the Rietberg Museum, each of the
T'ao-t'ieh on the four sides is flanked in the lower
corners by dragons turning their heads backwards.
All the areas in relief are clearly delineated against
the ground of delicate, raised spirals. On the upper
sections of the cylindrical legs, smaller *T'ao-t'ieh*
complement the decor. The vessel has a green
patina with scattered incrustations shading from
dark purple to brown.

On the underside of the bottom, we find ex-
tending diagonally from leg to leg two broad
smooth raised bands that are probably the result of
some technical necessity in casting. In the center of
the four triangles outlined by these bands, we see
another vestige of the casting: small chaplets firmly
enclosed in the bottom of the vessel.

On one of the long sides, between the handles,
along the upper edge of the inside of the *Fang-Ting*,
we can discern a short dedicatory inscription that is
hardly legible. Perhaps it reads: *Wen Fu Ting*. Wen
would thus be the donor of the ritual vessel dedi-
cated to Father Ting (see detail).

The Rietberg *Fang-Ting*, formerly in the collec-
tion of J.F.H. Menten, was published by Jung Keng
in 1941 with several other vessels of similar appear-
ance and formal character.[2] Practically identical
with the Rietberg tetrapod is a *Fang-Ting* acquired
by the Honolulu Academy of Arts in 1967 (fig. 28a).
It seems that we ought to consider the two pieces as
a pair originally belonging to a set of ritual vessels
that were cast in the same workshop probably some-
time during the eleventh century B.C.

Published: Jung Keng, *Shang Chou i-ch'i t'ung-k'ao* [The
Bronzes of Shang and Chou], Yenching Journal of
Chinese Studies, Monograph Series, no. 17 (Peking, 1941),
vol. 2, no. 121, p. 71; A. Salmony, *Sammlung J.F.H. Menten:
Chinesische Grabfunde und Bronzen* (Zürich, 1948), no. 2;
Higuchi Takayasu, ed., *Chūgoku Bijutsu* [Chinese Art in
Western Collections], vol. 4: *Bronze and Jade* (Tokyo, 1973),
black-and-white pl. 6; H. Brinker, "Chinesische Kunst im
Museum Rietberg, Zürich," *du* (April 1974), cover illustra-
tion; H. Brinker, *Bronzen aus dem alten China* (Zürich,
1975), no. 4.

Notes
1. M. Loehr, *Ritual Vessels of Bronze Age China* (New York,
 1968), no. 54
2. *Shang Chou i-ch'i t'ung-k'ao* [The Bronzes of Shang and
 Chou], Yenching Journal of Chinese Studies, Mono-
 graph Series, no. 17 (Peking, 1941), vol. 2, no. 121, p.
 71; see also no. 120, p. 70, no. 133, p. 77, and no. 138, p.
 79.

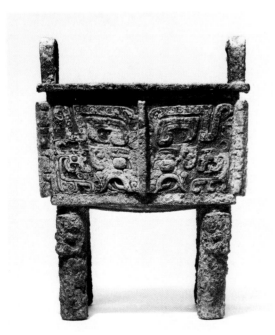

Fig. 28a.　Bronze *Fang-Ting*. China, ca. eleventh century
B.C. Honolulu Academy of Arts, Honolulu, Hawaii.

28.　Detail

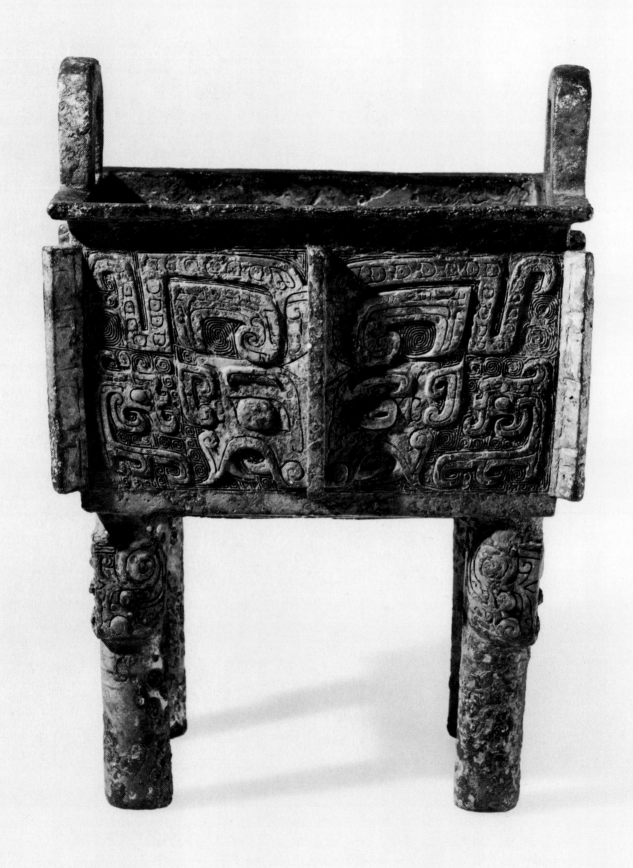

28. Fang-Ting

29 Kuei

China; Western Chou dynasty, ca. tenth century B.C.

Bronze; H. 15 cm, W. (including handles) 28.6 cm

Bequest of Mary Mantel-Hess

A conical ring foot supports the rounded body of the *Kuei* vessel. Below the everted lip, two round handles are placed diametrically on the sides. At the top they issue from animal heads, and near the bottom they have a small vertical appendage. A narrow band around the foot ring shows in the center concentric ovals with a small comma-shaped hook on either side; to the right and left we see elongated diagonal lines ending in spirals ornamented with the same hooks. The only decoration found on the plain body of the vessel is a frieze under the rim with *K'uei* dragons, spirals, and right-angle triangles filling the spaces in a symmetrical composition. These spiky designs in flat relief are placed on a ground of small spirals. Two conventionalized tiger heads in high relief with C-shaped horns provide central axes; they are

placed on the upper frieze midway between the two handles, almost exactly above the concentric ovals on the foot ring. A plain bowstring runs close below the frieze.

The spiky, elongated character of these designs on the frieze of the Rietberg *Kuei* seems to relate them to those seen on two ritual bronzes, a *Kuang* and a *Ho*, unearthed in 1954 at Yen-tun-shan in Kiangsu Province.[1] These two vessels were found together with nine other pieces; one of them, the so-called *Nieh Kuei*, has a cast inscription which says that the second Chou king, Ch'eng Wang (reigned 1024–1004 B.C.), performed a ritual sacrifice in honor of his father Wu Wang, who had attacked and overcome the Shang. We may be correct in assuming that this *Kuei* was cast during the time of Ch'eng Wang or soon after his death, and that the other pieces discovered at Yen-tun-shan are more or less contemporary with it. These facts, as well as the stylistic evidence, point to a date around 1000 B.C. or slightly later for the Rietberg *Kuei*. It is representative of the stage of evolution during which the Chou artists attempted to free themselves from the heritage of Shang traditions.

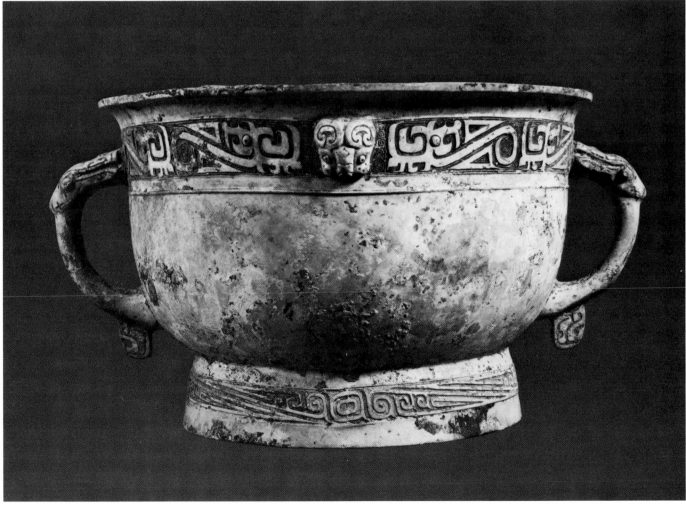

29. Kuei

29. Detail

The *Kuei* is covered by a melon peel patina of pale jade green with a few malachite green and purple incrustations. Traces of the casting process can be discerned on the body; they are small perforations of the wall which were closed up. Presumably these angular chaplets, later smoothed down, served to maintain the correct distance of the outer mold from the inner clay nucleus, and to forestall shifting. The underside of the bottom of the vessel still shows the mold seams in a rhomboid shape. Almost exactly in the center of the inside of the bottom we see an inscription in intaglio consisting of three characters, *tso yung kuei* (see detail).

Published: *Weltkunst aus Privatbesitz,* Ausstellung der Kölner Museen, Kunsthalle Köln (Cologne, 1968), no. C 49, pl. 31; H. Brinker, "Werke chinesischer und japanischer Kunst aus der Sammlung Mantel im Museum Rietberg, Zürich," *Asiatische Studien/Études Asiatiques* 25 (1971), fig. 5; H. Brinker, *Bronzen aus dem alten China* (Zürich, 1975), no. 15.

Notes
1. W. Watson, *Archaeology in China* (London, 1961), pls. 65-66; and Cheng Te-k'un, *Archaeology in China,* vol. 3: *Chou China* (Cambridge/Toronto, 1963), pl. 18a-b.

30 Tube Coupler with Tiger
China; late Eastern Chou dynasty, ca. third century B.C.
Bronze inlaid with gold and silver; L. 20 cm, Diam. 4.2 cm

It is possible that coupling devices such as this one are related to the appearance of chariots with thills during the late Chan-kuo period (481-221 B.C.), but their actual function is still not clearly known. The two bronze tubes are an exquisite work of art. They are coupled by a simple but ingenious slide catch and may have been used for attaching harness to the thills. Our piece presumably comes from Lo-yang in Honan Province. There the Rt. Rev. William Charles White, D.D., bishop of Honan and head of the Canadian Church Mission, found several couplers of this type in pairs. According to the excavators, these came from chariot burials. Their technical perfection and high artistic quality made a great stir. Bishop White gave the first account of these astonishing finds at Lo-yang in *The Illustrated London News* of October 28, 1933, under the headline "Knowledge of Early Chinese Culture Revolutionized." In his detailed publication, *Tombs of Old Lo-yang,* he expressed his fascination with the objects, writing: "The large variety and the standard of perfection of the bronze chariot fittings having a coupling use are a cause for wonder; the more so that although in north China wheeled vehicles are the common mode of conveyance, there is nothing in modern vehicles that can at all compare with the quality of the ancient chariot fittings, both in the high standard of technical workmanship, and

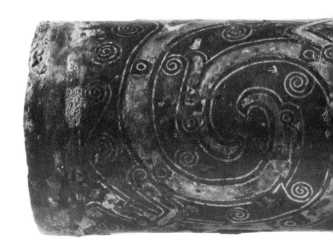

30. Tube Coupler with Tiger

in the mechanical ingenuity that is displayed. In these various couplers, the so-called 'knock-down' principle is strongly evident."[1]

Continuing, White describes the functioning of these couplers in detail: "By far the most interesting and artistic was a series of tube couplers. These tubes were 2 inches in diameter and a pair together were 7 inches in length. Wooden poles had been socketed in these tubes, the lower one of which, as we know from one of the objects, protruded through the tube, and in the complementary tube the pole was socketed only part way, in both cases the poles being fastened to the tubes by transverse pins. Where the ends of the tubes joined there was a circular beading, and overlying the beading of the lower tube was a crouched tiger in relief, the head extending above the tube rim for about an inch. In the beading of the upper tube was a notched opening which was filled by a small gate of beading, attached to the circle of beading on the one side by a small hinge, and on the other side fitting into a slot when the gate was closed. When it was desired to couple these two parts the nose of the tiger would push open the gate, a slight turn to the left would then allow the gate to fall into its slot again, and the coupling would be completed, for the head of the tiger pressing over the beading of the upper tube would keep the two parts together. (No. 030). Of this plain type two complete couplers and parts of two others were found, while several of the same size and style were found which were inlaid with gold and silver designs similar to the inlaid work mentioned above. (No. 031)."[2]

Similar to the Rietberg piece, which was ac-quired by the museum at a local auction in 1974, is a coupler with gold and silver inlay that was formerly in the Homberg Collection, Paris.[3] Another pair is owned by the Hakutsuru Bijutsukan in Kobe,[4] and a coupler with silver inlay from the Guennol Collection was recently presented to the Brooklyn Museum.[5] All these pieces impress us with their buoyant curvilinear decoration of exceedingly fine lines and broader bands of silver and gold, as well as with the taut sculptural treatment of the small tigers executed in high relief, almost in the round, which seem just about to pounce. Most of the artifacts in this sumptuous style evidently were made near the end of the Chan-kuo period, in the workshops at Chin-ts'un in the ancient city of Lo-yang. Recently, however, many bronze objects with very fine gold and silver inlay have also been found in other provinces of China.

Published: H. Brinker, *Das Gold in der Kunst Ostasiens* (Zürich, 1974), no. 1; H. Brinker, *Bronzen aus dem alten China* (Zürich, 1975), no. 135.

Notes
1. W. C. White, *Tombs of Old Lo-yang* (Shanghai, 1934), p. 37. Compare nos. 030–031, pls. XVI–XVII.
2. Ibid., pp. 38 ff.
3. W. Watson, *Ancient Chinese Bronzes* (London, 1962), pl. 80c.
4. Umehara Sueji, *Rakuyō Kinson Kobo Shūei* (Kyoto, 1937), pl. LXIV.
5. "Art of Asia Acquired by North American Museums, 1976–1977," *Archives of Asian Art* 31 (1977–1978), p. 116, fig. 3.

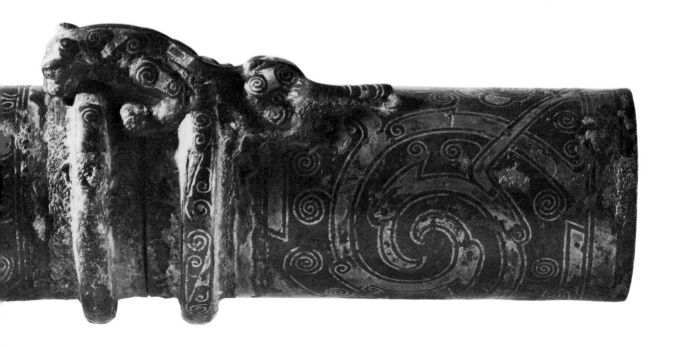

31 Belt Hook

China; late Eastern Chou dynasty, ca. third
century B.C.
Bronze inlaid with gold, silver, and turquoise;
L. 20 cm

In Chinese, belt hooks are generally called *tai-kou*. It
is not clear at what time they were first used in
China. In literary records, the term *tai-kou* appears
as early as the seventh century B.C. However, it is
thought that they were made fashionable only in
the beginning of the fourth century B.C., by King
Wu-ling-wang of Chao, who preferred nomadic
dress for riding. The introduction of these objects
seems to be closely related to the use of garments of
nomadic origin since the various terms used in
Chinese for the ancient belt hooks and buckles are
simply transliterations of a Hsiung-nu word.

The Rietberg belt hook, acquired in 1975, had
formerly been part of the famous collection of Mr.
and Mrs. Adolphe Stoclet in Brussels; it should not
be confused with another, very similar piece from
the same collection that appears in several publica-
tions.[1] The slightly curved belt hook with a flat
bottom and strongly convex top displays an elegant
geometric decor that is striking in its splendid col-
ors. The design is filled in with chips of turquoise in
varying shades of lustrous green that are accurately
pieced together and framed by the curvilinear gold
inlay. The button shaped knob with its rosette of
gold inlay creates a lively contrast to the plain sheet
of silver covering the underside. This knob served
to fasten the hook to a slit in the belt or a buttonhole
of the garment while the narrow end of the piece,
usually ending in a small animal head bent up-
wards, could be hooked into a loop. On the Rietberg
belt hook, this portion is decorated with silver inlay;
the animal head was broken off and has been re-
placed, though not very artfully.

Usually Chin-ts'un in Honan Province is
named as the place of origin of such superbly
crafted pieces. The Rietberg belt hook is indeed
similar to a piece with gold and turquoise inlay
acquired by Bishop White from one of the tombs
outside the gates of ancient Lo-yang.[2] Similar in
size, artistic form, and technical execution are a belt
hook in the Grenville L. Winthrop Collection in the
Fogg Art Museum, Harvard University, Cam-
bridge, Mass,[3] and another in the collection of Dr.
Paul Singer.[4]

During the excavations at Pao-lun-yüan,
Chao-hua County, Szechwan Province, several belt
hooks were discovered in June 1956 near the waist
of the deceased. Among them were two extraordi-
narily attractive pieces in the form of a rhinoceros
with gold and silver inlay. The position in situ allows
several interpretations: either they fastened the belt
or they served to suspend other objects, perhaps a
sword, at the belt. In some places, however, *tai-kou*
were found near the head, shoulders, or knees, or
at the feet of the corpse; this leads to the conclusion
that they could also be worn attached to other parts
of dress, or else were placed in the tomb merely as
mortuary gifts, perhaps pieces of personal jewelry.

Published: H. Brinker, *Das Gold in der Kunst Ostasiens*
(Zürich, 1974), no. 4; H. Brinker, *Bronzen aus dem alten
China* (Zürich, 1975), no. 106.

Notes
1. H.F.E. Visser, *Asiatic Art in Private Collections of Holland
 and Belgium* (Amsterdam, 1948), pl. 43, no. 60; and
 Umehara Sueji, *Rakuyō Kinson Kobo Shūei* (Kyoto,
 1937), pl. LXIX, 3.
2. W. C. White, *Tombs of Old Lo-yang* (Shanghai, 1934), pl.
 LVI, no. 135
3. Umehara, *Rakuyō Kinson Kobo Shūei*, pl. LXIX, 1/2.
4. M. Loehr, *Relics of Ancient China from the Collection of Dr.
 Paul Singer* (New York, 1965), no. 88.

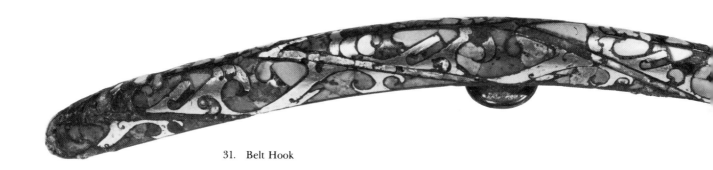

31. Belt Hook

32 "Jen-shou" Mirror

China; Sui dynasty, ca. A.D. 600
Bronze; Diam. 24.8 cm

The genesis of the Chinese bronze mirror can be traced far back into the Chou dynasty. Some pieces that may possibly date from the eighth century B.C., but certainly predate the year 655 B.C., were unearthed in 1956–1957 at Shang-ts'ung-ling near San-men-hsia in western Honan Province.[1] Of course, pieces of such early date are rare. The fact that mirrors have been placed in tombs as mortuary gifts since ancient times seems to indicate that they did not exclusively serve practical purposes. As in some other cultures, they may have been charged with religious, magic, and symbolic meaning and considered talismans and weapons against the evil powers of the netherworld.

The Rietberg mirror was acquired in 1974 from the former Ginsberg Collection. Like most Chinese mirrors, it is cast in a very light bronze alloy which usually contains twice as much tin as the archaic ritual bronzes (on the average 21–26%, with a copper content of 67–70%). This made it possible to give the obverse a highly reflective polish. The more interesting side of a Chinese mirror is the reverse, decorated with rich, multi-layered relief. In the center we find a hemispherical knob, horizontally pierced; a strong cord was threaded through it for holding and carrying the circular mirror. However, pieces as heavy as this one may have been put on a stand when they were used. The plain central knob is surrounded by a square frame decorated with rows of pearls. From the ground filled with swirling, curly ornaments emerge conventionalized lion heads in the corners of the square; these correspond with another set of four mask-like animal heads with long manes facing and closer to the rim; on the inside they are framed by

the sides of right-angle triangles, on the outside they overlap a sharply molded double circle decorated with a sawtooth design. These small monsters look as if they were biting into the narrower one of the two circles. The main motifs derived from the iconography of Han art are the *ssu-shen* or *ssu-ling*, creatures representing the four directions that are placed along the outside of the central square. They are: the "Black Warrior" of the North, a combination of tortoise and snake; the "Azure Dragon" of the East; the "Vermillion Bird" of the South; and the "White Tiger" of the West. Spread out over the inner circle, they are all shown in elegant, lively movement, surrounded by bits of conventionalized clouds and similar elements that fill in the background. The twelve animals of the zodiac are fitted into recessed rectangular fields of equal size that are framed with rows of pearls and separated by quatrefoil-like ornaments. These animals are rendered with surprising naturalism; all are arranged counterclockwise and thus endow the decor of the mirror with a dynamic rotating movement. Their sequence, however, has to be read in the clockwise direction and corresponds to the traditional Chinese scheme:

Points of the compass	Symbolical animals	Zodiacal animals	Hours of the day
NORTH	Tortoise-snake	Rat (Aries)	11-1 A.M.
NNE 3/4 E		Ox (Taurus)	1-3 A.M.
ENE 3/4 N		Tiger (Gemini)	3-5 A.M.
EAST	Dragon	Hare (Cancer)	5-7 A.M.
ESE 3/4 S		Dragon (Leo)	7-9 A.M.
SSE 3/4 E		Snake (Virgo)	9-11 A.M.
SOUTH	Bird	Horse (Libra)	11-1 P.M.
SSW 3/4 W		Ram (Scorpio)	1-3 P.M.
WSW 3/4 S		Monkey (Sagittarius)	3-5 P.M.
WEST	Tiger	Cock (Capricorn)	5-7 P.M.
WNW 3/4 N		Dog (Aquarius)	7-9 P.M.
NNW 3/4 W		Boar (Pisces)	9-11 P.M.

In this arrangement, the animals of the zodiac correspond with those representing the four directions. In the North, we see the rat correctly placed near the tortoise and the snake; in the East, the hare is next to the dragon; in the South, the horse is next to the bird (see detail), and in the West the cock is by the side of the tiger. This iconographic program is a diagrammatic representation of time and space. It ultimately conforms to ancient Chinese pictorial geomantic magic.

The outer border of the round mirror consists of a narrow band of interlaced, volute-shaped ornaments interspersed with short horizontal hatchings. Between the inner circle with the animals of the four directions and the zone with the animals of the zodiac, we find an inscription of forty characters in clear regular script *(k'ai-shu)* running in the clockwise direction. Beginning and end are marked by a dot above the horse. It is a poem of five four-character couplets. There seems to be no relation between the program of representation and the content of the poem. It appears to be a standard inscription of purely ornamental character that was often used. For instance, it is found in exactly the same wording on a "Sui" mirror in the Freer Gallery

of Art, Washington, D.C., which resembles our piece in other respects as well.[2] Archibald Wenley translates this poem as follows:

"The A-fang [mirror] reflected courage,
The Jen-shou [mirror] hung in the
 palace.
The water-chestnut is in the shade,
The laurel is in the vase.
A visible form may be sketched,
Though the inward view may be empty.
Mountain elves dare to come out,
But water forms work modestly.
Ephemeral is a piece of writing in the
 precious seal form;
Eternal is an inscription engraved on
 bronze."[3]

Two other identical inscriptions were pointed out by Otto Kümmel in 1930.[4] What all of them have in common with a number of other poems on similar mirrors of that time is the fact that somewhere in the text appears the binome *jen-shou*, "benevolence and longevity," which ultimately seems to refer to a maxim of Confucius. Yang Ch'ien, who as Emperor Wen became the founder of the Sui dynasty, chose *jen-shou* as a name not only for his palace begun in A.D. 593, but also for the last era of his reign (600–604). It does not seem farfetched to see a close connection between the occurrence of this auspicious concept in mirror inscriptions and the Sui dynasty which united the country again after centuries of political turmoil and territorial fragmentation. Closer studies have shown, however, that this relationship is merely coincidental and cannot be used as an argument in attempts to solve the problems of dating this interesting group of mirrors.[5] On the contrary, some scholars see them as works of a transitional phase from the late Southern Dynasties to the early T'ang period; they would thus be the artistic contribution of ingenious designers and bronze founders working under the Liang (502–557) and Ch'en (557–587) who continued their traditions under the new regimes.

Indeed, this theory of a southern origin of the so-called "Sui" mirrors, mainly advocated by Alexander Soper, seems to be supported by more recent archaeological finds made since the mid 1950s. Even occasional finds of similar pieces in tombs of around A.D. 600 in the environs of Sian in Shensi Province at the site of Ta-hsing-ch'eng, the ancient capital of the Sui, and the T'ang metropolis Ch'ang-an built over it, cannot deceive us about the fact that the leading centers of manufacture evidently lay south of the Yang-tze; for mirrors of this type have been unearthed mainly in Hunan Province. A typical example is the "Jen-shou" mirror excavated in Ssu-mao-ch'ung, Ch'ang-sha, ostensibly from a T'ang tomb.[6] We may perhaps assume that such mirrors, which apparently were often presented as gifts on birthdays and other festive occasions, had been family heirlooms used for some time before they accompanied the deceased into the grave. Thus a piece from a T'ang tomb need not necessarily be a product of that period.

32. Detail

Especially illuminating is one of the most recent finds of a "Jen-shou" mirror in the extreme south of China (fig. 32a). The Chinese archaeologists call it a work of the Sui dynasty, unfortunately without stating their reasons. It was discovered in 1976 at Hsing-an in the northeast of Kwangsi Chuang Autonomous Region.[7] The mirror, with a diameter of 21.4 centimeters, is amazingly similar to the Rietberg mirror in the layout of the relief decor, in details of figures and ornament, and in the arrangement and formal execution of

Fig. 32a. Bronze "Jen-shou" mirror. China, ca. A.D. 600.

92

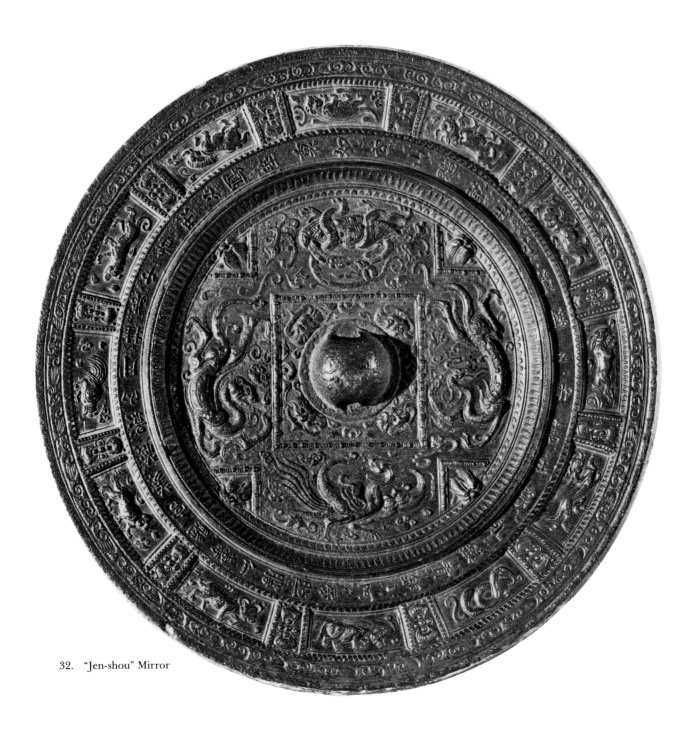

32. "Jen-shou" Mirror

the inscription. Even the wording of both inscriptions is exactly the same. Therefore one is inclined to consider these mirrors as products of one and the same foundry.

To this group belong also a mirror formerly in the famous collection of the lawyer Moriya in Kyoto that is identical with the Rietberg mirror and may have been cast in the same mold,[8] and a piece in the Charles Henry Ludington Loan Collection in the Santa Barbara Museum of Art. The latter has a different inscription and a heavy patina.[9]

Against attributing all these pieces to the Sui dynasty without hesitation speaks a "Jen-shou" mirror reproduced in the Sung imperial catalogue *Po-ku t'u-lu* (XXIX, 15) which has an inscription with a date corresponding to A.D. 622. On the other hand, it seems quite possible that the same workshop produced mirrors of this type for several decades following a basic design which was modified only slightly and adjusted to the occasion or the wishes of the customers.

The clarity and precision of the relief decoration on the Rietberg mirror, due to the technical perfection of the casting, contribute to its astonishing quality. The reverse is covered with a more or less even dark gray patina with a few green and reddish brown crusty spots; the obverse, originally of reflecting brilliance, is now mostly covered with a granular green and reddish brown patina showing the silvery bright metal only in a few places.

Published: *Ausstellung chinesischer Kunst* (Berlin, 1929), no. 459; 0. Kümmel, *Chinesische Kunst: 200 Hauptwerke der Ausstellung der Gesellschaft für Ostasiatische Kunst in der Preussischen Akademie der Künste* (Berlin, 1930), pl. 79; Umehara Sueji, *Ōbei ni Okeru Shina Kokyō* (Tokyo, 1931), pl. 55; Umehara Sueji, *Ōbei Shūchō Shina Kodō Seika* [Selected Relics of Ancient Chinese Bronzes from Collections in Europe and America] (Osaka, 1933-1935), vol. 5, pl. 114; Royal Academy of Arts, *Catalogue of the International Exhibition of Chinese Art 1935-6* (London, 1935), no. 499; H. Brinker, *Bronzen aus dem alten China* (Zürich, 1975), no. 95.

Notes

1. *Shang-ts'ung-ling Kuo-kuo mu-ti* (Peking: The Institute of Archaeology, Academia Sinica, 1959), p. 27, fig. 21; pl. 23: 1-2; pl. 40: 2.

2. A.G. Wenley, "A Chinese Sui Dynasty Mirror," *Artibus Asiae* 25, no. 2/3 (1962), pp. 141–148.

3. Ibid., p. 141.

4. O. Kümmel, "Neun chinesische Spiegel," *Ostasiatische Zeitschrift* N.F. 6 (1930), p. 176, footnote 1.

5. N. Thompson, "The Evolution of the T'ang Lion and Grapevine Mirror," and A.C. Soper's addendum "The 'Jen Shou' Mirrors," *Artibus Asiae* 29, no. 1 (1967), pp. 25–54 and pp. 55–66.

6. Akiyama Terukazu et al., *Arts of China: Neolithic Cultures to the T'ang Dynasty, Recent Discoveries* (Tokyo/Palo Alto, 1968), pl. 171.

7. Kuanghsi Chuang-tsu tzu-chih-ch'ü wen-wu kuan-li wei-yüan-hui, ed., *Kuanghsi ch'u-t'u wen-wu* (Peking, 1978), pl. 163.

8. O. Sirén, *Kinas Konst Under Tre Årtusenden* (Stockholm, 1942), vol. 1, pl. 89B, facing p. 220.

9. Thompson, "The Evolution of the T'ang Lion and Grapevine Mirror," fig. 5.

33 Belt Plaque with a Pair of Birds among Clouds

China; Northern Wei dynasty, first half of the sixth century A.D.
Yellow brown jade; H. 7.8 cm, L. 16.1 cm
Bequest of Gret Hasler

Highly valued in China, jade was one of the materials favored for fashioning personal ornaments. Leather belts decorated with plaques of carved jade had been popular since T'ang times. A famous example was found in 1942 in the tomb of Wang Chien (A.D. 847–918), the ruler of Shu, in Ch'eng-tu, Szechwan Province.[1] One of these eight belt plaques bears an inscription with a date corresponding to A.D. 915. In it we read: ". . . A broad belt was made with this jade; the plaques were three inches square, and the tail six-and-a-half inches long. . . ."[2]

The measurements given there for the end piece correspond almost exactly to the Rietberg jade plaque which has a thickness of six to seven millimeters. Six small round perforations at the four corners and in the center of the long sides were certainly used for affixing it to something and speak for its use as a belt plaque. A piece matching our plaque exactly was formerly in the D.Y. Wu Collection in Tientsin (fig. 33a).[3] Presumably, these two jade plaques, perhaps together with some smaller ones, say about six to eight almost square pieces, originally adorned the elegant belt of a person of distinction.

The decor, executed partly in openwork partly in low relief, consists of two birds with widely spread wings in heraldic confrontation among conventionalized clouds. The birds are presumably *feng-huang*, the pair of so-called phoenixes, each with three abnormally long, gracefully curved, trailing tail-plumes. Fine linear incisions contribute to the pleasing clarity of the design's details; the short hatchings convincingly render the plumage. The birds, their beaks open, seem to be engaged in the chase of a pearl or flaming jewel, resembling the traditional *yin-yang* symbol, placed in the center of the rectangular plaque. An undecorated frame four millimeters wide encloses the design. The dating of the Rietberg jade plaque offers some difficulties. Alfred Salmony assigned the corresponding piece to the T'ang dynasty and appositely called its style "decorative heraldism."[4] It certainly has nothing in common with the busy, crowded style of carving to be seen in openwork jade plaques of the later periods. It shows no similarities to the detailed naturalism that appears from the Sung period onward or to an inexpressive archaistic style executed with technical virtuosity.[5] On the other hand the jade carver of the Rietberg belt plaque and its companion piece has not yet reached the degree of artistic sophistication and sculptural complexity that, for example, the anonymous early T'ang master so generously displayed in his marble reliefs with representations of the four directional creatures and the twelve animals of the zodiac.[6] This set of eight slabs was probably carved in the seventh century. Since it has been preserved in Japan's old-

Fig. 33a. Jade belt plaque. China, first half of the sixth century A.D.

est surviving treasure-house, the Tōdaiji's famous Shōsō-in in Nara, it antedates the year A.D. 756 in all likelihood. The sculptor of the Shōsō-in reliefs clearly intends to give the illusion of tbjects moving in space by means of multiple relief planes, while the carver of our jade plaque apparently shows no interest in any three-dimensional effects. He designed his work more as a decorative screen than as a relief with various receding layers and resolute undercuts.

In our opinion, the Rietberg plaque represents, in the selection of subject matter as well as in the technical and artistic treatment, the somewhat dry and ornamental, almost heraldic style of the North toward the end of the Six Dynasties period. These fabulous birds, so-called phoenixes, are associated as one of the *ssu-shen,* the "creatures of the four directions," with the south quadrant as well as with several Taoist deities and considered as heralds of auspicious events in popular imagination. Here, however, they are combined with a Buddhist motif, the flaming pearl. This seems to be a typical reflection of the hybrid beliefs of the Six Dynasties, and at the same time permits us a glimpse of the wide range of decorative vocabulary prevalent during that particular period.

In the beginning of the sixth century, the design motifs developed in southern China with luxuriant variety and fantastic splendor were simplified by the craftsmen of Northern Wei and modified to suit northern taste. The northern carvers tended to restrain the dynamism of the southern style and turn the most elegant luxuriance into a decorative, somewhat schematic and repetitive effect. This can be conveniently studied and documented with a number of engraved stone tomb monuments and epitaph tablets from the end of the political division between North and South China, particularly the 520s. A tablet cover of the year 529 may be compared with our jade plaque (fig. 33b). It is the epitaph cover of Erh-chu Hsi's stone memorial tablet in the Hall of Inscriptions, Shensi Provincial Museum, Sian.[7] Here we encounter similar patterned, stylized abstract cloud scrolls as fillers around the figural motifs, the creatures of the four directions with riders. In both cases the representation is primarily conveyed as a silhouette with no real attempt to suggest spatial depth; the pictorial conception is to be thought of as a two-dimensional decorative pattern.

The preoccupation with auspicious creatures, the mode of carving and engraving in silhouetted designs, and especially the treatment of ornamental plaques in a screen-like manner may be considered as typical features of the decorative sculptural style of the Six Dynasties. Susan Bush, who added most interesting observations to our understanding of the art of this crucial period with her article "Thunder Monsters, Auspicious Animals, and Floral Ornament in Early Sixth-Century China," pointed out a detail which has some bearing on our present discussion: "Literary evidence indicates that such

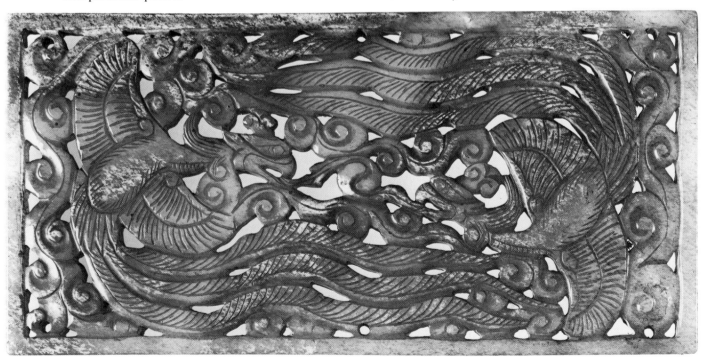

33. Belt Plaque with a Pair of Birds among Clouds

Fig. 33b. Rubbing of a stone tablet cover (detail). China, A.D. 529.

motifs were also worked in cut metal appliqués and used in interior decoration. At the beginning of the sixth century the bed-alcove of a Southern Ch'i ruler's favorite was ornamented with 'cut gold and silver made into characters, supernatural animals and birds, wind-blown clouds and ornamental torches'."[8]

Although archaeological evidence concerning personal ornaments carved in jade is rather sparse for the Six Dynasties and although the few significant examples that can be dated with any confidence to that period seem to have been produced in the more southerly provinces of China, we venture to assign our belt plaque on stylistic grounds to the late Northern Wei dynasty.

Not previously published.

Notes
1. Cheng Te-k'un, "The Royal Tomb of Wang Chien," *Harvard Journal of Asiatic Studies* 8 (1945), pp. 234–240.
2. M. Sullivan, "Excavation of the Royal Tomb of Wang Chien," *Transactions of the Oriental Ceramic Society* 23 (1947–1948), p. 26, pls. 3–4.
3. A. Salmony, *Carved Jade of Ancient China* (Berkeley, 1938), pl. LXXI, 6.
4. Ibid.
5. See, for example, the excellent Yüan or early Ming series of belt plaques in the collections of Dr. Paul Singer and of the British Museum, London, in J. Rawson and J. Ayers, *Chinese Jade Throughout the Ages* (London, 1975), nos. 346–347; and the set of nineteen openwork jade plaques from a pair of decorative belts published by Cheng Te-k'un, "T'ang and Ming Jades," *Transactions of the Oriental Ceramic Society* 28 (1953–1954), pp. 23–35, pls. 7–12.
6. B. Rowland, "Chinoiseries in T'ang Art," *Artibus Asiae* 10, no. 4 (1947), pp. 265–282, figs. 1-6.
7. See A.L. Juliano, *Art of the Six Dynasties* (New York, 1975), no. 45.
8. *Ars Orientalis* 10 (1975), p. 19, footnote 4.

34 Rhyton in the Shape of an Ox Head

China; Sui or early T'ang dynasty, ca. late sixth
or early seventh century A.D.
Dark brown jade; H. 8.4 cm
von der Heydt Collection

An entirely new light is thrown on some Chinese libation cups of this type by the discovery in October 1970 of a miniature rhyton in the shape of an antelope head carved in onyx; it was found at Ho-chia-ts'un near Sian in Shensi Province among a multitude of other precious objects comprising no less than 216 gold and silver vessels (fig. 34a).[1] For a long time it had been assumed that the prototypes for the Chinese rhyta had been Sassanian works in silver. Now, however, it will be necessary to take into consideration also works in other materials as sources of inspiration, particularly since the Iranian silver rhyta of the Sassanian period are generally much larger than the Chinese examples in jade, pottery, or gilt bronze known up to now.

Among the 1023 objects of the hoard found at Ho-chia-ts'un, the onyx rhyton with a small gold cap fitted over the nose of the antelope is certainly exceptional. Obviously it was an exceedingly rare piece imported from the West. Even in T'ang times it might already have been an antique. Byzantine, Sassanian, and Japanese coins found at the site bear witness to the original owner's interest in "exotica." He might have been Li Shou-li, prince of Pin, a cousin of the emperor Hsüan-tsung (reigned 712–756), who died in A.D. 741 leaving his estate and collections to his son. In 756 the latter presumably buried the treasure in two large pottery jars on the family estate at Ch'ang-an before he fled with the emperor and his suite to Szechwan to escape from An Lu-shan, a rebellious general of Turkic origins, and his looting troops. He seems never to have returned to claim his hidden treasures.

As to the origin and date of the unique onyx rhyton, opinions vary a great deal. Some scholars consider it a work of the early T'ang period made in China following an Iranian prototype. Others think it was imported from Khotan in Central Asia, or from Iran, or else consider it to be the product of a Hellenistic workshop in Ptolemaic Egypt, perhaps of the second century B.C. In that case it would have been in the time of the prince of Pin already an extremely well preserved collector's item with an age of approximately 900 years.[2]

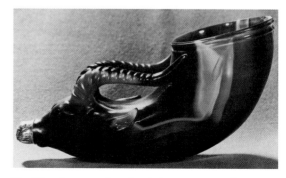

Fig. 34a. Onyx antelope head rhyton excavated at Ho-chia-ts'un near Sian, Shensi Province, China.

The Rietberg rhyton has the shape of an ox head; its horns are bent inwards, the ears pointed, and the jaws well articulated. The convex eyes are delineated by fine engraved lines, the nose with pierced nostrils is pointed, the muzzle only superficially cut. The cylindrical cup itself is slightly inclined and extends only a little beyond the tips of the horns; it has a diameter of 4.5 centimeters and a groove around the rim. The material is dark brown jade with a few lighter spots shading into green and brown. In its size, material, technical execution, and artistic form, the Rietberg rhyton closely resembles a piece in the Avery Brundage Collection in the Asian Art Museum of San Francisco.[3] In their circumspect and erudite catalogue, *Unearthing China's Past,* Jan Fontein and Tung Wu write about this piece: "Its somewhat dull luster may be due to treatment of the surface, designed to make it resemble natural horn, which the Chinese liked to use for drinking vessels because of its alleged poison-detecting property."[4] A rather small undecorated rhinoceros-horn rhyton of 8.7 centimeters height

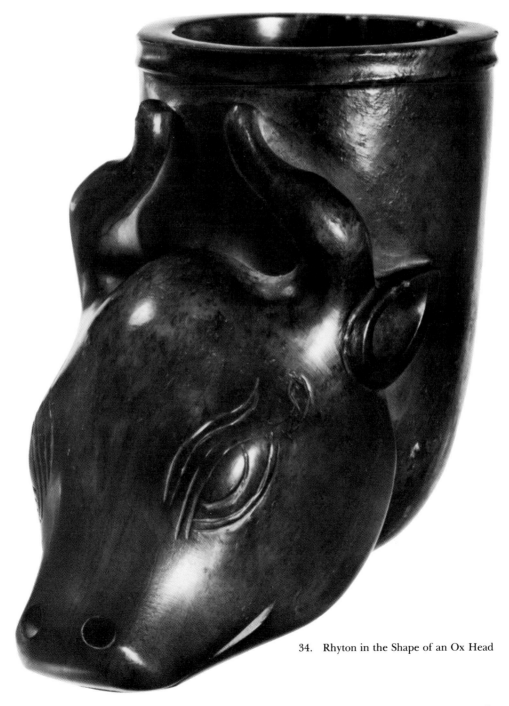

34. Rhyton in the Shape of an Ox Head

97

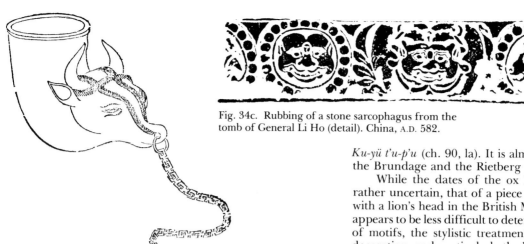

Fig. 34c. Rubbing of a stone sarcophagus from the tomb of General Li Ho (detail). China, A.D. 582.

Fig. 34b. Woodcut illustration of an ox-head rhyton from the Sung imperial catalogue, *Po-ku t'u-lu.*

in the shape of a curved horn has been preserved in the Shōsō-in of the Tōdaiji in Nara. It is thought to be of Chinese origin and is usually dated to the first half of the T'ang period.[5] Except for some slight variations in the accentuation of the proportions, which may be due to the original shape of the pieces of jade, the two rhyta in the Brundage Collection and the Rietberg Museum tally to the point that one is inclined to attribute them to the same workshop. Particularly striking is the treatment of the eyes and eyebrows which strongly recalls Iranian forms.[6] Both jade cups also closely resemble the representation of a rhyton on a Sassanian silver bowl in the Cleveland Museum of Art.[7] "That the Chinese were aware of the way foreigners used the rhyton is evident from a relief in the Museum of Fine Arts, Boston, which shows a Central Asian chieftain raising his rhyton while surrounded by a retinue of subjects. This relief dates from the Northern Ch'i period (A.D. 550–577), when the taste for exotic foreign things reached its first peak."[8]

Chinese libation cups like the rhyton in the Brundage Collection and that in the Rietberg Museum may have been made in the second half of the sixth century or early in the T'ang dynasty as a result of consecutive waves of Central Asian and Near Eastern influence. Earlier datings of such exotic drinking vessels are to be found in the archaeological catalogue *Chin-shih-so,* published in 1821 by the brothers Feng Yün-p'eng and Feng Yün-yüan. The authors describe the ox head rhyton featured in their work erroneously as a "Chou dynasty *ssu-kuang.*"[9] In the Sung imperial catalogue *Po-ku t'u-lu* (XVI, 18) a similar bronze rhyton is called *Han hsi shou pei,* "sacrificial [animal-] head cup of the Han dynasty." The woodcut illustration of this cup (fig. 34b) gives us an idea what purpose the pierced nostrils of the ox head originally might have had: they seem to have served for connecting a chain to suspend the drinking vessel. It cannot be entirely excluded, however, that small gold caps, like the one on the recently excavated onyx piece, were intended to be attached to the nose. Finally we must mention one more jade rhyton. It was published as early as A.D. 1341 by Chu Te-jun in his

Ku-yü t'u-p'u (ch. 90, la). It is almost identical with the Brundage and the Rietberg pieces.

While the dates of the ox head rhytons are rather uncertain, that of a piece in glazed ceramic with a lion's head in the British Museum, London, appears to be less difficult to determine. The choice of motifs, the stylistic treatment of the stamped decoration, and particularly the borders with rows of pearls and the medallions with masks lined up below the rim remind us of Chinese reliefs of the second half of the sixth century that show Iranian influence. In 1964, a sarcophagus richly decorated with engravings was excavated from the tomb of General Li Ho of the Sui dynasty at Shuang-sheng-ts'un near San-yüan in Shensi Province. On it we see very similar pearl-edged medallions, and interestingly enough, the front side also shows, among other things, near a frontal human mask an ox head which resembles that of our rhyton (fig. 34c).[10] The tomb of Li Ho and the mortuary furnishings of it can be dated quite certainly to the year of his death; this is more or less supported by the epitaph inscription dated A.D. 582. The sculptural treatment of the oxen frequently found among mortuary clay figurines from Sui tombs also supports the dating of our jade rhyton to the late sixth or early seventh century. The tomb of Li Ho alone contained no less than eleven such oxen of three different types.

Not previously published.

Notes
1. *Wen-hua ta-ke-ming ch'i-chien ch'u-t'u wen-wu* (Peking, 1972), pl. 70.
2. K. Parlasca, "Ein hellenistisches Achat-Rhyton in China," *Artibus Asiae* 37, no. 4 (1975), pp. 280–290.
3. R.-Y. Lefebvre d'Argencé, *Chinese Jades in the Avery Brundage Collection* (San Francisco, 1972, 2nd rev. ed. 1977), pl. XXXIV, pp. 82 ff.
4. J. Fontein and T. Wu, *Unearthing China's Past* (Boston, 1973), p. 181, no. 94.
5. Harada Jirō, *English Catalogue of Treasures in the Imperial Repository Shōsōin* (Tokyo, 1932), no. 401, p. 87; Teishitsu Hakubutsukan, ed., *Shōsōin Gyomotsu Zuroku* (Tokyo, 1934), vol. 7, pl. 8: left.
6. R. Ghirshman, "Le Rhyton en Iran," Notes Iraniennes XI, *Artibus Asiae* 25, no. 1 (1962), fig. 28.
7. Parlasca, "Ein hellenistisches Achat-Rhyton in China," fig. 3.
8. Fontein and Wu, *Unearthing China's Past,* p. 181; see also G. Scaglia, "Central Asians on a Northern Ch'i Gate Shrine," *Artibus Asiae* 21, no. 1 (1958), fig. 4.
9. W. Willetts, *Chinese Art* (Harmondsworth, 1958), vol. 2, p. 487, fig. 81.
10. Shan-hsi-sheng wen-wu kuan-li wei-yüan-hui, "Shan-hsi-sheng San-yüan-hsien Shuang-sheng-ts'un Sui Li Ho mu ch'ing li chien pao," *Wen-wu,* no. 1 (1966), p. 39, fig. 41: left.

35 T'ao-t'ieh Mask

China; late Shang dynasty, ca. twelfth–
eleventh century B.C.
Brownish white marble; H. 27.5 cm, W. 22.6
cm
von der Heydt Collection

From the wealth of archaeological material available today it is evident that the people who resided at the "Great City of Shang" near An-yang in Honan Province for—it seems—almost three centuries before their capital was destroyed by the Chou conquerors, possessed a highly developed art of stone sculpture. It is surprising, however, that this art was apparently not continued under the Chou dynasty; we are still awaiting the excavation of stone sculptures of this period that could match the technical skill and powerful artistic imagination evident in the Shang works. Perhaps such examples never will be found.

The material of these impressive pieces of Shang sculpture, some done in the full round, some in bas-relief, is white limestone or marble. Most of them were designed to adorn what appear to be the royal tombs of the Shang. At the western section of Hou-chia-chuang, the Hsi-pei-kang cemetery site (abbreviated HPKM) yielded a number of remarkable marble figures mainly representing mythical creatures, some half beast, half human, such as an aggressive, fierce looking tiger-headed monster with a semi-human crouching body, an owl-like creature with human ears and sturdy legs, a double-faced monster head with an elephantine nose, a frog-like double-bodied creature with hind parts joined, and a T'ao-t'ieh mask (fig. 35a).[1] Their meaning has more or less remained obscure. As Laurence Sickman writes: "A great many speculations and deductions by analogy have been advanced about the symbolic and magic significance of the animals and other motifs of Shang art. That these creatures had some religious significance to the people who made them and that all the complex of designs was purposeful rather than purely decorative there can be no doubt. But the exact, or in most cases even approximate, meanings of their symbolism and paraphernalia of sympathetic magic are at present in the realm of conjecture, though some of the theories that have been advanced may, of course, be very near the mark.

"In the case of the owl and tiger, it is apparent that they were once attached to some other object or either carried supports because both of them have deep, straight-sided grooves in their backs running vertically the length of the bodies. It is difficult even to conjecture what purpose they served before they were placed in the tomb, and it does not appear that the Shang made objects for burial only; the ming-ch'i, substitution objects, were of later date. In any event, the fact that they were placed in the tomb suggests that they were considered of good omen and would have a benevolent or protective influence. Whatever purpose they served, they are prime examples of the Chinese genius for creating fantastic creatures imbued with life and a convincing character far beyond the limits of the merely grotesque."[2]

Virtually none of the marble sculptures was found in situ. The majority, in fact, was recovered from the debris in the refilled plundered tunnels of the Hou-chia-chuang royal tomb designated as HPKM 1001 during the tenth and eleventh season of controlled excavation work carried out by the archaeological team of the Academia Sinica in the autumn of 1934 and the spring of 1935. Although the huge tombs without doubt had been ransacked more than once in the past, some of them probably as early as the Chou or at least the Western Han dynasty, the world-wide attention paid to the spectacular An-yang discoveries encouraged anew illegal treasure-hunting through secret excavations and unscrupulous robbing of tombs.

Therefore, it is not surprising to discover that the Rietberg T'ao-t'ieh mask had already appeared on the Peking antique market before controlled systematic excavations at Hou-chia-chuang began. The fine, unusual marble sculpture had already entered the Eumorfopoulos Collection when it was introduced to the European public at the famous exhibition held in the Royal Academy of Arts, London, in 1935–1936.[3] Four years later, on May 31, 1940, Baron Eduard von der Heydt acquired the piece at the London sale of "The Celebrated Collection of Chinese Ceramics, Bronzes, Gold Ornaments, Lacquer, Jade, Glass, and Works of Art formed by the late George Eumorfopoulos, Esq."[4]

The Rietberg marble T'ao-t'ieh has a strikingly similar companion piece that was discovered in HPKM 1001 at Hou-chia-chuang.[5] There is, however, no means of telling whether our piece might have also come from that particular tomb, because there are indications that the plunderers refilled their fairly precisely dug tunnels from mixed dumps of soils from several tombs sacked at the same time. But we may conclude that both sculptures served a similar, if not the same purpose, even if it is impossible to determine their exact position in the original context. Both sculptures are damaged near the bottom, both have a slightly convex front, and both have, as nearly every one of the larger marble sculptures has, a vertical trough on the flat back. On the top edge they have five, and on either side four slightly raised flanges with four linear horizontal ridges each. It seems quite obvious that such slots and projections would have served to attach the sculptures to a flat surface, perhaps to a wall, a pillar, or a sarcophagus.

The Shang sculptor of our marble T'ao-t'ieh displays an artistic and technical skill of a very high order. He carved his mask in several layers of relief, accentuating the C-shaped horns, the muzzle, and the pointed, curved fangs with distinct undercutting, and employing a fine linear thread-relief to render other details such as the contours of the bulging eyes, the eyebrows, and the nostrils. The lower, receding part of the piece, as well as the narrow verges around the T'ao-t'ieh proper, are cov-

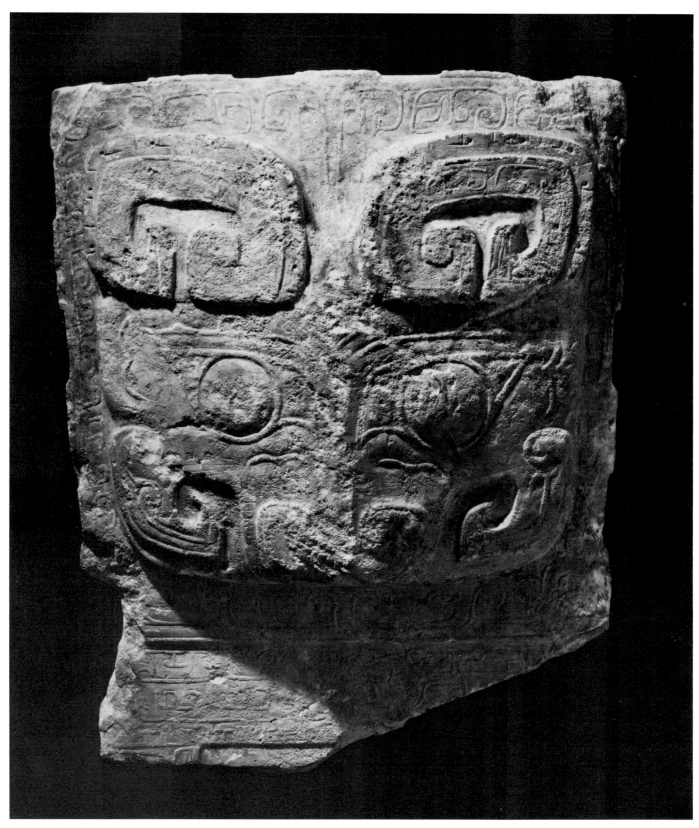

35. T'ao-t'ieh Mask

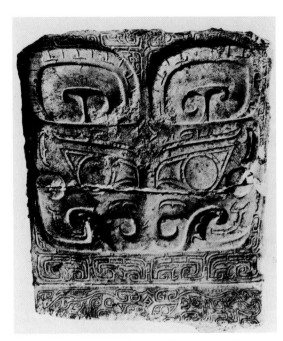

Fig. 35a. Marble *T'ao-t'ieh* mask. China, ca. twelfth–eleventh century B.C.

ered by a sensitively integrated curvilinear design, similar to the complex patterns on contemporaneous An-yang bronzes. This part of the relief is done in delicate, raised lines. The artist conceived of his *T'ao-t'ieh* mask in rigid frontality, emphasizing its formal austerity and its religious gravity. He succeeded in creating a convincing image from a sinister spirit world charged with apotropaic power and magic.

Published: H.G. Creel, *The Birth of China* (London, 1936), pl. V, opposite p. 106; O. Fischer, *Chinesische Plastik* (Munich, 1948), pl. 12; O. Sirén, *Chinesische Skulpturen der Sammlung Eduard von der Heydt —Chinese Sculptures in the von der Heydt Collection* (Zürich, 1959), no. 1; H. Brinker, "Chinesische Kunst im Museum Rietberg, Zürich," *du* (April 1974), p. 5.

Notes

1. Li Chi, *The Beginnings of Chinese Civilization* (Seattle, 1957) pls. XXI–XXVII; and Li Chi, *Anyang* (Seattle, 1977), pls. 3–5 and figs. 48–50.
2. L. Sickman and A. Soper, *The Art and Architecture of China* (Harmondsworth, 1956), pp. 4 ff.
3. Apparently the sculpture was presented with some hesitation, because one will look in vain for a reproduction of the piece listed under no. 269 in the illustrated catalogue.
4. *Sotheby and Co. Auction Catalogue: The Eumorfopoulos Collections* (London, 1940), p. 143, no. 474.
5. Li Chi, *Anyang*, p. 228, fig. 50.

36 Double Leaved Door from a Tomb

China; Eastern Han dynasty, first–second century A.D.
Brownish gray stone; H. 131.5 cm, W. 64 cm (left); H. 132 cm, W. 62.5 cm (right)
von der Heydt Collection

Over the past three decades a large number of Han grave sites have been investigated throughout China. Thanks to systematic studies of the vast corpus of reliefs recovered from these tombs, it has become possible to distinguish certain characteristics of regional styles in Han pictorial art.

A tomb probably dating from the end of the first century A.D. was excavated in May 1953 in the northwestern suburbs of Lo-yang in Honan Province (fig. 36a).[1] It shows that relief slabs such as the pair in the Rietberg Museum originally served as doors in a sepulchral setting. They have vertical pivots on the outside edges to keep them in place. But these heavy stone doors were not mounted to be ever opened again; they were rather intended to seal the entrance of a burial chamber or a cave tomb in order to ensure that the deceased could rest in peace forever. As in the case of the Lo-yang tomb designated as No. 30.14, the Rietberg door may have closed off the main burial chamber in the rear of a tomb from the antechamber. Double-leaved doors of this kind, however, were also found in Szechwan Province along the Min river system in the vicinity of Hsin-chin where they blocked the entrances to caves.[2] The local inhabitants believed that these caves were originally made for dwelling purposes by members of a primitive society and thus called them *man-tzu-tung*, "caves of the barbarians." But there is convincing evidence to prove that they were cave tombs carved into the sandstone cliffs of that region for burial purposes.

In comparing the Honan tomb doors with those from the Hsin-chin region in Szechwan Province, we notice certain differences in the techniques employed in rendering the reliefs. While the Honan sculptor set his design clearly outlined on a background of horizontal parallel striations using linear incisions to describe details of the various motifs with great skill, the Szechwan artist used for his reliefs a conspicuous crosshatch background. This disorderly pattern of striations is partly carried over into the areas of the slightly raised motifs, giving the whole a peculiar striped, combed effect of visual restlessness. Apparently no attempt has been made to conceal the traces of the sculptor's chisel in the somewhat mechanically regular, parallel striae. The stone slabs have not been smoothed on the back.

In these technical features, as well as in the lack of formal organization in the composition and in the unpretentious, naive rendering of several details, the Rietberg door seems to be closely related to the stone reliefs from the Hsin-chin region. The decoration of the two slabs complement each other. Nearly identical are the two monster masks in frontal view with three-pronged crowns on top and

rings in their muzzles. Such ring holders are familiar from bronzes of the period and from their purely decorative relief imitations on pottery vessels. Here they are, of course, meant to suggest handles for opening the door. The rest of the figural decoration is confined to rigid profile views. Along the bottom edges of the two reliefs a hunting scene is represented. At the lower left corner we can barely discern the silhouette of a standing hunter. He is holding a spear aimed at a stag. The two figures are separated by a highly stylized tree; it has been reduced to its simplest form. From the right a dog is chasing another stag which turns his head in fear and looks back at his persecutor.

The principal motifs are a leaping tiger on the left leaf of the door and a rearing dragon on the right leaf. These two fantastic creatures dominate the entire composition which, in its arbitrary spacing of all elements and the artist's obvious lack of concern for proportions, suggests *horror vacui*. Since the layout of tombs required a definite cosmological orientation in ancient China, tiger and dragon have been considered to symbolize the well-known pair of fundamental opposites, the cosmological principle of *yin* and *yang*. In the ancient Chinese cosmological system the tiger is identified with *yin*, the female principle, and therefore also with the western quadrant, with autumn, wind, and sunset. The dragon, identified with *yang*, the male principle, and hence the opposite of the tiger in every respect, stands for the east, for spring, rain, and sunrise. The Azure Dragon as the antipode of the White Tiger made his appearance as early as the Chou dynasty. The pair is mentioned in the "Book of Changes," or *I-ching*, which is one of the earliest Chinese books, perhaps the oldest book altogether. Combined with the Vermillion Bird of the South and the Black Warrior of the North, represented by a tortoise and a snake, they form the traditional quartet of the *ssu-shen* or *ssu-ling*, the "four supernatural creatures."

On the Rietberg door the tiger and dragon are accompanied by pheasant-like birds with elaborate crests and long tail plumes. They seem to be the fabulous pair of *feng-huang*, a mythical species associated with auspicious events, lasting peace, and lofty moral qualities; *feng* representing the male principle, *huang* the female. Whatever their exact meaning may have been, they are ubiquitously employed in Han representational art, and their conspicuously frequent appearance on doors to burial chambers leads to the conclusion that they were meant to transmit a profound idea in such a funerary setting.

Equally enigmatic are the two pairs of cranes or storks close to the upper edge of both leaves of the door. They join in lifting up a fish in their long beaks, each holding on to the prey with one leg. This motif can be more clearly studied on a Han relief slab in the Cleveland Museum of Art which is similar to the Rietberg door in its subject matter, style, and technical execution.[3] Large fish are also

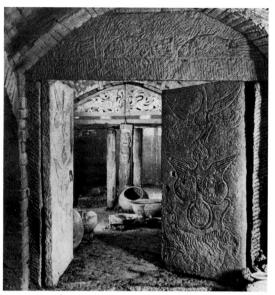

Fig. 36a. Tomb No. 30.14 at Lo-yang. China, probably end of first century A.D.

engraved on the tympanum of the entrance to the main burial chamber in the Lo-yang tomb No. 30.14 mentioned above. Owing to its reproductive powers the fish is generally emblematic of abundant regeneration. "From the resemblance in structure between fish and birds, their oviparous birth, and their adaption to elements differing from that of other created beings, the Chinese believe the nature of these creatures to be interchangeable. Many kinds of fish are reputed as being transformed at stated seasons into birds."[4] Although one can only speculate about the precise iconographic significance of this motif, its funereal, netherworld context suggests that it belongs to the supernatural realm and thus may be appropriately included with representations of the other primordial, cosmological and mythological symbols.

Published: O. Sirén, "An Exhibition of Early Chinese Sculptures, II," *The Burlington Magazine* 53, no. 307 (October 1928), p. 179, pl. 1A; O. Fischer, *Die chinesische Malerei der Han-Dynastie* (Berlin, 1931), pl. 1; O. Sirén, *Chinesische Skulpturen der Sammlung Eduard von der Heydt— Chinese Sculptures in the von der Heydt Collection* (Zürich 1959), no. 4; K. Finsterbusch, *Verzeichnis und Motivindex der Han-Darstellungen*, vol. 2 (Wiesbaden, 1971), pl. 198, no. 801.

Notes

1. J. Fontein and R. Hempel, *China, Korea, Japan*, Propyläen Kunstgeschichte, vol. 17 (Berlin, 1968), pl. 87.

2. R.C. Rudolph and Wen Yu, *Han Tomb Art of West China: A Collection of First- and Second-Century Reliefs* (Berkeley/Los Angeles, 1951), figs. 4–5, and pls. 60–63.

3. *The Bulletin of the Cleveland Museum of Art* 50, no. 10 (December 1963), p. 282, no. 77.

4. C.A.S. Williams, *Outlines of Chinese Symbolism and Art Motives* (Shanghai, 1941), p. 185.

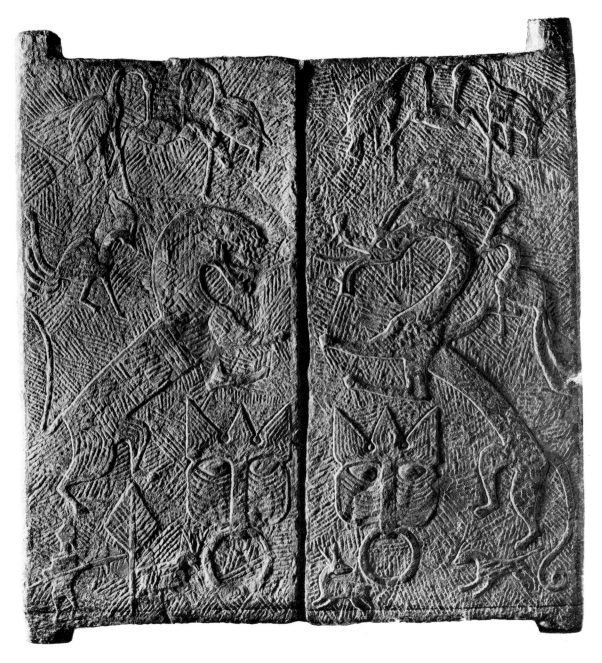

36. Double-Leaved Door from a Tomb

37 Recumbent Ram

China; Sui dynasty, late sixth century A.D.
Gray stone; H. 122.3 cm, W. 39.5 cm, L.
 82.4 cm
von der Heydt Collection

In China ideas of good fortune have been associated with the ram since ancient times because the character *yang,* meaning "ram," resembles the graph for "happiness, good luck, good omen," read *hsiang.* Thus it is not surprising to find this auspicious animal placed in effigy in or near the tombs of eminent dead. That the ram already fulfilled some essential religious or ceremonial demand in ritual sacrifices as early as the Shang period is affirmed by many oracle bone inscriptions. Several ritual vessels of the late Shang and early Western Chou dynasties also testify to its importance in China's Bronze Age culture and civilization. Such vessels are adorned with rams' heads in high or low relief or they may even be cast as double- or quadruple-ram *Tsun.* These astonishing sacrificial vessels may be the products of a local southern bronze industry, of imaginative independent artists working perhaps during the twelfth and eleventh centuries B.C. in the region of northern Hunan Province. In later periods, especially during the Han and Six Dynasties, small pottery figurines of rams as well as bronze lamps in the shape of recumbent rams, so-called *yang-teng,* seem to have been among the most common types of mortuary gifts destined to accompany the deceased into the spirit world.

A similar intention must have prompted the mounting of a clay head of a ram modelled in high relief at a prominent point of a tomb facing south, and also the placing of monumental stone sculptures of rams, often in the company of other auspicious animals, at the front of a grave. In most cases these stone sculptures were made in pairs so that they could be arranged in an orderly right-left symmetry on either side of the *shen-tao* or "spirit road" usually leading up from the south to the main entrance of a burial mound. Undoubtedly the Rietberg ram once guarded the grave site of an eminent Chinese grandee, as did the rams along the "spirit

Fig. 37a. Stone ram from the tomb of General Li Ho. China, A.D. 582.

road" of the Shun-ling, the grave of Lady Yang in Hsien-yang County, Shensi Province.[1] The notorious T'ang Empress Wu Tse-t'ien (reigned A.D. 684-705) had this tomb built probably around the year 700 in honor of her mother who had passed away in 670. Another pair of fine stone sculptures of recumbent rams are to be found in front of her second son's tomb, that of Prince Chang-huai (A.D. 654-684) at Ch'ien-hsien in Shensi Province, dating from the first decade of the eight century.[2]

The Rietberg ram, however, does not yet display the smooth stiffness and bloodless monumentality seen in the T'ang animals at Shun-ling and even more in corresponding stone sculptures of still later centuries. On the contrary, the work in the Rietberg Museum is striking in its powerful compactness. The block-like simplicity of its contour is strongly accentuated by the heavy rectangular plinth of a height of twenty-seven centimeters. The squat proportions of the body of the ram are nota-

37. Detail A

37. Detail B

37. Recumbent Ram

Fig. 37b. Rubbing of a stone sarcophagus from tomb of General Li Ho (detail). China, A.D. 582.

ble. Above the short rounded back, the mighty head rises proudly, with long horns curving down over the neck, almost round, watchful eyes, a sharply cut nose, a short rounded muzzle, and a goatee. Undoubtedly, the sculptor's interest was focused on the head of the ram. The animal's expressive liveliness, vital force, and almost majestic grandeur are concentrated in the head. Contrasting with the clearly cubic abstraction of the body of the animal to its basic volumetric forms, we notice in some places a tendency towards a naturalistic treatment. This appears most clearly in the texture of the hide suggested by means of innumerable irregular strokes of the chisel, the sharp striations on the horns, and the sensitive rendering of the nostrils.

Considering the basically robust sculptural conception of the ram, the subtle line engraving on the plinth must come as a surprise. Apparently earlier owners and authors failed to notice them. Only years after he had acquired the piece around 1923 or 1924 from C.T. Loo in Paris, did Baron Eduard von der Heydt notice the partly effaced engravings and bring them to the attention of William Cohn who published a short note about this unexpected discovery in 1936.[3] Due to heavy corrosion, only a few traces of the engraving remain visible on the left side. The right side, however, shows a crouching lion and a recumbent ram facing each other in profile view. The proportions of the latter correspond entirely with those of the sculpture in the round (details A,B). The front side of the plinth is decorated with a crouching lion in frontal view (detail C), and the back shows a fabulous creature with horns, a mane, and a bushy tail in side view facing left (detail D). This animal seems to

be a composite of several species of real fauna. Fantastic creatures of this type with a single curved horn protruding from the top of a lion-like head are not unfamiliar among clay tomb figurines of the Sui and T'ang dynasties. Each of the animals on the plinth is set into a rectangular scrollwork cartouche with rounded corners that narrows slightly toward the bottom.

Osvald Sirén believed he recognized in these engravings close relationships to corresponding monuments of the ninth and early tenth centuries.[4] In 1936 William Cohn proposed a date in the early T'ang period or the sixth century, although four years earlier, when he was unaware of the engravings, he had come to the conclusion that the ram was made sometime between the seventh and the ninth centuries. Recent archaeological finds seem to support the earlier date and even permit placing the ram more precisely in the late sixth century.

In 1964, during an investigation of the tomb of General Li Ho who had died in A.D. 582 at the age of seventy-seven and was buried at Shuang-sheng-ts'un near San-yüan, in Shensi Province, a pair of stone sculptures of recumbent rams measuring 95 centimeters in height and 110 centimeters in length, was discovered 59 meters in front of the burial mound (fig. 37a).[5] With their distinctive proportions, powerful heads, and short squat bodies with sloping backs, these two figures show an astonishing similarity to the Rietberg ram. Li Ho, who came from a family that had produced high officials for several generations, had just lived to see the founding of the Sui dynasty. According to the epitaph inscription, he was buried on the twenty-sixth day of the twelfth month of the second year of the

37. Detail C

37. Detail D

K'ai-huang era (A.D. 582), exactly eight months after he had died. Some of the engraved ornamental scroll patterns on his lavishly decorated stone sarcophagus closely resemble the scrollwork surrounding the animals engraved on the plinth of the Rietberg ram and thus help to establish the proposed Sui date for our sculpture more firmly (fig. 37b).[6] By contrast with this, the scrollwork in fine line engraving on the plinth of the early eighth century Chang-huai rams, though hard to discern in their present state of conservation, definitely conveys a typical T'ang flavor. How the Rietberg ram differs in style from earlier ram sculptures of the fifth century A.D. can be studied clearly by making a comparison with a recumbent ram that was excavated in 1957 at Pei-t'u-yen-ts'un, a Western suburb of T'ai-yüan, in Shansi Province.[7] This animal has a disproportionately long neck which supports a rather small head, while the body is characterized by massive heaviness. Though devoid of artistic significance, the excavated ram of 130 centimeters height and 90 centimeters length is important in that it represents an intermediary stage in the development of monumental animal stone sculpture in northern China before the unification of the country under the Sui dynasty.

Published: H. d'Ardenne de Tizac, *Animals in Chinese Art* (London, 1923), pl. XXXI; K. With, *Bildwerke Ost- und Südasiens aus der Sammlung Yi Yuan* (Basel, 1924), pls. 42–43; C. Glaser, *Ostasiatische Plastik,* Die Kunst des Ostens, vol. 11 (Berlin, 1925), pl. 59; R. Grousset, *Les civilisations de l'Orient,* vol. 3: *La Chine* (Paris, 1930), fig. 180; W. Cohn, *Asiatische Plastik: Sammlung Baron Eduard von der Heydt* (Berlin, 1932), pp. 78-81; W. Cohn, "Der Widder der Sammlung Baron von der Heydt," *Ostasiatische Zeitschrift* N.F. 12 (1936), p. 244, pl. 34; O. Sirén, *Chinesische Skulpturen der Sammlung Eduard von der Heydt—Chinese Sculptures in the von der Heydt Collection* (Zürich, 1959), no. 9.

Notes

1. É. Chavannes, *Mission archéologique dans la Chine septentrionale,* vol. 2 (Paris, 1909), pl. CCXCIX, no. 468.
2. To my knowledge, the Chang-huai rams have not yet been properly published.
3. "Der Widder der Sammlung Baron von der Heydt," *Ostasiatische Zeitschrift* N.F. 12 (1936), p. 244, pl. 34.
4. *Chinesische Skulpturen der Sammlung Eduard von der Heydt—Chinese Sculptures in the von der Heydt Collection* (Zürich, 1959), no. 9.
5. Shan-hsi-sheng wen-wu kuan-li wei-yüan-hui, "Shan-hsi-sheng San-yüan-hsien Shuang-sheng-ts'un Sui Li Ho mu ch'ing li chien pao," *Wen-wu,* no. 1 (1966), p. 27, fig. 1.
6. K. Finsterbusch, *Zur Archäologie der Pei-Ch'i- (550-577) und Sui-Zeit (581-618)* (Wiesbaden, 1976), pl. 75:12.
7. Shan-hsi-sheng po-wu-kuan, ed., *Shan-hsi shih-tiao i-shu* (Peking, 1962), pl. 28.

38 Fantastic Animal

China; Northern Wei dynasty, first third of the sixth century A.D.
Dark gray pottery with earth incrustations; H. 28.5 cm, W. 17.5 cm, L. 33.5 cm
von der Heydt Collection

Mortuary gifts are termed *ming-ch'i* in Chinese. When Western collectors first became aware of the subterranean multitude of these "spirit objects" shortly after 1900, the Chinese antique dealers were ready to cope with the great demand, and grave robbing, which had occurred in China throughout its entire history, intensified. Due to the lack of firsthand information on the bootleg "finds," until controlled excavations were carried out in recent years, little or nothing was known about the average inventory of a tomb of a certain period, about the nature, number, size, and arrangement of mortuary gifts—not to mention any noticeable changes that might have occurred in the tomb furnishings or the burial customs.

Fantastic animals with ferocious expressions had a protective function; they were placed at the entrance of a burial chamber to ward off evil spirits, supernatural as well as human, and hence to guarantee eternal peace for the deceased. The fabulous beast in the Rietberg Museum is placed on a rectangular plinth. Sitting on its haunches, the creature with its slim body and disproportionately long tubular front legs assumes an aggressive posture. The legs end in powerful tiger's paws. The animal's body is hollow underneath, modelled like a fragile shell. From the bent back three pointed horn-shaped spikes protrude. The fierce head of this beast is a masterwork of exquisite modelling, showing a remarkable sense of formal integration. Scowling, bulging eyes, flaring nostrils, and a broad, wide-open mouth with sharp fangs emphasize the apotropaic significance of the tomb guardian. These expressive features do not merely create an exaggerated grimace but imbue the animal with magic life.

This type of fabulous monster was apparently introduced during the Northern Wei dynasty (A.D. 386–535). What must be considered as unpretentious prototypes of our tomb figurine, though devoid of any artistic value, are two fantastic creatures with the conspicuous three pointed protrusions on their backs that were found side by side with a pair of guardian figures in military regalia on either side of the entrance to the vaulted burial chamber of tomb M 229 near Jen-chia-k'ou in the vicinity of Sian, Shensi Province.[1] It was the tomb of Shao Chen, once governor of Ho-yang, and it is said to have been constructed in A.D. 519. The archaeologists discovered it in 1955 completely intact, not once disturbed by grave robbers since the burial. In the meantime, other grave sites of the Northern Wei dynasty have been investigated. Of special interest in this context is the tomb of Prince Yüan Shao who died in A.D. 528.[2] The excavation, which was started in July 1965 north of the ancient city of Lo-yang near P'an-lung-chung-ts'un, provided clear-cut evidence as to the way in which these fig-

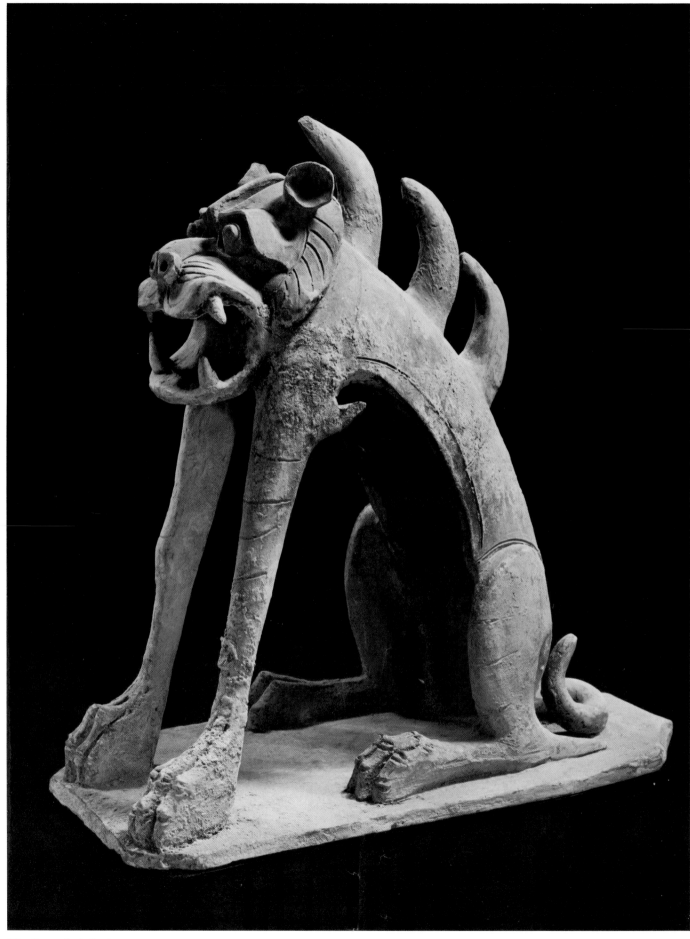

38. Fantastic Animal

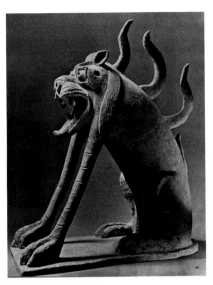

Fig. 38a.
Pottery tomb figurine
of a fantastic animal.
China, sixth century A.D.

39 Standing Guardian in Armor

China; T'ang dynasty, second half of the
seventh century A.D.

White clay with traces of red, green, blue, and
black pigments, gold leaf, and earth incrus-
tations; H. 36.1 cm

ures were displayed within the tomb. A pair of
guardian warriors in rigid frontal stance stood
watch at the entrance of the funerary chamber
along with two fantastic crouching monsters, one
with a face resembling that of a man, the other with
a lion-like head. Both were characterized, however,
by hollow animal bodies with three sharp spines
protruding from their backs. These four guardian
figures continued to form a definite indispensable
unit among the fixtures for the tomb of a high-
ranking official until the end of the T'ang dynasty.
They are usually referred to as *t'u-kuei,* or "earth
spirits," and indeed appear to represent the "spirit
of the ancestors" and an "earth spirit."

Taking into account this knowledge gained
from recent archaeological activities, it is likely that
the Rietberg monster was not originally matched
with an almost identical tomb guardian such as that
published by Lubor Hájek and Werner Forman
(fig. 38a),[3] but rather formed a pair with a compos-
ite creature of human physiognomy, such as the one
preserved in the collection of Mr. and Mrs. Ezekiel
Schloss or in the Haags Gemeentemuseum.[4] Pairs
of identical animal guardians cast from the same
mold have in most cases been arbitrarily combined
from the contents of different, though closely re-
lated, tombs by clever antique dealers.

Published: V. Griessmaier, *Sammlung Baron Eduard von der
Heydt: Ordos-Bronzen, Bronzen aus Luristan und dem
Kaukasus, Werke chinesischer Kleinkunst aus verschiedenen
Perioden,* Sonderpublikation der Wiener Beiträge zur
Kunst- und Kulturgeschichte Asiens (Vienna, 1936), no.
155.

Notes
1. Akiyama Terukazu et al., *Arts of China: Neolithic Cul-
 tures to the T'ang Dynasty, Recent Discoveries* (Tokyo/Palo
 Alto, 1968), pls. 327, 361.
2. Lo-yang po-wu-kuan, "Lo-yang Pei-Wei Yüan Shao
 mu," *Kaogu,* no. 4 (1973), pp. 218 ff., pl. 12: 1-2.
3. L. Hájek and W. Forman, *Chinesische Kunst* (Prague,
 1954), pl. 99.
4. E. Schloss, *Ancient Chinese Ceramic Sculpture from Han
 through T'ang* (Stamford, Conn., 1977), vol. 2, pl. 28A;
 B. Jansen, *Chinese Ceramiek* (The Hague, 1976), no. 28.

This figure of a guardian in martial attire, with his
angry posture and threatening grimace, was un-
doubtedly appropriate for protecting a tomb and
preventing evil natural and supernatural forces
that could disturb the peaceful rest of the deceased
from penetrating into the burial chamber. Al-
though the figure's wrinkled face is partially hidden
under a fantastic high-crested helmet in the shape
of an open-mouthed monster head with a strong
hooked beak, his physiognomy may at first sight be
identified as that of a foreigner; but perhaps the
figure is not even meant to represent a real human
being, because two sharp, upwardly bent fangs
protrude from his mouth. In our day he would have
a good chance of being classified as a vampire.

The menacing guardian is clad in armor, a
short pleated tunic, and a long mail skirt, under
which the contours of his large shoes with rounded,
upturned tips are discernible. The fabric of his skirt
falls down in sensitively modelled, flowing folds,
contrasting with what appears to be a rather stiff
leather part of the military costume. A wide scarf
worn like a stole and tied together high on the chest
is draped around the shoulders in dense, subtle
pleats. A long strap winding twice around the fig-
ure's hips, details of the armor including the
breastplates and a fantastic animal mask a little
below them, as well as the dragon head epaulets,
show the artist's love and care for accurate model-
ling of details. At the same time, they testify to his
keenly observant interest in the military outfit and
fashionable accessories of the day, and also to his
imaginative power to enrich reality by details born
from his own fantasy and predilection for gro-
tesque contrivance. The warrior guardian stands
with legs set apart. His right hand rests on his right
hip, while his left arm is raised and bent at the
elbow. The fist is firmly clenched, ready to hold a
spear or some other weapon, which may have been
made of wood, but, of course, has long since de-
cayed. His appearance and stance is so highly
dramatic that two similar guardians formerly in the
collection of Mr. T. Simon, Berlin, were considered
to represent actors by the authors of the catalogue
for the famous Berlin exhibition of Chinese art held
in 1929.[1]

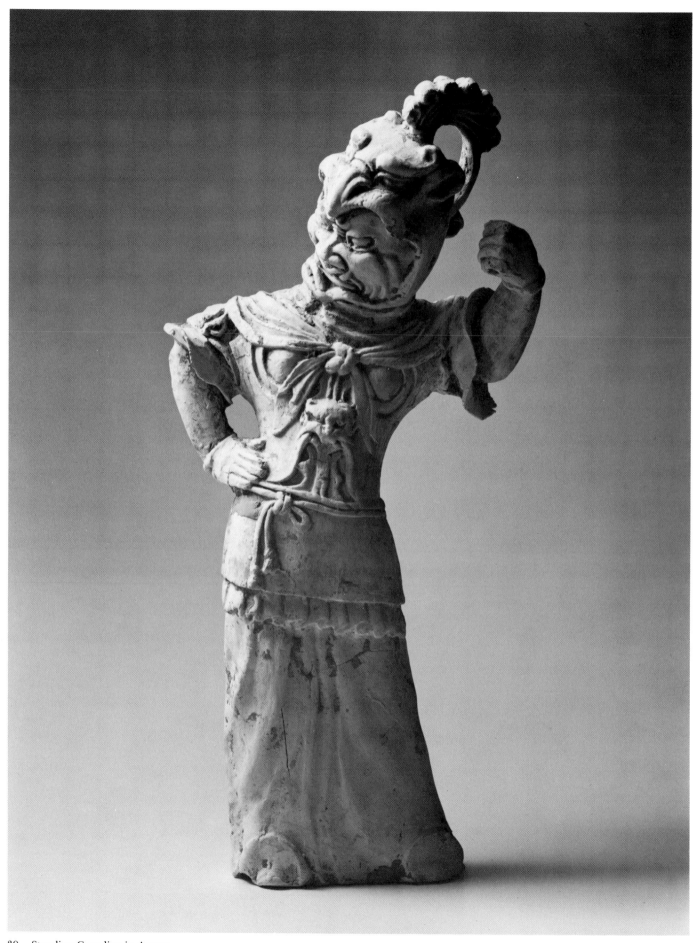

39. Standing Guardian in Armor

Together with a pair of fabulous monsters and another guardian with the same self-assurance and supernatural power, a figure such as this one was supposedly one of the most essential parts in the inventory of tomb furnishings installed for protective purposes at the entrance to a burial chamber. Having ultimately developed from a type of ancient genie called *fang-hsiang*, this guardian in armor seems to have been mixed with and to have assimilated aspects of the Buddhist "Four Heavenly Kings" or "Guardians of the Four Directions" over the centuries, so that by T'ang times these tomb figurines often appear as rather close copies of Buddhist *lokapālas*. These, however, are represented as a rule stamping on an evil-looking creature.

Published: A. Salmony, *Sammlung J. F. H. Menten: Chinesische Grabfunde und Bronzen* (Zürich, 1948), no. 67.

Notes
1. *Ausstellung chinesischer Kunst* (Berlin, 1929), no. 323.

40 Five Female Musicians and a Dancer

China; Sui dynasty, ca. A.D. 600
White clay with a thin cream-colored glaze and traces of unfired black, red, and green pigments; H. 25.5 – 27 cm

The official "History of the Sui Dynasty," the *Sui shu*, contains a chapter on music in which many different instruments, types of music, and dances from Central Asia are introduced. During the reign of Wen-ti (A.D. 581–604), the founder of the Sui dynasty, many foreign entertainers are reported to have performed at the imperial court, among them a whole orchestra of girls from the Kingdom of Kucha in the Turfan oasis of Western Turkestan. They were allegedly twenty in number, playing upon the harp, guitar, mouth organ, flutes, whistles, drums, and cymbals.[1] The *Sui shu* recounts that the music of the West had a great many admirers in China and that its popularity and influence had reached its height there in the Ho-ching era (A.D. 562–565) and after. When a lavish banquet was held at the imperial court in the year A.D. 581, orchestras from all over Asia, from India, Kucha, Bukhāra, Samarkand, Kashgar, Cambodia, Japan, and from the countries of the Turks, were sent to entertain the Chinese nobility.[2]

Once under Chinese control the foreign orchestras, instrumentalists as well as singers and dancers, became court employees required to present their exotic tunes and dances in imperial shows and palace entertainments. Western music rapidly became fashionable among all classes of urban society and continued to be in vogue well into T'ang times. "Of all the musical cultures of Serindia," writes Edward H. Schafer, "it was the Kuchean which had by far the greatest influence on that of T'ang. Refined and vulgar citizens alike were avid for the 'drum dance' tunes of the Kuchean bands. The instruments used by the performers from Kucha were also preferred. Most important of these was the Kuchean four-stringed bent-neck lute, upon whose technique and tuning were based the twenty-eight modes of T'ang popular music and the melodies developed from them. The oboe and the flute were also important in Kucha, and therefore popular in China. Best liked of all the Kuchean instruments was the little lacquered 'wether drum,' with its exciting music, and the exotic songs in mispronounced Sanskrit which were sung. The great Hsüan Tsung himself, like many other noble persons, was a trained performer on the wether drum."[3]

The drum, the flute, and the bent-neck lute, known as *p'i-p'a* in Chinese, are also represented in the Rietberg orchestra. Two ladies playing different types of Pan pipes and a graceful dancer complete this Kuchean band. In spite of the abbreviated treatment of the slim, elongated bodies with their closed outlines, the figures do not seem stiff. Their restrained movements are harmoniously suited to their specific arts. The five female musicians appear to be concentrating intently on their instru-

ments. They are all absorbed in their music, while the sixth lady, with her head bent gently to one side and her long sleeves falling back, sways in her dance. Rather than the rhythmic movement of body and legs, this type of Central Asian dance emphasizes the swinging of arms, accentuated by flying sleeves.

Not only because of their elegance in dance and music and, of course, their fascinating charm, were the Western ladies from Kucha so highly admired in China, but also because they represented the height of fashion in dressing as well as in hairstyling and makeup. The Chinese ladies of the late sixth and early seventh centuries readily adopted the foreign style of costume with narrow tight sleeves and a high-waisted, long skirt falling down to the ground. The graceful slenderness of this chemise-like dress, somewhat resembling our Empire fashion, is emphasized by a long sash tied in front and hanging down from the high bodice to below the knees. Another conspicuous and exotic fashion enthusiastically received in Sui times was the elaborate coiffure of our ladies. They wear their hair on top of the head, combed in a flat upsweep over the back of the head and held in place with a small comb. Their ears are uncovered and the hair

is ingeniously arranged in a flat, wavy creation accented on the right side with a flowery loop. In later years, during the T'ang period, it became fashionable to have the hair dressed in a large variety of fancy high arrangements on top of the head.

Since tomb figurines faithfully reflect the latest fashions it seems reasonable to assign the Rietberg ensemble of Kuchean ladies to the Sui dynasty. Such a dating is substantiated by a group of five dancing girls and an orchestra of eight seated female musicians discovered in May 1959 in the tomb of General Chang Sheng near An-yang in Honan Province.[4] The general died in A.D. 594 at the age of ninety-three years and was buried toward the end of the following year in the same tomb as his wife who had died in 586. Thus the excavated figurines, which show close affinities in style and in their fashionable attire to the Rietberg ladies, were probably made together with most of the other mortuary gifts for the Chang couple in the years 594 and 595.

All of these pieces, hollow inside and not closed at the bottom, are made of a soft white clay and covered with a cream-colored glaze which stops short of the base. The thin glaze on the Rietberg group has partially flaked off or disintegrated, and only very few traces have remained of the unfired

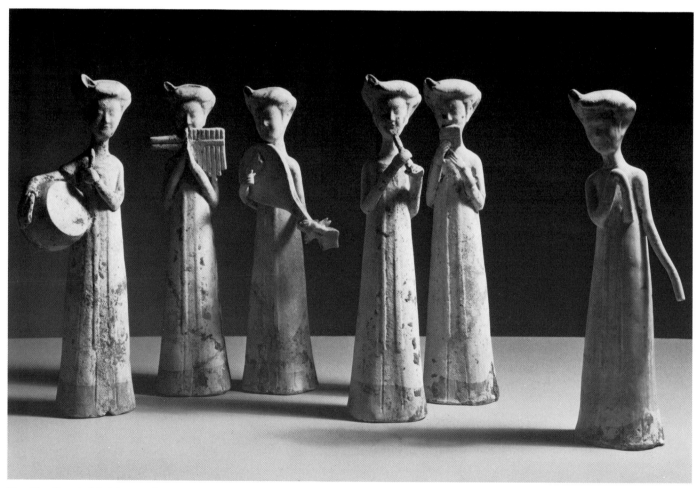

40. Five Female Musicians and a Dancer

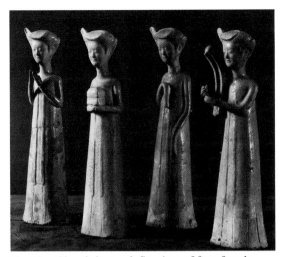

pigments which were used to paint details over the glaze.

Entertainers of this kind belong to the most common type of mortuary gifts of the Sui and early T'ang dynasties. Since they were produced from molds in well organized, specialized workshops, it is not surprising to find a number of similar figures with virtually identical features of face and body. The four Kuchean ladies in the University Museum, University of Pennsylvania, Philadelphia (fig. 40a)[5] and the three slender beauties in the collection of Baron Jo van der Elst, Brussels,[6] were most likely produced in the same tomb figurine workshop as the Rietberg orchestra during the decades of the short-lived Sui dynasty around A.D. 600, perhaps even commissioned by the same customer. Also stylistically related to this group are two slender Kuchean ladies, one a dancer, the other holding a pitcher, in the Hans Popper Collection.[7]

Published: A. Salmony, *Sammlung J. F. H. Menten: Chinesische Grabfunde und Bronzen* (Zürich, 1948), no. 37; J. Fontein and R. Hempel, *China, Korea, Japan,* Propyläen Kunstgeschichte, vol. 17 (Berlin, 1968), pl. 129; H. Brinker, "Chinesische Kunst im Museum Rietberg, Zürich," *du* (April 1974), pp. 14–15.

Notes

1. L.C. Goodrich and Ch'ü Tung-tsu, "Foreign Music at the Court of Sui Wen-ti," *Journal of the American Oriental Society* (July-Sept. 1949), p. 148.
2. J.G. Mahler, *The Westerners among the Figurines of the T'ang Dynasty of China* (Rome, 1959), p. 52.
3. E.H. Schafer, *The Golden Peaches of Samarkand: A Study of T'ang Exotics* (Berkeley/Los Angeles, 1963), p. 52.
4. "An-yang Sui Chang Sheng mu fa chüeh chi," *Kaogu,* no. 10 (1959), pp. 541–545.
5. E. Schloss, *Foreigners in Ancient Chinese Art* (New York, 1969), no. 29.
6. M. Prodan, *The Art of the T'ang Potter* (London, 1960) color pl. VII, p. 17.
7. R.-Y. Lefebvre d'Argencé, *The Hans Popper Collection of Oriental Art* (San Francisco, 1973), no. 51.

41 Seated Lady

China; T'ang dynasty, first quarter of the eighth century A.D.

White clay with green, brown, yellow, and white glazes, traces of unfired black pigment, and earth incrustations; H. 38.5 cm.

The Chinese T'ang ideal of feminine beauty in the first decades of the eighth century is exemplified by this superb tomb figurine of an elegant lady. She lived in an age of intense interest in fashion. Dazzling makeup, fancy coiffures, novel dresses, and fashionable accessories had become essential parts of a noble lady's life. The Western chic of Central Asia left a lasting impact, especially on the taste of Chinese women. While the traditional Chinese costume tended to conceal the body under wide robes of heavy fabrics, the new foreign style fit more closely and emphasized the contours of the body. It must have caused quite a sensation when the first women appeared on the scene in elegant Empire-style dresses such as the one worn by the Rietberg beauty. Her costume consists of a long striped skirt which is patterned with geometric ornaments of circlets neatly arranged in clusters of three. She is sitting on a high spool-shaped wicker stool and her knees protrude through the delicate fabric. Near the high waist the skirt is fitted more tightly. It is tied by a belt-like sash. In front of the bodice a blossom-shaped clasp has been fixed to the sash, whose ends the woman grasps with her right hand while her left hand rests comfortably on her left thigh. The skirt is combined with a long-sleeved blouse and a sleeveless short jacket with a sloping shoulderline. The generous and, by traditional Chinese standards, provocatively daring decolleté certainly must have had a startling effect on conservative minds. The lady wears a beaded necklace. Her hair is combed up in a high chignon on top of the head, a style that had been in vogue since the middle of the seventh century. Her elegant outfit is completed by large shoes, the upturned tips of which stick out under the hem of her long skirt. Her face is modelled in softly rounded forms. She has a small mouth with fleshy lips, a snub nose, and narrow eyes with arched eyebrows.

The famous T'ang poet Po Chü-i (A.D. 772–846) wrote a poem in which he alluded to fashionable details of the mid-eighth century:

"Shoes with small tips; tightly fitting robes.
The eyebrows dotted with deep purple; they are thin and elongated.
People outside the palace may laugh when they see them.
But that is the fashion in makeup of the later years of the T'ien-pao era [A.D. 742–756]."[1]

On the basis of Po Chü-i's observation and provided that the artists did not represent tomb figurines in attires that were *démodé* at the time of the funeral, we must conclude that some aspects of fashion had changed in the twenty years or so since the Rietberg

lady was made. "Shoes with small tips," for example, had replaced the earlier larger ones with upturned tips. Indeed, this conspicuous detail, as well as the elaborate hairdo and the long Empire-style dress we also encounter decades earlier in some murals recently discovered in the tombs of three young members of the imperial family in the cemetery at Ch'ien-hsien, Shensi Province: in the tomb of Prince Chang-huai (A.D. 654–684), that of Crown Prince I-te (A.D. 682 – 701), and that of Princess Yung-t'ai (A.D. 684 – 701). All the murals were painted no later than A.D. 711.[2]

There is good reason to believe that the Rietberg figure was made at about the same time and in the same area, i.e., in the vicinity of the ancient T'ang capital Ch'ang-an. Two charming tomb figurines of seated women support this assertion. Although they differ in size, and were excavated at different times, in 1954 and 1955, from different tombs, both were unearthed at the same site on the outskirts of Sian, at Wang-chia-fen-ts'un in Shensi Province.[3] In style and technique they comfortably match not only each other—the larger one, measuring 47.3 centimeters in height, being a little more sophisticated than the small one (H. 28.5 cm)—but also the Rietberg figurine. All three pieces are glazed in a similar palette predominantly of green, brown, and white, which is conventionally referred to as *T'ang san-ts'ai*, "three-color glazing of the T'ang dynasty." A fourth color, a straw yellow, has

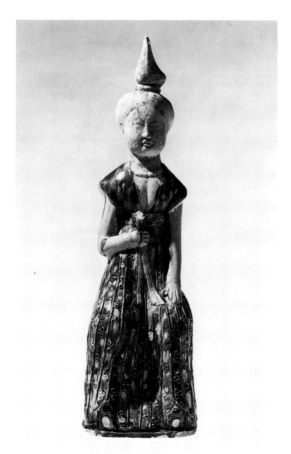

41. Seated Lady (color illustration p. 75)

been added to the stool of the Rietberg lady to suggest wickerwork. The hollow figure has a closed base with only a small hole in the center. The white slip applied to all of these tomb figurines before glazing definitely enhanced the remarkably clear quality and brilliance of the polychrome surface. Here the different colors are deliberately assigned to appropriate parts of the figure in contrast to other pieces where they are carelessly splashed on at random regardless of the design and contour. Grooved parallel lines serving as gutters and producing fine ridges at the same time are intended to prevent, though not always successfully, the different colors from coalescing. In all three figures great pains were taken over the final individual modelling and the execution of details. Small relief ornaments were harmoniously added to the costumes. Only the heads have been left unglazed. They were afterwards painted with unfired pigments to achieve realistic effects of greater immediacy.

We may assume that these high quality tomb figurines were manufactured in one of the metropolitan workshops in or near Ch'ang-an. However, in spite of the intensive recent archaeological activity in this area none of the kiln sites has been located as yet. The only kiln site discovered so far that has proven to have produced three-color lead glazed wares in T'ang times was found in Kung-hsien east of Lo-yang, the other capital city of the T'ang Empire.

But many of these kilns must have existed because the demand for tomb figurines reached an unprecedented height during the eighth century. In fact a number of T'ang officials drew up sumptuary regulations which prescribed both the dimensions and the number of tomb figurines permitted, depending on the rank of the deceased. Large, individually modelled figures were reserved for the highest dignitaries. People of lower rank and social status had to be satisfied with mass-produced, molded, standard types of a smaller size. But the augmented numbers given by each of the successively revised ordinances lead us to doubt the effectiveness of such restrictions. Ostentatious extravagance paired with the Confucian precept of filial piety seems to have rendered any restrictive stipulations ineffective, because ever larger and more luxurious figurines accompanied the dead into the tomb. Only the upheaval of the An Lu-shan rebellion in A.D. 756 put a sudden end to the prosperous artistic life and liberal cosmopolitanism in the country.

Published: A. Salmony, *Sammlung J. F. H. Menten: Chinesische Grabfunde und Bronzen* (Zürich, 1948), no. 36; H. Brinker, "Chinesische Kunst im Museum Rietberg, Zürich," *du* (April 1974), p. 16.

Notes
1. J. Fontein and Wu Tung, *Han and T'ang Murals Discovered in Tombs in the People's Republic of China and Copied by Contemporary Chinese Painters* (Boston, 1976), p. 117.
2. Ibid., pp. 90 – 123.
3. Akiyama Terukazu et al., *Arts of China: Neolithic Cultures to the T'ang Dynasty, Recent Discoveries* (Tokyo/Palo Alto, 1968), pls. 376, 378.

42 Central Asian Wine-Merchant

China; T'ang dynasty, first half of the eighth century A.D.

White clay with brown, green, and white glazes, traces of unfired red and black pigments, and earth incrustations; H. 33.5 cm

Contacts between China and the West had existed since early times, but by the seventh century A.D., when peace and prosperity seemed to be secured at home and the T'ang rulers had established an empire of unprecedented political power, economic strength, and cultural cosmopolitanism, the intensive commerce and exchange of exotic goods, men, and ideas with Western countries along the so-called "Silk Route" reached its highest peak. Because of the pyramidal structure of Chinese society and government, wealth and culture of the empire were focused in the metropolitan centers Ch'ang-an and Lo-yang, the twin capitals of the T'ang dynasty. Natives from almost every nation of Asia and even a number of people from Europe and Africa flocked to the big cities of T'ang China — some, however, not of their own free will. Ch'ang-an, the greatest capital of the age, with almost two million taxable residents, had a fairly large foreign population. There were, of course, numerous foreign envoys and clerics representing the great interest in international politics and religion, but there were even more foreign merchants who brought the delightful exotic rarities and luxuries which the Chinese of all social classes so much admired and desired. Chinese attitudes toward foreigners nevertheless remained rather ambiguous, for although they were fascinated by foreign clothes, food and drink, arts, music and literature, they considered themselves and their own culture superior, referring with unshakable self-assurance to persons and goods from many foreign countries as *hu,* which means "barbarian."

The T'ang taste for the exotic permeated not only every part of the daily life, it even permeated the spirit world of the afterlife. Aristocrats as well as their imitators in lower social strata wished to be buried with effigies of these "barbarians," and the artists commissioned to provide them were no doubt fascinated by the large variety of racial and ethnic types and characters they daily encountered

among the kaleidoscopic population of cosmopolitan cities such as Ch'ang-an, Lo-yang, Yang-chou, or Canton. The accurate rendering of so many expressive non-Chinese physiognomies and the meticulous care in representing details of the foreign costumes indicate the T'ang artists' keenly observant interest and delight in exoticism, and at the same time testify to their ingenuity and technical skill. It has not proven to be an easy undertaking to classify the tomb figurines of foreigners according to their ethnic origin. Jane Gaston Mahler and Ezekiel Schloss have tried to determine with appropriate caution some of the most prominent types of foreign visitors to China.[1]

Based on their research we might venture to identify the wine-merchant in the Rietberg Museum as a member of one of the eastern Iranian city-states. He has an oval face, a pronounced hawk's nose, deep-set, bulging eyes with bushy eyebrows separated by a deep vertical crease, and a broad mouth with fleshy lips. His facial features are reminiscent of those of one of the three envoys anxiously waiting to be greeted by Chinese court officials in the painting on the east wall toward the mortuary chambers in Li Hsien's or Prince Chang-huai's (A.D. 654–684) tomb at the imperial cemetery in present Ch'ien County, Shensi Province.[2] These wall paintings discovered in 1971–1972 were executed between A.D. 706 and 711. Unfortunately the ethnic origin of the bald-headed foreign emissary has not yet been clearly determined, but he may well be of the same stock as the Rietberg wine-merchant.

Most of the wine-merchant's business colleagues represented among the T'ang tomb figurines appear to be of different ethnic extraction: they have been identified either as Armenoids possessing Caucasian facial features—deep-set, lustrous dark eyes with bushy eyebrows, an aquiline nose, and a squarish chin with a luxuriant black beard — or as Khorezmians. The most celebrated pieces of this type are in the Seattle Art Museum; the Museum of Fine Arts, Boston; the Royal Ontario Museum, Toronto; and the Asian Art Museum of San Francisco, The Avery Brundage Collection.[3] These robust figures are shown in a rather uncomfortable squatting position holding a taut leather wineskin on their laps. In contrast to them the Riet-

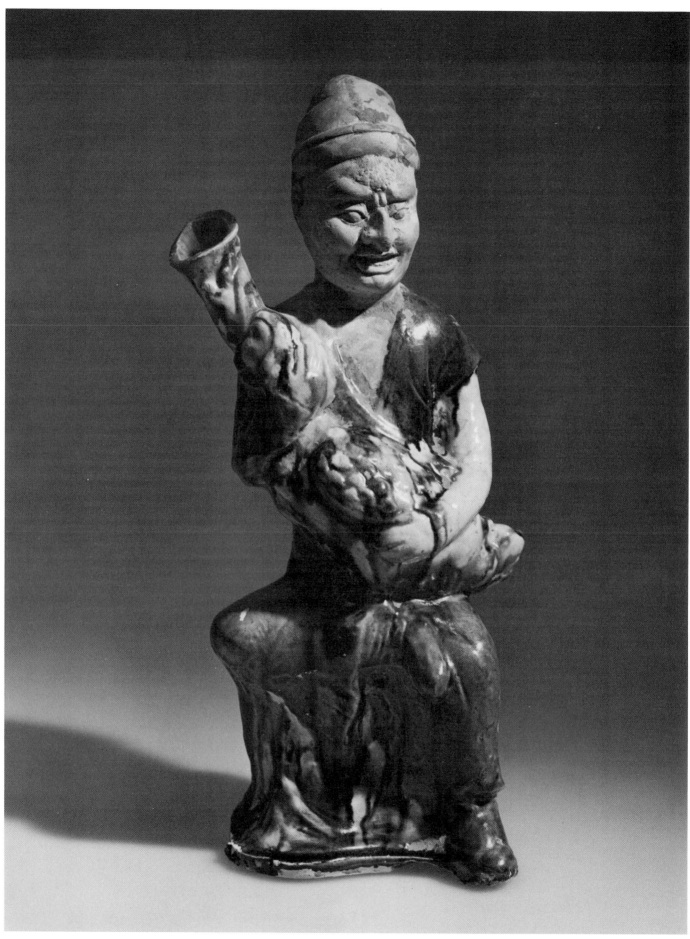

42. Central Asian Wine-Merchant

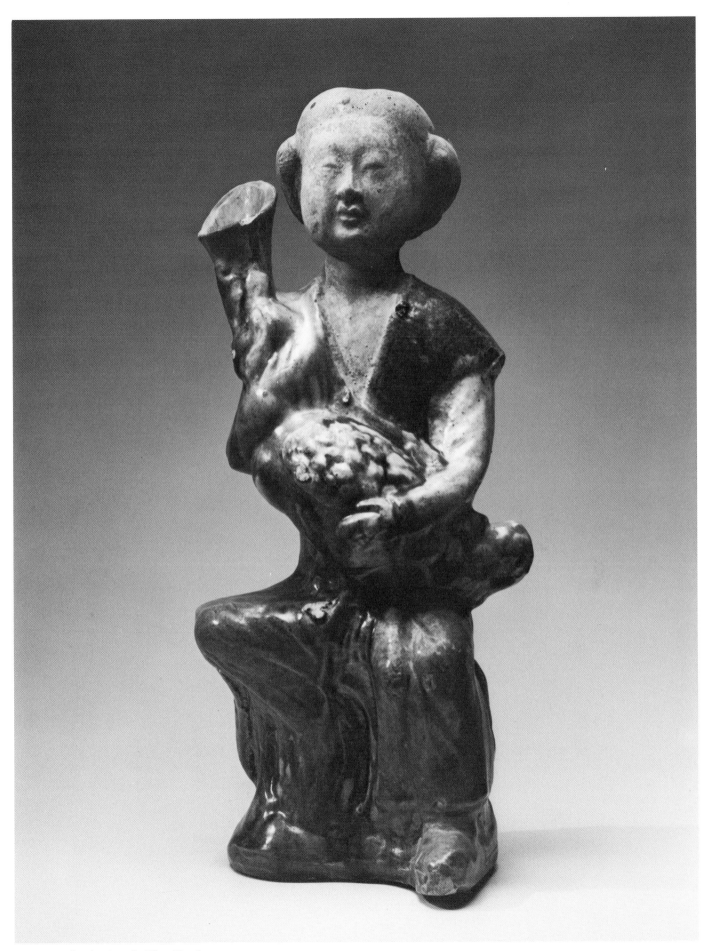

43. Central Asian Female Wine-Merchant

berg wine merchant sits upon a stool in the relaxed, half cross-legged position mainly known from sculptures of Buddhist deities such as Avalokiteśvara, Maitreya, or Kshitigarbha as *lalitāsana*. The body of the wineskin has the shape of a goose, and the merchant embraces his precious merchandise like a baby. On his head he has a tight felt cap with the rim folded up and the peak falling backwards. He wears a costume with wide trousers tied with a belt low on the hips. A tight sleeveless jacket is combined with a long-sleeved shirt and a scarf draped over his right shoulder. On his forehead he has an intriguing, though unintelligible emblem that looks like a cluster of grapes. It might have been a type of trademark, making the gentleman readily identifiable by prospective customers among merchants of other branches in the crowded markets of the big cities. In Ch'ang-an, for example, each merchant was required by law to display a sign indicating his specialty.

The glaze of the tomb figurine, in which brown predominates over green and white, shows a combination of thoughtful arrangement of the colors and careless splashing. It covers the entire body of the figure. Only the head has been left unglazed in order to receive special treatment with realistic details painted in unfired pigments of which only some traces of red and black remain along with vestiges of white slip. The hollow figure has been closed at the bottom.

Published: A. Salmony, *Sammlung J. F. H. Menten: Chinesische Grabfunde und Bronzen* (Zürich, 1948), no. 65.

Notes
1. J.G. Mahler, *The Westerners among the Figurines of the T'ang Dynasty of China* (Rome, 1959); E. Schloss, *Foreigners in Ancient Chinese Art* (New York, 1969); and E. Schloss, *Ancient Chinese Ceramic Sculpture from Han through T'ang* (Stamford, Conn., 1977), vol. 1, pp. 93–110.
2. Shan-hsi-sheng po-wu-kuan and Shan-hsi-sheng wen-wu kuan-li wei-yüan-hui, eds., *T'ang Li Hsien mu Li Chung-jun mu pi-hua* (Peking, 1974), pls. 25–27.
3. Mahler, *Westerners among the Figurines of the T'ang Dynasty*, pl. III a-e; Schloss, *Foreigners in Ancient Chinese Art*, nos. 16–17; and H. Trubner, *Royal Ontario Museum: The Far Eastern Collection* (Toronto, 1968), no. 54.

43 Central Asian Female Wine-Merchant

China; T'ang dynasty, first half of the eighth century A.D.
White clay with brown, green, and white glazes, traces of unfired black pigment, and earth incrustations; H. 30.8 cm

This charming tomb figurine represents a woman who was also active in T'ang China's liquor business. She sits in the same half cross-legged manner on the same kind of Central Asian stool as her male colleague, and she also holds a wineskin in the shape of a fat goose in her arms. Because she is a little smaller, but otherwise executed in the same style, with the same technique, the same clay, and similar glazes of the typical T'ang three-color scheme applied in a similar manner, it seems likely that these two figurines were ordered as a pair from one workshop in the first half of the eighth century and may have served as tomb furnishings for a cultivated connoisseur of wine.

The woman's features are very different from those of the male wine-merchant. Her face has a round contour, full, fleshy cheeks, softly modelled eyes, a snub nose, and a small mouth with puffy lips.

Fig. 43a. Glazed clay tomb figurine of a female wine-merchant. China, first half of eighth century A.D.

She wears her hair braided in a semi-circular wreath on the back of her head. This hairstyle has sometimes been identified as a fashion of Turkish origin. Her costume is of the same style as that of her male companion (perhaps her husband?).

Besides the Romans and the Arabs, the Uighur Turks were well known as great wine producers and wine drinkers. This woman has certainly come from afar to make her fortune in China, but precisely from where she came is difficult to determine. She may well have been of Sogdian origin. In China Sogdians had a reputation as first-rate merchants dealing with grape wine among other luxury goods. "In T'ang times," Edward H. Schafer informs us, "there was the strange wine made from the myrobalans of Persia, available in the taverns of Ch'ang-an; the 'dragon fat' wine, as black as lacquer, brought from Alexandria (!) at the beginning of the ninth century, was, however, probably a product of the fertile mind of the romancer Su O. Grape wine, made in the Iranian fashion, undoubtedly came from Chāch [near modern Tashkent] in the eighth century, when grape wine technology was already established in China."[1]

The head of our figure was left unglazed. Finishing details were originally painted on after the firing, though only a few traces of black and of the white slip have remained. Due to the absence of clearly recognizable details, the face, which is only moderately modelled, has an expression of vacuous complacency. The glazes have partially flooded the bottom of the figure, indicating that the piece was not set in the kiln in an upright position. It was fired while slanting slightly backwards. Spur marks on the glaze corroborate this.

Of closest resemblance to the Rietberg figure is a female wine-merchant in a Chinese collection (fig. 43a).[2] Both seem to have been made in the same workshop, perhaps even in the same molds, though some details vary because they were apparently individually worked by hand after the basic structure of the figure had been formed in the molds. Another related tomb figurine of a woman with a wineskin sitting in half cross-legged position is in a private Tokyo collection.[3]

Published: A. Salmony, *Sammlung J. F. H. Menten: Chinesische Grabfunde und Bronzen* (Zürich, 1948), no. 59.

Notes
1. E.H. Schafer, *The Golden Peaches of Samarkand: A Study of T'ang Exotics* (Berkeley/Los Angeles, 1963), p. 144.
2. Ch'en Wan-li, ed., *T'ao-yung* (Peking, 1957), pl. 42.
3. Sato Masahiko, *Chūgoku no Dogū* (Tokyo, 1965), no. 129.

44 Seated Lion Scratching His Chin

China; T'ang dynasty, first quarter of the eighth century A.D.
White clay with white, green, and brown glazes; H. 21.8 cm, W. 16.2 cm

Although alien to China's indigenous fauna, the lion nevertheless left a profound impact on the arts. He made his appearance under the patronage of Buddhism as early as the fourth century A.D. and became one of the most frequently depicted animals throughout the entire history of sculpture, painting, and applied arts.

In India the lion was considered a suitable emblem for the historical Buddha Śākyamuni, who was named the "Lion of the Śākya Clan," the Śākyasimha. Flanking the throne of the Buddha, which was actually called *simhāsana* ("the lion seat"), the lordly animal appears as guardian of the sacred Law on numerous gilt bronze altarpieces and among the sculptures in the famous cave-temples of northern China. The irresistible authoritative preaching of the Buddha was likened to the lion's roar. According to traditional Mahāyāna iconography, the lion is the animal vehicle of the bodhisattva Mañjuśrī, the personification of wisdom, whose mount symbolizes superior power and energy, both physical and spiritual, the indispensable components of wisdom. It was in this religious capacity that the king of beasts made a profound impression on the Chinese imagination.

Chinese imagery of the lion had to rely almost entirely upon imported models, and the further away the place of origin and the greater the rarity, the more the lordly animal was endowed with spiritual potency and mystic qualities. By T'ang times his Buddhist image of awful majesty was already intermingled with traditional Chinese cosmological aspects of no less authority. Due to his Buddhist descent, the lion was associated in China with India and thus looked upon as a creature of the West. Equipped with an aura of terrible power and savageness, the king of beasts was readily incorporated into the cosmological system and entrusted with the same functions, rights, and powers as the tiger. "Clearly the lion, an alter ego of the Tiger of the West, had supernatural faculties attuned to the effluvia of the Dragon of the East, its opposite number."[1]

Because of his supernatural faculties, it was only a matter of time before the lion joined the kaleidoscopic entourage of fabulous and naturalistic, human and mythical creatures that served as guardians of the dead. As a door guardian we find him already in front of two Sui tombs. Stone sculptures representing pairs of recumbent lions flank the entrance of Li Ho's (died A.D. 582) burial chamber in Shuang-sheng-ts'un near San-yüan, Shensi Province, and Chi Wei's (died A.D. 610) in Sian.[2] In the repertoire of funerary pottery, however, the lion seems not to have appeared before the beginning of the eighth century A.D. Taking into account that Chinese imagery of the lordly animal had been supported almost solely by Buddhist conceptions until well into T'ang times, one would ex-

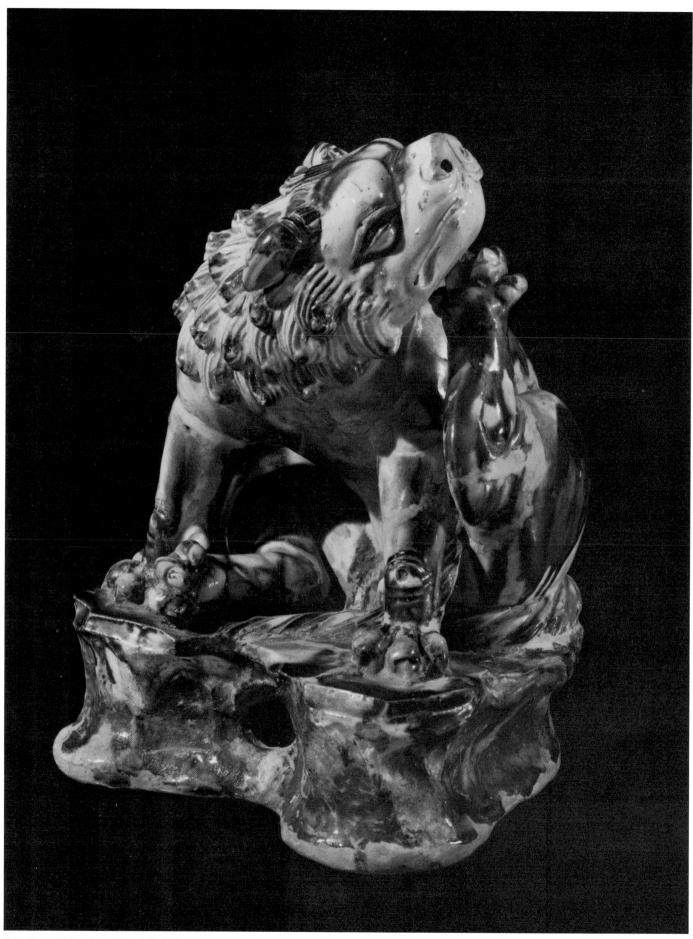

44. Seated Lion Scratching His Chin

pect potters of the tomb figurines to represent the lion in accordance with his religious prototype, i.e., sitting on his haunches with erect head, open mouth, and rigid front legs in roaring majestic grandeur. Seen in profile such sculptures had a triangular silhouette. But in this posture we meet him only in a very few instances.[3]

By contrast, the Rietberg lion and his corresponding counterparts in other collections have an astonishing sculptural quality and convey an impressive feeling of vigor and movement. This type marks a radical departure from the traditional, imported lion image. It captures the animal in a moment of relaxation, either scratching himself or licking his paw while sitting on a flat, rock-shaped pedestal. The luxuriantly maned Rietberg lion, unconcerned about his surroundings, is a small masterpiece of impressionistic animal sculpture. The authoritative king of beasts has become loveable, playful. The strength of his pose lies in the twisting complex movement of the body. With admirable ingenuity the artist rendered the flowing lines of the modelling and succeeded in applying his glazes in pleasing harmony with the sculptural form. Each time the piece is slightly turned, one gets the impression of being confronted with a totally different sculpture. The artist — one hesitates to use the word potter — imparted a strong dynamic momentum to his work, and yet retained a playful unrestraint.

This drastic change in artistic conception must have been generated by exposure to the "real thing." Literary sources tell us that now and then lions reached the imperial court in Ch'ang-an as tributary gifts. The most famous instance perhaps is the arrival of a lion from Samarkand in the year A.D. 635. Emperor T'ai-tsung (reigned A.D. 626 – 649) was so impressed by the awful majesty of the king of beasts that he ordered his aged, trusted adviser Yü Shih-nan (A.D. 558 – 638), a celebrated

expert in calligraphy and poetry, to write a rhapsody in honor of the animal.[4]

The question arises: Why were lions of this type, which in their harmless, playful self-absorption certainly were not fit to ward off evil spirits, placed in tombs? Perhaps it was simply the spontaneous invention of an artist, a whimsical response to an exotic wonder, which soon became fashionable. T'ang funerary ordinances apparently required that a pair of such figurines be buried with the deceased—one lion scratching himself and the other one licking his paw, both of male sex. The excavation carried out in 1955 at Wang-chia-fents'un, an eastern suburb of Sian in Shensi Province, substantiates this assertion, since two polychrome glazed tomb figurines of lions measuring 19.5 centimeters in height were unearthed from tomb No. 90 (figs. 44a, 44b).[5] Another pair has been preserved in the collection of the Seikadō Foundation in Tokyo.[6] Therefore, the Rietberg specimen as well as the fine example of a lion licking his paw in the Freer Gallery of Art, Washington, D.C.,[7] must have lost their original companion pieces.

Published: A. Salmony, *Sammlung J. F. H. Menten: Chinesische Grabfunde und Bronzen* (Zürich, 1948), no. 50.

Notes
1. E.H. Schafer, *The Golden Peaches of Samarkand: A Study of T'ang Exotics* (Berkeley/Los Angeles, 1963), p. 86.
2. K. Finsterbusch, *Zur Archäologie der Pei-Ch'i- (550-577) und Sui-Zeit (581-618)* (Wiesbaden, 1976), pl. 10, figs. 1– 2.
3. One fine three-colored glazed example is in the British Museum, London. See Nagahiro Toshio, ed., *Chūgoku Bijutsu* [Chinese Art in Western Collections], vol. 3: *Sculpture* (Tokyo, 1972), pl. 102.
4. Schafer, *Golden Peaches of Samarkand*, p. 85.
5. Shan-hsi-sheng wen-wu kuan-li wei-yüan-hui, ed., *Shan-hsi-sheng ch'u-t'u T'ang yung hsüan-chi* (Peking, 1958), pl. 128: 1–2.
6. Sato Masahiko, *Chūgoku no Dogū* (Tokyo, 1965), no. 157, p. 131.
7. Nagahiro, *Chūgoku Bijutsu*, vol. 3: *Sculpture*, pl. 103.

Fig. 44a, 44b. Glazed clay tomb figurines of lions from tomb No. 90 at Wang-chia-fen-ts'un, Shensi Province. China, first quarter of the eighth century A.D.

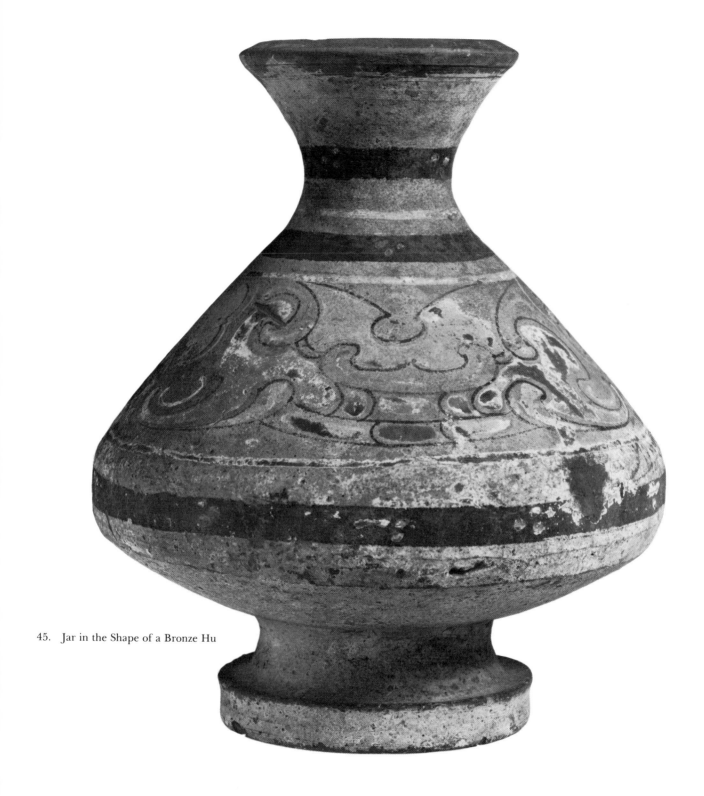

45. Jar in the Shape of a Bronze Hu

45 Jar in the Shape of a Bronze Hu

China; Western Han dynasty, second or first
century B.C.
Gray pottery with unfired lilac, black, and
dark brown pigments on a white slip; H.
26.2 cm
von der Heydt Collection

Jars of this shape resembling or, to be more precise, imitating bronze vessels of the age are usually called *Hu*, sometimes also *Chung*. Most of them, if not all, were once provided with slightly convex lids as is verified by many examples excavated chiefly from Western Han tombs in the vicinity of Lo-yang in Honan Province. They were made as burial vessels to contain grain for use of the deceased in the afterlife. From the specimens that have survived with their original decoration intact, we can surmise that these wares must have been quite colorful and splendid when they were deposited in the tombs.

The pear-shaped body of the Rietberg jar rests on a sharply splayed foot. The straight shoulder sloping down to a prominent, accentuated belly and the flaring mouth endow this pot with austere elegance. A white slip was applied to the gray body as undercoat for the colors, which proved to be rather impermanent. The slip has also partially peeled off. Bordered by dark brown bands, a horizontal frieze of comparatively large-scale, broad, energetically curving cloud scrolls encircles the body. The relationship to bronze vessels is emphasized by painted imitations of two ring handles suspended from masks below the neck. The design was apparently first outlined in black and then the other colors were filled in. The style and character of the decoration appears to be ultimately derived from gold- and silver-inlaid bronzes of the late Eastern Chou dynasty.

Published: *Asiatische Kunst: Indien, Tibet, China, Korea, Japan*, Erinnerungen an die Asiatische Ausstellung aus Schweizer Sammlungen vom 17. Mai bis 7. September 1941 im Kunstgewerbemuseum Zürich (Zürich, 1941), p. 95, fig. a; A. Graf Strachwitz, "Eine bemalte Tonvase der Sammlung von der Heydt," *Ostasiatische Zeitschrift* N.F. 17 (1941), pp. 157 ff., pl. 18.

46 Foreigner on an Elephant Bearing a Candle-Holder

China; Sui dynasty, late sixth or early seventh
century A.D.
Grayish white stoneware with transparent
glaze; H. 19.5 cm, L. 14 cm, Diam. of
candle-holder 11 cm

Candelabra of this type were manufactured in China during the short-lived Sui dynasty and at the beginning of the T'ang period. As a rule they are made of what is sometimes termed "porcelaneous stoneware," a hard whitish material that is surprisingly resonant when struck. The earlier specimens, such as the one in the Rietberg Museum, were partially produced in a two-part mold. The joins at the elephant's head and hindquarters are only roughly cleaned up and not really camouflaged by the relief details or the neutral, transparent, crazed glaze. The seated figure was modelled independently and then luted on to the elephant's back, while the disproportionately large, undecorated candlestick with its collared receptacle and vertical tube was thrown on a potter's wheel. The man seems to be barely able to support and balance it with his left arm and his right shoulder. Courageously he clasps the stem of the candle-holder with his right arm. Sitting in an awkwardly compressed, slanting position he tries to gain a footing on the elephant's head. His saddle is trimmed with stylized floral motifs and a string of pearls. The main ornament on the elephant's harness is reminiscent of a fleur-de-lis turned upside-down. Neatly aligned lotus petals adorn the open oval stand below the animal.

Sui and T'ang artists must have considered the elephant a thing of wonder. Only occasionally did wild or trained specimens of this colossus of tropical southern fauna make their appearance in the north. Artists may have had a chance to study them when foreign embassies, particularly those from Southeast Asian nations, sent them to the imperial court as tributary gifts and for show purposes. Perhaps influenced by the exoticism associated with the elephant, the potter has chosen to represent man and animal as if they were performing a much practiced number in the circus ring, something like "The Equilibrist and His Trained Elephant." It seems not entirely impossible that the artist had a picturesque scene from one of the imperial shows in mind when he modelled the figure as a naked foreigner clad only in a scanty loin cloth. His hair is combed in a flat upsweep and tied in a tuft on top of the head. The facial features include a pronounced

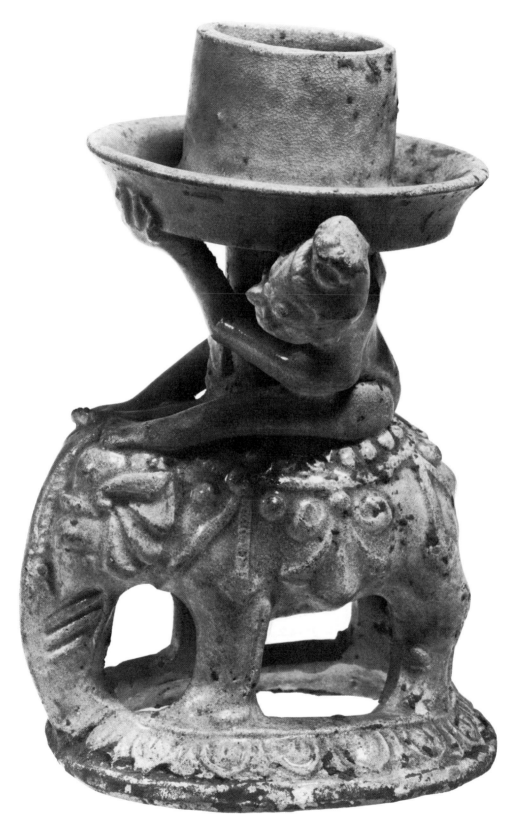

46. Foreigner on an Elephant Bearing a Candle-Holder

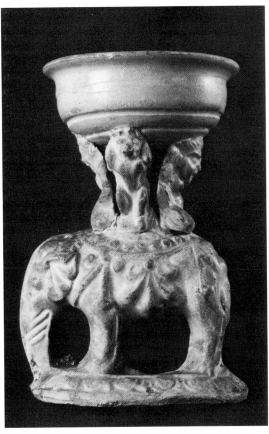

Fig. 46a. Glazed clay tomb figurine of four creatures on an elephant supporting a large, round dish. China, late sixth or early seventh century A.D. The British Museum, London.

nose, protruding cheek-bones, thick eyebrows, and deep-set eyes. The clear distinction between this racial type and all representations of Central Asians or other Westerners found among Chinese tomb figurines—especially in regard to the style of dress or rather the absence of it—leads us to believe that the figure represents a Southerner, perhaps a native of Cambodia or the great Kingdom of Champa.

Glazed white stoneware elephants as bearers of candelabra or incense burners are fairly well represented in Western collections. A magnificent specimen was recently given to the William Rockhill Nelson Gallery of Art in Kansas City,[1] and two other superb seventh-century examples were formerly in the collection of Jakob Goldschmidt, Berlin.[2] The latter two certainly formed a pair, since both elephants were undoubtedly cast from the same

mold. One carries a half-nude, bearded man, who firmly clasps his arms around the stem of a lotus shaped bowl; the other bears an elaborate arrangement of six tubular candle-holders resting on lotus stems. The piece with the closest stylistic affinities to the Rietberg example, however, is an elephant of the same size and material in the British Museum (fig. 46a).[3] He carries on his back four squatting figures. Two of them are dwarf-like, half-naked creatures, the other two look like animals. They support a disproportionately large, round dish with an everted rim, probably for burning incense. One is tempted to suggest that the two pieces in London and in Zürich originally belonged together, like the ones formerly in the Goldschmidt Collection, and that they once formed part of larger sets of mortuary furnishings which are likely to have been made for actual use in the burial ceremony before they were deposited in a tomb. What kind of objects would have been included in such a set of mortuary ceramics in Sui times is suggested by the rich material excavated in 1959 from the tomb of General Chang Sheng and his wife. He died in A.D. 594 and was buried toward the end of the following year in the vicinity of An-yang, Honan Province.[4] Among numerous covered and uncovered jars, plates, dishes, and cups, all of whitish stoneware with pale straw-colored glazes, we find an incense burner with a domed cover of the *po-shan-lu* type, two other ones imitating bronze *Ting* tripods, and two candelabra—unfortunately none with a white elephant. Recent archaeological finds have proved the existence of similar mortuary ceramic fixtures for earlier periods as well.[5]

Published: A. Salmony, *Sammlung J. F. H. Menten: Chinesische Grabfunde und Bronzen* (Zürich, 1948), no. 85.

Notes:
1. "Art of Asia Acquired by North American Museums, 1976–77," *Archives of Asian Art* 31 (1977–1978), p. 122, fig. 22.
2. O. Kümmel, *Jörg Trübner zum Gedächtnis: Ergebnisse seiner letzten Reise* (Berlin, 1930), pls. 74–75.
3. E.H. Schafer, *The Golden Peaches of Samarkand: A Study of T'ang Exotics* (Berkeley/Los Angeles, 1963), pl. XIV.
4. K. Finsterbusch, *Zur Archäologie der Pei-Ch'i- (550–577) und Sui-Zeit (581–618)* (Wiesbaden, 1976), pls. 55–56, figs. 50–67.
5. J. Fontein and T. Wu, *Unearthing China's Past* (Boston, 1973), nos. 64, 67a-d; J.M. Addis, *Chinese Ceramics from Datable Tombs and Some Other Dated Material* (London/New York, 1978), pls. 5a-b, 7a-c; R.J. Herold, "A Family of Post-Han Ritual Bronze Vessels," *Artibus Asiae* 37, no. 4 (1975), pp. 259–279.

47 Four-Legged Money Chest with Bronze Padlock

China; T'ang dynasty, first quarter of the eighth century A.D.

Grayish white clay with dark brown, amber, green, and white glazes; H. 18.3 cm, W. 15.9 cm, L. 20 cm

In its basic shape this unusual chest is vaguely reminiscent of Bronze Age tetrapods with rectangular cauldron known as *Fang-Ting*. Four straight legs of square cross-section running all the way up to the top edge of the chest accentuate the four corners. They make one think of squared timbers rather than ceramic forms and, indeed, the entire construction seems to suggest that the potter attempted to produce a replica of a wooden chest. All the forms seem incongruous in ceramic. The lion-head masks in high relief on the front panel and on the narrow sides as well as the floral ornaments in low relief on all four panels seem to imitate chased metal sheathings. So do the three ducklings and the heavy studs on top of the casket. It does not come as a surprise to find the small hinged lid secured by a bronze padlock. Two bronze loops projecting from square gilt metal sheathings are affixed near the front panel's upper edge in order to support the lock. A narrow slot in the lid accounts for the identification of this exceptional box as a money chest.

Clasp-like padlocks of this type were not uncommon in T'ang China. A fairly large number of such locks were discovered in October 1970 among the precious objects of the enormous gold and silver hoard of Ho-chia-ts'un, a southern suburb of Sian.[1] No less than seventeen were made of gilt silver and six were cast in pure silver; all probably predate the year A.D. 756.

A money chest similar to the Rietberg example, but somewhat smaller and heavier in its proportions, was unearthed in 1954 from tomb No. 90 at Wang-chia-fen-ts'un near Sian in Shensi Province (fig. 47a). The Chinese archaeologists found it placed in front of a *san-ts'ai* glazed figure of an elegant woman as if she were supposed to supervise the accumulated monetary wealth of the chest in the other world.[2] We are inclined to locate the place of origin of the Rietberg treasure casket in the vicinity of the ancient metropolitan center Ch'ang-an. Its ostensible provenance, presumably disseminated by the excavators, transmitted to former owners, and repeated by Alfred Salmony as "Dorf Tchang Ping, Distrikt Siung Yang, Staat Sien Yu," sounds apocryphal, particularly because the occupant of the tomb from which it allegedly was recovered is even identified: a certain "Liu tse," who died in A.D. 609.[3]

This date is at least a century too early for the production of our piece. The palmette medallion on the back panel of the chest as well as the other floral relief appliqués closely resemble the decoration of many T'ang wares made during the first half of the eighth century. Additional evidence for such a dating is supplied by the similar flower design painted on the upper section of the west wall of the third interim passage in Li Chung-jun's tomb, which was excavated in July 1971 at the imperial cemetery in Ch'ien-hsien, Shensi Province. Li Chung-jun, put to death by Empress Wu Tse-t'ien in A.D. 701, was posthumously elevated in rank to Crown Prince I-te and, after the abdication of the empress in A.D. 706, was exhumed and reburied in that lavishly decorated mausoleum.[4]

The Rietberg money chest is glazed with hues of the typical *T'ang san-ts'ai* palette. The potter applied the colors in random patches without much regard for the relief design and its contours. He allowed the polychrome glaze to spread unchecked. Heavy drops along the edges of the unglazed underside and on the bottom of the legs indicate that the chest was placed on a support in the kiln during the firing.

Published: A. Salmony, *Sammlung J. F. H. Menten: Chinesische Grabfunde und Bronzen* (Zürich, 1948), no. 52; Mizuno Sei'ichi, ed., *Sekai Tōji Zenshū*, vol. 9: *Zui-Tō-hen* [Collection of World's Ceramics, vol. 9: China. Sui and T'ang Dynasties] (Tokyo, 1961), fig. 75, p. 193; H. Brinker, "Chinesische Kunst im Museum Rietberg, Zürich," *du* (April 1974), p. 16.

Notes:
1. *Wen-hua ta-ke-ming ch'i-chien ch'u-t'u wen-wu* (Peking, 1972), p. 61: top.
2. Akiyama Terukazu et al., *Arts of China: Neolithic Cultures to the T'ang Dynasty, Recent Discoveries* (Tokyo/Palo Alto, 1968), pls. 376–377.
3. A. Salmony, *Sammlung J.F.H. Menten: Chinesische Grabfunde und Bronzen* (Zürich, 1948), p. 10.
4. Shan-hsi-sheng po-wu-kuan and Shan-hsi-sheng wen-wu kuan-li wei-yüan-hui, eds., *T'ang Li Hsien mu Li Chung-jun mu pi-hua* (Peking, 1974), pl. 39.

Fig. 47a. Glazed clay money chest from tomb No. 90 at Wang-chia-fen-ts'un, Shensi Province. China, first quarter of the eighth century A.D.

47. Four-Legged Money Chest with Bronze Padlock

48 Four-Legged Quatrefoil Offering Dish

China; T'ang dynasty, first half of the eighth
century A.D.
Light gray clay with blue and yellow glazes; H.
5.5 cm, W. 16.5 cm

The exquisite shape of this shallow quatrefoil offer-
ing dish betokens the T'ang potter's delight in ex-
travagant taste and his dependence upon forms
actually alien to his material, because this shape is
clearly derived from metalwork on which, as on so
many other aspects of contemporaneous Chinese
art, Near Eastern forms and decorative techniques
made a strong, though not always lasting, impact.
Each of the four main pointed lobes has two smaller
lobes curving outward from its base, endowing the
dish with its sophisticated quality and giving it the
effect of a multi-petaled flower. The dish is sup-
ported on four short cabriole feet. The areas
around the feet are covered with a straw-yellow
glaze, while the blue glaze on the upper surface was
produced with cobalt.

Cobalt made its sudden appearance in Chinese
ceramics early in the eighth century A.D. The pig-
ment, which is said to have been imported from the
Near East in ready-made form, needed only to be
pulverized and fritted with the lead glazing sub-
stance. Being a rather rare material in China, cobalt
blue glazes therefore were, on the whole, only spar-
ingly applied by T'ang potters. Max Loehr, how-

ever, has pronounced his doubts about the use of
cobalt for the production of lustrous, deep blue
glazes on T'ang wares, since "cobalt blue does not
seem to antedate the tenth century in Persian
ceramics, and the chemical analyses of T'ang wares
offering proof of the presence of cobalt have yet to
be done."[1] He prefers to think of an "alkaline glaze,
perhaps consisting of potash or potassium (K_2O),
lead (PbO), and silica (SiO_2), with copper, that is,
cupric oxide (CuO) as the coloring agent."[2]

The present iridescent discolorations of the
blue are due to a change in the chemical structure of
the glaze because of exposure to acids in the soil in
which this piece was buried as a mortuary gift more
than a millennium ago. Moreover, the piece has
undergone numerous repairs.

Several collections contain trays of this metal-
derived shape. One of the examples most similar to
our quatrefoil dish, also showing the favored blue-
yellow combination of glazes, is in the Haags
Gemeentemuseum.[3]

Published: A. Salmony, *Sammlung J. F. H. Menten:
Chinesische Grabfunde und Bronzen* (Zürich, 1948), no. 90.

Notes:
1. M. Loehr, *Chinese Art: Symbols and Images* (Wellesley,
Mass., 1967), no. 16, p. 32.
2. Ibid.
3. B. Jansen, *Chinese Ceramiek* (The Hague, 1976), no. 47.

48. Four-Legged Quatrefoil Offering Dish

49 Buddhist Votive Stele

China; late Northern Wei dynasty, first quarter of the sixth century A.D.
Dark gray limestone; H. 135.5 cm, W. 68 cm, Depth 7–7.5 cm
von der Heydt Collection

It is surprising how many testimonials from the first flourishing period of Buddhist art in China have been preserved. Among them we find an abundance of votive stelae, richly decorated with reliefs, which had usually been erected within the precincts of a temple. Their prototypes may be seen in the memorial and other inscribed stelae customary since Han times. During the fifth century A.D., Western forms and styles of art were gradually assimilated. They were introduced with the Buddhist faith, which travelled from India along the ancient trade routes of Central Asia or by sea around Southeast Asia and represented the first foreign ideology to thoroughly permeate Chinese culture. At the turn of the century, after the Northern Wei court was transferred in A.D. 495 from Ta-t'ung in Shansi Province to Lo-yang, the ancient Chou and Han capital near the Lo River in Honan Province, the style of religious sculpture became more distinctly Chinese in character. In contrast to the well-defined and sensitively modelled images of earlier periods, which reflected Indian influence, Buddhist sculptures of the Northern Wei dynasty were clad in garments whose flat, overlapping pleats disguised anatomical features; they project a strong sense of formal symmetry and of compellingly majestic poise.

Looking at the Rietberg stele, which is a piece of the highest quality, one cannot help feeling that the formative influence on the style and also on the iconographic composition of sculptures of this type may have come from small portable Buddhist altars in gilt bronze. In the transmission of the rigorously fixed canon of proportions and form and in the propagation of new styles across the entire Buddhist world, the role of these altars was at least as important as that of the iconographic manuals with their descriptions and illustrations. The gentle forward curve of the pointed aureole, the engraved wreath of flames on the outer border, and other details of the Rietberg stele remind us strongly of gilt bronze images mainly dated by inscriptions to the first quarter of the sixth century A.D. Certain proof for such a supposition is provided by an unassuming, badly damaged, Southern Ch'i stele in the Museum of Fine Arts, Boston, which is dated in accordance with A.D. 494; a small early sixth century Northern Wei limestone altarpiece in the Field Museum of Natural History, Chicago; and a Buddha triad said to have come from Tsao-t'ang-ssu in the vicinity of Sian, Shensi Province. In all three cases the sculptors clearly revealed their models by faithfully copying even the customary four-legged rectangular bases of gilt-bronze images.[1] In the case of a bodhisattva stele from the end of the Northern Ch'i dynasty, found at Chin-ch'eng-hsien in Shansi Province, the imitation was carried to an extreme. Here the sculptor went to great pains to transfer to his sandstone work the characteristic features of a gilt bronze altarpiece with a two-tier dais.[2] Incidentally, the dense, dark gray limestone with its present, partially shiny patina lends the Rietberg stele an almost metallic quality. But one should not forget that originally most, if not all, Buddhist stone stelae were probably gilded and painted.

On the Rietberg stele, the youthfully slender Buddha, perhaps Śākyamuni or Maitreya, is represented in solemn frontality; with clear contours he stands out in heavy relief against the background. The body, which appears to be almost ethereal, seems to hover in front of the mandorla. The face of the Buddha radiates serene tranquility and an otherworldly certitude of salvation. On his head rises the *ushnīsha* as a sign of his supreme enlightenment and sublime power of omniscience. The straight, horizontal hairline and the smooth dome with the towering protuberance almost give the head the appearance of a miniature architectural structure composed of integrated stereometric forms. The Buddha is wearing a plain monk's robe hanging from his narrow shoulders in heavy folds. The right hand is raised in *abhaya-mudrā*, the gesture of granting protection and release from fear; the left is holding the robe.

The sculptor of our piece has strictly followed the iconometric rules of Buddhist art. As in the canon of classical beauty in Greek sculpture, here too the proportions and measurements of the body are of fundamental significance. Iconometry or "doctrine of measuring icons," known as *pratima māna* in Sanskrit, is based on the module of the length of the palm, which corresponds to the length of the face from the hairline to the tip of the chin. This basic unit taken seven times equals the height of a standing Buddhist savior figure. Our Buddha statue corresponds completely in all its measurements to the standards of proportion for such figures.

On the leaf-shaped mandorla appears an abundance of subordinate details in clear line engraving. Directly around the head of the Buddha we see a lotus and a circle with floral tendrils. Flying *apsaras* offer flowers to the enlightened one and sound heavenly music in his honor; their fluttering scarfs overlap the outer edge of the triple halo in graceful linear configurations. Even this secondary artistic effect contributes in suggesting the atmosphere of transcendental spheres. Right above the Buddha's *ushnīsha* appears a strange mask of a fabulous monster in frontal view among the *apsaras*. Above this group are the Seven Buddhas: Śākyamuni and his six predecessors of earlier eons.

The main figure of the stele is flanked by the engraved images of two smaller bodhisattvas standing on lotus pedestals and holding lantern-like jewel pendants in their hands. Next to them appear several donors of still smaller size, some of them under ceremonial parasols; their names are in-

scribed near them. The awkward, uncertain writing style of the characters contrasts strongly with the fluid elegance of the line engravings in the upper part of the stele. The bodhisattvas and donor figures too show a certain stiffness and seem a bit lifeless and mechanical (see detail). It may be that in the course of work on this stele the original plan was changed for some reason. Perhaps the financial circumstances of the donors deteriorated or conditions in the workshop changed and caused this peculiar decline in quality. Such an assumption is supported by the fact that on the back of the stele the engraving of one donor's name was apparently suddenly interrupted, while other names are commemorated repeatedly and several prepared cartouches have remained empty. On the other hand, we cannot exclude the possibility that the stele was partially recut—hardly, however, in such a drastic and sweeping fashion as William Cohn assumed. He thought the entire mandorla could have been shaved down and two original bodhisattva figures in high relief removed, as happened sometimes, to make way for the present linear engravings.[3]

The names of the donors are given in eight vertical lines. A certain Su Chen-an is mentioned as the donor of the Buddha image (*fo-chu*), Cheng Yüan-po as donor of the "eye opening" ceremony (*kuang-ming-chu*), and Yu Pao-shan and Wang Tao-nien as donors of the two bodhisattva figures (*p'u-sa-chu*). The rest of the donors are introduced as *fo-ti-tzu*, "disciples of the Buddha," a common clerical title. The reverse of the stele shows in the upper section a Buddha under a richly decorated canopy. Next to him and below him numerous donors are represented, most of them carrying long-stemmed lotus flowers. Six registers of vertical lines offer space for forty-one names of donors. In twenty-seven cases the names have been engraved, the remaining spaces were left empty. The repeated naming of donors on the front side and reverse may be considered as a sign of particular religious devotion and sustained financial support for the execution of the stele.

The narrow sides are decorated with a continuous grapevine, an ornament ultimately borrowed from the Near East and classical antiquity, which was carried by Buddhist art across the Asian continent. The feet of the Buddha and the two lower corners of the leaf-shaped aureole have been sacrificed, presumably because a later owner wished to fit the heavy stele into a solid base. In the process some donor figures and their names were severely mutilated. By comparison, slight chips at the outer edge of the stele appear as minor damages. Unfortunately the chipped nose robs the face

of some of its delicately animated expression.

The exact provenance of the stele is unknown. The renowned German scholar Otto Kümmel acquired it in China in the 1920s. Baron von der Heydt must have added it to his collection after 1924 but prior to 1929.

Published: *Ausstellung chinesischer Kunst* (Berlin, 1929), no. 1156; W. Cohn, *Asiatische Plastik: Sammlung Baron Eduard von der Heydt* (Berlin, 1932), pp. 30–33; S. Balázs, "Die Inschriften der Sammlung Baron von der Heydt," *Ostasiatische Zeitschrift* N.F. 10 (1934), pp. 83–85, pl. 11; O. Sirén, *Chinesische Skulpturen der Sammlung Eduard von der Heydt — Chinese Sculptures in the von der Heydt Collection* (Zürich, 1959), no. 13; H. Brinker, "Chinesische Kunst im Museum Rietberg, Zürich," *du* (April 1974), pp. 20 ff.

Notes

1. O. Sirén, *Chinese Sculpture from the Fifth to the Fourteenth Century,* vol. 2 (London, 1925), pls. 16B, 141A, 173A.
2. Akiyama Terukazu and Matsubara Saburō, *Arts of China: Buddhist Cave Temples, New Researches* (Tokyo/Palo Alto, 1969), pl. 181.
3. W. Cohn, *Asiatische Plastik: Sammlung Baron Eduard von der Heydt* (Berlin, 1932), p. 30.

49. Detail

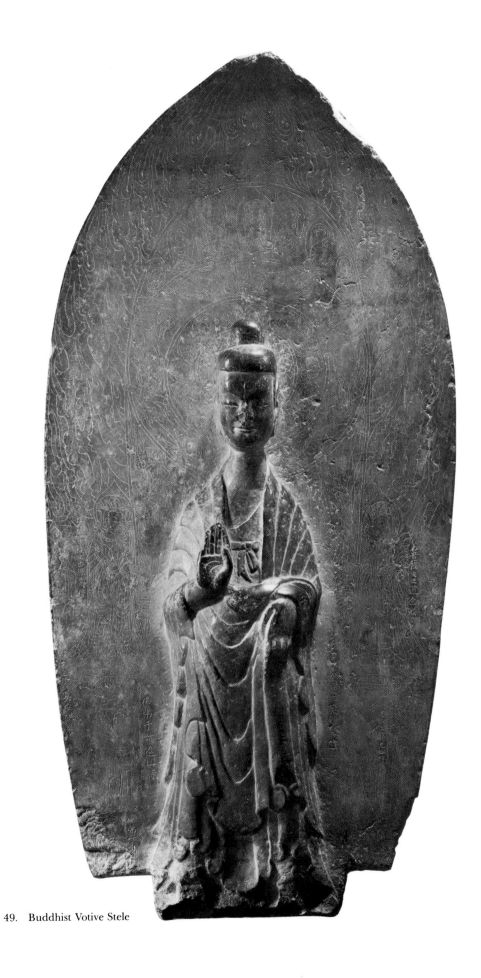

49. Buddhist Votive Stele

50 Śākyamuni Stele

China; Eastern Wei dynasty, dated A.D. 536
Buff-gray limestone; H. 103.5 cm, W. 88 cm,
 Depth 19–19.5 cm
von der Heydt Collection

Perhaps the most important monument of Chinese
Buddhist sculpture in the Rietberg collection, this
stele was acquired by Baron von der Heydt before
1924, after having been in the possession of C.T.
Loo, Paris. It is most likely the work of a metropoli-
tan sculptor's atelier located in the vicinity of pres-
ent Cheng-chou in Honan Province. According to
the inscription on its back, the stele, whose donors
were mostly members of the Feng family, was made
in A.D. 536. The milder, more softly curved treat-
ment of the folds of the robes shows distinctive
features of the Eastern Wei style as opposed to the
harder, more sharply cut style of the Northern Wei.

At the center of the group of seven figures is
the historical Buddha Śākyamuni seated with his
legs crossed in the *vajrāsana* pose. The stately, erect
body is presented in strict frontality and majestic
grandeur. His high head, characterized by a bliss-
fully withdrawn smile, rests on a comparatively long
cylindrical neck, which rises from the slightly slop-
ing shoulders. The damaged right hand is raised in
the reassuring *abhaya-mudrā*, conferring fearless-
ness or offering protection to devotees; it is coun-
terbalanced by the *varada-mudrā* of the pendant left
hand with outward turned palm, denoting benevo-
lence and generosity. These silent gestures are in-
deed appropriate for conferring powerful dogmat-
ic messages to the devout beholder. The Buddha's
simple garment envelopes his body. Curving down
from his shoulders in flat, formal folds, it is draped
over his legs and the stepped, lion-guarded throne
in dense, sinuous pleats like an abstract pattern of
overlapping scales. Minute, precise incisions, obvi-
ously indicating pearl beading, enhance the rich
decorative effect of the drapery in several areas.

Two of Śākyamuni's disciples, slightly turned in
three-quarter profile views toward the center, stand
on lotus calyxes, the old Mahākāshyapa to the
Buddha's right and the youthful Ānanda to his left.
Their hands are covered by their monkish robes.
They are flanked, in turn, by two standing
bodhisattvas raising their hands in adoration to
perform the *anjali-mudrā*. Two forceful *dvārapālas*
near the edges protect the saintly assembly. These
bearded, muscular guardian figures, supported in
their aim by a pair of ferocious lions, have alert,
menacing facial expressions and agitated dramatic
stances that contrast markedly with the postures of
the other figures in the group, who remain in quiet,
introverted withdrawal.

The various types of figures are differentiated
by their size and the degree of relief. Because of his
supreme level of existence and religious preemi-
nence, the Buddha has the greatest stature and is
shown by far most fully in the round; the
bodhisattvas and *dvārapālas* are considerably smal-
ler and flatter while the human beings, the disciples

50. Details A and B

50. Detail C

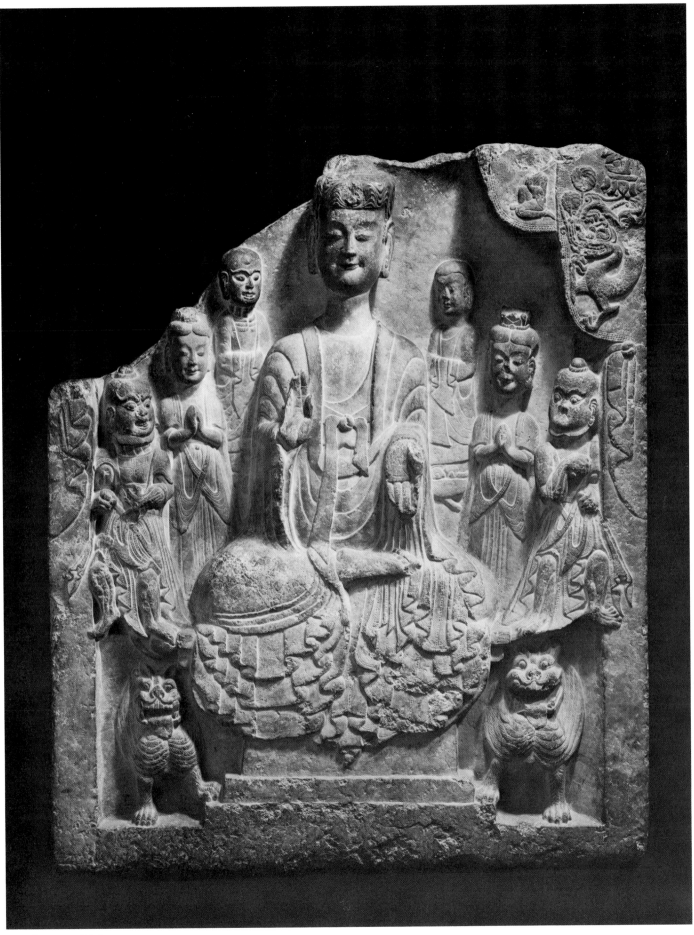

50. Śākyamuni Stele

of the historical Buddha, are the smallest and are rendered in the lowest relief. The principle of hieratic scaling is applied with sensible differentiation. The varied formal treatment of the figures and especially their facial expressions is subject to a similar gradation. This ranges from the transcendent, solemn tranquility and unshakable certitude of salvation of the Buddha to the somewhat less idealized bodhisattvas, immobile in reverent awe, and down to the disciples of the Buddha who belong to the cycle of youth and aging and are realistically "portrayed," as well as to the demonically expressive guardian figures full of concentrated strength and energy.

As we see in some Buddhist cave temples of the period, the group has been placed in a niche with a canopy and curtains; the upper part is broken off, leaving only a few traces, but comparing it with works of similar structure we are able to gain an idea of its original appearance. It seems that originally the configuration was crowned by pairs of interlaced dragons and a number of other figures in the Buddhist pantheon. Some details of the drapery of the curtain, in low relief, are still recognizable at the upper right edge; next to a dragon whose body curves back over his head, a few lotus leaves, and a lotus pedestal on which only the feet of a standing figure are left, we find a small kneeling figure worshipping.

Attractive low reliefs decorate the two narrow sides of the stele (details A and B). The left side shows a pensive figure, perhaps Prince Siddhārtha, in half cross-legged pose with one leg pendant, under a tree. He is accompanied by a standing official with a high tiara-like hat. Below this scene a lively monkey and a rather strange fabulous animal sitting on his haunches enjoy themselves in a mountainous landscape with umbrella-like, conventional trees. On the right side we see wide, round mountains and groups of stylized trees at the bottom. Above the landscape two small figures are represented on a garland of lotus petals, from which large lotus leaves and calyxes rise as if they will carry the platform and its passengers through the air like a balloon. Another fancy arrangement of lotuses adorns the upper part. The sculptor took delight in contrasting rear and frontal views of two leaves on tall stems. Of a larger figure on a lotus seat at the top edge only the lower part of the garment is preserved.

On the reverse of the stele in the upper section we find the remnants of a figural relief that must have represented the famous discourse between the semi-legendary Indian layman Vimalakīrti and the bodhisattva Mañjuśrī, the embodiment of wisdom (detail C). This illustration of the *Vimalakīrti-nirdesha-sūtra* enjoyed great popularity throughout the sixth century. It may be encountered on a number of Buddhist stelae. Between the two principal personages on high daises, a seated monk enveloped in his mantle is placed in a simple architectural setting. The rest of the upper part has been destroyed and only a few engraved details remain.

Fig. 50a. Stone stele with Śākyamuni and attendants discovered at Cheng-chou, Honan Province. China, A.D. 535 (?).

A long dedicatory inscription and the names of no less than 105 donors occupy the lower two-thirds of the stele's reverse. In Stefan Balázs' translation the dedication runs as follows: "3. Jahr T'ien-p'ing der grossen Wei [-Dynastie], in der Jahresfolge das Jahr *ping-ch'en*, erster Monat [beginnend mit dem Tag] *kuei-mao*, 23. Tag [dessen Zeichen] *yi-ch'ou* [=1. März 536]. Seit die Spur der göttlichen Weisheit unterging, gedenkt man sehnsüchtig der fernen Glanzzeit. Weht die wandelnde Wirkung wie ein würziger Wind dahin, so hören [bald] die duftenden Laute zu tönen auf. Verändert das gesammelte Licht seine Urform, so fächelt der verbliebene Wohlgeruch dem Osten zu. Einen weiteren Aufschwung kann nur der Menschen Wollen herbeiführen. Deshalb vermochten all die Bewohner, mit verschiedenen Mündern doch gleicher Gesinnung, ihre Herzen [der Lehre] zu öffnen und Verständnis zu erlangen. Als die fertige Buddhastatue mit allen Schnitzereien im Glanze erstrahlte, gedachten sie dieses Tages von ihrer unbedeutenden Auffassung aus in folgenden Zeilen: Einhundert Leute aus verschiedenen Ortschaften verfertigten ehrerbietig eine Statue des Śākya, an erster Stelle für [das Heil] Seiner Majestät des Kaisers, [sodann für das Heil] ihrer Lehrer, Väter und Mütter und aller Lebewesen der Welt des Gesetzes. Mögen [Väter und Mütter] die noch am Leben sind, Glück erlangen; möge der Maitreya bei erster Gelegenheit die in obigen Zeilen enthaltenen Wünsche in Erfüllung gehen lassen."[1]

The discovery of a virtually identical stele in 1963 at Erh-chung in Cheng-chou, Honan Province, has stirred up some excitement and confusion as to the authenticity of the Rietberg stele (figs. 50a

and 50b).² Since that time our sculpture has been regarded by some as a highly suspicious piece. However, not every find that is reported from China is entitled to claim unquestionable authenticity. In this particular case ample internal evidence permits us by comparison to reveal the true relation of the two works even without having seen the Cheng-chou stele. Unfortunately, the *Wen-wu* report does not mention any details of its discovery, neither where exactly nor under what circumstances the sculpture reappeared. But it seems not to be an excavated piece. Its measurements are very close to those of the Rietberg stele: 105 centimeters high, 84 centimeters wide, and 18 centimeters thick. Damage has affected the same parts: the top and the upper left corner, and even the Buddha's right hand. A superficial comparison shows that on the Cheng-chou stele the proportions of the figures are more slender, the bodies longer, and the heads smaller; the garment folds on the shoulders and the upper arms of the Buddha are arranged in an illogical sequence different from that of the Śākyamuni of the Rietberg stele. The left hand is disproportionately long and hangs down further, almost touching the foot of the crossed right leg. Unlike the right knee, which looks somewhat like a blown-up balloon, the left one is almost completely ignored so that the folds hanging from the lower left arm run diagonally down to the right in a limp and unrelated manner. The pleated hems, asymmetrically superimposed and rich in tension, that cover the throne of the Buddha in the Rietberg stele, show on the recently discovered piece a mechanical repetition, a rigid, boring pattern without descriptive function. Furthermore, the sculptor

Fig. 50b. Rubbing of front and sides of the Buddhist stone stele discovered at Cheng-chou, Honan Province.

is unable to conceal his misunderstandings and inaccuracies in the execution of some details which are disfigured by damage on the Rietberg piece. For instance, the lotus pedestal and the bottom part of the robes of the incomplete seated figure on the upper edge of the narrow right side, have become something like a hanging canopy in the Cheng-chou stele (fig. 50b).

These weaknesses of the stele from Cheng-chou show still more clearly on the inscription on the reverse (fig. 50c). In addition to the fact that it is not in the writing style of typical inscriptions on Wei stelae, a number of simplifications or changes in characters, due to misinterpretation, shows that this is a replica. Striking and significant is the fact that most of these discrepancies appear in those places where the text of the Rietberg stele has become almost illegible due to damage. This led Ts'ao Kuei-ts'en in his report on the newly found stele to the conclusion that the two characters Ching Shao 景紹 in the seventh line from the right are a personal name. In the original text of the Rietberg stele we find instead *ying mien* 影緬 and judging by the context this could hardly be a personal name. Another obvious misinterpretation occurs in the beginning of the eleventh line from the left. Instead of the customary phonetic transcription of the name of the historical Buddha Śākyamuni, *Shih-chia,* used in *tsao Shih-chia hsiang* (造釋加〔迦〕像) "made an image of Śākyamuni," we find a totally different phrase, namely *yü yin hsü chia* (遇禋〔?〕旭稼).

However, the copyist made his most flagrant mistake in the writing of the date. In the original stele a crack running from the upper right to the lower left touches the top stroke of the number three (三); thus in the replica *T'ien-p'ing san nien* has become the second year of the era "Heavenly Peace," which corresponds to A.D. 535. And it seems to have been overlooked that only the next year, 536, is actually in accordance with the cyclical date *ping-ch'en* mentioned in both inscriptions. This grave error exposes the work found recently at

Fig. 50c. Rubbing of inscription on reverse of the Buddhist stone stele discovered at Cheng-chou, Honan Province.

Cheng-chou as a copy. Faced with such numerous discrepancies, one is inclined to believe that the copyist may have worked from a rubbing instead of the original. When this newly found copy was made seems impossible to determine. Perhaps it was made secretly in order to replace the stele now in the Rietberg Museum before that piece left its original site in China early in this century. It is known that such a practice has existed for as long as there has been a flourishing art market in China—about one and half millennia.

Published: K. With, *Bildwerke Ost- und Südasiens aus der Sammlung Yi Yuan* (Basel, 1924), pls. 14–15 and 19; O. Sirén, *Chinese Sculpture from the Fifth to the Fourteenth Century*, vol. 2 (London, 1925), pls. 176–178; R. Wilhelm, *Geschichte der chinesischen Kultur* (Munich, 1928), pl. 14; W. Cohn, *Asiatische Plastik: Sammlung Baron Eduard von der Heydt* (Berlin, 1932), pp. 36–41; S. Balázs, "Die Inschriften der Sammlung Baron von der Heydt," *Ostasiatische Zeitschrift* N.F. 10 (1934), pp. 85–89, pl. 12; Royal Academy of Arts, *Catalogue of the International Exhibition of Chinese Art 1935-6* (London, 1935), no. 2398; O. Sirén, *Chinesische Skulpturen der Sammlung Eduard von der Heydt — Chinese Sculptures in the von der Heydt Collection* (Zürich, 1959), no. 22; J. Fontein and R. Hempel, *China, Korea, Japan*, Propyläen Kunstgeschichte, vol. 17 (Berlin, 1968), pl. 99; Nagahiro Toshio, ed., *Chūgoku Bijutsu* [Chinese Art in Western Collections], vol. 3: *Sculpture* (Tokyo, 1972), pl. 25; H. Brinker, "Chinesische Kunst im Museum Rietberg, Zürich," *du* (April 1974), pp. 24 ff.

Notes
1. S. Balázs, "Die Inschriften der Sammlung Baron von der Heydt," *Ostasiatische Zeitschrift* N.F. 10 (1934), pp. 87 ff.
2. Ts'ao Kuei-ts'en, "Cheng-chou fa-hsien Tung-Wei tsao hsiang-pei," *Wen-wu* (1963), no. 7, pp. 51–53.

51 Head of the Buddha

China; Northern Ch'i dynasty, second half of
 the sixth century A.D.
Gray limestone; H. 39.5 cm
von der Heydt Collection

This powerful head of the Buddha is said to have come from the imperial cave-chapels at Hsiang-t'ang-shan not far from the ancient capital Yeh of the Northern Ch'i dynasty (A.D. 550–577). The establishment of this Buddhist monument in the far southwestern corner of present Hopei Province can be connected with the founding of that capital. Literary evidence and inscriptions on stelae permit us to assume that the Emperor Wen-hsüan (reigned A.D. 550–559) was the initiator of this project. In Buddhist texts he is described as a "devoted and generous follower of the Church."[1]

The two sites of this sanctuary, about twelve kilometers apart, are known as Pei (North) and Nan (South) Hsiang-t'ang-shan. In 1921 the Japanese scholar Tokiwa Daijō discovered here a series of cave-chapels which were hollowed out of the limestone cliff and decorated with beautiful sculptures in full round forms, virtually free-standing, as well as many fine bas-reliefs.[2] When Mizuno Sei'ichi and Nagahiro Toshio visited Hsiang-t'ang-shan in 1936, concentrating their investigations on the southern site near the ancient city Han-tan, they found the caves in deplorable condition; in the course of an inadequate recent restoration, many of the damaged sculptures had been furnished with poor replacements of their heads.[3] More recently, in the 1950s, some of the caves are reported to have been occupied by industrial installations of the new mining town Feng-feng.[4]

One of the heads that vanished from the southern cave complex at Hsiang-t'ang-shan before 1936 may indeed have found its way into the von der Heydt Collection. It must have originally adorned an imposing, over life-size figure of the Buddha. An oval contour, full cheeks, sensitively modelled eyes with sharp linear incisions, gently arched eyebrows issuing from the bridge of a rather prominent nose with swelling nostrils, and a sharply cut, sinuous mouth, characterized by a distinct depression in the center of the upper lip, give a strong plastic effect to the face. The sculptor succeeded in conferring upon the Buddha a serene and absorbed tranquility that is typical of the best Northern Ch'i sculptures, such as the magnificent group of two bodhisattvas and a monk in the University Museum, University of Pennsylvania, Philadelphia, which is also said to have come from Nan Hsiang-t'ang-shan.[5]

The Rietberg head has suffered some damage. Substantial parts of the left ear and the tip of the nose were chipped off. Restorations are visible on the chin and above the left eyebrow. At the back of the head is a small rectangular cavity, probably

51. Head of the Buddha

added in modern times to secure the heavy stone to a base by means of a hooked bar.

Published: O. Sirén, *Chinesische Skulpturen der Sammlung Eduard von der Heydt—Chinese Sculptures in the von der Heydt Collection* (Zürich, 1959), no. 34; Nagahiro Toshio, ed., *Chūgoku Bijutsu* [Chinese Art in Western Collections], vol. 3: *Sculpture* (Tokyo, 1972), pl. 36.

Notes
1. A.C. Soper, "Imperial Cave-Chapels of the Northern Dynasties: Donors, Beneficiaries, Dates," *Artibus Asiae* 28, no. 4 (1966), p. 260.
2. Tokiwa Daijō and Sekino Tadashi, *Shina Bukkyō Shiseki,* vol. 3 (Tokyo, 1926), pp. 90–119, pls. 75–107.
3. Mizuno Sei'ichi and Nagahiro Toshio, *Kyōdōzan Sekkutsu* (Kyoto, 1937).
4. Lo Shu-tzu, *Pei-ch'ao shih-k'u i-shu* (Shanghai, 1955), p. 187.
5. L. Sickman and A. Soper, *The Art and Architecture of China* (Harmondsworth, 1956), pl. 43.

52 Seated Bodhisattva

China; T'ang dynasty, mid-eighth century A.D. Buff-gray sandstone with traces of polychromy; H. 101 cm, W. 50 cm
von der Heydt Collection

The large complex of Buddhist cave-temples on the southwestern slope of T'ien-lung-shan in Shansi Province, located to the southwest of the provincial capital T'ai-yüan, was systematically despoiled of many of its fine sculptures soon after its rediscovery in the first two decades of our century. Fortunately, Japanese and Western scholars were able to study and document this most important Buddhist site before the destruction occurred. They took photographs of the sculptures in situ, showing that they were carved directly into the living soft sandstone rocks, most of them in extremely high relief so that they appeared scarcely attached to the walls. Unscrupulous antique dealers seem to have played a lamentable, inexcusable role in the tragedy that overwhelmed T'ien-lung-shan around 1923. A great number of heads was initially removed and sold, and later many torsos were stolen and scattered throughout the world to numerous private collectors and public museums.

Until less than sixty years ago the Rietberg bodhisattva had remained undisturbed in its original location for over eleven centuries. In 1935-1936 the sculpture was presented to a Western audience for the first time at the Royal Academy of Arts, London, in the famous "International Exhibition of Chinese Art" on loan from Mr. Yamanaka Sadajirō, New York. A year later Baron von der Heydt was able to acquire the piece from Yamanaka & Company.

The work on the T'ien-lung-shan caves is likely to have begun in the 530s and seems to have continued until the middle of the eighth century, after more than a hundred years of suspended activity, under the patronage of influential people closely connected with the ruling T'ang dynasty. In all probability the Rietberg bodhisattva belongs to this latest phase of stylistic development in the years around A.D. 750.

Luckily in this case the head and body of the figure were not separated. The bodhisattva is in a relaxed pose, known as *lalitāsana,* his left leg pendant and his folded right leg drawn up. His left hand is placed in repose on his left knee. He raises his right forearm and offers with a gesture of gentle invitation a spherical object in his hand. It is the *cintāmani,* an attribute of several Buddhist deities, which symbolizes the power to aid devotees and to gratify their every wish. Therefore, the image may represent Cintāmanichakra-Avalokiteśvara, one of the six manifestations of Kuan-yin, who is capable of saving mankind by using the limitless power and resources of his fabulous gem (*cintāmani*), and his Wheel of the Law (*chakra*). Although the latter emblem is absent, the other iconographical attribute together with the characteristic pose may be sufficient evidence to reveal the bodhisattva's identity.

52. Seated Bodhisattva

The scarf falling down on either side of his head, which is accentuated by a high, elaborate chignon, and the folds and pleats of garment and scarfs draped around his shoulders and legs follow the form of the body closely. But they are somewhat lacking in the striking linear tension and structural articulation that so emphatically mark T'ien-lung-shan sculpture at its zenith in the early decades of the eighth century A.D. This may also be said of the modelling of face and body as well as the rendering of jewelry around the bodhisattva's neck. The image is not imbued with the same sensuous and tactile beauty as, for example, the two superb standing bodhisattva torsoes of cave No. 14, now also in the Rietberg Museum.[1]

In 1922 our seated bodhisattva was still in its original context, as is evident from photographs published that year by Tomura Taijirō (fig. 52a).[2] The figure was seated along the northern wall of cave No. 17 facing the entrance (fig. 52b).[3] It served as an attendant to a larger, majestic preaching Buddha sitting in the familiar cross-legged *vajrāsana* posture. This image may be identified as Amitābha. A painted halo behind the head of our bodhisattva was encircled by a yet larger, pear-shaped halo in low relief, tapering to a point at the top. He was seated on a round, stepped pedestal with stylized lotus petals at the base, and his left foot rested on a lotus flower that sprouted from a rhizome in front of his draped seat.

Because of fractures and cracks the Rietberg sculpture has undergone some restoration that altered its original appearance. The most noticeable modification is the less pronounced slant of the head toward the left. The original pose definitely contributed more to the dignity and gracious character of the image. Also, the left ankle was not flexed as sharply and the foot was turned more strongly toward the left. The surface of the soft, granular sandstone has obviously suffered from exposure to unfavorable atmospheric conditions.

Harry Vanderstappen and Marylin Rhie, who successfully embarked on the Herculean task of reconstructing the sculptural arrangements of the T'ien-lung-shan caves as well as single figures and of bringing the stylistic development into art historical focus, gave the following pertinent characterization of the sculptures in cave No. 17: "Further fulfilment of a harmony of parts towards the creation of wholly unified figures exhibiting an ease of

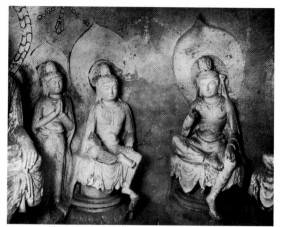

Fig. 52a. Group of stone figures in cave No. 17 at T'ien-lung-shan, Shansi Province. China, mid-eighth century A.D.

bearing in their environment is the most salient feature of the sculpture of Cave XVII. Forms are lumpy and softly modeled. The moulded garment folds and lines, the jewelry and hair lack textural distinction from the surface and the modeling of the slightly obese parts of the body itself. The unifying element of textural blandness is strengthened by lines which easily flow into each other and by the restrained and sensitive balance of parts which are easily contained within the fluid continuity of the outlines. Manneristic elements are obviously evident in the uniformity of garment patterns, in the large heads and in the similarity of the bulky eyes, eyebrows and lips present in all figures in this cave. The mannered rhythm of the attractively rounded and weighty forms creates the effect of opulent solemnity. The gently swaying figures with well balanced gestures and satiny surfaces are imbued with a slightly effeminate and passive tranquility. These images may lack the austerity of earlier Chinese Buddhist sculpture, yet they facilitate an unconstrained communicative relation between themselves and the beholder."[4]

Published: Tomura Taijirō, *Tenryūzan Sekkutsu* (Tokyo, 1922), pls. 69, 73; Royal Academy of Arts, *Catalogue of the International Exhibition of Chinese Art 1935-6* (London, 1935), no. 2388; O. Sirén, *Chinesische Skulpturen der Sammlung Eduard von der Heydt — Chinese Sculptures in the von der Heydt Collection* (Zürich, 1959), no. 43; Nagahiro Toshio, ed., *Chūgoku Bijutsu* [Chinese Art in Western Collections], vol. 3: *Sculpture* (Tokyo, 1972), pl. 67.

Notes

1. O. Sirén, *Chinesische Skulpturen der Sammlung Eduard von der Heydt — Chinese Sculptures in the von der Heydt Collection* (Zürich, 1959), nos. 41–42.

2. Tomura Taijirō, *Tenryūzan Sekkutsu* (Tokyo, 1922), pl. 73.

3. O. Sirén, *Chinese Sculpture from the Fifth to the Fourteenth Century*, vol. 1 (London, 1925), p. 57.

4. H. Vanderstappen and M. Rhie, "The Sculpture of T'ien Lung Shan: Reconstruction and Dating," *Artibus Asiae* 27, no. 3 (1965), p. 219.

Fig. 52b. Map of caves at T'ien-lung-shan, Shansi Province.

53 Seated Bodhisattva

China; Five Dynasties, ca. tenth century A.D.
Wood with traces of lacquer undercoat and
 gold; H. 15 cm, W. 12.6 cm
von der Heydt Collection

The small, richly attired figure, seated in the pose of "royal ease," *mahārājalīlā* in Sanskrit, was carved from four blocks of fine-grained sandalwood that were afterwards joined by mortises and tenons. Its present appearance is marred by the loss of most of its original gilding, but this allows us to study the construction technique: one block was used for the upright part of the body and the head, another for the front part with the legs, and two blocks were used for the forearms and hands. The joints were concealed by a coating of reddish brown lacquer. It smoothed and prepared the surface for the final finish, the application of gold. Although the two blocks with the hands are missing, their proper position is indicated by the directions and clear contours of the planes of the remaining parts. The right hand or forearm of the figure apparently rested on its right knee, while the left hand, perhaps holding an attribute, extended forward. A wooden panel closes a rectangular cavity at the back designed to hold relics, scriptures, or other sacred objects intended to increase the magic power of the image.

The sculptor's care is particularly evident in the design of garment and scarfs, and in the carving of the face. Fine strings of beads once ornamented the figure's bare chest. Its youthful face, with eyes almost closed in contemplative withdrawal, radiates unworldly bliss and benevolence. The head is distinguished by a high chignon, which is covered from the back with a neatly draped scarf streaming down to the shoulders on either side in subtle folds. This conspicuous feature also occurs in a famous Kuan-yin image engraved on a stone stele at the Lin-lao-shan in Honan Province.[1] This image of the bodhisattva of divine compassion, mainly known through rubbings, is said to have been executed after a lost painting by the celebrated T'ang master Wu Tao-tzu (active ca. A.D. 720–760), who, interestingly enough, began his career as a student of the sculptor Chang Hsiao-shih.

Of course, that correspondence and the relaxed pose are not sufficient criteria for the iconographical identification of the Rietberg sculpture as Avalokiteśvara. It may just as well represent Mahāsthāmaprāpta (Ta-shih-chih in Chinese), Kuan-yin's companion and the other bodhisattva in attendance upon the Lord of the Western Paradise, the Buddha Amitābha. A small image of Amitābha at the front of Kuan-yin's headdress allows certain identification of the bodhisattva, but that image is missing here.

As a result of the devastating persecution and iconoclasm that affected the Buddhist religion, its art and architecture around the years A.D. 843–845, wooden sculptures of the T'ang dynasty are extremely sparse. After this catastrophe, religious sculpture was not able to recapture the position it had once held. Works that have survived from the succeeding periods are mainly imposing wooden figures, invariably attributed to the Sung dynasty, among which images of Kuan-yin clearly predominate. Painting, on the other hand, continued to flourish, and in view of the surviving evidence, one cannot escape the impression that painting actually stimulated and influenced a more pictorial style of sculpture. On the other hand, elements derived from the great T'ang tradition were retained and amalgamated into the new style. This and the fact that only a very limited number of wooden statues can be safely dated by inscriptions or other documented evidence explain the insecurity we face in trying to fit these sculptures into their proper art historical setting.

Because it was an object of private worship, the small Rietberg bodhisattva lacks the sense of omnipresence and majestic poise of most larger, life-size images in Western collections. It does not have the heavy proportions, the sometimes almost baroque treatment of the garment with deeply undercut folds, and the emphatic fleshiness of the face typical of so many Sung, Liao, and Chin fig-

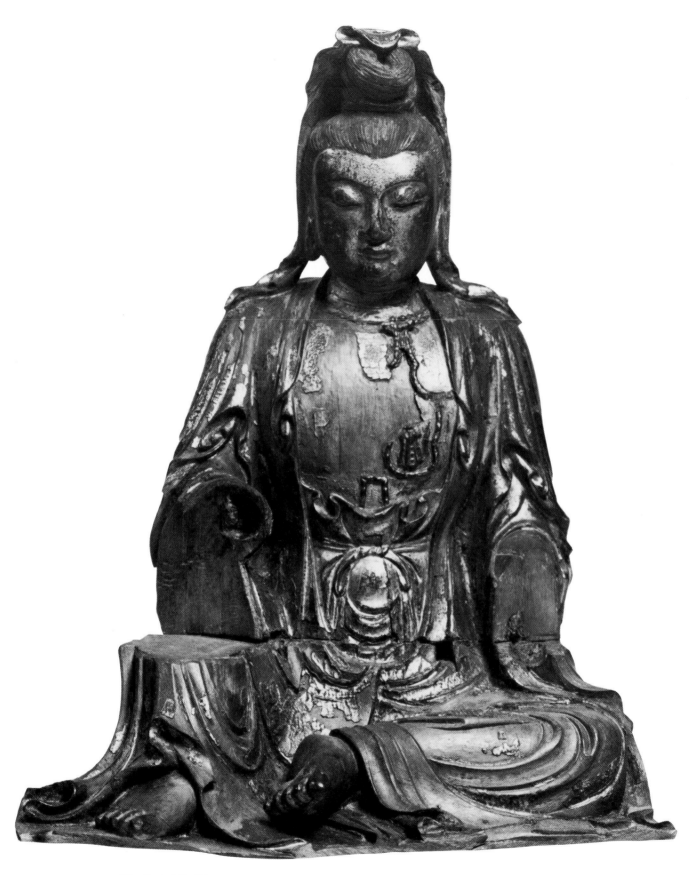

53. Seated Bodhisattva

ures. In fact, our graceful miniature sculpture bears a resemblance to some exquisitely cast gilt bronze bodhisattvas of similar size, dating from the eighth and ninth centuries A.D. And yet, the influence of a new sculptural style that may have developed in the tenth century cannot be denied. Another difference should be mentioned. While the majority of the so-called Sung sculptures were painted in bright colors on a gesso undercoating, the Rietberg piece was gilded on a lacquer base, a technique that seems to reach back well into T'ang times. The Metropolitan Museum of Art, New York, owns a wooden panel of a small portable T'ang shrine with a seated Kuan-yin image that is decorated in this very technique.[2]

Finally, attention should be drawn to the hairstyle of our bodhisattva. His hair is pulled down lightly over his forehead and arranged in an even, unbroken line. We encounter this conspicuous trait in an excavated stone sculpture of a seated Buddha from Yü-hsien in Shansi Province that is said to date from the Five Dynasties period (A.D. 907–960).[3] By contrast, works of the twelfth and thirteenth centuries, as a rule, have their hair divided by a part in the middle of the forehead.

In summing up our observations it may be said that the Rietberg bodhisattva seems to represent a transitional stage in the development of Chinese sculpture from T'ang to Sung, since it retains some of the traditional elements of the eighth and ninth centuries and has not fully acquired the mature style of Sung sculpture. An immense amount of research remains to be done in this particular field, but for the time being a tenth century date is proposed, in full recognition of the risk.

Not previously published.

Notes
1. O. Sirén, *Chinese Painting: Leading Masters and Principles,* vol. 1 (London/New York, 1956), fig. 17, facing p. 114.
2. Nagahiro Toshio, ed., *Chūgoku Bijutsu* [Chinese Art in Western Collections], vol. 3: *Sculpture* (Tokyo, 1972), pl. 73.
3. Shan-hsi-sheng po-wu-kuan, ed., *Shan-hsi shih-tiao i-shu* (Peking, 1962), pl. 53.

54 Seated Bodhisattva

China; Yüan dynasty, ca. A.D. 1300
Porcelain with bluish white glaze, *ch'ing-pai* ware; H. 51.5 cm, W. 32 cm

Small Buddhist sculptures in porcelain antedating the Yüan period are virtually unknown. In this period, however, some seated Buddha and bodhisattva figures with a bluish or greenish white glaze were made. Some of these show a very rich ensemble of jewelled ornaments, whose elements are executed with great perfection, distributed over the head and ears, chest, arms, and legs. The sculptural treatment of the robes and body and the relationship between them show the Yüan artist's familiarity with the forms of the empirical world. This genuine feeling for living nature and its imitation is not impaired by the monochrome glaze. Indeed, that the bodhisattva figures in particular lost some of the hieratic character of cult images may be partly due to the soft lustre of the pale blue glaze, and may have been the intention of the ceramic artist. And yet the glaze imparts a dignified superhuman purity to the deities.

The manufacture of *ch'ing-pai,* literally meaning "bluish or greenish white," appears to have been confined during the Yüan period to the more southerly regions of China, with the kilns of Jao-chou Prefecture in northern Kiangsi Province, including those of Ching-te-chen, as the principal source of production. From this area the main supply for the domestic market as well as for the extensive foreign trade was drawn. A superb *ch'ing-pai* figure of the bodhisattva Kuan-yin, seated in an easy pose, was unearthed in 1955 at the western end of the Ting-fu thoroughfare in the western sector of Peking (fig. 54a).[1] Among the sculptures of this type known today, it is unsurpassed in the quality of its subtle craftsmanship and in size, measuring sixty-seven centimeters in height. Besides other examples in the Royal Ontario Museum, Toronto, a private London collection, the Victoria and Albert Museum, London, the Metropolitan Museum of Art, New York, the Field Museum of Natural History, Chicago, and the Staatliche Porzellansammlung, Dresden, the excellent *ch'ing-pai* "Water-Moon Kuan-yin" in the William Rockhill Nelson Gallery of Art, Kansas City, is, from an art historical point of view, the most significant figure because of its documentary evidence.[2] On the unglazed base an inscription was discovered written in bald characters and dated in accordance with either A.D. 1298 or 1299.[3] In its impressive sculptural quality it resembles the Rietberg bodhisattva, for whom, in turn, a date around A.D. 1300 appears plausible.

Neither attributes nor the gesture of the hands give a clear indication as to the iconographical identity of our piece. Seated in the customary cross-legged posture, the bodhisattva has his right hand

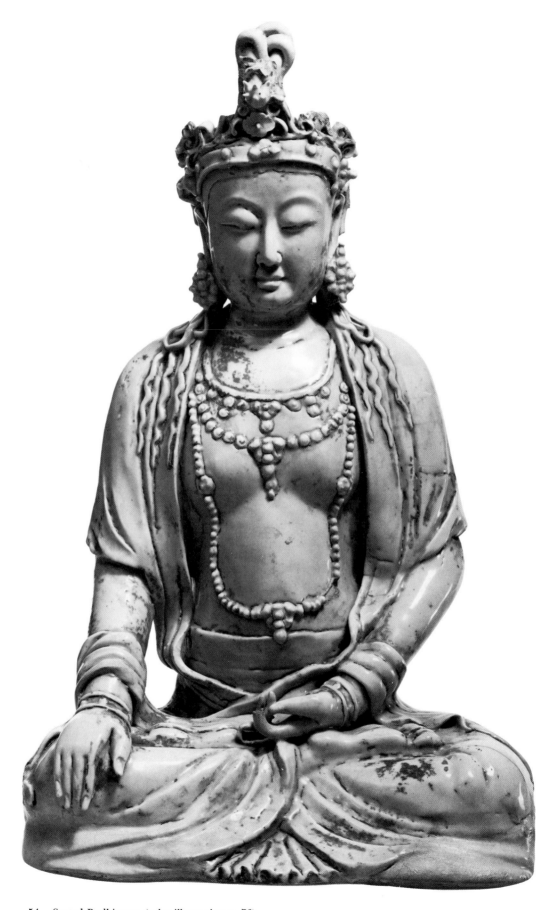

54. Seated Bodhisattva (color illustration p. 76)

palm downwards on the right knee, while the left hand rests open on the lap, as if it were holding a (now missing) attribute. In regard to the sculpture's style, a Nepalese influence is obvious, particularly in the heart-shaped contour of the face, the sensitive modelling of the heavy eyelids, the high-arched eyebrows, the finely-cut nose, and the small mouth with its blissfully withdrawn smile, and also, of course, in the profusion of elaborate jewelry rendered in peculiar pearl beading relief. This special technique may have been stimulated by smaller, portable gilt bronze or dried lacquer images in the Nepalese tradition, one of the finest extant examples being the late thirteenth century dried lacquer bodhisattva in the Freer Gallery of Art, Washington, D.C.[4] Due to the direct cultural exchange between the two nations, most clearly shown by the introduction of Lamaism under Kubilai Khan in the third quarter of the thirteenth century A.D. and the presence of Nepalese artists and craftsmen in the Yüan capital, religious arts of China under the Mongols were imbued with a distinct foreign flavor.

The Rietberg bodhisattva as well as the other *ch'ing-pai* images mark an exceptional departure from traditional materials of Buddhist sculpture. The new use for porcelain, however, confronted the Yüan potter with several unaccustomed technical problems, such as basic construction, firing, and proper diffusion of the glaze on complex objects of this size. It looks as if one part of the base plate of the Rietberg figure was removed by accident, which allows convenient study of the basic principles of constructing hollow sculptures such as this. Inside it has a strong longitudinal strut running up from the roughly finished base to support the considerable weight of the figure's shoulders and head. A variety of technical deficiencies can be detected in the surface of the glaze. Oxidation of impurities caused black specks to emerge in the porcelain; surprisingly long and numerous cracks appeared during the firing process, particularly along the beaded necklace; and the glaze had a tendency to agglomerate in unattractive lumps or ripples, allowing the development of orange burnt biscuit stains where the clay was uncovered. Secondary defects are earth incrustations and the inadequate restoration of the high chignon behind the lotus diadem on top of the head. Substantial repairs have been made along the lower front edge of the figure's robe; the index and fourth finger of the left hand and the tip of the third finger of the right hand also show minor restorations. Nevertheless, the Rietberg *ch'ing-pai* bodhisattva represents a major work at a crucial juncture in the evolution of Chinese sculpture and porcelain.

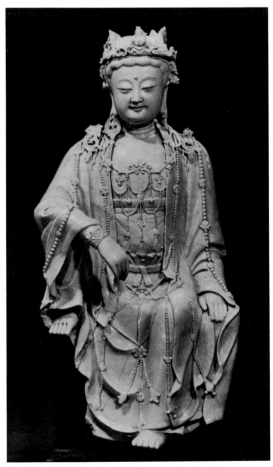

Fig. 54a. Glazed porcelain figure of the bodhisattva Kuan-yin. China, ca. A.D. 1300.

Published: A. Salmony, *Sammlung J. F. H. Menten: Chinesische Grabfunde und Bronzen* (Zürich, 1948), no. 93; M. Beurdeley, *China: Kunst und Sammler durch die Jahrhunderte* (Fribourg, 1966), p. 246, no. 133; S.E. Lee and Wai-kam Ho, *Chinese Art Under the Mongols: The Yüan Dynasty (1279–1368)* (Cleveland, 1968), no. 25; J. Ayers, "Buddhist Porcelain Figures of the Yüan Dynasty," *Victoria and Albert Museum Year Book* (London, 1969), figs. 5, 11; H. Brinker, "Chinesische Kunst im Museum Rietberg, Zürich," *du* (April 1974), p. 35.

Notes

1. *Historical Relics Unearthed in New China* (Peking, 1972), pl. 194.
2. S.E. Lee and Wai-kam Ho, *Chinese Art under the Mongols: The Yüan Dynasty (1279–1368)* (Cleveland, 1968), nos. 24–26, 28; and J. Ayers, "Buddhist Porcelain Figures of the Yüan Dynasty," *Victoria and Albert Museum Year Book* (London, 1969), figs. 1–13, 15.
3. L. Sickman, "A Ch'ing-Pai Porcelain Figure Bearing a Date," *Archives of the Chinese Art Society of America* 15 (1961), p. 34.
4. Nagahiro Toshio, ed., *Chūgoku Bijutsu* [Chinese Art in Western Collections], vol. 3: *Sculpture* (Tokyo, 1972), pl. 86.

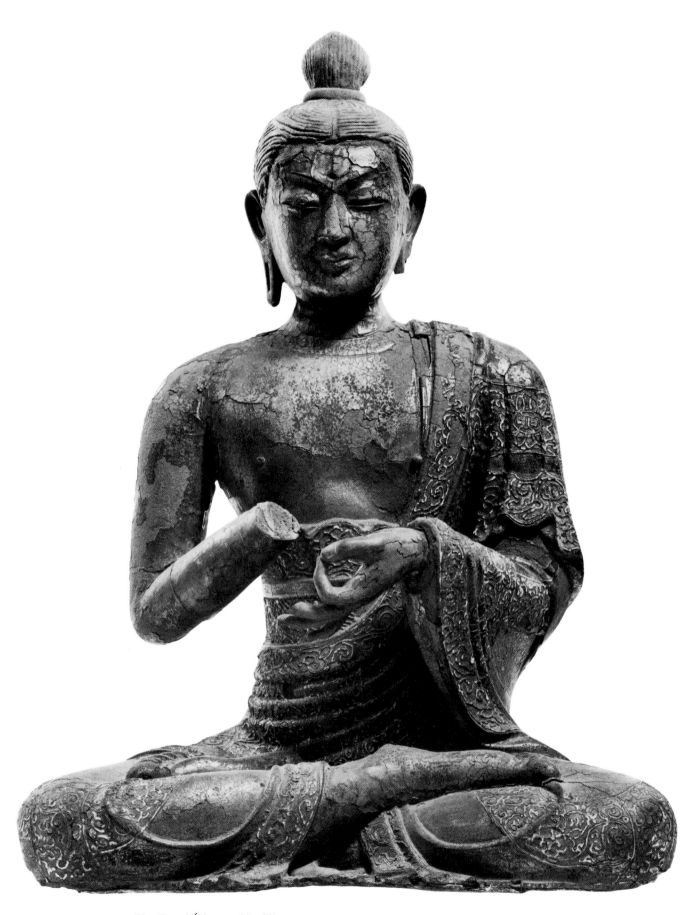

55. Seated Śākyamuni Buddha

55 Seated Śākyamuni Buddha

China; Yüan dynasty, fourteenth century A.D.
Hollow dried lacquer with traces of gold; H.
44.5 cm, W. 33.5 cm
von der Heydt Collection

Śākyamuni, the historical founder of the Buddhist faith, is seated cross-legged in the familiar pose of meditation, known as *padmāsana, vajrāsana,* or *dhyānāsana.* Although his right hand is missing, the gesture of his left hand and the position of his bent right arm extending forward seem to indicate the *dharmachakra-mudrā,* symbolizing the turning of the Wheel of the Law, i.e. Śākyamuni's first sermon.

The facial features, the proportions and modelling of the body, as well as the treatment of the garment, reveal a certain Nepalese feeling. It is recorded that Nepalese artists and craftsmen worked at the court of the Mongol rulers after the great Kubilai Khan (1215–1294) had officially introduced Lamaism in A.D. 1270. The robe's rich decorative relief in typical Yüan taste not only adds to the Buddha's elegant appearance, but also bespeaks a fourteenth century date for our figure. The *urna* on the forehead was probably inlaid with rock crystal or another semi-precious stone.

In the technique of dried lacquer, known as *chia-chu* in Chinese or *kanshitsu* in Japanese, the image was first roughly modelled in clay. Layers of silk or hemp soaked in lacquer were successively spread over the clay core to create the desired thickness. When the lacquer had dried and hardened, the clay core was removed and finer details of the sculpture were modelled in gesso or a thick lacquer paste before a thin final coat of lacquer was applied to the outer surface and sometimes also, as in the case of our figure, to the inner surface. The resultant lacquer shell image, then painted and gilded, was durable, impervious to insects and light — suitable to be carried in processions. The origin of the technique may reach back as far as the Six Dynasties period. For its popularity in Yüan times, one artist seems to have been mainly responsible, the great sculptor (and painter?) Liu Yüan, active at the turn of the fourteenth century. From some very interesting remarks of T'ao Tsung-i (ca. 1320–1402) in his *Nan-tsun cho-keng-lu,* we gather that Liu Yüan, serving in the Mongol administration, was commissioned in A.D. 1270 to provide Buddhist images for a newly built imperial temple. "After receiving the call, he went to the Kuo-kung, A-ni-ke [a Mongol, according to Ch'en Yüan, *Western and Central Asians in China Under the Mongols,* trans. Ch'ien Hsing-hai and L.C. Goodrich (Los Angeles, 1966), p. 188, but more commonly known as a Nepalese], to study Indian Buddhist iconography. He succeeded in bringing the spirit and the concepts into a wonderful harmony, and as a result became supreme in the art. Of the Buddhist sculpture in famous temples in the two capitals, either in clay, in bronze, or in *t'uan-huan,* those that were created by Liu Yüan were always unequalled in the world. *T'uan-huan* refers to the process of laying cloth over a clay model and then applying layers of lacquer over that. Afterward, the clay core was removed and the resultant shell of lacquered cloth made a stunning image. This had been done in the past but came into its finest development in the hands of Liu Yüan. The technique *t'uan-yüan* [*huan*] was also called *t'o-huo.* This was the colloquial expression in the capital."[1]

Published: H. Brinker, *Das Gold in der Kunst Ostasiens* (Zürich, 1974), no. 35.

Notes
1. S.E. Lee and Wai-kam Ho, *Chinese Art under the Mongols: The Yüan Dynasty (1279–1368)* (Cleveland, 1968), no. 19, p. 127.

56 The Four Pleasures of Nan Sheng-lu

By Ch'en Hung-shou (1599–1652)
China; Ch'ing dynasty, dated A.D. 1649
Handscroll, ink and light colors on silk; H. 31
 cm, L. 289.5 cm
Drenowatz Collection

Ch'en Hung-shou was born into a noble family of
Chu-chi, south of Hang-chou in Chekiang Pro-
vince. As a child he is said to have developed great
skill in painting, and his pictures were allegedly
admired by nobody less than Lan Ying (1585–1644),
his teacher. By the time he passed his prefectural
examination in 1618, failing the provincial one, he
was already renowned for his painting and calli-
graphy. In 1642 he was appointed as court painter in
Peking, but soon became frustrated in his pursuit of
an official career. After the Manchu conquest in
1644 he retired to the southern provinces, leading a
restless life and devoting himself to wine, women,
and other sensual pleasures. Obviously to console
his deep inner conflict he took refuge in a Buddhist
monastery, and received the tonsure in 1646. But in
spite of this, he maintained close contacts with the
underground Ming loyalists. He could never for-
give himself for not having shown the same courage
as some of his friends who committed suicide to
avoid serving under the alien regime. Actually he
was taken captive by the Manchu, but soon released
because of his fame as an artist. Later in his life he
left the monastery and became a professional
painter.

"In the work of Ch'en Hung-shou," to quote
Thomas Lawton's pertinent remarks, "earlier fig-
ure painting traditions were so reinterpreted as to
acquire an art historical complexity that is charac-
teristic of late Ming and early Ch'ing painting. Con-
sidering the unsettled period during which Ch'en
Hung-shou lived, the compulsion to protest foreign
rule, and the paucity of politically acceptable means
of expression available, it was perhaps inevitable
that his images, outwardly serene, should actually
be fraught with humour or poignancy."[1]

In accordance with an old established tradition
of classical Chinese figure painting, Ch'en Hung-
shou's superb handscroll from the Drenowatz Col-
lection is organized in four sections separated by
short poetic inscriptions. The painter placed his
figures on the empty ground. He employed long,
curving, tensile lines, often in accentuated, con-
trolled repetition, to depict the robes. There can be
no doubt that Ch'en Hung-shou intended an allu-
sion to paintings of the distant past with his archaic
composition and orthodox, suave style of linea-
ment. Since the protagonist of all four scenes is
evidently the same, namely his friend Nan Sheng-
lu, the faces not only convey a warm, intimate emo-
tion, but also have the quality of portraits.

Ch'en Hung-shou explains the deliberate evo-
cation of remoteness in subject and presentation at
the end of his scroll by saying: "Li Lung-mien [Li
Kung-lin, b. 1049] painted four scenes showing Po
Hsiang-shan [Po Chü-i, 772-846, the well-known
T'ang poet]. The Taoist Emperor [Hui-tsung,

56. Detail A

reigned 1101-1126] inscribed on them the title, 'Four Pleasures of Old Man Po'. Po Hsiang-shan was once Magistrate of Hangchou, and in his refinement and simplicity, and his understanding of Taoism and Buddhism, he was just like Mr. [Nan] Sheng-lu, a spiritual correspondence spanning a thousand ages. For this reason I have painted these pictures for Mr. Sheng-lu in the spirit of Li Lung-mien's work. I have entrusted the task of adding the colors to my disciple Yen Chan and my son Ch'en Ming-ju. The second month of winter in the year *chi-ch'ou* [1649]. — Mountain Man Hung-shou."[2]

The idealized subject is presented with great attention to aesthetic effect. In the first scene, entitled "The Knowledgeable Old Crone," Nan Sheng-lu is seated behind a low, rough stone desk with an empty sheet of paper in front of him (detail A). In his right hand he holds a brush ready to write a poem. To the left an old woman with a wrinkled face is leaning on a stick. Ch'en's poem has been translated by Chu-tsing Li as follows:

"When the poet tries too hard,
 racking his brain,
His work will lack a natural grace.
Thus the monk who is a connoisseur of
 lute music
Must yield to this old crone."[3]

The second episode is called "Drunken Chanting" (detail B). Without question Ch'en Hung-shou intended to recapture in his picture as well as in his poem the antique spirit of the famous nature poet T'ao Yüan-ming (A.D. 365-427) by representing a wanderer with a coarse staff in his right hand, a long-haired fur stole around his shoulders, and a chrysanthemum in his hair. The painter commented upon his subject:

"I listen to chanting in my grass hut on Mt. Lu,
 Not going out for a walk.
When drunk I like to chant out loud
Poems that make sense, crisp and clear."[4]

"Talking about Music" is the third theme illustrated in this scroll (detail C). Here we find a man seated on a bizarre, twisted rock in the company of a young lady musician with a string instrument behind her on a simple table of unfinished wood. Ch'en Hung-shou added the following poem:

"Green ripples in a wine cup . . .
A silhouette of sound in a red window . . .
When a piece has entered the soul of a
 man who knows music,
Autumn seems eternal from the terrace."[5]

The four pleasures are completed by "Meditation" (color illustration, p. 77). Ch'en Hung-shou depicted a gentleman sitting cross-legged in the customary pose of meditation on a large banana leaf in front of a strange geological formation that serves as a narrow stand for a small Buddha statue, an archaistic vase in the shape of a bronze *Tsun* with lotus flowers, and two Sung type ceramic bowls, one with a spray of bamboo. The accompanying poem reveals the painter's concern for Buddhist ideas.

56. Detail B

"Others have spoken of the lotus flower's
 life;
I will mention the sandalwood's fragrance.
Whenever I experience that which is
 beyond dharmas
I understand the meaning of 'Nothing
 lasts forever'."[6]

Several other poems for this work were provided by
Ch'en Hung-shou's close friend T'ang Chiu-ching
and a contemporary monk named Mi-yin; the
mid-nineteenth century collector K'ung Kuang-t'ao
of Canton added a long colophon at the end of the
handscroll.

Published: Liu Hai-su, ed., *Chin, T'ang, Sung, Yüan, Ming,
Ch'ing ming-hua pao-chien* (Shanghai, n.d.), no. 85; Cheng
Chen-to, ed., *The Great Heritage of Chinese Art* (Shanghai,
1951), vol. 2, no. 10, pls. 7–8; Huang Yung-ch'üan, *Ch'en
Hung-shou* (Shanghai, 1958), pl. 11; Huang Yung-ch'üan,
Ch'en Hung-shou nien-p'u (Peking, 1960), fig. 20; The Arts
Council of Great Britain and the Oriental Ceramic Society,
eds., *The Arts of the Ch'ing Dynasty* (London, 1964), no. 39;
Kohara Hironobu, "On Ch'en Hung-shou," *Bijutsu-shi* 16,
no. 2 (September 1966), p. 68, fig. 18; Chu-tsing Li,
"Orientalia Helvetica: Chinese Paintings in the Charles A.
Drenowatz Collection," *Asiatische Studien/Études Asiatiques*
21 (1967), pl. 2a-d; J. Fontein and R. Hempel, *China,
Korea, Japan,* Propyläen Kunstgeschichte, vol. 17 (Berlin,
1968), pl. XXIX; *Weltkunst aus Privatbesitz,* Ausstellung der
Kölner Museen, Kunsthalle Köln (Cologne, 1968), no.
C 18, color pl. VIII; V. Contag, *Chinese Masters of the 17th
Century* (London, 1969), pl. 83A–B; H. Brinker,
"Chinesische Kunst im Museum Rietberg, Zürich," *du*
(April 1974), p. 43; Chu-tsing Li, *A Thousand Peaks and
Myriad Ravines: Chinese Paintings in the Charles A. Drenowatz
Collection,* Artibus Asiae Supplementum 30 (Ascona,
1974), no. 5.

Notes
1. T. Lawton, *Chinese Figure Painting* (Washington, D.C.,
 1973), p. 193.
2. Chu-tsing Li, *A Thousand Peaks and Myriad Ravines:
 Chinese Paintings in the Charles A. Drenowatz Collection,*
 Artibus Asiae Supplementum 30 (Ascona, 1974), vol.
 1, no. 5, p. 29.
3. Ibid., p. 31.
4. Ibid., p. 32.
5. Ibid., p. 33.
6. Ibid., p. 34.

56. Detail C (color illustration of fourth detail p. 77)

57 The Song of the Great Land of Wu

By Lu Chih (1496–1576)
China; Ming dynasty, dated A.D. 1534
Handscroll, ink and light colors on paper; H.
31 cm, L. 127.5 cm
Drenowatz Collection

During the fifteenth and sixteenth centuries, the city of Su-chou became one of the leading cultural centers of China. The region along the east coast south of the Yang-tze and north of Chekiang, rich in picturesque landscapes, attracted artists, poets, and scholars who engaged in an intensive exchange of ideas. Referring to the ancient name of this region, Wu-hsien, art historians have classified the scholar painters of this circle under the term Wu school. One of the school's members was Lu Chih who, although he successfully passed the government examinations, preferred an independent life as a hermit, devoted to the study of the Confucian classics and the arts, to a career as a civil servant. Like his teacher in painting, the great Wen Cheng-ming (1470–1559), Lu Chih was highly respected in his native region not only because of his proficiency in painting, calligraphy, and poetry, but also because of his lofty ethical ideals, his upright character, his filial piety, and his unconcern for worldly wealth.

In the present work from the Drenowatz Collection, Lu Chih's eminent talent as a poet, calligrapher, and painter appears in a sublime synthesis. Moreover, the painting gives us a glimpse of the closely knit Su-chou coterie of artists and scholars, its special flavor and color, and at the same time reflects the enchantment of the legendary physical beauty of the Wu region with its mountains and multitude of lakes and rivers. At first the title of the landscape handscroll, "The Song of the Great Land of Wu," might come as a surprise and not be immediately comprehensible. But the painter's short statement at the end of the composition gives us a clue as to how to interpret it: "When I presented my calligraphy, *The Song of the Great Land of Wu*, to Ching-kuan, he again asked me to do this painting. His undue treasuring of my works reminds me of the strange habit of eating fingernails. Pao-shan-tzu, on the fifteenth day of the seventh month of the year *chia-wu* [1534]."[1]

Originally the landscape served as an illustration of a poem composed by Lu Chih a year earlier, in 1533, and written by him in the fluent, cursive style known as *ts'ao-shu*. This long ode was separated from the painting, however, before the latter entered the Drenowatz Collection. Luckily it is known through photographs, and Chu-tsing Li, on whose research our remarks are based, has given a full translation of it.[2] The painter constantly alludes to and eulogizes the legendary past of the Wu area and glorifies the ideal of the secluded literatus, "the ability of the hermit to rise above the vicissitudes of life and to achieve a union between the mind and the great universe. The painting expresses the same idea in its movement from the right to the left, from the crowded composition to the open lake view."[3]

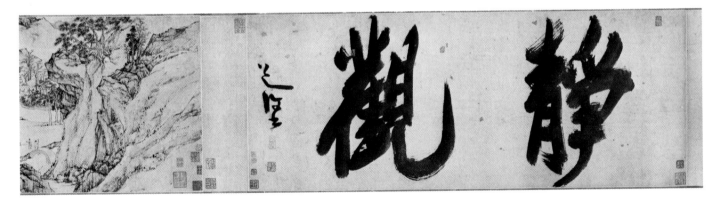

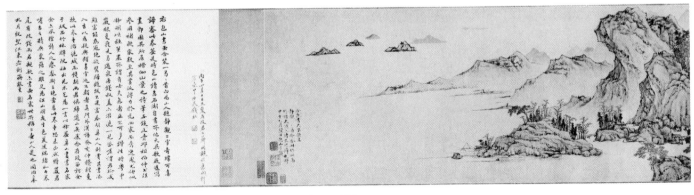

57. The Song of the Great Land of Wu, details (color illustration p. 78)

The marvelous scenery most likely represents Mount Leng-chia, mentioned in the poem, and the Shih Hu or "Stone Lake," both located to the southwest of Su-chou. Mr. Ching-kuan, the recipient of this complex and fascinating masterwork, has not yet been identified. But he was probably a member of the literati circle of Su-chou. His name reappears on the frontispiece to our handscroll in bold, monumental, semi-cursive script *(hsing-shu),* written by Ch'en Shun (1483–1544), another artist of the Wen Cheng-ming coterie and—so it seems—a mutual friend of Lu Chih and Ching-kuan. Literally the two characters mean "contemplation" or "quiet beholding." The *yin-shou,* or title, certainly was conceived as an ingenious pun, for it not only refers to the dedicatee, but also suggests how the following painting and calligraphy should be treated and appreciated. In its original condition this handscroll doubtlessly epitomized the Ming literati ideal, being a condensed record of sixteenth century Su-chou culture and a result of the interplay of several personalities and forms of art—of painting, calligraphy, and poetry.

"The Song of the Great Land of Wu" of 1534 is a comparatively early painting in Lu Chih's extant oeuvre, but it already contains most of the stylistic traits characteristic of his later works. He employs bent outlines of a distinctive angularity for his mountains and rocks and imparts a three-dimensional quality to the multifaceted masses through dry, sparingly applied texture strokes of *chiao-mo,* or "roasted ink." Although he enhanced the rocky landscape with colors of his peculiar palette—faint tinges of red, variants of brown moving toward orange, hues of bluish to olive green, and soft washes of pale blue—he managed to maintain his fundamental lightness and transparency. Lu Chih inherited these stylistic properties from the Yüan masters, notably from Ni Tsan (1301–1374), for whom he cherished a life-long admiration. In James Cahill's words "Lu is perhaps the supreme master of that special mode of landscape cultivated in sixteenth-century Soochow that treats the local scenery as neat, fragile, cleansed of clutter; appeals to tactile sensation are avoided in such paintings, as are overt emotional statements; figures and buildings are depicted with a light ingeniousness that expresses, as the artist intended it should, disengagement from mundane reality."[4]

Published: H. Brinker, "Chinesische Kunst im Museum Rietberg, Zürich," *du* (April 1974), p. 40; Chu-tsing Li, *A Thousand Peaks and Myriad Ravines: Chinese Paintings in the Charles A. Drenowatz Collection,* Artibus Asiae Supplementum 30 (Ascona, 1974), no. 10.

Notes
1. Chu-tsing Li, *A Thousand Peaks and Myriad Ravines: Chinese Paintings in the Charles A. Drenowatz Collection,* Artibus Asiae Supplementum 30 (Ascona, 1974), vol. 1 p. 66.
2. Ibid., pp. 66 ff.
3. Ibid., p. 69.
4. J. Cahill, *Parting at the Shore: Chinese Painting of the Early and Middle Ming Dynasty, 1368–1580* (New York/Tokyo, 1978), p. 240.

58 A Thousand Peaks and Myriad Ravines
By Kung Hsien (ca. 1618/20–1689)
China; Ch'ing dynasty, ca. A.D. 1665–1670
Hanging scroll, ink on paper; H. 62 cm, W. 102 cm
Drenowatz Collection

Kung Hsien's grand landscape panorama is one of the outstanding masterpieces of all Chinese painting and—in its present curator's experience—one of the most frequently and emphatically admired paintings. It is signed and sealed by the artist near the lower right margin. Although Kung Hsien was the leading master of the so-called "Nanking School" of landscape painting and his work and biography have been thoroughly investigated by several experts, especially during the past decade, he has remained a somewhat shadowy figure as a personality and a provocatively puzzling phenomenon as an artist. He was born around 1618/20 in K'un-shan, located about halfway between Su-chou and Shanghai in Kiangsu Province. With the exception of a decade of aimless wandering after the collapse of the Ming dynasty in 1644, he seems to have lived in Nanking the rest of his life, more or less in secluded retirement. His friends described him as a stubborn idealist and an uncompromising conservative with eccentric habits. The decline of the native regime and the upheavals of the barbarian Manchu conquest, which Kung Hsien witnessed as a young man with strong political convictions, had a shattering impact on him.

His art cannot be understood apart from his age, a time of social and political disorder. Aside from the personal hardship that he had to endure, destruction and desolation are recurrent themes in his writings. Some of his poems appeared during his lifetime together with works of other Ming loyalists in a dissident, politically rather daring anthology.[1] Kung Hsien's resistance to and discontent with the alien Ch'ing rule is often expressed in the disguise of nature poetry. An example, which sounds almost like the artist's own description and interpretation of our landscape, is a poem entitled "In the Evening, Traveling East below the Yen-tzu Jetty":

"The river and sky have suddenly merged together,
An isolated boat drifts between them.
The distant peaks are already about to disappear;
The evening sun, too, cannot be retrieved.
With self-pity for being a 'constant traveler',
My changing feelings turn towar'd the sorrows of home;
Just sobering up from the wine of parting—
A white gull beneath the azure mist."

This is the translation of Jerome Silbergeld, who successfully uncovered the political, social, and autobiographical content of the arts of Kung Hsien in his excellent study "The Political Landscapes of

Kung Hsien, in Painting and Poetry."[2] He writes: "This poem, on first reading, might be taken as an idyllic ode to an evening upon the river, but an analysis of the traditional landscape symbolism of the poem reveals something deeper and darker. The first line, 'The river and sky have suddenly merged together', reveals a confusion in the fundamental order of nature. The element of Heaven, above, has become confused with the earth below, clearly symbolizing a nation in chaos. The 'evening sun which cannot be retrieved' may be the fallen Ming emperor, whose imperial radiance has vanished forever. So too may the 'distant peaks about to disappear' stand for the Chinese scholar class, or perhaps for the entire Confucian cultural heritage, now threatened by foreign domination. And trapped in the midst of these overturned elements is the poet himself, personified by the line, 'An isolated boat drifts between them'. The third couplet makes the poem more personal, the term 'constant traveler' often being used by Kung Hsien in reference to his years of forced wandering, away from his home. In the final lines, Kung Hsien's 'Just sobering up from the wine of parting' might signify that he is still waking up to the painful realization that China has parted forever with its native Ming dynasty. The white gull is a standard reference to the scholar in exile or retirement; its white feathers recall the plain cloth robes worn in China by scholars without office, in contrast to the colored silks of the official. In this case, the white gull is Kung Hsien himself. Mist and smoke, fallen low upon the earth, obscuring forms and creating patterns of separation and isolation, have long been used in Chinese literature to symbolize political discord and factionalism. Finally, the 'azure mist' is possibly a pun on the 'blue cloud' of official status, and might give to this line the parting lament that its author may never fly to the (official) heights of which he is capable. Here, then, is a self-portrayal of the artist as a victim of what we might truly refer to as 'interesting times' in China, and yet much of the 'interest' here lies concealed far beneath the surface of this outwardly bland landscape setting."[3]

In another poetic inscription on a painting, which coincidentally bears the same title as our landscape, Kung Hsien alludes to his "flight across

58. A Thousand Peaks and Myriad Ravines

the shattered political landscape of China and his frightening inability to escape the harsh political realities of his time." It reads:

"A thousand peaks and myriad ravines,
 with an isolated dwelling;
White stones are the grain which brew
 up purple evening clouds.
It is as if you were fleeing [the emperor]
 Yao, but still could not get away,
Or like one in flight from the
 [tyrannical] Ch'in [emperor], facing a
 cloudy horizon."[4]

None of Kung Hsien's other paintings parallel the artist's complex poetry more closely than this one from the Drenowatz Collection. *A Thousand Peaks and Myriad Ravines* is an intensely oppressive vision of fearful loneliness, reflecting the painter's state of mind with great directness. "The image of a conquered nation seems lodged in every hidden corner of this landscape, where the foreground trees hang withered, where no path offers a secure passageway, where explosive forms and unyielding structures seem to create a sinister menace to the outside viewer, and where man himself seems to have been driven from the face of the earth."[5] Unearthly distortion and mysterious permeation of light and darkness radiate a compelling force and create visual excitement. And yet, in all its ambiguities the picture retains an amazing homogeneity. The horizontal composition, which fills the unusually large picture format to the upper edge, consists of an extremely complex arrangement of vertical mountain peaks, plunging waterfalls, bizarre trees, and

58. Detail

mist-covered gorges that lead diagonally into the distance. Deserted dwellings are hidden in the river valleys. No human being appears here.

The very personal and unmistakable style of Kung Hsien is characterized by a brush technique that uses pointillistic short strokes and dry ink dots in a dense staccato. "Stability" and "excitement from the bizarre" are in his own words an irrevocable postulate for landscape painting: "'Hills and Ravines' is a general term for composition," he writes, and continues: "It is fitting that a composition be stabile; but it ought to be both excitingly bizarre and stabile, for if it is not excitingly bizarre, there is no particular value in stability [alone]. If stabile but not excitingly bizarre, then it is stupidly inept. If excitingly bizarre, but not stabile, then it is awkwardly inexperienced. . . . The more excitingly bizarre, the more stabile: this is the zenith of painting. It comes from natural endowment and long practice."[6]

Published: *Tō-Sō-Gen-Min Meiga Taikan* (Tokyo, 1929), pl. 419; L. Sickman and A. Soper, *The Art and Architecture of China* (Harmondsworth, 1956), pl. 149; A. Lippe, "Kung Hsien and the Nanking School, I," *Oriental Art* n.s. 2, no. 1 (Spring 1956), p. 24, fig. 2; M. Sullivan, *An Introduction to Chinese Art* (London, 1961), pl. 138; The Arts Council of Great Britain and the Oriental Ceramic Society, eds., *The Arts of the Ch'ing Dynasty* (London, 1964), no. 15, pl. 12; S.E. Lee, *A History of Far Eastern Art* (New York, 1964), fig. 596; J. Cahill, *Fantastics and Eccentrics in Chinese Painting* (New York, 1967), no. 25; Chu-tsing Li, "Orientalia Helvetica: Chinese Paintings in the Charles A. Drenowatz Collection," *Asiatische Studien/Études Asiatiques* 21 (1967), pl. 7; J. Fontein and R. Hempel, *China, Korea, Japan*, Propyläen Kunstgeschichte, vol. 17 (Berlin, 1968), pl. 186; *Weltkunst aus Privatbesitz*, Ausstellung der Kölner Museen, Kunsthalle Köln (Cologne, 1968), no. C 26, pl. 14; V. Contag, *Chinese Masters of the 17th Century* (London, 1969), pl. 62; J. Cahill, "The Early Styles of Kung Hsien," *Oriental Art* n.s. 16, no. 1 (Spring 1970), p. 67, fig. 26; H. Brinker, "Chinesische Kunst im Museum Rietberg, Zürich," *du* (April 1974), pp. 38 ff.; W. Watson, *Style in the Arts of China* (Harmondsworth, 1974), pl. 121; Chu-tsing Li, *A Thousand Peaks and Myriad Ravines: Chinese Paintings in the Charles A. Drenowatz Collection*, Artibus Asiae Supplementum 30 (Ascona, 1974), no. 48; R. Edwards, "The Orthodoxy of the Unorthodox," in C.F. Murck, ed., *Artists and Traditions: Uses of the Past in Chinese Culture* (Princeton, 1976), p. 193, fig. 7; J. Silbergeld, "The Political Landscapes of Kung Hsien, in Painting and Poetry," *Proceedings of the Symposium on Paintings and Calligraphy by Ming I-min*, The Journal of the Institute of Chinese Studies, The Chinese University of Hong Kong, vol. 8, no. 2 (December 1976), fig. 6.

Notes

1. Cho Erh-k'an, *Ming-mo ssu-pai-chia i-min shih* (Shanghai, 1960).

2. *Proceedings of the Symposium on Paintings and Calligraphy by Ming I-min*, The Journal of the Institute of Chinese Studies, The Chinese University of Hong Kong, vol. 8, no. 2 (December 1976), pp. 561–574.

3. Ibid., pp. 566 ff.

4. Ibid., p. 572.

5. Ibid.

6. M.F. Wilson, "Kung Hsien: Theorist and Technician in Painting," *The Nelson Gallery and Atkins Museum Bulletin* 4, no. 9 (1969), p. 23.

59 Seated Jizō Bosatsu

Japan; late Heian period, second half of the twelfth century A.D.
Wood with gesso coating and traces of paint; H. (of figure) 67.8 cm, W. 41.8 cm
Gift of Dr. Pierre Uldry

This image of the bodhisattva Jizō was made by the assembled wood-block technique, known in Japanese as *yosegi-zukuri*. It is hollow inside. An interesting feature of the method of construction can be seen inside the head, which was not assembled from a facial mask and a covering back plate; instead it was carefully glued and pegged together from thin-walled right and left halves and then inserted into the torso. The joints as well as the entire surface of the statue were covered with a gesso coating. Traces of red paint for the garment remain in several areas, and some painted details such as the eyes, the hair, and the necklace are other remnants of the original polychromy. The present metal necklace is an Edo period addition. Modern restorations are the index and small finger of the left hand; the gilded *cintāmani* (*nyoi-hōju* in Japanese), a fabulous jewel with which the bodhisattva is capable of gratifying every wish; the long monk's staff, or *shakujō*, in his right hand; and the heavy lotus pedestal.

Jizō, seated in half cross-legged position, the so-called *hanka-shiyui*, is represented as a monk with shaved head and wears a simple monk's robe. Theologically, however, he maintains the rank of a bodhisattva endowed with supernatural powers, one who was worshiped in Japan since late Heian times as one of the most popular salvation deities of Mahāyāna Buddhism. Large numbers of his images in stone can be found today along Buddhist temple paths and country roads and also near cemeteries. He is the savior of the souls of the dead condemned to purgatory or hell; he intervenes for the sake of those beings who are reborn in each of the six realms of transmigration, the *rokudō*; he guards travelers on their journeys and warriors on the battlefield, and offers safety to their families; and he protects women during pregnancy and childbirth.

As perhaps the most gentle of all Buddhist deities, he devotes his supermundane powers especially to the aid of children, to all weak and helpless creatures. It was in this capacity, as the embodiment of compassion and service to humble and suffering people, that he appealed to the imagination of the common folk, although he was introduced into Japan essentially as an Esoteric Buddhist deity of minor significance. His presence in Japan can be traced back to the mid-eighth century. In the complex pantheon devised by the powerful religio-philosophic Mikkyō, or Esoteric, movement, the two bodhisattvas Jizō and Kokūzō symbolized the physical and metaphysical aspects of the world, as indicated by their Sanskrit names: Kshitigarbha, meaning "Womb of the Earth," and Ākāśagarbha, meaning "Womb of the Void."

The Rietberg Jizō is said to have come from a small temple in Kyoto, but there is no inscription or other documentary evidence to provide final proof for Kurata Bunsaku's suggestion that the statue was possibly made in a Kyoto atelier. Stylistically, it represents the characteristic mode of expression at the end of the Heian period. The sculptor has not yet adopted the innovations and stylistic traits, such as the highly descriptive realism, of Buddhist imagery that is evident in wood sculptures of the transitional phase between the late Heian and early Kamakura periods around 1200. He has treated the folds of the robe with restraint and given them an almost geometric refinement; the idealized facial expression suggests cool detachment from humanity. The eyes are not inlaid with crystal; only the *urna* was carved from that material and inlaid in the forehead.

In its aesthetic and sculptural quality the statue resembles the standing Jizō of the Shōkyūji in Mie Prefecture most closely,[1] and it may be also associated with a Jizō, seated in the same informal, half cross-legged position, that belongs to the Daichōji in Mie Prefecture.[2]

Not previously published.

Notes
1. *Jūyō Bunkazai*, vol. 3: *Chōkoku III* (Tokyo, 1973), no. 308.
2. Ibid., no. 290.

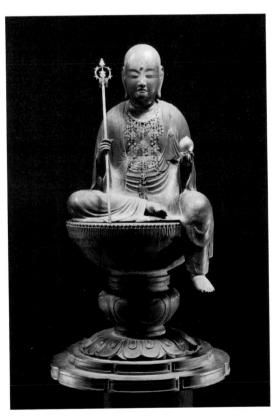

59. Seated Jizō Bosatsu (color illustration p. 79)

60 Fragment of a Bodhisattva Head

Japan; Kamakura period, mid-thirteenth century A.D.

Wood with fabric, gesso, lacquer, and traces of paint and gold; H. 27.2 cm, W. 13.4 cm

Gift of Dr. Pierre Uldry

This wooden fragment once formed the main part of a charming bodhisattva head which was inserted by a scalloped tenon into the torso of a sculpture made by the assembled wood-block method (*yosegizukuri*). The facial mask includes the ears and most of the hair. A relatively flat piece must have closed the back of the head. The hollowed inside of the fragment shows rough marks of the sculptor's chisel. It also reveals the technique of affixing crystal eyes inside the head, known as *gyokugan*. Two small crystal or glass chips are lined with white silk on which the pupils are painted in black and red pigments. They are kept in place behind the narrow eye slits with a padding of glue soaked fabric which in turn is pressed against the inner surface of the facial mask with a small horizontal wooden bar with notches to take three wooden pegs. This method, certainly intended to increase the realistic expression of a figure, to "enliven" the image, had been employed since the middle of the twelfth century and is most characteristic of Kamakura sculpture. On top of the head is a round hole indicating that a separately carved high chignon, known from so many other bodhisattva statues, once adorned the head and gave it a tapering contour rather different from its present rounded appearance. This is further confirmed by the parallel grooves representing the hair, which stop short at the area originally covered by the top knot. Also lost is the *urna*. It was probably carved of crystal and inserted in the small round hole in the forehead between the eyes.

The sculptural technique evident in this piece is highly refined. The surface treatment attests to the artist's remarkable skill and sensitivity in imparting an extraordinary grace and lively delicacy to the bodhisattva's youthful face. With eyes cast down in contemplative withdrawal, it is pervaded by a sense of dispassionate, unworldly bliss. Great care has gone into the carving of the elegant curvature of the eyebrows, the gently protruding eyelids, the fine nose, and particularly the small mouth with its precise, sinuous contours. Traces of red paint have remained on the lips. The hair lies in parallel strands around the long distended ears. It is held by a narrow double band on which scattered particles of gold leaf are visible under the dark patina. Furthermore, small holes and the remnants of wooden pegs indicate that the head was once adorned with metal ornaments.

The face has the quality of mathematical balance and calculated symmetry. In its composed elegance and subtle lyricism we may find elements that are characteristic of Buddhist imagery of the Kamakura period around the middle of the thirteenth century developed in the tradition of the Jōchō school and of Kaikei (active ca. 1180–1220) and his followers. According to Kurata Bunsaku this work manifests the aesthetic achievements of a Kyoto sculptor.

Not previously published.

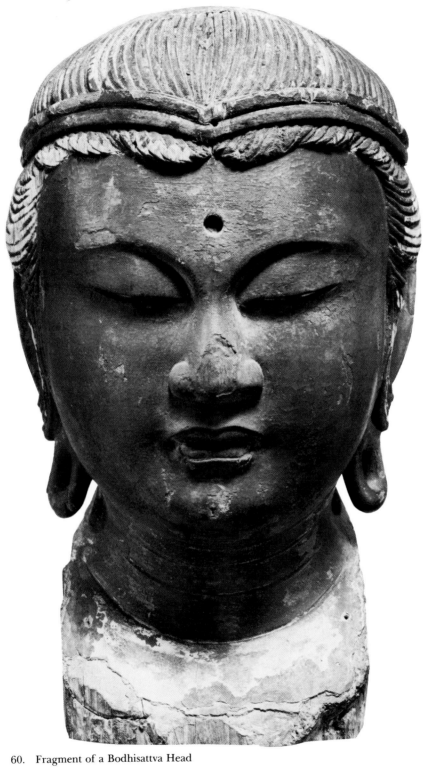

60. Fragment of a Bodhisattva Head

61 Aizen Myōō
Japan; late Kamakura period, first half of the
 fourteenth century A.D.
Hanging scroll, colors and gold paint on silk;
 H. 83.7 cm, W. 37.4 cm
Gift of Heinz Brasch

This painting, which unfortunately has suffered
considerable damage over the centuries, shows
Aizen Myōō, one of the most prominent Esoteric
Buddhist deities, whose cult was apparently intro-
duced to Japan during the early ninth century. His
Sanskrit name Rāgarāja or Mahārāja, literally
meaning the "King of Passion" or the "Great Pas-
sion," gives a clue to his significance and function in
the vast Mikkyō pantheon. Although he was not
included among the Five Great Bright Kings, or
vidyārājas, the manifestations of the Five Wisdom
Buddhas' wrath against evil, "he symbolizes one of
the most fundamental Mahāyāna Buddhist concep-
tions, namely that illusion and human passions are
identical with enlightenment, that the metaphysical
ground of all being permeates even that which can
be called illusory and morally evil. Man in an en-
lightened state of insight, filled with the rapture of
pure wisdom, loses all sense of discrimination be-
tween good and evil, ugliness and beauty—for these
are relative conceptions, the products of our own
interpretation of things, hence essentially unreal.
Only the dharma of the Buddha is real and endur-
ing."[1]

Like so many Esoteric Buddhist deities, Aizen
Myōō is the embodiment of two seemingly conflict-
ing aspects. As God of Love he is worshipped be-
cause of his determination to combat vulgar, carnal
love and sublimate it into spiritual, sacred love. This
aspect is symbolized by the warm, deep red color of
his body. His furious, awesome visage, on the other
hand, with scowling mouth, bestial fangs, knotted
eyebrows, and a third eye on the forehead, ex-
presses the *vidyārāja*'s destructive energies and ag-
gressiveness in the face of threatening evil forces,
both physical and spiritual. The fierce lion's head in
his flamboyant hair, which is damaged past recogni-
tion in the Rietberg painting, once supported a
vajra, as can be seen on better preserved images of
Aizen Myōō.

These features, as well as the other attributes in
five of his six hands, the lotus, the golden *vajra*
(*kongō-sho* in Japanese) and *vajra* bell (*kongō-rei*), and
particularly the bow and arrow, add to the deity's
ferocious violence and demonic wrath, as does the
fist of the sixth hand.

Seated cross-legged on an elaborate lotus
pedestal and adorned with a garment of delicate
fabric around the lower part of the body, with ele-
gant scarfs and golden jewelry in profusion, Aizen
is encircled by a halo of swirling dark red flames;
short stylized golden flames radiate from two circu-
lar halos around his body and head. Below the
image, covering almost the lower third of the rela-
tively narrow hanging scroll, a cloud-and-lozenge
patterned carpet is spread out. A large vase, or

kalaśa (*byō* in Japanese), a sort of cornucopia often
used in Esoteric Buddhist rituals to mark off the
magic border of a sacred area at the four corners
(*kekkai*) and frequently represented in mandalas, is
placed in the center of the carpet. It is almost en-
tirely effaced. Only the lotus base and the gold
ornamented purple scarf draped around the ves-
sel's shoulder retain the original coloring. Also
blurred in parts are the five groups of *cintāmani*, or
wish-granting jewels, surrounding the magic vase.
They are neatly arranged in triangular clusters of
three, placed on small lotus pedestals, and encom-
passed by licking red flames. Some other *cintāmani*
appear in symmetrical order around the vessel's
neck as if they had dropped off the overflowing
vase. The presence of these wish-granting jewels
confirms the abundant aid that the King of Passion
gives his devotees in all kinds of hardships and
peril, in love affairs as well as in warfare.

Here, as in certain types of classical mandalas
and several other Esoteric Buddhist icons, we en-
counter the phenomenon of superimposing two
different conceptions of space: while the central
image is represented in strict frontal view, the car-
pet, the lotus pedestal of the figure, the vase, and
other details are to be seen from a rather high focal
point, hence foreshortening is employed.

The anonymous painter of the Rietberg Aizen
Myōō faithfully observed iconographic details pre-
scribed in the *Kongō-hō Rōkaku Issai Yuga Yugi-kyō*,
abbreviated to *Yugi-kyō*.[2] The great Indian theolo-
gian Vajrabodhi (671–741), known in Japan as
Kongōchi, was responsible for the translation of
this scripture into Chinese. In A.D. 720 the fifth
patriarch of Esoteric Buddhism arrived at Ch'ang-
an with many Sanskrit texts and took residence at
the Great Tz'u-en-ssu in the southeastern part of
the T'ang capital. The *Yugi-kyō* describes the physi-
cal appearance of the deity as well as the attributes
and the raised left hand forming a fist. This last
detail has been occasionally altered in representa-
tions of the Rāgarāja. He is then depicted either
with a sun disk (*nichirin*), an empty circle (*enrin*), a
human head or body, or some jewels that fulfil all
wishes (*nyoi-hōju*) in his third left hand.[3]

The *Hōbōgirin* gives the following translation of
the relevant passage in the *Yugi-kyō*: "Son corps a la
couleur des rayons du soleil; il se tient dans une
Roue ardente, et de ses trois yeux regarde avec
colère. Il a une coiffure de lion, surmontée d'un
croc à cinq pointes; sa chevelure hérissée lui donne
un aspect irrité, et de sa tête pendent de guirlandes
de cinq couleurs. Des écharpes divines couvrent ses
oreilles. Dans la main gauche supérieure il tient une
clochette d'or, dans la droite un Diamant à cinq
pointes; son Attitude est celle d'un Etre maintenant
le Plan des Etres. Dans la main gauche du milieu il
tient un arc de Diamant, dans la droite une flèche
de Diamant, comme s'il décochait de la lumière
d'étoile pour créer l'Essence de la grande Attrac-
tion. La main gauche inférieur tient 'cela' (un objet
dont le choix est laissé aux fidèles: Joyau, corps
humain, tête humain, sac, etc.; en général c'est le

61. Aizen Myōō

Joyau; cf. Kkzs. V qui donne plusieurs images ne variant que par l'attribut tenu dans cette main), et la droite un lotus Il est assis les jambes croisées sur un lotus rouge placé sur un vase précieux, des bords duquel s'échappent des Joyaux".[4]

The iconographic significance of the fist remains mysterious and traditional commentaries on this matter are rather vague. Vajrabodhi used in his Chinese translation the enigmatic phrase *ch'ih pi,* literally meaning "to hold that" or "to restrain that." A similar term, for example, is *ch'ih shen,* "to restrain the passions." Since all other attributes of Aizen Myōō seem to point to the basic dual aspects of human nature, male and female, one is tempted to interpret the fist of the King of Passion as an erotic gesture. This certainly would not be unusual in Esoteric Buddhist imagery. In Left-handed Tantrism the *vajra* is the mystic symbol of the *linga* or phallus, the corresponding *ghantā* or *vajra* bell indicates the female sex. The same relation may be established for the bow and arrow, derived from the emblems of Kāma, the Hindu God of Love, and the magic fist representing the male principle would correspond in this context to the *padma* or lotus symbolizing the female principle, or, to be more precise, the *yoni* or vulva. Such an interpretation does not seem too far-fetched for the Mahārāja, the "Great Passion," or God of Love, as the common people looked upon him.

The Rietberg painting belongs to the traditional "mystic fist" type which was already incorporated by the monk Shinkaku (1117–1180) in his extensive compilation entitled *Besson Zakki,* "Notes on Objects of Particular Reverence."[5] Shinkaku, who collected and coordinated the iconographic works of both schools of Esoteric Buddhism, Shingon and Tendai, for the last twenty years of his life on Mount Kōya, did his drawings in the spirit of systematic, faithful transmission of sacred icons and their specific features. In the case of his Aizen Myōō, he added a personal note to the effect that his image was executed in the style of the Endō of the Ninnaji in Kyoto. Commenting upon this vague statement some decades later, the priest Kakukyō

(1167–1242) pointed out in his *Sansō-ki Ruijū* that it probably referred to the style of an older, probably eleventh century prototype preserved in the sutra library of the Ninnaji's "Polygonal Hall" or Endō.[6]

The oldest extant painting of this type is now owned by the Bunka-chō.[7] It probably dates from the late twelfth century. Closest in style to the Rietberg Aizen Myōō, however, is the example preserved in the Gokoku-in, Tokyo.[8] The general color scheme, especially in the intricate gold patterns and subtle nuances of red, the tendency towards severe hieratic symmetry, and the decorative, ornamental qualities support a late Kamakura period date for both paintings. Although the worship of Aizen Myōō rapidly increased after the eleventh century, most of the surviving paintings of the deity were made during the Kamakura period. His popularity rose to such a degree that Japanese dyers made Aizen their special object of worship because of sheer incidental homophony of his name with the term for their business (*ai* = indigo, *zen* = dyeing).

Not previously published.

Notes

1. J. Rosenfield, *Japanese Arts of the Heian Period: 794–1185* (New York, 1967), p. 108, no. 4.
2. Takakusu Junjirō and Watanabe Kaigyoku, eds., *Taishō Shinshū Daizōkyō* (Tokyo, 1924–1932), vol. 18, no. 867, pp. 253–269, especially p. 256.
3. Sekiguchi Masayuki, "Hosomi-ke Shozō Aizen Myōō Ga-zō ni tsuite," *Bijutsu Kenkyū,* no. 274 (March 1971), pp. 209–222.
4. S. Lévi, J. Takakusu, P. Demiéville, eds., *Hōbōgirin,* Dictionnaire encyclopédique du Bouddhisme d'après les sources chinoises et japonaises, premier fascicule: A–Bombai (Tokyo, 1929), p. 16.
5. Takakusu Junjirō and Ono Gemmyō, eds., *Taishō Shinshū Daizōkyō Zuzō,* vol. 3 (Tokyo, 1932), p. 461, fig. 184.
6. Sekiguchi Masayuki, "Bunka-chō Hokan — Aizen Myōō Gazō," Zuhan Kaisetsu, *Bijutsu Kenkyū,* no. 280 (March 1972), pp. 224–227.
7. Ibid., pls. I, II.
8. *Jūyō Bunkazai,* vol. 7: *Kaiga I* (Tokyo, 1972), no. 236.

62 Blue Fudō Myōō (Ao Fudō) with Kongara and Seitaka Dōji

Japan; Nambokuchō period, third quarter of the fourteenth century A.D.
Hanging scroll, colors and gold paint on silk;
H. 129 cm, W. 56.7 cm
Gift of the Schweizerischer Bankverein

In Esoteric Buddhism the *vidyārājas*, or Bright Kings, manifest the awesome power and militant energy of the five *tathāgatas* brought to bear against heresy, passion, ignorance, illusion, and other spiritual obstacles. Although their physical appearance is wrathful and terrifying, their anger is compassionate. The *godai myōō*, as they are called in Japanese, are considered to possess great magical strength. The most commonly depicted of these five in Japanese Mikkyō art is undoubtedly Fudō. His Sanskrit name Acala or Acalanātha means the "Immovable One," the unshakable, indomitable adherent and protector of the Buddhist Law. From a subordinate deity, converted to Buddhism, he rose to the level of the wrathful incarnation of the supreme Buddha Mahāvairocana, known as Dainichi Nyorai in Japanese.

Although his name and iconography are thought to be of Indian origin, Acala does not appear in the art of either India or Central Asia. The earliest images hitherto known were discovered in China. Of ten white marble sculptures with traces of gold and polychromy that were excavated in 1959 in the old Ch'ang-lo ward of the T'ang capital Ch'ang-an, just outside the northeastern corner of present Sian City, two represent the ferocious-looking Acala in full regalia seated on a rock shaped pedestal.[1] These statues, probably dating from the second quarter of the eighth century, are likely to have been made for the great monastery An-kuo-ssu which historical records locate in this ward. It was founded in A.D. 710 and fell victim to the anti-Buddhist persecution of the middle of the ninth century.

In Japan the earliest Fudō representations do not antedate the beginning of the ninth century. In scriptural sources the Immovable One seems to have made his first appearance along with the other four *vidyārājas* as a set group in the "Sutra of the Benevolent Kings," known in Japan as *Ninnō-kyō*, of which the Sanskrit original has been lost. There are, however, two Chinese translations of this scripture, one attributed to the Indo-Iranian missionary Kumārajīva (ca. A.D. 350–410), but thought to be of slightly later Chinese invention, and the other prepared in A.D. 765 by Amoghavajra (705–774). Important textual evidence for Fudō Myōō, his physical characteristics and attributes, is provided by two early eighth century Chinese translations. In A.D. 709 the southern Indian monk Bodhiruci (672–727) translated the *Amoghapāśakalparāja-sūtra* (*Fukū-kensaku Jimben Shingon-kyō* in Japanese),[2] and sixteen years later the famous Indian theologian Śubhakarasimha (637–735) received assistance from his Chinese disciple I-hsing (638–727) in translating and commenting on one of the fundamental Esoteric Buddhist texts, the *Mahāvairocana*

bhisambodhi-sūtra, known in Japan as *Dai-Birushana Jōbutsu Jimben Kaji-kyō* or under its abbreviated popular title *Dainichi-kyō*.[3]

In traditional Japanese painting three basic types of Fudō representations may be distinguished: the yellow Acala or Ki Fudō, the red one or Aka Fudō, and the blue one or Ao Fudō. The Rietberg picture belongs to the latter category and the outstanding example of this type is, without question, the Ao Fudō of the Shōren-in, Kyoto, dating from the mid-eleventh century.[4] Accompanied by his two boyish acolytes Kongara and Seitaka, this iconographic type was to remain the most prominent and enduring one throughout the development of Japanese Buddhist painting, since popular interest and trust in the protective powers of the raging *vidyārājas* and their miracle-working servants increased during the middle ages.

The Rietberg painting, like several older versions, is laid out in a triangular composition. Fudō Myōō sits in a slightly informal position atop a bizarre flat rock surrounded by turbulent waters. This relaxed pose with the left leg pendant, the foot resting on a rocky promontory, and the right leg drawn onto the seat, is more familiar as *lalitāsana* from representations of other Buddhist deities and rather unusual, perhaps even inappropriate, in the imagery of the Immovable One. His head is turned in three-quarter view toward the left. In keeping with the prescriptions of traditional Esoteric Buddhist texts his body has a dark blue color. He is cross-eyed, and two terrifying white fangs protrude from the corners of his mouth, giving his face an expression of ferocious aggressiveness. His curly hair, adorned with a lotus flower, is gathered in a plait over his left ear. A gold brocade robe with a delicate design of dragons among waves and with stylized floral patterns covers his lap and legs, while an elegant scarf billowing in the wind is draped over his left shoulder. The Bright King's necklace, armlets, and bracelets are painted with gold (*kindei*); so is the *vajra* haft of the sword in his right hand, which he uses to repel enemies and cleave the darkness of ignorance. The other attribute, invariably given to Fudō Myōō, is a noose in his left hand for fettering evil forces and for extending as a rescue-line to those reaching out for his help. Swirling flames in modulated tones of red and hues of gold dust surround the central image. They contrast beautifully with Fudō's dark body and add to the gloomy, mystical fervor and the divine severity of the icon.

Among the eight *dōji* or youthful attendants who serve Fudō Myōō, Kongara and Seitaka are the two most prominent and most frequently depicted. Both their names, Kimkara and Cetaka in Sanskrit, mean "servant" or "slave." Here they stand on rocky platforms that rise from the agitated waters. The most striking feature of these two figures is the color of their bodies; the warm red of Seitaka on the left contrasts with the cool white of Kongara on the right. Like that of his master, the body of Kongara is rendered with no indication of any modelling. Seitaka, on the other hand, is represented with soft ink washes along the contour lines to suggest vol-

ume and corporeality. He is shown in a rather awkward stance in frontal view and the slight inclination of his short neck and head toward the left as well as the position of his arms impart a sense of clumsiness and uncouth movement to the young servant. His face is characterized by an arched mouth, a flat, wide nose, and small eyes which challenge the beholder. He bites his lips in firm determination or anger. In his right hand he holds a rough, though gilded, stick, while his left clasps a three-pronged *vajra,* emblem of the "three secrets," or *sammitsu,* in Esoteric Buddhism: the secret of the body *(shin),* the speech *(ku),* and the mind *(i)* of the highest principle of the universe not immediately comprehensible to unenlightened human beings. Kongara is equipped with a long-stemmed lotus flower in his right hand and a thunderbolt of the *dokkosho* type in his left. The latter is usually likened to the essential true wisdom of the Absolute. Such attributes clearly demonstrate that Fudō's acolytes Kongara and Seitaka belong to the class of miracle-workers. They are endowed with supernatural powers to assist their master in his immovable commitment to protect the faith and its adherents.

Although the Rietberg Fudō image is imbued with violent energy and deterrent force, this representation does not convey the psychological drama and overwhelming presence of some of the best Heian and Kamakura icons. A tendency towards decorative, ornamental surface cannot be overlooked. The artist has emphasized complex, small-scale patterns of the textiles and in certain parts also the strong, bold use of line. The heavy dark contours of the rocky promontories, for example, are enhanced by a thin film of gold paint along the inside. Such a convention of highlighting a contour may also be observed in works of the semi-professional painter-monk Ryōzen, who flourished in the 1360s. Akiyama Terukazu and Yanagisawa Taka have recently expressed the opinion that the Rietberg painting reveals some stylistic affinities to the standing Fudō Myōō in the Seikadō Foundation, Tokyo, a work that bears a hidden signature of Takuma Eiga, active during the second half of the fourteenth century.[5] Therefore, the Rietberg Fudō may be dated with some confidence to the third quarter of the fourteenth century, as has been suggested by these two Japanese authorities.

62. Blue Fudō Myōō with Kongara and Seitaka Dōji (color illustration p. 80)

Not previously published.

Notes

1. Ch'eng Hsüeh-hua, "T'ang t'ieh chin-ts'ai-hui shih-k'e-tsao hsiang," *Wen-wu* (1961), no. 7, pp. 61–63.

2. Takakusu Junjirō and Watanabe Kaigyoku, eds., *Taishō Shinshū Daizōkyō* (Tokyo, 1924–1932), vol. 20, no. 1092, pp. 227–398.

3. Ibid., vol. 18, no. 848, pp. 1–55.

4. Takada Osamu and Yanagisawa Taka, *Butsuga,* Genshoku Nihon no Bijutsu, vol. 7 (Tokyo, 1969), pls. 56, 57.

5. *Jūyō Bunkazai,* vol. 7: *Kaiga I* (Tokyo, 1972), no. 212; and Tanaka Ichimatsu, *Nihon Kaigashi Ronshū* (Tokyo, 1966), fig. 67, p. 142.

63 Fudō Myōō with Kongara and Seitaka Dōji

By Chūan Bonshi (1346–died after 1437)
Japan; Muromachi period, second quarter of
the fifteenth century A.D.
Three hanging scrolls, ink and red and brown
color on silk
Fudō: H. 100.4 cm, W. 38.6 cm; Kongara: H.
100.1 cm. W. 37.4 cm; Seitaka: H. 100.2 cm,
W. 37.4 cm

As a wrathful manifestation of Dainichi Nyorai, in
Sanskrit Mahāvairocana, Fudō Myōō or Acala (also
Acalanātha) embodies the supreme Buddha's great
force to extinguish all evil and symbolizes, among
other aspects, fearlessness and steadfastness in the
face of temptation, passion, and egoism. In this
capacity he was not only worshipped in Esoteric
Buddhism, but apparently also had a certain appeal
to austere Zen adherents in Japan. Ryūshū Shūtaku
(1308–1388), better known by his popular name
Myōtaku, was one of the first Zen priests to dedicate
his main artistic activity to representations of Fudō.
Having received his religious education and train-
ing from the famous Zen master Musō Soseki
(1275-1351), he was appointed head of several re-
nowned Zen institutions in Kyoto, among them
Tenryūji, Kenninji, and Nanzenji. According to his
biography, towards the end of his life Myōtaku
painted Fudō images every day for twenty years.
The practice of painting, drawing, or printing a
certain number of Buddhist images each day or
month in untiring repetition to fulfil a religious vow
was believed to be an effective method of ac-
cumulating religious merit and virtue. There is, for
example, documentary evidence for the printing of
ten thousand Fudō images in the late Heian period,
and a series of Jizō images is known, in which the
prints were made each day from the first to the
fourth month of the year 1327.[1] Woodblock prints
of this sort were often placed inside Buddhist
statues in order to increase their religious content
and efficacy as well as to add to their donors' merit.

Among the extant representations of Fudō by
Ryūshū Shūtaku is a hand-colored print of 1385.[2]
Other images of the Immovable One by his hand,
drawn with fluent, dynamic black brushlines and
light coloring on silk, have been preserved in the
Tokiwayama Bunko, Kamakura (dated 1379);[3] the
Tokyo National Museum (dated 1386);[4] the Freer
Gallery of Art, Washington, D.C. (reg. no. 07.651);
the Masaki Art Museum, Izumi-Ōtsu near Osaka;
the Henshōkō-in in Wakayama Prefecture (trip-
tych, dated 1387);[5] and the Junei-in, a subtemple of
Tenryūji that was founded by Ryūshū Shūtaku
(triptych, undated). Iconographical dicta left little
or no room for drastic changes or an artist's indi-
vidual interpretation in rendering a Buddhist deity,
so images of the same figure are apt to look very
much alike. But the fact that Myōtaku's Fudō rep-
resentations are virtually identical can only be ex-
plained by his devotional frame of mind. His im-
ages seem to have initiated a lasting stylistic tradi-
tion.

That he considered painting a spiritual exer-
cise and a daily self-imposed clerical duty probably
also accounts for the surprisingly identical Fudō
images done by the Zen priest Chūan Bonshi.[6] He
seems to have dedicated his entire artistic energy to
this religious theme, since no works other than
paintings of Fudō and his two acolytes Kongara and
Seitaka Dōji survived from his brush. He repeated
the figure of the Immovable One over and over
again, so that in inscriptions on two of his paintings
he refers to this image as *Nyo-nyo-Fudō*, "One like
another Fudō." Like Ryūshū Shūtaku half a century
earlier, Chūan Bonshi did not pursue his devotional
artistic activities merely for his own sake and for an
increase in virtue. Some of his works were made for
other priests or Buddhist laymen, as can be seen
from the dedicatory remarks inscribed on his paint-
ings. These inscriptions also reveal that he began
making repetitive images of Fudō Myōō, in some
cases flanked by his two boy attendants on separate
scrolls forming a triptych, only toward the end of
his life, in his eighties and nineties, when he called
himself *rōnō*, "the old priest."

Little is known about Chūan Bonshi's biog-
raphy. Traditional sources, such as Kanō Einō's
(1634–1700) *Honchō Gashi* of 1678 or the *Koga Bikō*
by Asaoka Okisada (1800–1856), give the informa-
tion that he was a follower of the well-known Zen
prelate Shunoku Myōha (1311–1388) of Tenryūji in
Kyoto, that he headed Kenninji in the ninety-third
and Nanzenji in the ninety-sixth generation as ab-
bot, that he produced a number of Fudō pictures
closely related to those of Ryūshū Shūtaku and that
he painted in the style of the famous Chinese Sung
master Mu-ch'i (died between 1269 and 1274), a
favored statement in Japanese sources which
should not be taken at face value. Considering the
high offices he held, Chūan Bonshi must have been
a prominent member of the Kyoto Zen circle
around 1400.

In the closely knit cultural sphere of *gozan*
monasteries, the fourth Ashikaga Shogun
Yoshimochi (1386–1428) played an integral role. He
often sponsored literary gatherings for monks
talented in poetry in the Chinese style. It was
Yoshimochi who commissioned Josetsu of the
Shōkokuji, perhaps the most brilliant *suiboku* artist
of his generation, to paint *Catching a Catfish With a
Gourd* in around 1413. This famous hanging scroll
owned by the Taizō-in of Myōshinji in Kyoto was
inscribed with verses in Chinese by thirty-one nota-
ble Zen monks, among them such famous per-
sonalities as Gyokuen Bompō (1348–died after
1420), Genchū Shūgaku (1359–1428), and also our
Fudō devotee Chūan Bonshi.[7] The picture may
have served some commemorative purpose, possi-
bly celebrating a poetry gathering of so-called
bunjin-sō, or "humanist monks." This sheds some
light on Bonshi's personality and his rank in Kyoto's
clerical and intellectual community of the early fif-
teenth century.

Additional biographical evidence can be
gained from inscriptions and signatures on Chūan
Bonshi's extant paintings. The most significant
work in this context is a triptych with Fudō Myōō
and his two young servants in the Hosomi collection
in Osaka, formerly owned by the Rokuō-in in Kyoto
(fig. 63a).[8] It is dated in two of the colophons in

accordance with 1425, and in his signature on the central scroll Bonshi states that he was eighty years old (seventy-nine by Western count) when he painted the pictures. Thus the year of his birth can be established as 1346. His latest extant work, hitherto known, is the Fudō scroll in the Museum of Fine Arts, Boston (fig. 63b). Chūan Bonshi executed it at the age of ninety-two years, in 1437.[9]

Eight years earlier, in 1429, he painted a Fudō image for Yōken Shūkan, a descendant of the imperial family and a Zen adherent of the Shūkō-in, who is said to have died in 1431 at the age of fifty-six years. This painting has been preserved in the Jinkō-in in Kyoto (fig. 63c). Another dated work is a Fudō triptych owned by the Masaki Art Museum.[10] It is dated in correspondence with 1434. Of about the same period is the undated representation of Fudō Myōō and his two acolytes which entered the Rietberg Museum in 1972. The three hanging scrolls were discovered in a private collection in Basel. They were, as one might expect, mislabeled as paintings by Myōtaku. Closer examination, however, clearly reveals on the central Fudō scroll near the lower right margin Chūan Bonshi's signature

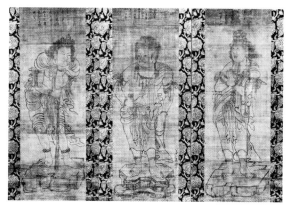

Fig. 63a. Fudō Myōō with Kongara and Seitaka Dōji by Chūan Bonshi. Japan, A.D. 1425. Hosomi Collection, Osaka.

reading: *Chūan rōnō zu en*, "a drawing by the old priest Chūan." The five-line inscription at the top of the scroll, placed off center toward the left, has become illegible. But it should no doubt be read from left to right. In keeping with an established practice of the time observed mainly in religious figure painting, Chūan Bonshi always started his inscriptions on that side towards which the image in three-quarter view is facing. This rule was particularly applied to Zen Buddhist portraiture, where the direction toward which the image faced distinguished portraits done during the sitter's lifetime from posthumous ones. The two flanking pictures of the Rietberg triptych bear no inscriptions. When they were remounted, all three hanging scrolls were obviously trimmed, most notably at the bottom. Numerous horizontal cracks run through the darkened brown silk.

All five extant works from Chūan Bonshi's brush show the ferocious-looking Immovable One in the same posture. Motionless he stands atop a stepped pedestal, representing a rocky crag. He carries his customary attributes, a sword in his right and a lasso in his left hand. The elaborate necklace, bracelets, armlets, and anklets add to the royal appearance of the Bright King. Almost hypnotic force radiates from his expressive facial features, espe-

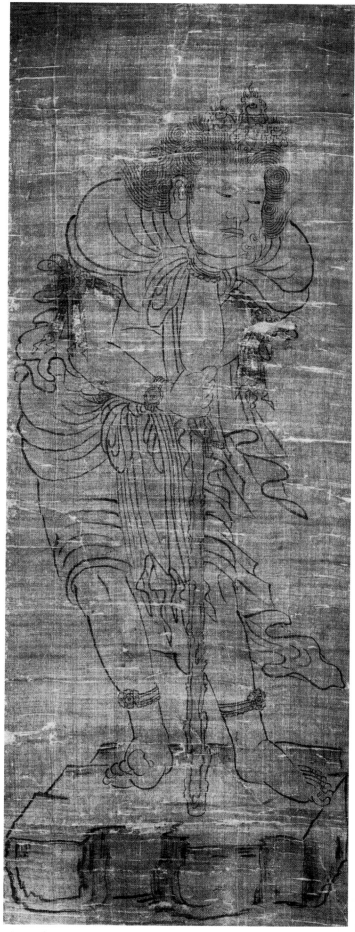

63. Fudō Myōō with Kongara and Seitaka Dōji

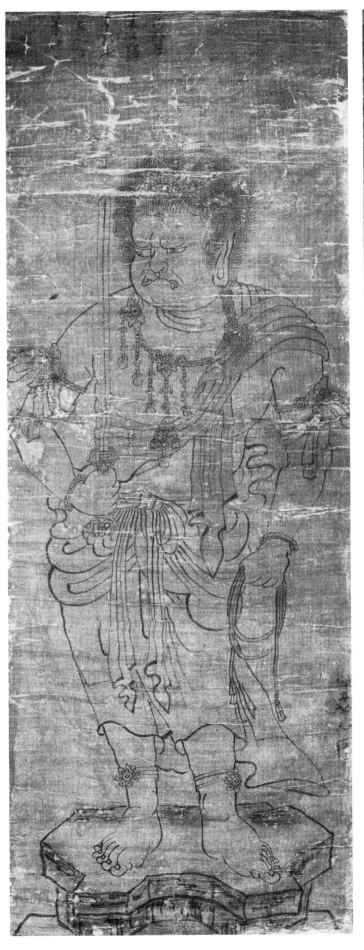
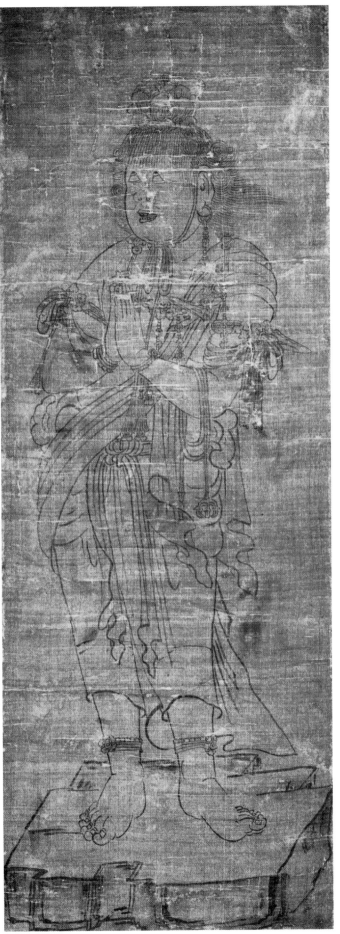

cially the bulging, uneven, squinting eyes and the wide, wry mouth with protruding fangs and the lips firmly pressed together in intense determination. In his curly hair, tied in a plait over his left shoulder, he wears a lotus flower to show his support of the Buddhist Law. Scarfs and skirt sweep around his mighty, half-naked body in sinuous interlocking movements. In fact, Chūan Bonshi's line is never static; it is fluid and modulated. His images are infused with an animated sense of pulsating life and vigor, although he repeated them without any changes even in the minutest details.

In the three triptychs in the Hosomi collection, the Masaki Art Museum, and the Rietberg Museum, the two young miracle-workers are also represented very similarly. Seitaka Dōji, flanking his master on the left, leans upon his stick in a provokingly apathetic stance, his eyes uninterestedly cast down and his chin resting in his left hand. The toes of his right foot are lifted up, as if they were moving in sheer boredom. His companion Kongara on the other side has clasped his hands together in a pose of devout adoration. Under his left arm he holds a thunderbolt, and a noose is hanging from his left forearm, an attribute that he can use to support his master in arresting evil spirits or extend to those seeking Fudō's aid. Originally his glance may have been directed up at the Bright King, but here it seems as if the naive, boyish servant was more concerned about his flowery headgear tied with a string around his chin. This corresponds to three flaming pearls on a flower arrangement that Seitaka supports on his head. Both attendants stand on flat rock formations with rigid contours. The Zen painter rendered Fudō's acolytes with a remarkable touch of human movement and humor.

Not only in his general conception of the theme, but also in his style and technical execution — he mainly employed fluent, modulated, firm brushlines and only a little, subdued color—Chūan Bonshi followed very closely in the tradition of Ryūshū Shūtaku. He must have known the Fudō images of his older Zen colleague, and there can be

no doubt that this manner of representing the Immovable One with his two boyish attendants harks back to an older prototype created in the middle of the thirteenth century by Takuma Chōga.

An artist Hōgen Chōga is recorded to have been active in 1253. He seems to have worked mainly for the renowned Shingon temple Daigoji near Kyoto, which still owns a superb ink drawing of a seated Fudō Myōō from his brush.[11] Two paintings in color with Kongara and Seitaka Dōji standing atop rocky crags surrounded by turbulent waters were acquired by the Freer Gallery of Art in 1970. Near the outside edge of each scroll a seal reading *Chōga* is barely discernible above the water.[12] The central scroll with Fudō Myōō has been lost. It must have looked like Myōtaku's version of 1378 which has survived as an intact triptych in the Henshōkō-in.[13] Without doubt, more than a century later the Zen priest-painter Myōtaku modelled his various Fudō representations upon Chōga's influential work and through his untiring artistic efforts he provided the source of inspiration for Chūan Bonshi. Their Fudō images represent a type of Buddhist figure painting that turns away from the colorful orthodox pictures. Their masterly *hakubyōga*, stimulated by a deep religious devotion for the Immovable One, stand between the sketchy iconographic drawings, or *zuzō*, and more elaborate monochrome ink paintings favored by other Zen priest-painters of that time.

Not previously published.

Notes
1. Ishida Mosaku, *Japanese Buddhist Prints* (Tokyo, 1964). p. 30.
2. Ibid., pl. 6.
3. Sugahara Hisao, *Japanese Ink Painting and Calligraphy* (Brooklyn, 1967), no. 9.
4. Tani Shin'ichi, ed., *Chūsei Kaiga*, Nihon Bijutsu Taikei, vol. 4 (Tokyo, 1960), pl. 62.
5. Kanazawa Hiroshi, *Shoki Suibokuga*, Nihon no Bijutsu, vol. 69 (Tokyo, 1972), pl. 125.
6. Umezu Jirō, "Chūan Bonshi Hitsu Fudō Ni-Dōji-zō ni Kanshite," *Bijutsu Kenkyū*, no. 69 (September 1937), pp. 365–370.
7. Matsushita Taka'aki and Tamamura Takeji, *Josetsu, Shūbun, San-ami*, Suiboku Bijutsu Taikei, vol. 6 (Tokyo, 1974), pl. 5, pp. 168, 187, 204.
8. Umezu Jirō, "Chūan Bonshi Hitsu Fudō Ni-Dōji-zō ni Kanshite," pl. V.
9. Horioka Chimyō, "Hakubyō Zuzō ni tsuite," *Bukkyō Geijutsu/Ars Buddhica*, no. 90 (February 1973), special issue: The Museum of Fine Arts, Boston, pp. 73 and 76, fig. 19.
10. *Masaki Bijutsukan: Shuppin Mokuroku*, no. 3 (1969), p. 2.
11. Tanaka Ichimatsu and Yonezawa Yoshiho, *Hakubyōga kara Suiboku e no Tenkai*, Suiboku Bijutsu Taikei, vol. 1 (Tokyo, 1975), pl. 97.
12. Tanaka Ichimatsu, "Ebusshi Chōga to sono Sakuhin," *Nihon Kaigashi Ronshū* (Tokyo, 1966), pp. 134–147; and *Masterpieces of Chinese and Japanese Art*, Freer Gallery of Art Handbook (Washington, D.C., 1976), p. 97.
13. Umezu Jirō, "Chūan Bonshi Hitsu Fudō Ni-Dōji-zō ni Kanshite," pl. VI; and Kanazawa Hiroshi, *Shoki Suibokuga*, pl. 125.

Fig. 63b.
Fudō Myōō by
Chūan Bonshi. Japan,
A.D. 1437. Museum
of Fine Arts, Boston

Fig. 63c.
Fudō Myōō by
Chūan Bonshi.
Japan, A.D. 1429.
Jinkō-in, Kyoto

64 Little Horned Devil among Tiger Lilies

By Hinaya Ryūho (1595–1669)
Japan; Edo period, ca. mid-seventeenth century A.D.
Hanging scroll, ink on paper; H. 28.5 cm, W. 50.3 cm
Gift of the Rietberggesellschaft

Little is known about the life and career of Hinaya Ryūho. The information and dates provided by traditional sources are rather scarce and contradictory. Some say he was born as Nonoguchi Chikashige in Hotsu, a place in old Tamba Province, others introduce him as a native of Kyoto. Most of them agree on the year of his death as 1669, but there seems to have been considerable uncertainty concerning his age; the statements vary between seventy and seventy-five years. We are told that he was the owner of a traditional Kyoto doll shop, a *hinaya*, and hence became known as Hinaya Ryūho or Rippo. He certainly was not a professional artist; he seems to have created paintings and poems mainly for his own and his friends' amusement. The *Koga Bikō* (vol. 1, 12, pp. 451 ff.), compiled by Asaoka Okisada (1800–1856), gives the information that he was taken with the new style of poetry which had become popular early in the seventeenth century, the *haikai* linked-verse. He reportedly was an ardent admirer and student of Matsunaga Teitoku (1571–1653), who led a new movement in *haikai* poetry and compiled for it a special code. His teachers in painting are said to have been Tawaraya Sōtatsu (active ca. 1600–1640) and Kanō Tanyū (1602–1674), one of the most prolific artists and connoisseurs of the time.

A somewhat clearer picture of this shadowy figure with obvious artistic and literary inclinations and talents was provided by Mori Tōru in his article "Kyūsoku Kasen-e ni tsuite."[1] According to Ryūho's own assertion in his *Naniwa no Wakare*, a work preserved in the Tenri Toshokan, he was born in the Ichijō quarter, located in the northern part of Kyoto. From all available evidence it was most likely in the year 1595. He probably had no choice but to join his family's business making *hina-ningyō*, or "festival dolls," which he seems to have also sold in Edo on certain occasions. Around 1642, however, he closed the doll shop, apparently in order to devote himself exclusively to his true interests, poetry and the arts. Already in 1633, when he was presumably thirty-eight years old (by Western count), he had compiled a collection of *haiku* under the title *Haikai Hokku-chō* and four years later, in 1637, he published in honor of his deceased father the *Tsuizen Kyūhyaku-in*, "Nine-Hundred Verses of the Buddhist Memorial Service." The sixth decade of his life he spent mainly in Edo, travelling to Osaka and as far south as Tsukushi on Kyūshū. Around 1651 he is reported to have served the feudal clan of Fukuyama in ancient Bingo Province as *haikai* expert. Mizuno Katsushige had built his residence there in 1619 and his descendants resided in the castle until 1698. Ryūho seems to have established close ties with the Mizuno family, because he travelled back and forth between Fukuyama, Kyoto, and

Edo. It must have been during the mid-fifties that he painted the framed picture series of the "Thirty-Six Immortal Poets" (*Sanjūrokkasen*) for the Myōō-in in Fukuyama City.[2] He cultivated not only the friendship of influential lords, but also that of the clergy. This is evinced by his association with the Buddhist priest Hōrin Shōshō (died 1668) of the Rokuonji in Kyoto, who was appointed ninety-fifth abbot of the Zen temple Shōkokuji in 1625. Shōshō recorded in particular Ryūho's relations to the nobility of the day for the period between 1652 and 1660 in his *Kakumei-ki*. Furthermore, a number of recorded and extant paintings testify to the artist's interest in Buddhist subjects. Among others, he painted at least two versions of the *Tomo no Kannon-dō Engi*, one of which has been preserved in the Tōkyō Geijutsu Daigaku Toshokan and presumably dates from around 1661.[3] Since the middle ages Tomo was renowned for its scenic beauty. It is the port of Fukuyama on the Inland Sea and its Kannon temple on a craggy promontory high above the waters commands an impressive view. Among his ink paintings in *zenga* style, a picture of "Śākyamuni Returning from the Mountains" (*Shussan Shaka-zu*) with a *haiku* inscription ought to be mentioned in this context. Ryūho used in his signature and seal the term *Nichiyū*, indicating that he, like many other artists and poets of the age, was affiliated with the powerful Nichiren sect. On another painting showing a courtesan in purest *ukiyo-e* style,[4] he styled himself *Kyōunshi*, "Master of the Crazy Cloud," confirming his admiration for and spiritual kinship with the popular eccentric Zen priest Ikkyū Sōjun (1394–1481) by using the same sobriquet.

Hinaya Ryūho was on one hand a facile, rather eclectic painter receptive to a broad range of artistic trends. He experimented with a rich variety of styles, ranging from conventional *yamato-e* in the Kanō school tradition to *Nara-e*, *ukiyo-e*, and illustrations for woodblock prints. On the other hand, however, he was primarily concerned with lending to his poetic ideas and feelings an appropriate pictorial expression, because temperamentally, he was unquestionably a poet, gifted in both *haiku* and *kyōka*, comic or satirical verses. He was the first to represent the "Thirty-Six Immortal Poets at Ease" (*Kyūsoku Kasen-e*), not without a touch of humor and caricature.[5] But above all he must be considered instrumental in the establishment of *haiga*. His imaginative, sketchy ink paintings accompanied by his evocative seventeen-syllable *haiku* were quite adventurous innovations in the first half of the seventeenth century, but he seems not to have received the proper credit for it during his lifetime and sank into oblivion soon after his death. Ryūho, who emerged from the merchant class like one of his supposed teachers, Sōtatsu, appears to have been an isolated figure in spite of his occasional contacts with the nobility and the clergy of the new Tokugawa establishment. He is said to have been unhappy, frustrated and disappointed perhaps with the lack of recognition and appreciation of his artistic efforts after he had sacrificed his family business for more idealistic pursuits. According to the *Hanami Guruma*, published in 1702, he was buried at

the Yōhōji in the Nijō Teramachi quarter of Kyoto. But since this temple was moved from its original site in 1708, no traces of his tomb are to be found.

Besides the three scrolls of the *Kanei Gyōkō-zu* in the Brooklyn Museum, the inspired little ink painting from the Rietberg Museum appears to be one of the few works by Hinaya Ryūho in a Western collection. Stylistically, it compares favorably to some of his *sumi-e* in the three handscrolls owned by the Tenri Toshokan, which clearly reflect the influence of Kanō Tanyū.[6] The Rietberg scroll skillfully mingles calligraphy and painting, poem and picture, word and image; it is a *haiga*, a *haiku* combined with a painting (*ga*). To present his poetic vision not only in extreme brevity, but also in a correspondingly condensed pictorial manner, the artist limited himself to a few abbreviated, absolutely essential elements. He placed them carefully and rendered the little horned demon and the tiger lilies with great economy of brush and ink, contrasting light washes with dry, rough, cursory brush-sweeps and elegant, curved, graceful lines with jagged, wiggly, partly "nail-headed" strokes.

The calligraphy of the *haiku*, written with a sure, vigorous brush in dark ink, is immediate and expressive. The characters are arranged in seemingly casual, but in fact precisely calculated asymmetry, and their placement in the upper right quarter of the horizontal scroll is essential for the balance of the whole composition. The poem is juxtaposed with the artist's signature at the lower left reading *Ryūho sho*, "written by Ryūho." His seal can be deciphered as *Shōō*, "The Venerable Pine."

Since poem and picture constitute an insepar-able unit, it is of crucial importance to understand the meaning of the *haiku*.

Oniyuri no	A dewdrop of a tiger lily,
Tsuyu ya nomori no	A water-mirror
Mizukagami	For a field-guard

<div align="right">(translated by Fumiko E. Cranston)</div>

The picture is not merely an illustration of the poem; this would be too simple. It is surpassingly imaginative and suggestive of several dimensions. The only obvious reference is to the flowers, the tiger lily. Ryūho avoids any directness in revealing the quintessence of his poetic idea. He provokes the viewer to ponder the poem-painting and to enter into the sphere of the artist's own personal emotions in relation to the subject-matter. On one level Ryūho's *haiga* is a pun on the Japanese term for the tiger lily (*tigridia pavoma*), because the first of the three characters that stand for this magnificent flower means "demon, devil, ghost, spirits of the dead" (*oni*), while the second and third (*yuri*) mean "lily." Thus the literal translation of *oniyuri* could be "demon-lily."

This, however, does not explain the significance of the field-guard and water-mirror motif. It alludes in a typical Japanese recondite conceit to a Nō drama entitled *Nomori* or *Nomori no Kagami*, "The Mirror of the Field-Guard."[7] The play, which was performed for the first time in 1505, draws from several older sources, tales, and legends. It tells about a *yamabushi* of Mount Haguro, an ascetic adherent of the Shugendō who retires sometimes for weeks to one or another sacred mountain. He

64. Little Horned Devil Among Tiger Lilies

once set out on a trip to visit Mount Ōmine and Mount Katsuragi, roughly between Nara Prefecture and the Kawachi district. On his way he met an old field-guard in Kasuga and they started to reminisce about stories of ancient times. They both remembered well the famous incident involving the twenty-first Japanese Emperor Yūryaku (reigned A.D. 456–479) whose beloved hawk Hashitaka had escaped during a hunting-party and finally was recaptured because a field-guard had discovered his reflection in the water. Touching also upon the legend of the owner of a mirror, who was a human being during the day and a roaming underworld demon at night, the old field-guard revealed his true identity. He was the proprietor of this mirror and instantly he disappeared into his grave. The *yamabushi* began to pray at the tomb and the ghost rose again to the surface. Although he tried to escape once more, the monk prevented him from doing so by calling upon the help of the Bright King Fudō Myōō and his miracle-working equipage. Thereupon the demon demonstrated his supernatural faculties: in the east he made the mirror image of the *vidyārāja* Gōzanze appear as well as the other Bright Kings of the South, West and North, and the reflections of Heaven and Hell. Then he was swallowed up by the ground.

This is the story relating to this unassuming little picture. Upon seeing his image reflected in a dewdrop, the underworld creature becomes aware of his deplorable nature. Ryūho imparted a melancholy expression to the face of his demon, who squats in a pose of grieved helplessness. He evokes the fundamental human emotions of loneliness and lament for the inevitable passing of life in the face of the reflection of mankind's ultimate mortality. The dewdrop epitomizes the oldest universal mirror, the glittering surface of water. Hinaya Ryūho captured the essence of *haiga*. With minimal, deceptively simple means, he conveyed a fascinating abundance of profound poetic and pictorial imagery shaped with sensitivity and a spirited imagination. *Haiga* must be considered the climax of casual, evocative precision in the arts of Japan, the ultimate in the fusion of poetry, calligraphy, and painting. Ryūho's art historical significance, however, his importance as the protagonist of this genre, as a versatile painter and talented poet, still awaits full recognition.

Published: H. Brasch, *Japanische Tuschmalerei: Nanga und Haiga* (Zürich, 1962), no. 1.

Notes
1. *Kokka*, no. 852 (March 1963), pp. 5–17.
2. Ibid., fig. 5, p. 10.
3. Ibid., figs. 6 and 7, p. 11.
4. Ibid., fig. 8, p. 12.
5. Ibid., fig. 1, p. 6 and fig. 3, p. 7.
6. Ibid., fig. 11, p. 15; see also fig. 9, p. 13 and fig. 10, p. 14.
7. H. Bohner, *Nō: Die einzelnen Nō*, Mitteilungen der deutschen Gesellschaft für Natur- und Völkerkunde Ostasiens, Supplementband 22 (Tokyo, 1956), pp. 590 ff.

65 Idealized Portrait of the Haiku Poet Matsuo Bashō (1644–1694)

By Kuwayama Gyokushū (1746–1799)
Inscribed by Katsumi Jiryū (1723–1803)
Japan; Edo period, last quarter of the eighteenth century A.D.
Hanging scroll, ink and light colors on paper; H. 97.5 cm, W. 28.3 cm
Gift of the Schweizerische Kreditanstalt

The Japanese term *bunjinga* (derived from the Chinese *wen-jen hua*), referring to the painting of scholar-amateurs or literati, is in modern writings on this chapter of the history of Japanese art more or less equated with the term *nanga*, an abbreviation of *nanshū-ga*, which literally means "Painting of the Southern School." Bunjinga denotes the social and intellectual status of the painter whereas Nanga represents an attempt to define an artistic tradition that involves matters of style. Kuwayama Gyokushū was one of the very few Japanese Nanga artists to verbalize his ideas and theories on painting and, even more unusual, to publish them, thanks to his financial affluence. In his *Gyokushū Gashu*, which he had printed in 1790, he wrote that he did not like to paint on large formats such as sliding doors or folding screens, since those were usually done on commission by professional artists for mere decorative purposes. He was fascinated by what eighteenth century artists in Japan considered to be the true Chinese literati tradition. Gyokushū himself certainly was a *bunjin* and had an astonishingly original view of the literati concept and the principles of Nanga, which he presented in his *Kaiji Higen*. This treatise was published by his admirer, the Confucian scholar Kimura Kenkadō (1736–1802), in 1800, one year after Gyokushū's death.

Like the great Chinese Ming painter-theorist Tung Ch'i-ch'ang (1555–1636), who had loosely arranged the scholar-amateur artists into a "Southern School" and contrasted them with the professional painters of the so-called "Northern School," Gyokushū set up a lineage of Nanga artists in his own country. Along with the highly esteemed masters Sōtatsu (active ca. 1600–1640) and Kōrin (1658–1716), he designated two less-known, but very distinguished artists, the courtier Konoe Iehiro (1667–1736) and the Shingon monk Shōkadō Shōjō (1584–1639), among his representatives of the Japanese "Southern School." Although Sōtatsu's and Kōrin's best known paintings are of rather decorative quality and bear little or no resemblance

to literati painting, Gyokushū probably included them mainly because they were not professionals. He highly respected them as cultivated gentlemen with wide ranging artistic interests. Shōkadō and Iehiro, both leading calligraphers of their day, were strongly independent spirits with conservative concepts with which they intended to restore the integrity of their culture. Above all, however, Gyokushū considered Ike no Taiga (1723–1776) "the best of our painters" and on his achievements he seems to have based his whole evaluation of Nanga.

Gyokushū met the great Nanga artist a few years before the master's death and became an intimate friend of his. This undoubtedly left a lasting impact on his artistic career. Born into a family of rich shipping agents in Kishū, Wakayama Prefecture, Gyokushū was privileged to lead the carefree life of a real gentleman-scholar-artist. Together with his life-long friend Noro Kaiseki (1747–1828), he travelled extensively, exchanged ideas, collected and studied books, obviously Chinese painting manuals in particular, and dedicated all his activities to the aesthetic ideals of Nanga.

In the Rietberg scroll Gyokushū evoked the lofty ideal of the true literatus with utmost sensitivity. He painted an idealized portrait of the celebrated *haiku* master Matsuo Bashō (1644–1694) and employed for his composition a formula which had become a standard in eighteenth century Japanese literati painting. The bearded aged poet sits content at the window of a simple, thatched hut under a gnarled old tree in quiet harmony with nature and in remote seclusion from the rest of the world. Contemplatively he gazes towards the left into the distance. In his right hand he holds a brush ready to write a poem on an immaculate sheet of paper placed on his desk next to the other writing utensils: ink stone, ink stick, and water dropper. A hat and a rough raincoat, visible at the upper left corner of the window, allude to the travelling scholar taking his ease in undisturbed solitude.

Through the close-up view and the undefined openness of the composition at top and bottom of the picture, all attention is focused on the pensive poet. Although Gyokushū was not particularly fond of painting figures, as he stated in his treatise of 1790, he successfully portrayed Bashō using soft ink washes and modulated, somewhat wavering brushlines. Dense dots of varying intensity characterize the foliage of the tree and fibrous texture strokes indicate the weathered surface of its trunk. Gyokushū's application of colors, an orange and pinkish red along with blue-gray combinations, tes-

65. Idealized Portrait of the Haiku Poet Matsuo Bashō (color illustration p. 81)

tify to his sensitivity and moreover to his special taste, which in all likelihood he developed through his studies of Chinese colored woodblock prints. The Chinese flavor of this work is intensified by the seclusion of the scene and yet the sense of warm intimacy with the venerated master of the past.

The inscription, occupying the upper third of the hanging scroll, was written by Katsumi Jiryū (1723–1803). He signed his paean to Matsuo Bashō with his pseudonym *Jiryūan.* Known as a poet in the Bashō tradition, he was probably a friend of the painter. He was a native of Yamanaka in ancient Kaga Province. Jiryū praises Bashō's cultivated sense of elegance and refinement and makes reference to the master poet's "Hermitage of Vision," the Genjū-an, in the shade of the Shii tree (*pasania cuspidata*), to his raincoat (*sugamino*), and his travelling hat (*hinokigasa*), represented in the painting. They appear to be allusions to Bashō's famous journey of more than two and half years to northern Japan and the coastal regions. Upon his departure in the spring of 1689 he is said to have sold his house in Edo; apparently he did not expect to return from his trip. Bashō's travel diary *Oku no Hosomichi,* "The Narrow Road to the Deep North," was to become one of his most celebrated and popular works. Katsumi Jiryū ends his eulogy with a *haiku:*

Sumikaeru	Changing a place of living,
Kokoro ni suzushi	My heart feels a fresh breeze
Shii ga moto	At the foot of the sweet acorn.

(translated by Fumiko E. Cranston)

This evocative poem captures the essence of Gyokushū's abbreviated pictorial reverence to Matsuo Bashō with whom the painter might have identified himself as Yosa Buson (1716–1783) did. The Rietberg portrait, done perhaps in memory of Bashō's famous journey but about a century later, epitomizes the feelings and affection that many eighteenth century literati cherished for the great *haiku* master of a past generation. The painter's signature *Sō-Shisan* and the double seals reading *Gyoku* and *Shū* at the lower left margin substantiate the assumption that the undated scroll should be considered a later work in Gyokushū's oeuvre, because he employed that particular way of writing his name (*san* with the "fire" radical) only toward the end of his career, probably in the 1780s and later.

Published: H. Brasch, *Japanische Tuschmalerei: Nanga und Haiga* (Zürich, 1962), no. 13.

66 Fan, Hat, and Long Sword

By Sakai Hōitsu (1761–1828) and Tani Bunchō (1763–1840)
Inscribed by Kameda Bōsai (1752–1826)
Japan; Edo period, first quarter of the nineteenth century A.D.
Hanging scroll, ink and light brownish red color on satin; H. 103.5 cm, W. 45.3 cm
Gift of Balthasar Reinhart

This hanging scroll is a vivid record of a drinking party in which three leading artists of their time participated and at which perhaps a fourth performing artist, a Kabuki actor, was present. In exuberant spirits they tried to outmatch each other in amateurish simplicity and ungainly boldness. It is a joint work of the aristocratic painter, wealthy collector, and art historian Sakai Hōitsu (1761–1828), who painted the folding fan and the ceremonial hat; the versatile Nanga master Tani Bunchō (1763–1840), who contributed the long sword; and the Confucian scholar, poet, philosopher, musician, painter, and calligrapher Kameda Bōsai (1752–1826), who added the inscription. All belonged to a coterie of artists in Edo, the present-day Tokyo, and each of these cultivated gentlemen probably would have been able to paint a better picture alone. But it was the joy of the momentary experience that inspired this bravura performance of wild, relaxed brushwork.

The three friends had gone to the Nakamuraza theater for the opening of the Kabuki season, probably sometime between 1815 and 1823. They thoroughly enjoyed themselves and were particularly enthusiastic about the traditional *Shibaraku* interlude, one of the eighteen classical Kabuki pieces. It was customarily interpolated during the introductory performances at the annual season opening (in the eleventh month), the so-called *kaomise,* or "face-showing," of all actors engaged for the current season. The title of this act means "Tarry a Moment!" and the plot is as simple as it is effective. The actor in this role usually posed dramatically on the *hanamichi,* the raised passage extending from the stage to the auditorium, and shouted with penetrating voice "Shibaraku," trying to prevent the villain on the stage from murdering his victim. Since 1697, when Ichikawa Danjūrō I (1660–1704) had performed this impressive interact for the first time at the Nakamuraza, it was the exclusive privilege of the leading actors of the Ichikawa line to play this spectacular role. Danjūrō VII (1791–1859) appeared in it as early as 1815 and again in a performance of the eleventh month of 1823, as vouched for by a number of colored woodblock prints.

This provides a certain clue to the dating of our painting, which the three friends Bōsai, Hōitsu and Bunchō did in spontaneous response to their joint visit to the Kabuki theater. But instead of depicting the actor himself in a complete and detailed manner, as the Ukiyo-e masters did, they chose to represent only the essentials of his outfit for the *Shibaraku*

role: an enormous sword (ōdachi), a folding fan (sensu or ōgi), and a black court hat (eboshi). In typical literati manner they left it to the educated viewer to appreciate the total resonance of the abbreviated, casual composition by steeping in the cultural atmosphere of the past. Bōsai's commemorative inscription makes it easier for us to share their creative experience and enjoyment:

"At seeing Danjūrō VII in the Shibaraku play. When a long sword and a large hat [the dressed actor] went up on the stage, applause and shouting voices did not calm down for a moment [shibaraku]. Yūmō [Danjūrō VII] transmitted his family tradition for seven generations and still now he is called the best in Edo. When Bōsai playfully wrote this he was terribly intoxicated."

(translated by Fumiko E. Cranston)

The calligraphy, written in Chinese, displays not only Bōsai's characteristic loose, uninhibited, swirling brush, but the abandon of his accelerated cursive script betrays his mood and inebriated state. Kameda Bōsai was a true literatus with a deep interest in Chinese philosophy and Confucian studies, here evinced through the phrasing of his inscription as well as through his reference to Yu Meng, Yūmō in Japanese, a Chinese actor of the Ch'un-ch'iu period (722–481 B.C.), to whom Bōsai likened his own Japanese contemporary Ichikawa Danjūrō VII. The seal he used for this joint work also testifies to his wide ranging knowledge and classical learning. It is quite unusual and the six characters ought to be read Udonbarage-an. They allude to the legendary tree ficus glomerata, called udumbara in Sanskirt, which is supposed to bear fruits without flowering. Since the tree is thought to blossom once in three thousand years it has become—mainly in Buddhist writings—a metaphor for exceptional rarity. In transfering this imagery to his studio name "Hermitage of the Blossoming Udumbara Tree," Bosai gave a hint of how he judged his position in his own age. Unfortunately he suggested reforms to the Edo government without success and his introspective Confucian teachings were eventually even proscribed. Bōsai took refuge in scholarship, arts, and wine. Some of his best calligraphies and paintings were done while drunk. On a painting in the Kurt and Millie Gitter Collection, New Orleans, he wrote:

"Without sake, Sarashima with its moonlight, snow and flowers is just another place;
Without sake to drink, Li Po and Liu Ling were just ordinary men."[1]

Something of the character of the two other artists who collaborated on this work is revealed in their respective brushwork. Bunchō loaded his brush heavily with ink before dashing it down to paint the sword with a bold, single, curved downward sweep. He liked to use stiff or worn-out brushes to create

the bristling, broad line quality with the effect of "flying white" or hi-haku (fei-pai in Chinese). Some sloppy dry brush strokes indicate the tsuba, the sword guard, and the scabbard's kurikata, a pair of slotted projections to which the cord for carrying the weapon was attached. The sageo, the tying-cord itself, is rendered with a wetter, relaxed brush in a light brownish red. Three tiny concentric squares indicate the surface structure of the hilt (tsuka), wrapped with a strong, flat silk braid, but at the same time they might be a hidden reference to the badge or mon of the Ichikawa line of actors, the famous mimasu. To the unsuspecting, inexperienced viewer, Bunchō's signature at the lower left must look like an unintentional ink blot with some casual scribbles. As in many of his works he wrote the first character of his name with a heavily loaded, extremely wet brush and the second one only with the thin tip of it.

Tani Bunchō was the leading painter of his age in Edo, and although he is usually grouped with members of the literati school, he experimented with a large variety of styles and followed many artistic trends. He must have been a brilliant, fascinating personality, witty and facile, producing paintings for his own pleasure and for his friends at a prodigious rate and giving them to anyone who wanted them. Large numbers of students and disciples gathered around him and his tremendous popularity made him a wealthy man. He enjoyed the comforts of life, participating in the usual carousing and pleasures of his day. He liked the Yoshiwara, the gay-quarters of Edo, and sake, the potent Japanese rice wine. In fact Bunchō is recorded to have preferred a special brand of sake named for him. One wonders whether he or his friend Bōsai drank more of it while playing with brush and ink to produce the present work.

Sakai Hōitsu, the third of the trio, was a man of strong character and conviction. He executed his part of the picture—the slightly opened folding fan and the actor's hat—in a more restrained, but for him eccentric, brush technique employing sharp, precise, and fairly descriptive lines as well as wet-ink washes. Hōitsu created just enough form and shape to tell the full story of that Kabuki performance. He even signed his contribution with Hōitsu hitsu, "painted by Hōitsu," and used his familiar seal, which, however, has not yet been adequately deciphered. The effects of his brushwork are muted in keeping with his image as an artist with monkish ways. He had taken the tonsure in 1797 to become a Buddhist priest of the Jōdo Shin sect.

Born in Edo into the Sakai family of wealthy samurai residing in the Himeiji castle west of Kobe, Hōitsu had received a conventional education. He was trained in the Chinese classics and Confucian thought, in literary as well as martial arts. After receiving painting instruction in various styles prevalent in his day, Hōitsu met Tani Bunchō, who is said to have encouraged him to revive the tradition of Ogata Kōrin (1658–1716). It suited his refined and somewhat aristocratic taste, and he developed

66. Fan, Hat, and Long Sword

his own distinctive style in the Kōrin manner, making lavish use of costly pigments and materials of finest quality and preferring subjects like flowers and plants, figures, birds and fish, but rarely turning to landscapes. One should not forget that the Sakai family had sponsored Kōrin since 1707, long before Hōitsu was born, and that in grateful return for this generous patronage he had left a number of his works in the Sakai household. Together with his friend Tani Bunchō, who wrote the foreword, Hōitsu published on the centennial of Kōrin's death in 1815 a connoisseur's record of the old master's authentic works that he had inspected, the *Kōrin Hyakuzu*, "One Hundred Masterpieces by Kōrin."

Sakai Hōitsu collaborated not only with Tani Bunchō, but also in a number of instances with Kameda Bōsai. Two of their finest joint works are a "Peony Flowering in the Winter"[2] and a "Sparrow on Bamboo" in the collection of Jean Pierre Dubosc, Paris and Tokyo (fig. 66a). In contrast to Hōitsu's meticulous brush technique these paintings represent his spontaneous, swift, expressionistic style in the best spirit of the literati and reveal another, lesser known aspect of his diversified talents and skills.

Without giving too much credence to the story, it should be noted that the Rietberg hanging scroll was supposedly mounted with the actor's original garment. Danjūrō VII is said to have joined the party after his performance and to have been so deeply moved by the high esteem for his art expressed by the three respected literati that he offered his red brown *suō* robe for the mounting. The work was certainly dedicated to the gifted young actor. It allegedly remained in the possession of the Ichikawa family for more than a hundred years, until it passed into the collection of Yamashita Kamesaburō, Kobe. In 1931 it was included in a Bunchō memorial exhibition held at the Tōkyō-to Bijutsukan to celebrate the inauguration of a monument in honor of Tani Bunchō. After the Second World War the hanging scroll appeared in an auction; it was then acquired by Heinz Brasch and later, in 1978, by Balthasar Reinhart, who in turn generously gave it to the Rietberg Museum.

Published: H. Brasch, *Japanische Tuschmalerei: Nanga und Haiga* (Zürich, 1962), no. 19; Collections Baur, Genève, *Peinture à l'encre du Japon (Nanga et Haiga),* Collection Heinz Brasch, Zürich (Geneva, 1968), no. 14.

Notes:
1. S. Addiss, *Zenga and Nanga: Paintings by Japanese Monks and Scholars* (New Orleans, 1976), no. 50, p. 134.
2. Tokyo National Museum, *Rimpa* (Tokyo, 1972), no. 221.

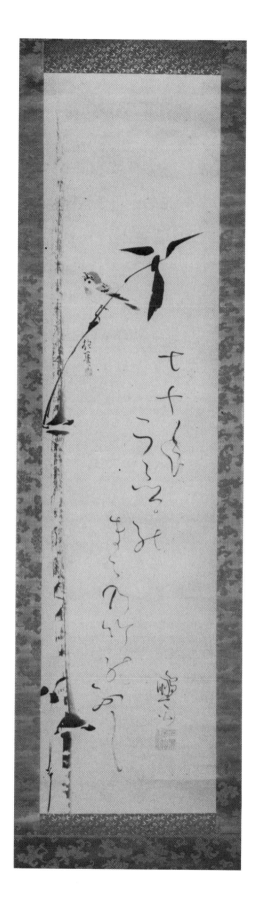

Fig. 66a. Sparrow on Bamboo
by Sakai Hōitsu with calligraphy by
Kameda Bōsai. Japan, first quarter
of the nineteenth century A.D.
Collection of Jean Pierre Dubosc.

174

All photographs of objects in the Rietberg Museum by
Isabelle Wettstein and Brigitte Kauf. Fig. 28a courtesy of
the Honolulu Academy of Arts; fig. 33b courtesy of Laur-
ence Sickman; fig. 36a by Werner Forman; fig. 40a cour-
tesy of The University Museum, University of Pennsyl-
vania; fig. 46a courtesy of The British Museum; fig. 63b
courtesy of the Museum of Fine Arts, Boston.

fig. 1a from D. Faccenna, *Sculptures from the Sacred Area of
Butkara*, vol. 1, part 2 (Rome, 1962), p. 23, pl. 63.

fig. 6a from U. Agarwal, *Khajurāho Sculptures and Their
Significance* (Delhi, 1964), p. 56.

fig. 16a from J. Soustiel and M.C. David, *Miniatures orien-
tales de l'Inde* (Paris, 1974), vol. 2, p. 16.

fig. 20a from M.S. Randhawa and J. K. Galbraith, *Indian
Painting* (London, 1969), pl. 17.

fig. 21a from Sotheby Parke-Bernet, *Catalogue*, sale 4264
(New York, 1979), no. 54.

fig. 22a from G. Groslier, "Les Collections Khmères du
Musée Albert Sarraut à Phnom-Penh," *Ars Asiatica* 11
(1931), p. 68.

fig. 22b from P. Dupont, *La Statuaire Préangkorienne* (As-
cona, 1955), p. 169.

fig. 24a from J. Boisselier, *La Statuaire du Champa* (Paris
1963), fig. 50.

fig. 32a from Kuanghsi Chuang-tsu tzu-chih-ch'u wen-wu
kuan-li wei-yüan-hui, ed., *Kuanghsi ch'u-t'u wen-wu*
(Peking, 1978), pl. 163.

fig. 33a from A. Salmony, *Carved Jades of Ancient China*
(Berkeley, 1938), pl. LXXI, 6.

fig. 34a from *Wen-hua ta-ke-ming ch'i-chien ch'u-t'u wen-wu*
(Peking, 1972), pl. 70.

fig. 34c from *Wen-wu*, no. 1 (1966), p. 39, fig. 41, left.

fig. 35a from Li Chi, *Anyang* (Seattle, 1977), fig. 50.

fig. 37a from *Wen-wu*, no. 1 (1966), p. 27, fig. 1.

fig. 37b from K. Finsterbusch, *Zur Archäologie der Pei-Chi-
(550 – 577) und Sui-Zeit (581 – 618)* (Wiesbaden, 1976),
pl. 75:12.

fig. 38a from L. Hájek and W. Forman, *Chinesische Kunst*
(Prague, 1954), pl. 99.

fig. 43a from Chen Wan-li, ed., *T'ao-yung* (Peking, 1957),
pl. 42.

figs. 44a, 44b from Shan-hsi-sheng wen-wu kuan-li wei-
yüan-hui, ed., *Shan-hsi-sheng ch'u-t'u T'ang yung hsüan-
chi* (Peking, 1958), pl. 128:1 – 2.

fig. 47a from Akiyama Terukazu et al., *Arts of China:
Neolithic Cultures to the T'ang Dynasty, Recent Discoveries*
(Tokyo/Palo Alto, 1968), pl. 377.

figs. 50a, 50b, 50c from *Wen-wu*, no. 7(1963), pp. 52–53.

fig. 52a from Tomura Taijirō, *Tenryūzan Sekkutsu* (Tokyo,
1922), pl. 73.

fig. 52b from O. Sirén, *Chinese Sculpture from the Fifth to the
Fourteenth Century*, vol. 1 (London, 1925), p. 57.

fig. 54a from *Historical Relics Unearthed in New China*
(Peking, 1972), pl. 194.

fig. 63a from Umezu Jirō, "Chūan Bonshi Hitsu Fudō
Ni-Dōji-zō ni Kanshite," *Bijutsu Kenkyū*, no. 69 (Sep-
tember 1937), pl. V.

Design by Dana Levy
Composition by LCR Graphics
Printed at the Press of A. Colish, Mount Vernon, N.Y.